5A

WITHDRAWN

P9-ARD-646

PROPERTY OF THE

Public Library of the City of Beverly

PUBLIC LIBRARY OF THE CITY OF BEVERLY

1855.

A Colossal Hoax

A Colossal Hoax

The Giant from Cardiff that Fooled America

Scott Tribble

ROWMAN & LITTLEFIELD PUBLISHERS, INC.
Lanham • Boulder • New York • Toronto • Plymouth, UK

ROWMAN & LITTLEFIELD PUBLISHERS, INC.

Published in the United States of America
by Rowman & Littlefield Publishers, Inc.
A wholly owned subsidary of The Rowman & Littlefield Publishing Group, Inc.
4501 Forbes Boulevard, Suite 200, Lanham, Maryland 20706
www.rowmanlittlefield.com

Estover Road
Plymouth PL6 7PY
United Kingdom

Copyright © 2009 by Scott Tribble

All rights reserved. No part of this publication may be reproduced, stored in a
retrieval system, or transmitted in any form or by any means, electronic, mechanical,
photocopying, recording, or otherwise, without the prior permission of the publisher.

British Library Cataloguing in Publication Information Available

Library of Congress Cataloging-in-Publication Data

Tribble, Scott, 1975–
 A colossal hoax : the giant from Cardiff that fooled America / Scott Tribble
 p. cm.
 Includes bibliographical references.
 ISBN-13: 978-0-7425-6050-5 (cloth : alk. paper)
 ISBN-10: 0-7425-6050-3 (cloth : alk. paper)
 eISBN-13: 978-0-7525-6472-5
 eISBN-10: 0-7425-6472-X
 1. Cardiff giant. 2. Cardiff (N.Y.)—Antiquities. 3. Forgery of antiquities—New York
(State)—Cardiff—History—19th century. 4. Impostors and imposture—New York
(State)—Cardiff—History—19th century. I. Title.
 F129.C27T75 2009
 974.7'65—dc22 2008025178

Printed in the United States of America

♾ ™ The paper used in this publication meets the minimum requirements of
American National Standard for Information Sciences—Permanence of Paper
for Printed Library Materials, ANSI/NISO Z39.48-1992.

Speak out, O Giant! stiff, and stark, and grim,
Open thy lips of stone, thy story tell;

—"D. P. P." in *Syracuse Daily Journal*, October 21, 1869

~

Contents

~

Preface

In 1869, America was on the cusp of its great leap forward, a period of unprecedented growth that ultimately would yield a thoroughly modern nation. Citizens once again were looking forward, dwelling less and less on the recent Civil War and more on the renewed march of progress. The discovery of a fossil giant in October, however, turned their attention to the past—the very distant past. In this colossus, Americans saw evidence that their continent had been not only a cradle of civilization—rivaling if not surpassing the grandeur of ancient Egypt, Greece, and Rome—but also, from its earliest days, a land of destiny and empires.

Over the first five decades of the nineteenth century, the scale of all things American had become so much more vast. The number of states grew from sixteen to thirty-three, with the frontier shifting all the way from Ohio to California. New York City and Philadelphia grew ever larger, while sizable new cities emerged in Cincinnati, Chicago, and St. Louis. The Erie Canal, a massive engineering feat, originally laid the groundwork for a continental economy, but even its heyday had been brief, as railroads soon blanketed the North and South and outmoded earlier methods of transportation. Newly expanded newspapers included telegraph reports from all over the world, and even religion took on a broader scope, as preachers converted thousands of spiritually hungry men and women at massive tent revivals. By 1857, John Fanning Watson, a Philadelphia historian, already was pining for simpler times, bemoaning how modern Americans insisted on "doing all things upon a great and grand scale."[1]

The Civil War interrupted this American progress in dramatic fashion. The conflict had been of unprecedented magnitude, claiming more than 600,000 lives and costing roughly $15 billion. Focus shifted away from commerce, expansion, and Manifest Destiny, and, as one French sojourner observed in 1862, "men and women talk of war, and of war only." Railroad building, for the most part, stopped amid the conflict, and Union soldiers even tore up thousands of miles of track in the South. Scientists halted personal studies, applying themselves to martial technologies and, in many cases, even taking up arms. Still, the conflict had not ended with the surrender at Appomattox in 1865. Andrew Johnson and Congress fought bitterly over the military occupation of the South, the terms of readmission, as well as the perplexing Negro question. The debate over the legacy of war grew so fierce that legislators took the unprecedented step of impeaching a president, mainly to advance their own program of peace.[2]

By 1869, however, Americans were growing weary of Reconstruction and the issues of war, increasingly turning their attention to the renewal of progress. The new transcontinental railroad was a reminder of past attainments, but also pointed to a grand—and distinctly national—future. Along with other developments in technology and commerce, the railroad laid the groundwork for a practical reunion that eventually superseded Reconstruction's political and social program. The United States already was big, but, with its focus returning to development and expansion, it was about to get much, much bigger. As one German writer observed around this time: "North America is advancing with giant steps toward the supremacy of the world."[3]

Despite impressive strides over preceding decades, many American institutions belied continued growing pains as well as cracks within their systems. Already, in politics and business, unscrupulous men were exploiting these failings on an unprecedented scale. William M. "Boss" Tweed was busily converting New York City into his own personal fiefdom, bilking taxpayers to the tune of millions. In the absence of regulatory oversight, corrupt financiers such as Jim Fisk and Jay Gould were amassing vast fortunes, booming and busting railroad companies at the expense of stockholders. In reviewing the "tendencies" of contemporary American business, Ezra Champion Seaman astutely characterized them as "very alarming" and an ominous sign of things to come.[4]

At this critical juncture in history, Americans turned their attention to a remarkable scientific discovery. On October 16, 1869, workers unearthed a ten-foot giant in Cardiff, New York. Over the course of several months, newspapers devoted daily headlines to the great wonder, and more than

60,000 Americans flocked to see its exhibition. The giant was one of the absorbing topics of its day, with one newspaper asserting: "We advise all to see it, for the leading question of the day will be 'Have you seen the giant?'" Some of the most familiar names of the nineteenth century examined the colossus, among them Ralph Waldo Emerson, Oliver Wendell Holmes, and P. T. Barnum.[5]

In attempting to divine the giant's origins, American science revealed its own growing pains, including the shortcomings of traditional education, the weakness of archaeological methodology, as well as the vexing presence of amateurs and charlatans within the ranks. The public cared little, however, for most Americans still paid little heed to scientists and experts more generally, largely dismissing these men as buffoons and deeming themselves the best judges of science and history. To understand the great wonder, these men and women leveraged their personal knowledge of the natural world, as gleaned from curiosity museums as well as popular lectures. Americans likewise drew upon disparate sources that claimed scientific and historical truth: newspapers, local history books, antiquarian tracts, popular encyclopedias, and, of course, the Bible. Where these resources offered inconsistent and unsatisfying assessments, men and women turned inward to make sense of the giant, leaning upon their faith, their common sense, as well as their superstitions. Clergymen, hucksters, school superintendents, bricklayers, and farmers alike joined scientists in a national debate over the giant's origins, all played out in the newspapers. Editors and reporters themselves interspersed personal opinions into coverage, playing fast and loose with facts to advance their own pet theories. Most Americans believed that the great wonder was a petrified man, possibly one of the giants from the Bible or perhaps one of the original founders of America. Others regarded the great wonder as a statue, the handiwork of seafaring Vikings or Phoenicians. For others, it was the monumental remains of a lost American race, one whose attainments rivaled the great civilizations of the Old World. The giant indeed was one of the leading questions of the day, and how men and women answered it said much about Americans in 1869 as well as America more generally.

The story of the Cardiff giant is a familiar one, told and retold countless times over the nearly century and a half since its discovery. Newspaper and magazine retrospectives effectively have transformed the episode into a twice-told tale, sometimes bearing little relation to the facts. Previous histories have been altogether brief, and, owing to large gaps in the historical record, have focused on only part of the story. True, not all the facts have survived, but many still exist in unusual and unconventional forms. The story lives in faded gravestones, family trees, personal contracts, church

records, and, most significantly, a tattered manuscript previously consigned to the dustbin of history. Even these sources do not tell us everything, but they give us a fuller picture than ever before of what the giant was—and is—and how it came into being in the first place.

I first became interested in the Cardiff giant in the spring of 1997 while taking Stephen Jay Gould's History of Life class at Harvard College. In a seminal essay for *Natural History*, Gould recounted the historical affair, while ruminating on the larger subject of human origins. As ever, Gould was inspirational, and I wrote about the giant for my thesis. The publication focused mainly on latter-day remembrances within popular culture, and, consequently, I spent little time discovering and evaluating contemporary accounts. Later returning to the topic, I learned how much of the story remained untold, particularly concerning George Hull. The final stages of this book brought me full circle, as I unexpectedly met Tom Heitz, who introduced Gould to the giant many years earlier. Tom, the former librarian of the National Baseball Hall of Fame and Museum, continues to inspire new interest in the giant, playing the role of modern showman at the Farmers' Museum in Cooperstown.

Over the years, I benefited from the extraordinary support of several individuals. Ron Yanosky spent countless hours discussing the subject and broadening my perspective on the cultural milieu. Judith Richardson offered valuable insight into the specific New York context, while Terry A. Barnhart opened doors by graciously sharing his working bibliography on Wills De Hass. I am especially grateful to Ken Feder, who offered an archaeologist's perspective in reviewing early drafts and whose own writings on myths and mysteries of the past have been a constant source of inspiration. Ken deserves special mention as a longtime champion of the giant, and I deeply appreciate his encouraging my own research.

The following institutions and offices offered invaluable resources and support: Onondaga Historical Association, Onondaga County Public Library, New York State Historical Association, Broome County Historical Society, Broome County Supreme Court, Broome County Clerk, Cornell University, Cortland County Historical Society, New York Supreme Court, New York City County Clerk, Kent Memorial Library of Suffield, Suffield Town Clerk, Hampden County Registy of Deeds, Springfield City Clerk, West Springfield Town Clerk, Connecticut Valley Historical Museum, Massachusetts Historical Society, Fort Dodge Chamber of Commerce, Fort Museum, United States Geological Survey, Harvard Forest, Harvard College, Fort Edward Historical Society, Columbus Metropolitan Library, Westerville Public Library, State Library of Ohio, Miami University of Ohio, Ohio State

University, Otterbein College, Westerville Family History Center, and the Ohio Library and Information Network (OhioLINK). Among many helpful individuals, I would like to thank Roger Natte of the Fort Dodge Chamber of Commerce, William Kappel and James Reddy of the United States Geological Survey, Suffield's town historian Lester Smith, and Shirley Spalik of the Broome County Historical Society. Shirley, in particular, furnished me with significant resources prior to my first visit, while confirming my suspicions about Hull's marriage.

Like any modern historian, I leaned heavily on electronic resources, among them Ancestry.com, ProQuest, NewspaperARCHIVE.com, Google Book Search, the New England Historic Genealogical Society's website, as well as early newspaper databases. The volunteers at RootsWeb and Random Acts of Genealogical Kindness graciously responded to questions about local history and the availability of records, and both Doug Negus and Susan Grace kindly performed lookups into public documents.

For sharing their personal experiences with the giant, I am indebted to Harvey Jacobs, Brian Washburn, Marvin Yagoda, and Davis Robinson. Fred Fedler and Donald Smith also were kind enough to answer electronic queries related to their fields of expertise.

Given the scope of the topic, I accrued many intellectual debts along the way, and, in addition to scholars cited earlier, I would like to thank Neil Harris and Stephen Williams for their vital historical analysis. Others deserve credit for keeping the story of the giant alive over the years, including James Taylor Dunn, Stephen Sears, Carol Kammen, William Plymat Jr., Michael Pettit, and especially Barbara Franco, whose 1969 master's thesis represented the first significant history of the affair.

Tiny Cardiff welcomed me with big arms. Anne Smith, LaFayette's town historian, gave me a personal tour, while introducing me to Roy Dodge, who played a major role in this project. No one knows more about Cardiff and LaFayette than Roy, the author of several local history books. Roy offered his time and research support, retrieving materials from local archives, while graciously sharing his own personal genealogical research into Cardiff families. He also reviewed early drafts and served as a sounding board on vexing issues. If I have portrayed the towns and past residents of Onondaga County in the appropriate spirit, I owe it all to him. Appropriately enough, Roy boasts a connection to the giant. The brother of his great-great-grandmother was Gideon Emmons, one of the workers who discovered the great wonder in October 1869.

Beyond professional acknowledgements, I would like to thank my sisters Susan and Laurie for going above and beyond the call of familial duty in

reviewing the episode from a legal perspective. Along with my sister Christine, they allowed their homes to become writing spaces. Bill and Carol Rand encouraged me at every step of the way, and I cannot thank them enough for their ample enthusiasm, humor, and warmth. Sincere thanks to friends and family: David Blagg, Brian Panoff, Garrick Lau, David Renton, Jeff Blagg, Jerry Brennan, Peter Stringer, Summer Lopez, Eamonn Casey, Stacey Gilchrist, Herman Sanchez, Dorothy Resig, Marc Taylor, Julie Evett, Adam St. James, John Welborn, Jennifer Burns, Katherine Brown, Greg Botelho, Jeannie Goodwin, Sean Slingsby, Carl and Colleen Clark, Elizabeth Rabe, Allison Hastie, Tyler Rand, Cara Rand, Livian Rand, Roy and Elaine Tribble, Rob and Jan Tribble, and Norma and Bob Hoaglund. In addition to being a great friend, Chile Hidalgo offered valuable feedback on an early draft, and, at least in my estimation, he outclasses Barnum as Bridgeport's finest.

In closing, I am indebted to Niels Aaboe, my editor at Rowman & Littlefield Publishers, for his guidance of the project. I also appreciate Asa Johnson and Elaine McGarraugh's many efforts on behalf of this book. I owe a very special thanks to Michael McGandy, who offered insight into early versions of the manuscript—and perspective on the historical episode—that was at once incisive, thought provoking, and encouraging. Michael's collaboration broadened and deepened this study, and it is considerably better for his involvement. I wish to thank Rick Balkin, my agent, for his belief in the project and for his expertise, professionalism, and kindness throughout the entire process. Finally, my deepest appreciation to Joseph and Ann Tribble, Fred Eid, Kelsey, and especially Megan Rand, who not only understood this undertaking but supported it in every way imaginable.

CHAPTER ONE

~

A Giant in the Earth

For some Americans, the War Between the States had been a clash between two distinct cultures and economies, while others regarded the conflict as a struggle for states' rights and the emancipation of slaves. But, for one and all, the Civil War had been a great interruption, a stunning break from the steady advancement that marked the antebellum years. Prior to the onset of war, the young nation spawned canals of unprecedented scope, a vast railroad network, as well as a communications revolution with the telegraph. Developments by and large favored the North, but, still, they represented American achievements, for the Old World remained the most common benchmark in these days. The conquest of the western wilderness also had begun, with each new state and territory asserting America's continental breadth as well as challenging the supremacy of European nations. The Civil War changed everything, however, stalling the march of progress and expansion, while calling into question the tenability of American destiny. Amid the brutal thunderclap of war, even the fiercest ideologues recalled earlier progress and yearned for its ultimate renewal. As Confederate Congressman William C. Rives wrote in July 1864: "We are not afraid to avow a sincere desire for peace on terms consistent with our honor and the permanent security of our rights, and an earnest aspiration to see the world once more restored to the beneficent pursuits of industry and of mutual intercourse and exchanges, so essential to its well-being, and which have been so gravely interrupted by the existence of this unnatural war in America."[1]

In the tiny hamlet of Cardiff, New York, nestled in the central part of the state, the war had been a noticeable disruption. Ten or so men enlisted in support of the Union cause. In absolute terms, it was an infinitesimal number—after all, more than two million men fought to suppress the rebellion—but, in Cardiff, where the total population was 150, the enlistment number hardly was insignificant. Roughly 15 percent of adult males put down their plows and left their mill stations, leaving in their wake a changed village. Roads and buildings sat in disrepair, as administrators earmarked 80 percent of tax revenue for enlistment expenses. Agricultural production similarly suffered from the loss of manpower. From the battlefields of the South, the men of Cardiff longed for the familiar trappings of the life that they had known. Frederick G. Fields, a twenty-four-year-old farm laborer, wrote to Charles B. Fellows back home: "I should like to be in Uncle Hiram's cellar a little while. The apples and cider would suffer I can assure you. It makes my mouth fairly water now to think of it."[2]

After the cessation of hostilities, both America generally and Cardiff specifically negotiated the war's fallout. Less than a week after the surrender at Appomattox, Americans suffered through the assassination of Abraham Lincoln, then watched as his successor Andrew Johnson grappled with Congress over Reconstruction and the legacy of war. Like Lincoln, Johnson prized leniency and speed in restoring the former Confederate states to the Union. A radical faction of Congressional Republicans, however, conceived of reunion differently. "We are making a nation," Thaddeus Stevens reminded his House colleagues. Radical Republicans sought to remake the South in the image of the antebellum North, while, at the same time, fashioning a stronger central government and advancing a program of Negro equality. In new amendments to the Constitution, former slaves received their freedom as well as equal protection under the law, but Johnson and Congress differed over the enforcement of these measures as well as the ultimate terms of readmission. Congress eventually expanded the military occupation of the South, while taking the unprecedented step of impeaching Johnson, largely on political grounds. A single vote allowed the president to remain in office, but, in November 1868, Americans selected war hero Ulysses S. Grant as their new standard-bearer, less for the political novice's specific policies and more to endorse his vague campaign promise: "Let us have peace." In 1869, however, the war remained at the forefront, with Virginia, Mississippi, Texas, and Georgia still without representation in Congress and with Republicans pushing a new amendment for Negro suffrage. Even Grant's good name had been sullied, as newspapers indirectly connected the president to Jim Fisk and Jay Gould, the corrupt financiers who sparked a brief panic while attempting to corner the gold market.[3]

By contrast, Cardiff had succeeded in restoring antebellum normalcy. The hamlet was wholly white, so the major social issues hardly had any practical relevance. The war also had little effect on Cardiff's agricultural prices and wages, so the economic fallout had been manageable. The human cost of war, of course, posed the greatest challenge. Several men from the hamlet died in service of the Union. Measured against national losses, the number again was meaningless, but, in Cardiff, even the loss of a few men could take its toll. Survivors strove to fill the void, physically from a work standpoint as well as emotionally, and, by and large, they succeeded at their task. One native of the region noted that, by the fall of 1869, Cardiff looked much the same as it did before the war: "The surviving solders returned, went on with their accustomed vocations, and all was quiet as before." Indeed, while America elected a president to put an end to conflict, Cardiff already was—according to its chronicler—a "land of peace."[4]

Not the great issues of the day, but rather the standard chores of a small farming community roused villagers on the morning of Saturday, October 16, 1869. Harvest had come and gone, but cows needed milking and livestock clamored for food. Over the course of the day, adults of the village hoped to run errands as well as pay visits. The only urgency stemmed from the fact that it was Saturday and that other, higher responsibilities would command their full attention tomorrow. The brisk temperatures, roughly forty-five degrees Fahrenheit, did little to deter the men, women, and children from rising. These were hardy sorts, well accustomed to the harsh winters of central New York. There were no sounds of rain or storms outdoors, but the barometer did register the air as unsettled—an appropriate harbinger for events to come. As villagers emerged from their homes into the dawn, the landscape hinted at the spectacular views that awaited them on this day. The hemlock and maple trees that lined the valley walls had exchanged their bright green colors for the scarlets, yellows, and oranges of autumn. The light of the rising sun behind these leaves produced a stunning richness and depth of color, a gorgeous natural scene at which any landscape painter might have marveled. Nevertheless, the villagers gave little pause to their surroundings. Most had been seeing it for years, and, veterans notwithstanding, it was the only landscape many had ever known. Still, the warmth of the sunlight undoubtedly comforted even the most jaded villager. After all, it was a sign that winter was at least one more day in the future.[5]

Sometime before eight o'clock that morning, Gideon Emmons started out from his family's homestead, heading north on the road alongside Bear Mountain. Emmons was one of the few men of Cardiff who, try as he might, could not ever shut the Civil War out of his mind. At the Battle of Gravelly Run in Virginia some four years earlier, Emmons lost his left arm in combat.

The timing of it all added insult to injury. Emmons only had been in service for a couple of months and had seen limited action. More significant, the 185th Infantry belonged to the Appomattox campaign. A mere nine days after Gravelly Run, Robert E. Lee surrendered his forces, bringing an end to armed conflict between North and South. While fellow infantrymen celebrated the armistice, Emmons recuperated in a military hospital. He later returned to Cardiff, the beneficiary of a full pension for his disability, but the experience of war left him flush with emotional scars. A bachelor who lived with his family, Emmons spent much of his eighteen-dollar monthly stipend on whiskey at the Cardiff Hotel. Emmons's fondness for alcohol eventually became the stuff of village folklore. In one oft-told story from later years, a Syracuse inspector asked an elderly Emmons about the quality of water in Cardiff. The latter pleaded ignorance, stating that he had not tasted it in more than forty years.[6]

A mile or so up the road, Emmons met up with Henry Nichols. The latter lived over by the bridge that spanned the creek, and, at twenty-seven, was a few years younger than Emmons. Nichols likewise had fought for the Union, enlisting within weeks of the first cannon volleys at Fort Sumter. After two years with the 12th New York Volunteers, Nichols reenlisted with the 185th Infantry, joining Emmons on the fateful campaign through Virginia. After his discharge at war's end, Nichols came home to Cardiff and eventually married Harriet Newell. In 1869, the young couple had two small children, and Henry Nichols supported his family by laboring on local farms—just as he would on this day. He wore the typical work clothes of the time: a long-sleeved cotton shirt, a woolen vest, as well as loose-fitting trousers supported by suspenders. Heavy boots and a broad-brimmed hat completed the homespun picture.

Heading north together on the mountain road, Nichols and Emmons arrived at Stub Newell's farm within minutes. Indeed, in a tiny hamlet less than one square mile in area, nothing was truly far. A day earlier, Newell approached Nichols and Emmons about digging a well for him. Nichols frequently did that kind of work for his brother-in-law, but Emmons's disability rendered him an odd choice. Newell simply may have wanted to help an old friend with productive work, or, possibly, if Nichols and Emmons had been together at the time, he avoided an awkward situation by engaging them both. Of course, the Cardiff farmer may have had reasons known only to him.[7]

Newell, whose nickname alluded to his diminutive stature, bought the farm two and a half years earlier. Stub and Lydia Newell had spent the early years of their marriage with his parents, who lived near the Tully line. Stub

Newell remained in Cardiff during the war, and, as a result, had been present for the birth of his son William Jr. William and Lydia Newell eventually purchased the modest farm, where the latter spent part of her youth. In addition to the small white wooden house, there was a barn, which offered ample room for Newell's mere two cows and a horse, and, on the rare occasions that he needed help with his simple operation, Newell had ready assistance in Nichols as well as his wife's brother Barzilla.[8]

Just like his farm, Newell was entirely unremarkable. In the coming weeks, as the Cardiff farmer joined the ranks of celebrity, a prominent New York academic who made his acquaintance characterized him thusly: "A man of pretty good intelligence, understanding his vocation, but not an educated or learned man in any way." The same observer noted that Newell was simple and unostentatious in his habits, and, for the most part,

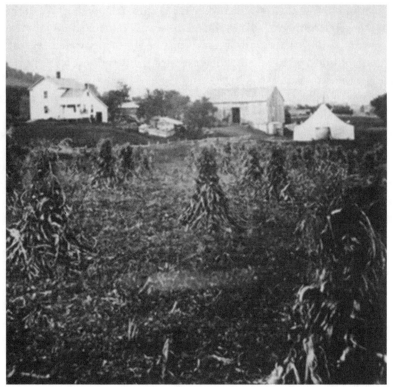

A later photograph of Stub Newell's property in Cardiff, New York. The tent (pictured on the right) exhibited the sensational discovery made on October 16, 1869. Source: Onondaga Historical Association Museum and Research Center, Syracuse, New York.

the latter's neighbors concurred. According to these men and women, the only thing unusual about Newell was the fact that he hardly ever left his farm. Only rarely did the Cardiff farmer cross the creek to venture into the business district, where both the country store and post office were located. It seemed that, within the little world of Cardiff, Newell enjoyed an even smaller existence unto himself.[9]

When Nichols and Emmons arrived at the farm, Newell immediately took them to the spot planned for the well. They walked past the house and down the gradual slope upon which the barn sat. Roughly ten feet beyond that structure, the three men stopped in their tracks. A long meadow roughly three hundred feet in length stretched before them, terminating in the snaky outline of Onondaga Creek. Looming large in the distance was the valley's eastern wall, atop which the town of LaFayette was situated. For all intents and purposes, the meadow was a marsh. Between the water that washed down from the nearby hills and the numerous underground streams, the land was soft and unfriendly to man and beast. Fortunately for Nichols and Emmons, Newell told them to dig in the relatively dry spot, or swale, where they now stood. While drier than the rest of the meadow, the swale nevertheless was quite "porridgey," as one man later termed it. At the very least, however, digging promised to be easygoing.[10]

Nichols and Emmons struck their shovels into the earth around eight o'clock. Newell returned to the side of the house, where he and another hired laborer, John Parker, worked to draw stone for the well. With Emmons contributing only minimally, however, Newell and Parker outpaced them from the start. Over the course of the next three hours, the latter two men brought several loads of stone to the swale, while the diggers made only slow progress. Sometime during this stretch, Smith Woodmansee arrived at the farm. Newell hired him to stone the well, but, as his services would not be needed for some time, Woodmansee joined Lydia Newell and her son inside the house. Newell's wife, who supplied the men with refreshments over the course of the morning, donned a long linsey-woolsey dress for the day, with the durable fabric offering protection from the brisk autumn temperatures.[11]

Around eleven o'clock, just as Newell was depositing another batch of stones, Nichols and Emmons struck a solid object. Newell told them that it likely was a large rock and bounded back up the hill to retrieve a pickaxe. The two men, who had dug roughly two and a half feet by this point, continued digging and quickly learned that it was no ordinary stone. It was shaped like a foot, prompting one of the men—it is not clear which—to exclaim: "I declare, some old Indian has been buried here!" Oddly, though, the foot

was not skeletal. It looked like one of their own, only made of stone. More remarkably, it was two feet in length. Nichols and Emmons excitedly called for Newell to return, and, as the farm owner descended the hill, Parker and Woodmansee joined him to investigate the commotion.[12]

None of the men knew the best course of action. On one hand, they desperately wanted to know just what Nichols and Emmons had discovered. At the same time, though, they were guarded, as they might not like what they would see. As the men debated their next move, Woodmansee glanced back at the road and saw a familiar face. It was John Haynes, who was heading to the nearby reservation's fair. Racing up the hill, Woodmansee beseeched his friend to stop his horse and wagon: "They have found a man's foot down there!" His curiosity piqued, Haynes quickly disembarked from the buggy. The Indian Fair could wait.[13]

Meanwhile, Nichols and Emmons resumed their digging. By the time that Haynes joined them, the two men already had exposed more of the leg. "It is a foot," Haynes exclaimed upon arriving at the scene. A farm laborer himself, he grabbed an extra shovel and worked on the area surrounding the legs and midsection, while Nichols and Emmons moved up to where the head and torso might lay. As Haynes later recalled: "I took a shovel and got down into the hole, and as fast as they uncovered the body toward the head, I cleared the dirt off about up to the hand on the belly." After only a few minutes, the three men managed to expose the entire body. Climbing out of the makeshift pit, they joined the other men in beholding it from above.[14]

Without question, it looked human. All the limbs and body parts were present, except for part of the left ear, which seemed to have broken off. Like the foot, every inch of the body was filled out and solid as a rock. The surface was bluish gray, with signs of erosion clearly evident in several places. It was difficult for the men to articulate, but this thing gave the impression of being very, very old. Whatever it was, it definitely was male—that much was obvious with a simple glance to the midsection. Indeed, many anatomical details were plainly visible: nostrils, toenails, fingernails, ribs, Adam's apple, even the outline of muscles. Of the common features, it lacked only hair. While the head and shoulders lay flat—befitting a corpse—the left leg and foot were thrown over the right, and one of the hands spread over the lower abdomen. It almost looked as though it were clutching its side in pain, though the calm countenance certainly belied no sign of stress. Perhaps most vexing was its size. At more than ten feet in length, it verily was a giant. All the men had heard stories of such beings before, but now it seemed that they actually had found one—in tiny Cardiff, New York, of all places.[15]

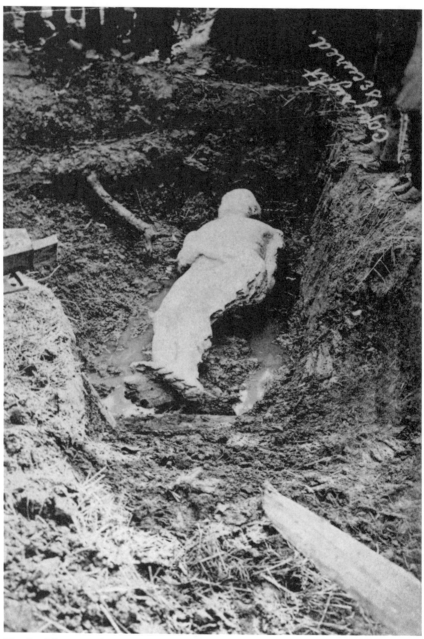

The Cardiff giant in the pit at Stub Newell's farm. Source: Courtesy of the New York State Historical Association Library, Cooperstown, New York.

* * *

Contrary to prevailing opinion, even among its own residents, Cardiff had not always been a sleepy hamlet. Long before the morning of October 16, 1869, when its grounds revealed the body of a ten-foot giant, Cardiff had been a land where chieftains and diplomats made war and peace, with their decisions determining the course of empires.

For centuries, Onondaga County was the domain of the Onondaga Indians and the heart of the Iroquois Confederacy, a political federation formed sometime between the mid-1400s and early 1600s. The Onondaga were allied with the Oneida, Mohawk, Cayuga, and Seneca, but, as the Onondaga enjoyed the most centralized and protected location, their villages served as the confederacy's de facto capitals. For much of their early history, the Onondaga settled along Limestone and Butternut Creeks in the present-day towns of Pompey and LaFayette, but, during the eighteenth century, tribe members situated their villages along Onondaga Creek, only a few miles from where Newell's farm later sat.

During the age of European settlement, the confederacy held the balance of power between the French and the rising British power on the continent. Diplomats and missionaries—French Jesuits, most notably—ventured to the valley of the Onondaga, negotiating alliances as well as terms of trade. During the Revolutionary War, the Onondaga became divided in their loyalties, and the former British colonists made the tribe pay dearly. Over the course of several treaties beginning in 1788, the Onondaga ceded nearly all of their lands to the new United States. By 1822, the tribe's empire in central New York had been reduced to a mere 6,100 acres. For the sale of their lands, the Onondaga received $33,380 in cash, $1,000 in clothing, an annuity of $2,403, and 150 bushels of salt.

White settlement of the region commenced shortly after the initial treaty's signing, and, by April 1825, the high ridge between Onondaga and Butternut Creeks boasted twenty-four hundred inhabitants. That year, the New York State Legislature incorporated the town of LaFayette, whose name honored the Marquis de LaFayette, the French general and Revolutionary War hero who soon would pass through the region. From the earliest period of settlement, the southwestern portion of LaFayette, separated from the rest of town by the ridge, evolved along vastly different lines. Set within the valley of Onondaga Creek, the area initially was a dense forest of hardwood trees, with rattlesnakes harassing settlers at every turn. Ultimately, men succeeded in clearing the forest, and a small community known as Christian Hollow emerged. Three years after the incorporation of LaFayette, federal authorities

saw fit to give Christian Hollow its own post office, but directed community members to adopt a more distinctive name. John Spencer proposed Cardiff, ostensibly in honor of early settler John F. Card, but, conveniently, the name also invoked the capital city of Spencer's native Wales. After some debate, community members agreed upon Cardiff, and, on January 15, 1830, the new hamlet was born.

While nominally a part of LaFayette, Cardiff soon developed a unique economic and social existence. Residents of the hamlet very early leveraged Onondaga Creek to power small factories and shops. Volney Houghton constructed an aqueduct to bring water into his blacksmith and carriage stores, while Edward Voight and William Wright—Stub Newell's father-in-law—also utilized waterpower at their mills. By contrast, LaFayette, which sat atop the high ridge, did not enjoy the same access to the creek, and consequently its economy was not nearly as modern or diversified as that of Cardiff. The ridge—LaFayette residents called it Cardiff Hill, while the villagers of Cardiff referred to it as LaFayette Hill—further reinforced the divide between town and hamlet. Travel between the two communities was exceedingly difficult, and thus Cardiff residents sought trade and contact with the growing village of Syracuse to the north as well as the town of Tully to the south. The completion of a hemlock-plank road between Syracuse and Tully in 1849 facilitated the interaction, while taking travelers directly through Cardiff's business district. The subsequent arrival of the Syracuse & Binghamton Railroad, which established a station at Tully, further cemented the relationship, though a slight detour in the railroad's route also took passengers through LaFayette. By 1869, Cardiff boasted a reasonably impressive business district. In addition to nearby mills and farms, the hamlet possessed two wagon shops, two shoe shops, two blacksmith shops, a harness shop, and three stores. The Cardiff Hotel offered stage travelers respite, while the nearby Ebenezer Methodist Episcopal Church catered to weary souls.

Decades after Nichols and Emmons unearthed the giant on Newell's farm, Andrew White, the first president of Cornell University and a native of Onondaga County, described what Cardiff was like in the days before its world turned upside down. White gave a simple anecdote that, at least in his mind, captured the essence of the village and its residents: "I have known one of these farmers, week after week, during the storms of a hard winter, drive four miles to borrow a volume of [Sir Walter] Scott's novels, and, what is better, drive four miles each week to return it." While seemingly no different from countless other American towns full of thrifty, hard-working, and God-fearing sorts, Cardiff nevertheless was the sort of community that would have made Thomas Jefferson proud. Whether it could remain modest after the discovery of a giant in its earth, however, was another matter entirely.[16]

* * *

News of the discovery spread rapidly throughout Cardiff. Newell's hired hands eventually returned home, bringing with them reports of the giant, while other villagers, like Haynes, stumbled upon the scene en route to Syracuse and the Indian Fair. By the middle of the afternoon, a small crowd assembled at the farm, and the according commotion led Newell to make a shocking announcement: he was planning to reinter the giant, and every man, woman, and child needed to forget what he had seen. Newell's reasoning was twofold. On one hand, he had responsibilities to his family and farm. He already had lost a half-day's work, and his new well was nowhere close to complete. The Cardiff farmer also explained that an earlier owner of the property found a razor hidden within a hollow stump. Newell was convinced that a murder had taken place on the property, and, while the former owner had located the weapon, the Cardiff farmer feared that Nichols and Emmons just discovered the corpse. If the murderer were still at large, he or she might not take kindly to this development, and the victim's spirit almost certainly would not appreciate prolonged disinterment. While sympathetic to Newell's plight, the villagers nevertheless were dumbfounded. After all, the giant already was the most significant thing to happen in Cardiff within their lifetimes—possibly ever. What if it had historic or scientific value? Besides, practically speaking, keeping this kind of secret would be next to impossible—no one would be able to forget what he had seen. Pressed by his fellow villagers, Newell finally relented and promised not to squelch the great discovery.[17]

The satisfied crowd quickly turned its attention to a more pressing matter, namely the giant's origin. Like the workers, the men and women agreed that it was very old, with some villagers observing that the giant lay beneath the roots of a tree long since felled—a clear sign of its earlier burial. Billy Houghton, who kept the country store, wondered whether the giant was a petrifaction, with running water from underground streams changing its flesh into stone. The storekeeper's hypothesis certainly seemed plausible to members of the crowd. After all, nearby farms and quarries had yielded a bevy of fossils, many of which looked similarly complete, though not nearly as lifelike. Clutching its side, the giant very much appeared frozen in time—the handiwork of a powerful and mysterious nature. None of the villagers showed any concern for the fact that Houghton's petrifaction also was a giant. After all, the Bible itself confirmed the existence of historical giants, with every man, woman, and child intimately familiar with the stories of Goliath (also known as Goliah) and Og. But the villagers did not even need to go back to biblical times to find traces of giants. In *History of Onondaga*, published two

decades earlier, Joshua Clark reported that residents of nearby Delphi discov-ered skulls and bones within the ruins of an old fort and burial place. While the fossils in actuality belonged to mastodons and other large animals, Clark had written that earlier inhabitants of the valley were massive in size: "The skeletons taken from here, have usually been of a size averaging far above that of common men. Several exceeded seven feet."[18]

By the end of the afternoon, Newell, still annoyed at all the commotion, let his fellow villagers decide what to do next. After some debate, the men of Cardiff resolved to raise the giant and bring it to the Indian Fair. While someone there might have a clue as to its origin, they also might stage an exhibition and make Newell some money. After all, whether he liked it or not, the Cardiff farmer now was the owner of the giant. Several men headed to the store for rope, but, by the time they returned, dusk had fallen, and the fair was soon to close. Attention also had shifted to another matter. Over the course of the day, underground streams gradually had been filling the pit, and now the giant was nearly covered. Fearing that water might harm the curios-ity, the villagers debated a hasty removal, though, in the end, decided to wait until proper authorities—whoever they were—offered guidance.[19]

On one point, Newell remained thoroughly engaged. Over the course of the day, several villagers offered to buy the giant. One man pledged fifty dollars for a quarter share, while other offers climbed into the hundreds. One bid, though, trumped all others. James Andrews, the local Methodist preacher, offered the Cardiff farmer real estate valued at seventeen thousand dollars. Though his own property was worth only a quarter of that sum, New-ell firmly declared that he would sleep on any and all offers.[20]

As dusk turned to dark, the scene changed to a candlelight vigil. Even at this late hour, new visitors still were arriving at Newell's farm. One curiosity seeker was John Clark, who, earlier that evening, delivered a temperance lecture to a rather sparse Cardiff audience. After beholding the giant, the Syracuse lawyer headed back to the city, arriving there around midnight. De-spite the late hour, Clark visited hotel lounges and other public places, shar-ing news of the great discovery with anyone still awake at that hour. Back in Cardiff, crowds eventually dissipated until Newell was left alone with the giant, and the farmer remained by its side the entire night. So much was unclear to Newell at this point, but one thing was for certain: his life—and Cardiff's—never would be the same again.[21]

CHAPTER TWO

~

Like Wildfire

At dawn on Sunday morning, Stub Newell no longer could resist the urge of sleep, finally forsaking the giant and retreating into his house for shut-eye. The Cardiff farmer had been awake for nearly twenty-four hours, but his respite would prove brief, as sounds of horses, wagons, and buzzing crowds soon stirred the slumbering giant owner. At first light on the Lord's Day, men and women had set forth for Newell's farm in droves, all to catch a glimpse of the great discovery that already was the talk of the valley.[1]

Many in the crowd were familiar faces. Some were Cardiff residents who, for whatever reason, failed to see the giant on Saturday. Others returned for a second look, hoping that the new day would yield insight into its origins. Still others were complete strangers, arriving from nearby towns and villages, including LaFayette, Tully, Pompey, and Otisco. By the end of the day, Newell even would receive visitors from Syracuse, located some twelve miles distant. The rate at which news spread truly was remarkable. Today, most Americans—no matter where they live—enjoy real-time access to information, whether through radio, television, the Internet, or even telephone conversations. At the time of the giant, the delivery of information was fast improving, but the scope remained limited. Over preceding decades, Samuel Morse's electric telegraph revolutionized communication to the point that telegraph reports from New York City and Washington, D.C. became staples of daily newspapers. The recent establishment of a transatlantic cable expanded the network to Europe, with domestic newspapers now carrying international dispatches. For more than two decades, Syracuse had been part of a New York

telegraph system that included Albany and Buffalo, and coverage recently expanded to include Binghamton, Oswego, and Ogdensburg. Still, despite the growth of communication networks, no telegraph cables connected Cardiff and Syracuse. Even prior to publication in newspapers, Syracuse citizens might learn of breaking news by hanging around the telegraph offices. In rural towns and villages, however, Americans largely were beholden to newspapers, typically suffering at least a day's lag on major developments. On the weekends, the delay was even more pronounced. The *Standard, Journal,* and *Courier* of Syracuse, for instance, did not publish Sunday editions, nor did parochial presses such as Tully's new *Southern Onondaga.*

Lacking newspaper coverage, news of the giant traveled as hearsay, emanating forth from Cardiff and passing from person to person. John Haynes and others brought reports of the discovery to fairgoers at the Onondaga Reservation, while John Clark apprised the night owls of Syracuse. Even before that point, Silas Forbes had taken steps to spread word in the city. Forbes lived a half mile down the road from Newell and, prior to heading north on business, had borne witness to the giant. In Syracuse, Forbes visited the offices of the *Standard,* alerting that newspaper's editors to the hubbub in the valley. As word spread through Onondaga County, the giant's tale grew taller and taller. Syracuse citizens later recalled hearing that the great wonder measured more than twenty-five feet in length. Without newspaper confirmation of details, however, the truth very much was anybody's guess.[2]

Though the discovery transpired in Cardiff and no newspapers carried reports over the weekend, the *Standard* later estimated that more than ten thousand citizens of Syracuse had heard of the giant by Sunday evening—more than a third of that city's population. The newspaper may have overstated numbers to dramatize the story, but, still, the *Courier* qualitatively confirmed the assessment, noting that the giant was the "chief topic of conversation" at hotels and public places. Newell had not even removed the giant from the pit, and yet the great wonder already had disturbed the peace of the Sabbath in Cardiff and Syracuse—and everywhere in between.[3]

* * *

Among the earliest visitors to Newell's farm on Sunday morning were members of the Onondaga tribe, who undoubtedly heard of the discovery from fairgoers. Even without having laid eyes upon the giant, tribe-members had strong reason to believe that it belonged to their lore.

Giants, as a concept, predate the advent of literature, likely tracing their origins to the earliest forms of storytelling and folklore. Men of colossal

stature play prominent roles within several disparate cultural traditions. In Greek mythology, the Titans, a race of giant creatures sprung from Gaia and Uranus, ruled during the golden age, while the Gigantes later staged an unsuccessful uprising against Zeus and the Olympians. The Cyclopes, a race of one-eyed monsters, perhaps are the most familiar giants within this tradition. In Homer's *Odyssey*, Odysseus lands on the island of the Cyclopes, with the fearsome Polyphemus consuming several members of his crew. Men of giant stature also abound within the Judeo-Christian Bible. The Book of Genesis, for instance, notes the early prevalence of giants in history: "There were giants in the earth in those days; and also after that, when the sons of God came in unto the daughters of men, and they bare children to them, the same became mighty men which were of old, men of renown." Both Genesis and Deuteronomy record a variety of colossal races, among them the Nephilim, Zamzummim, Anakim, and Rephaim. One noted descendent of the latter race was Goliath, the Philistine warrior who stood nine feet, nine inches, but who proved no match for David's ingenuity—or his slingshot. Throughout the early modern period, Western traditions typically characterized giants as figures of unremitting evil. Oral traditions and fairy tales such as *Jack the Giant Killer* (the predecessor of the more familiar *Jack and the Beanstalk*) and *Hop o' My Thumb* cast their antagonists as brutes and ogres. The image eventually softened, and folk giants such as Ireland's Finn McCool emerged as wise and superior figures as well as the founders of modern nations. Later manifestations such as Paul Bunyan, the mythical American lumberjack, exemplify the powerful but ultimately gentle modern giant.[4]

In the Onondaga tradition, the Stone Giants bore resemblance to earlier Western depictions, as these brutal creatures had been responsible for the death of countless men and women. One particular legend related how an Onondaga family lost sight of its humanity, eating animal flesh and committing unpardonable sins. Once, while frolicking in the sand, family members discovered that their skin had turned hard and that they had grown in stature. Flush with power, the so-called Stone Giants overran the countryside and subjugated their former people. The Holder of the Heavens, an Indian deity, heard the supplications of the Onondaga and concocted a plan to defeat their conquerors. After assuming their appearance, the divine being bid the giants to aid him in toppling an Onondaga fort. On the night before the planned attack, the family slept in a nearby hollow, with the Holder of the Heavens laying a massive boulder upon them. Only a single giant reportedly escaped. The Onondaga were free once more, and the surviving colossus never harassed the tribe again.

Even before laying eyes upon Cardiff's giant, the Onondaga assumed that Nichols and Emmons discovered the last of the Stone Giants. The belief certainly had a strong circumstantial basis. After all, Cardiff was situated within a hollow, and several Onondaga forts once were located in the vicinity. Still, one look at its Caucasian features was enough to convince tribe members that the giant bore no connection to their past. According to a later newspaper report, one disappointed tribesman turned away from the pit, muttering only: "No Injun." At least one of the Onondaga, however, proposed an altogether different identity, informing the assembled crowd that the great wonder was Abel, son of Adam. The tribesman undoubtedly was flaunting his missionary education, for, at this point, nothing distinguished the giant from Christopher Columbus, let alone Abel. Still, the idle speculation sent shockwaves through the early morning crowd. Perhaps Cardiff had ties to biblical history.[5]

The tribesman's claim hardly was novel, as leaders of religious movements and charismatic individuals had been claiming for decades that God revealed himself in central and western New York, both in ancient and modern times. In the first half of the nineteenth century, the United States experienced a rebirth of religious sentiment known as the Second Great Awakening, which, in part, originated as a conservative response to emerging liberal creeds such as Unitarianism. Nowhere was the fervor more intense than in central and western New York. Revivalists rode though the region, preaching hellfire gospels and calling upon sinners to repent. During the peak years of the 1820s and 1830s, spiritually hungry men and women lined up at massive tent meetings to experience the power of religious conversion. The lands west of the Catskills and Adirondacks ultimately earned the moniker "The Burned-over District," a nod to incendiary gospels as well as the frequency with which evangelicals traipsed through the region.

Several factors combined to make central and western New Yorkers particularly susceptible to religious excitement. In his sociological study of the region, Whitney Cross argued that early migration patterns created a populace predisposed to intense religious expression. The typical immigrant to these lands was a younger son, limited in opportunity and hungry for adventure. Many early settlers hailed from the poor frontier outposts of New England, where revivals took hold as early as the 1790s. These men and women thus had exposure to religious outpouring and tended toward frequent changes in spiritual affiliation. At the same time, while traditional New England faiths enjoyed representation in New York, smaller sectarian groups also took hold, very early fostering a culture of dissent and alternative belief. Finally, despite cosmopolitan influences from the East, the region retained what Cross

called a "youthful awkwardness." At times, the lands of central and western New York resembled the stereotypical Wild West, with superstition running amuck and the general public—in Cross's words—"amazingly uncritical." Thurlow Weed, for one, recalled slitting a cat's throat and tracking the spatter of blood in his youth. According to the New York political boss, he had hoped that it would point him to buried treasure.[6]

Economic and social factors also played a role in the concentration of religious intensity. The completion of the Erie Canal in the 1820s dramatically transformed rural communities in central and western New York. Seemingly overnight, small towns and villages—where religious fervor later expressed itself most intensely—developed stable agrarian economies. Cross argued that mature markets permitted New Yorkers to devote more time and attention to spiritual matters. Around the same time, economic opportunities in Michigan and Illinois drew away materially minded men and women, leaving in their wake a higher concentration of spiritually focused citizens. Finally, the William Morgan affair exposed New Yorkers to the communal aspects of a public crusade. In 1826, Genesee County Freemasons allegedly kidnapped and murdered Morgan, a Batavia bricklayer who was planning to expose the secrets of the order in a tell-all book. Vigilance committees sprang up all over central and western New York, coordinating the search for Morgan's body—which never was found—and discerning the scope of the Freemason conspiracy. The movement eventually became politicized, with a new party emerging to capitalize on intense anti-Masonic sentiment, but, still, the crusade bore strong religious and moral overtones. Freemasons came under fire for placing their order not only above the American judicial system, but also God and church.

Baptists and Methodists proved most adept at converting burned-over masses, but the region also gave rise to entirely new religious movements. The most influential and enduring, of course, was Mormonism. After years of poverty in Vermont, Joseph Smith's family relocated to the greater Rochester area in 1816, settling on the border between Palmyra and Manchester. Both communities played host to revivals, and, in 1820, a debate between competing evangelists led fourteen-year-old Joseph Smith Jr. to seek solace in a grove. There, Smith asked God which denomination he should join. According to Smith, God and Jesus appeared to him on that day, instructing him not to align with a particular sect, but rather to prepare for his life's work, which soon would become manifest. Three years later, the angel Moroni revealed himself to Smith, directing him to retrieve an ancient book from the nearby hills. After securing the text, written upon golden plates, Smith transcribed its contents with the aid of two decoding stones and prepared the volume for

publication. The resulting *Book of Mormon*, published in 1830, chronicled the history of Israelite tribes in ancient America, while offering insight into the spiritual path between death and resurrection.

Within a few weeks of the book's publication, Smith founded and organized the Church of Christ. Congregations arose in Palmyra, Fayette, and Colesville, but the young religious leader informed followers that their destiny lay in establishing a City of Zion in the West. Over the next decade, Mormon missionaries recruited followers in New England and New York, while Smith and his disciples established communities in Ohio, Missouri, and Illinois. Mormons faced severe persecution in these lands, not only for their unconventional Christian beliefs but also for opposing slavery. Anti-Mormon sentiment gained still more momentum after Smith claimed that a new revelation sanctioned the practice of polygamy. In June 1844, after a dispute with the local press, Smith and his brother were incarcerated in Carthage, Illinois. An angry mob stormed the jail and brutally murdered the two men, thus elevating Smith to martyrdom within the Mormon faith. Brigham Young ultimately led the westward migration into the Territory of Utah and later incorporated the Church of Jesus Christ of Latter-Day Saints. Today, the denomination that originated in rural New York counts more than twelve million members worldwide.

Another influential movement emerged from Low Hampton, near the Vermont border. Farmer William Miller had a passion for Scripture and a knack for numbers. In 1818, while studying the Book of Daniel, Miller fixated on the passage: "Unto two thousand and three hundred days, then shall the sanctuary be cleansed." Assuming the starting point as the rebuilding of Jerusalem in 457 B.C. and believing that days, in fact, represented years, Miller extrapolated that the cleansing—or Second Coming—would occur in 1843. Over the next two decades, through lectures and published materials, Miller amassed a sizable following. The farmer-preacher enjoyed special resonance in New York, where thousands attended his tent meetings and heeded his call for repentance. Though 1843 passed without incident, Miller's popularity endured. He eventually revised his calculations and fixed the new date of the apocalypse as October 22, 1844. On that date, Miller and thousands of followers in New York and other states climbed hills and congregated in graveyards, all awaiting an end of the world that never came. Miller died within a few years, but disciples honored his legacy by founding several Adventist churches, among them Jehovah's Witnesses.

Still another notable denomination emerged from Hydesville, located only a few miles from the birthplace of Mormonism. In March 1848, teenagers Maggie and Kate Fox allegedly began communicating with the dead.

The girls posed questions to spirits within their home, and the latter responded in kind with rapping noises, forming a sort of communicative code. The disembodied souls eventually asked for a public forum, and, with the help of older sister Leah, the Fox sisters took their show on the road, appearing in theaters throughout New York and New England. Horace Greeley, editor of the *New York Daily Tribune*, opened his home in New York City, and the young girls performed private séances for prominent writers such as George Bancroft and William Cullen Bryant. Reports of spiritual communication quickly surfaced all over America, and fervent believers established so-called Spiritualist chapters for organized séances. Spiritualism partly capitalized on intellectual interest in the mystical philosophy of Emanuel Swedenborg, but the movement's wider resonance owed to overt religiosity. Communication with spirits confirmed the existence of an afterlife, while depicting heaven as an inviting place where the dead maintained relations with the living. Arriving on the heels of Miller's disappointment, Spiritualism rekindled religious fervor by offering the most exotic revelation to date. Not until 1888 would Margaret Fox reveal that her spiritual communication had been a fraud, though she later would retract these statements. Even today, Spiritualism remains a minor religion, with adherents both in the United States and Europe.

Not long after the Onondaga tribesman put forth the claim that the giant was Abel, the arrival of several new visitors stoked the crowd's excitement further. Miron McDonald, Elizah Park, Eugene Cuykendall, and Henry Dana, all local surgeons and doctors, offered to examine the great wonder, and, in so doing, would be the first to pass scientific judgment on it. In these days, Americans enjoyed a love-hate relationship with science and scientists—both exceedingly broad terms that encompassed medicine, anatomy, earth sciences, life sciences, chemistry, physics, astronomy, mathematics, archaeology, and ethnology. On one hand, Americans took tremendous interest in science and technology. Not only did citizens hail the steamboat, railroad, and telegraph for improving quality of life, they also embraced science for patriotic reasons. With each new advance, the United States not only distinguished itself from European nations but also more firmly fixed its position relative to the great civilizations of history. One letter writer to the *Daily National Intelligencer* scoffed at how recent innovations made the Roman Empire look positively backward by comparison:

She [Old Rome], to be sure, had her Appian and Flaminian Ways, on which she possibly made time at the rate of "2.40 on the shells," (which we, in sooth, consider pretty good,) and her post-horse telegraph; but what are they

compared with our "crashing, dashing, smashing" speed of railroad transportation, and our chain-lightning instantaneity of communication![7]

Consumer culture capitalized on—and amplified—the public appetite for science and technology. A new weekly publication, *Scientific American*, emerged in 1845, bringing developments in both theoretical and applied sciences to the public, while technological institutes in New York City, Philadelphia, and Baltimore staged public fairs to demonstrate the latest mechanical manufactures. Still, the primary purveyor of science in these years was the urban museum. The museum movement in the United States traced its roots to the early republic and the rise of Enlightenment-styled thinking, which emphasized human reason and encouraged scientific inquiry. Enlightened republicans such as Thomas Jefferson believed that the dissemination of scientific and historical knowledge would foster virtue as well as patriotism, with the public gaining an appreciation for America's unique place in the world. Scientific items such as fossils and minerals bore added significance, for these natural works reflected the hand of the divine Creator. Influenced by Enlightenment ideals, American philanthropists, in the final years of the eighteenth century, opened their private collections to the public. Peale's Museum, established at Philadelphia in 1784, was the most significant of these early institutions. In addition to portraits of great Americans, the museum exhibited thousands of stuffed birds, fish, and land animals, along with the skeleton of a mastodon. Peale's Museum inspired legions of amateur bone hunters and mineral collectors, enhancing the overall American cabinet, while contributing to scientific knowledge more generally.

In the 1820s, as new entertainments such as the circus and popular theater competed for the public dollar, the museum landscape changed dramatically. To remain solvent, managers retreated from original Enlightenment principles, instead resorting to outlandish curios to attract urban masses. Cincinnati's Western Museum exhibited fake specimens such as mermaids, and, of curator Joseph Dorfeuille's collection, contemporary writer John Parsons Foote observed: "That which was chiefly desired, was specimens of animals that did not exist, or of deformities that ought not to exist." Colonel Joseph H. Wood later boasted more than sixty cases of birds, insects, and reptiles at his Randolph Street museum in Chicago, but also promoted a series of dubious items, including a rifle allegedly belonging to Daniel Boone as well as the Great Zeuglodon. The latter item supposedly represented the remains of a ninety-six-foot prehistoric whale, but, in reality, Wood had cobbled together the bones of sundry animals to fashion the scientific curio. Still, Wood hardly could compare to the king of sensational novelties:

P. T. Barnum. Between 1842 and 1865, Barnum sold more than thirty million tickets to his five-story American Museum in the heart of New York City. The great showman drew crowds into the museum with imaginative curiosities such as the Feejee Mermaid and the rotating What Is It? exhibit. Historian Neil Harris argues that the prevalence of pseudoscience in these years paradoxically belied popular scientific literacy. Spoiled by recent advances in railroad and telegraph technology, nineteenth-century Americans accepted virtually anything presented in a quasi-scientific vocabulary, or, in the case of museums, within a broad scientific context.[8]

Amid the sensationalized science at urban museums, giants and dwarfs played particularly prominent roles. The Western Museum exhibited the skull of an alleged human giant, taken from one of the mounds at Chillicothe, Ohio, though the bones likely belonged to a mastodon or similarly large animal. In New York, Barnum took to exhibiting living giants and dwarfs, exaggerating and diminishing actual sizes for promotional effect. Colonel Roth Goshen, who became a featured performer in theatrical presentations of Hop o' My Thumb, The Giant of Palestine, and Jack the Giant Killer, reportedly stood seven feet eight inches. Midgets Tom Thumb, Lavinia Warren, and Commodore Nutt also proved box-office bonanzas for Barnum, with the Fairy Wedding of Thumb and Warren in 1863 attracting politicians and dignitaries alike. While the appeal of these figures stemmed from long-standing folk traditions, America's faith in the possibilities of science also bolstered the phenomenon. Giants and dwarfs, in pushing the limits of the anatomical spectrum, played into scientific potential, seemingly validating the idea that, in both past and present times, humans could be much taller—and shorter—than previously imagined. Fascination with freaks of nature, though, was hardly confined to popular culture. No less an intellectual than Oliver Wendell Holmes lectured on human giants before the Boston Society for Medical Improvement, and, for the purposes of illustration on one particular occasion, brought with him a man of freakishly tall dimensions. Though fake giant fossils and other dubious curios bore little or no scientific value, popular audiences nevertheless enjoyed access to legitimate geological, zoological, and ethnographic displays at curiosity museums and thus gained a valuable scientific education.[9]

Public interest in science also manifested itself in attendance at popular lectures. As with museums, the adult education movement of the 1830s owed to Enlightenment-styled thinking in the early republic, but it also was an expression of Jacksonian Democracy. During the Revolutionary War, American colonists rebelled not only against religious and political strictures, but also the customs and aristocracy of the Old World. The democratic

movement gained steam in the early years of the republic, culminating in 1828 with the election of Andrew Jackson. Unlike his predecessors, who came from either the first families of Virginia or New England, Jackson had been born in a backwoods settlement in the Carolinas. Old Hickory made a name for himself as a hero during the War of 1812, garnering additional public support when Washington powerbrokers seemingly stole the election of 1824 from him. During his eventual two terms as president, Jackson consistently challenged American aristocracy, establishing rotation of office within the patronage system and vetoing the recharter of the elitist Second Bank of the United States. Politicians, lecturers, and newspaper editors increasingly championed the common man, arguing that his empowerment would guarantee the success of American democracy. The new focus on ordinary Americans spawned the lyceum movement, an adult education series offering instruction in theology, literature, moral philosophy, and science. Steeled by public support, common men and women regularly attended these lectures, with science fast becoming the most popular subject. Demand for one geology lecture in Boston left thousands of citizens without tickets, and an angry mob subsequently smashed box-office windows. By the 1840s, the lecture circuit expanded to the new cities of the Midwest, and liberal speaking fees attracted prominent scientists such as Benjamin Silliman, Thomas Nuttall, and Joseph Lovering.

While attending their popular lectures, Americans nevertheless regarded scientists with much distrust. Jacksonian Democrats criticized men of science—and experts—for developing and amassing knowledge in secret. In this respect, the scientific community was no better than malevolent secret societies, which threatened the open and inclusive spirit of American democracy. One writer to the *Baltimore Patriot* criticized the attempt of a local medical convention to limit entry: "While any one who may have learned to rehearse the writings of the ancients in their original language by rote, and to write a prescription thus . . . is qualified for initiation into the mysteries of your order, and to wear the enviable appendix, M.D. to his name." Perhaps more damningly, the public regarded scientists as impractical buffoons. Newspaper editors and the public alike derided what they perceived to be a lack of common sense among men of science. In reviewing proposed revisions to time-honored taxonomies, the *Norwich Courier* scoffed at the lack of overriding logic and organization:

> In the ridiculous vanity of desiring to give a new name to some animal, plant, or mineral, learned men seem to have arrived at the very antipodes of the beautiful simplicity of Lavoisier's system; and it is to be hoped that they will

find their way back to the regions of common sense with all convenient expe-
dition: though there is no small danger of their being lost in the mists of their
own excessive erudition.

Citing the growing number of deaths in New York City due to hydrophobia,
the *New York Journal of Commerce* blamed the medical community's stub-
bornness as well as its lack of common sense: "To try a quack remedy, under
such circumstances, would seem to be no unreasonable homage of science to
common sense."[10]
 Within this climate of distrust, the common man ultimately came to
be regarded as the most sensible and impartial judge of scientific matters.
The Monthly Repository, and Library of Entertaining Knowledge, for instance,
charged readers with vetting the scientific muddle on the origin of earth-
quakes: "Who is to decide when learned doctors disagree? . . . The reader has
here a choice of opinions on this subject, and is at perfect liberty to choose,
or even to reject the whole of them." After an epidemic of yellow fever in
France, the *New Orleans Commercial Bulletin* outlined various prescribed
treatments and called upon the public to choose the best course of action: "In
such contrariety of practice as exists, in our medical faculty we must claim
. . . the right of deciding for ourselves . . . The public will judge with impar-
tiality, and bestow its confidence on those [physicians] to whom it is most
deservedly due." Barnum made a fortune uplifting the common man at the
expense of scientists. Promoting his fake Feejee Mermaid with the tagline
"when doctors disagree," the great showman called upon the public to judge
the mysterious curiosity and thus succeed where men of science allegedly
failed. Thousands of Americans heeded the call and paid admission fees for
the right to assess his scientific curio. Even as late as 1869, distrust of scien-
tists remained a powerful force in American society. Newspapers sought the
opinion of these men on vexing matters, but the greater public din typically
overwhelmed expert voices.[11]
 In truth, the American scientific community was not undeserving of its
dubious reputation. On one hand, virtually anyone could present himself as
a scientist. Over the first half of the nineteenth century, many legitimate
practitioners did pursue science as a full-time vocation. At the same time,
however, amateur enthusiasts stood at the forefront on public matters of
science, offering ill-informed assessments of fossils, antiquities, and natu-
ral processes. Far more malevolent, though, were the outright quacks that
plagued the medical community in particular. Capitalizing on the lack of
a credentialing process, these men earned a physician's wage, all the while
doling out questionable treatments to the sick. One writer to the *Daily*

National Intelligencer bemoaned the many lives lost as a result of these charla-
tans: "Multitudes in every part of our country, who obtain a little smattering
of the science from some obscure practitioner; but never find it convenient
to attend the lectures of professors, and, nevertheless, usher themselves into
the world as Doctors . . . We ought not think it strange if more die by the
disease called the *Doctor* than did formerly." The *New York Herald* likewise
noted the prevalence of medical imposters in New York City: "No city is
so cursed with quacks and imposters as New York. Every street, every lane,
every alley, every hole has a quack." Despite its obvious disdain for sham
doctors, the *Herald* nevertheless offered cheeky names for these men: Dr.
Dunderhead, Peter Hoax, and Dr. Humbug Hanks. The public's faith in its
own scientific judgment made the situation worse, for Americans became
inveterate purchasers of cure-all medicines. The Yankee peddler was a time-
honored American character, traveling from village to village, hawking
questionable herbal portions as well as wooden nutmegs—whittled wood
made to resemble the popular seed. The practice eventually morphed into
full-blown traveling medicine shows. Hucksters drew curiosity seekers into
their tents with comedy and dance routines, later pitching them patent
medicines to cure a wide variety of vague illnesses. The potions invariably
consisted of little more than sugar water and common herbs, but salesmen
sold them under the guise of scientific research. With the rise of major
urban newspapers, patent medicine salesmen became leading advertisers.
One writer to the *Daily Cleveland Herald* decried how these medical hustlers
overwhelmed the public: "Newspaper puffs for the benefit of nostrum ven-
dors and wholesale quacks have become so common at the present day that
the inquiring invalid is at a loss to determine what course to pursue in order
to regain a comfortable degree of health and vigor."[12]

Even where legitimate men of science were concerned, there was dif-
ficulty in arriving at common standards and methods of procedure. Not
every scientist enjoyed the benefit of collegiate education, with many
geologists and mineralogists acquiring their expertise through mining and
other professional work. Throughout much of the antebellum period, most
American colleges offered courses in physics, chemistry, astronomy, botany,
mineralogy, geology, and zoology, but budding scientists, for the most part,
learned in the classroom, rather than in the laboratory or in the field. At
the same time, texts were predominantly European, as American scientific
disciplines lacked their own definitive manuals. No graduate-level instruc-
tion was available, and, rather than cultivating limited specialties, early
colleges emphasized broad knowledge across multiple scientific fields. Many
preeminent geologists in these days also were leading paleontologists, and

designations such as the naturalist-geologist and the geologist-chemist very much represented the norm. The landscape shifted somewhat during the 1840s. In that decade, Yale established professorships in agricultural and practical chemistry, laying the groundwork for what ultimately became the Sheffield Scientific School, which offered specialized training in applied sciences. The Harvard Corporation similarly inaugurated the Lawrence Scientific School to meet the growing demand for engineers. The Smithsonian Institution was founded in 1847, promoting the study of both theoretical and applied sciences, and, more so than early professional organizations such as the American Association for the Advancement of Science, became the primary sponsor of research in geology and natural history. By the time of the Civil War, Louis Agassiz, Augustus Gould, Asa Gray, and James Dwight Dana had written seminal manuals within the fields of zoology, botany, mineralogy, and geology, drawing upon uniquely American data points, while establishing fundamental knowledge for domestic study. By the end of the decade, the broad foundations for graduate education in the theoretical sciences were emerging, with Yale awarding the first doctorate in geology in 1867. In a further sign of development, legitimate museums of natural history and ethnology were appearing, partly in response to the excesses of curiosity museums. Following the earlier lead of the Boston Society of Natural History and Harvard's Museum of Comparative Zoology, scientists and educators established the Peabody Museum at Harvard, the Peabody Museum of Natural History at Yale, and, chartered in 1869, the American Museum of Natural History in New York.

Still, at least to some degree, the Civil War had set back the burgeoning professional movement in American science. Though the war was thoroughly modern in its use of railroad, telegraph, and munitions technology, historian Robert V. Bruce argued that these developments predated the conflict and that the war itself spurred little innovation. The experience of war served as a distraction for scientists in the North and South, while precluding dialogue between researchers in the two regions. With the South serving as the conflict's battleground, opportunities for fieldwork were limited, and, in some cases, Southern scientists even suffered the loss of research materials. Botanist Henry W. Ravenel, for instance, lost several key manuscripts when a Confederate cavalry sacked his home. Even more critically, many young scientists lost their lives in service to the Union and Confederate causes. After the cessation of hostilities, lingering sectional animosities hindered full professional reunion. The American Association for the Advancement of Science, which suspended activities during the war, reconvened at Buffalo in 1866, but Southern board members refused to attend the meeting. By 1869,

some scientists from the South had rejoined the organization, but still more lacked the means or desire to reestablish professional connections.

The reception of the physicians and surgeons at Newell's farm foreshadowed the complex dynamic that would emerge between science and the American public in the coming weeks. Though the assembled crowd already concluded that the giant was a petrifaction, men and women eagerly anticipated the assessment of McDonald, Cuykendall, Park, and Dana. When the four men ultimately confirmed that the giant was a petrified man, members of the crowd were both satisfied and relieved. Had the physicians rendered a different judgment, men and women undoubtedly would have been unmoved, but, where scientists endorsed popular opinion or the giant more generally, the public embraced these men, hailing them for their insight while reveling in the added groundswell.[13]

Though the general feeling at the farm was one of enthusiasm, there was some consternation. The leading men of Cardiff evinced concern for the giant's exposed manhood and the effect that it might have on village females, particularly young daughters. With the exception of girls who assisted in rearing younger brothers, most females knew little or nothing of male anatomy prior to marriage. Concerned that the giant's penis would lead their daughters—not to mention their wives—toward licentious thoughts, the men secured a fig leaf, and, in the grand tradition of Western art, placed it upon the genitals. The makeshift solution lasted all of one day, however, as Cardiff women overruled them and allowed the giant to lay in all its glory.[14]

Later that afternoon, the first visitors from Syracuse arrived at Newell's farm. The group included reporters from the *Standard* and *Courier*, brewer John Greenway, as well as noted scientific lecturer John Boynton. The latter, in particular, would play a major role in the coming weeks, eventually helping to decide the giant's fate. At the time, Boynton stood at the pinnacle of a long and varied career in science and technology. After stints at Columbia College and the St. Louis Medical College in the 1830s and 1840s, Boynton practiced medicine for a time, but eventually turned his attention to other scientific pursuits. He joined the Queen's commissioner on a geological survey of Lake Superior, and, during that expedition, discovered artifacts of prehistoric cultures. Boynton later applied his practical knowledge of earth sciences as a forty-niner on the West Coast, but ultimately left the prospectors' life for a more comfortable existence in Syracuse. From his James Street estate in that city, Boynton concocted a series of scientific inventions, among them a modified fire extinguisher, a variation of Portland cement, as well as a soda fountain. He likewise took to the popular lecture circuit, amassing a small fortune through his presentations on geology, mineralogy,

and the antiquities of America. In 1858, the *Brooklyn Eagle* wrote of the "celebrated" lecturer: "No man living [is] better acquainted with the science of Geology." The Civil War arguably provided Boynton with his finest hour, as the scientist's implementation of new torpedo technology helped to take down the Confederacy's ironclad ram, the *C.S.S. Albemarle*.[15]

Despite Boynton's myriad achievements, Syracusans generally regarded the lecturer as an oddball, and his recent marriage did little to dispel the perception. On November 8, 1865, Boynton married Mary West Jenkins, his second wife, on Sixth Street in New York City. The ceremony took place in the basket of a hot-air balloon, and, upon concluding their vows, the newlyweds ascended into the skies, delighting more than six thousand assembled spectators. The stunt had been the brainchild of Thaddeus Lowe, chief of army aeronautics during the war and a close friend of the lecturer. In addition to piloting the wedding balloon, Lowe himself bore witness to the union and joined the newlyweds in eating cake above New York. Boynton's prominence in the early Mormon Church also may have colored his reputation, especially given persistent intolerance. Long before devoting himself to science, Boynton, who originally hailed from Bradford, Massachusetts, had been swept up in the religious fervor of the Second Great Awakening. He followed the Mormon migration to Kirtland, Ohio, where Joseph Smith established a small community in 1832. Smith personally baptized the twenty-one-year-old Boynton, charging him with missionary work in Pennsylvania and Maine. After two years converting souls, Boynton returned to Kirtland, where, in February 1835, he became an inaugural member of the Council of Twelve Apostles. The appointment, also held by Brigham Young, Orson Hyde, and Smith's brother William, represented the highest office of priesthood within church hierarchy.[16]

Boynton, however, quickly found himself at odds with Smith's leadership. In 1836, the church founder organized a bank to serve the Kirtland community, but, within a year, the institution failed amid allegations of mismanagement and embezzlement. Tensions grew within the community of the faithful, and, while Smith was away in August 1837, an armed confrontation broke out in the temple. According to Smith's mother, Boynton drew a sword on Joseph's son and enjoined him to stay away from his father's critics: "If you advance one step further, I will run you through." Soon thereafter, the council revoked Boynton's apostleship. In his own defense, he cited Smith's earlier claim that God ordained the Kirtland bank and that the divinely inspired institution could not fail. Given the bank's ultimate insolvency, Boynton wondered whether Smith was fit to interpret divine revelations as well as guide the spiritual lives of church members. The council initially

declined to reinstate Boynton, but relented a week later after the latter offered a full apology. Still, the episode represented the beginning of the end for Boynton within the church. Already under fire for mercantile pursuits, the young apostle hosted a ball in November and encouraged attendees to dance. A few days later, the council disfellowshipped Boynton, effectively excluding him from church activities. Along with other apostates, Boynton renounced Smith altogether, establishing a rival community and thus occasioning his formal excommunication from the church. The new denomination proved short lived, however, with Boynton soon embarking upon his scientific studies. According to one erstwhile colleague, the lecturer never bore a grudge against the church and, in fact, was an outspoken critic of persecution: "He has always been considerate to his former friends and colaborers in the ministry, and never said or done anything against the Church. When he visited Utah in 1872, he called on President B. Young twice, in my company. The President was then a prisoner in his own house, guarded by U.S. marshals, and Boynton denounced in strong terms the persecutions then being carried on against the Saints."[17]

At Newell's farm, the eccentric lecturer raised eyebrows with his unusual manner of inspecting the giant. After ordering workmen to bail out the pit, Boynton lowered himself into the soggy muck, digging further under the recumbent giant and cradling its neck in his arms. The lecturer utilized his various senses, tasting, touching, and smelling the great wonder, much to the amusement of the crowd. Still, the lengthy examination ultimately annoyed curiosity seekers, who eagerly awaited further validation of petrifaction. After some time, Boynton climbed out of the pit and rendered an unexpected verdict: the giant was not a petrifaction, but rather a statue. According to the lecturer, the sculpture likely was the handiwork of French Jesuit missionaries from the seventeenth century. After fashioning the giant from Onondaga limestone, these men buried the statue and thus protected it from their enemies. Members of the crowd were respectful of Boynton, but nevertheless the lecturer did little to sway them from the prevailing belief of petrifaction.[18]

While the crowd picked apart his hypothesis, Boynton sought out Newell for a private conversation. Though sleep-deprived, the Cardiff farmer, by all accounts, had shown far more composure on this second day. Newell fielded a bevy of offers to purchase the great wonder, but rejected them all outright. Indeed, only one had given him pause. The proprietor of a local curiosity museum proposed that together they install a tent and charge admission. By contrast, Boynton hoped to secure the item for science. The lecturer urged

Newell to hand the giant over to him, as only a man of science could ensure safe removal and proper exhibition. The Cardiff farmer must have given Boynton some hope, as the lecturer later told reporters from the *Standard* and *Courier* that, as an agent of city and county, he would return in the morning to fence off the giant from public view. As a collector of artifacts, Boynton undoubtedly knew that he had no basis for such a claim. If the giant represented a petrifaction, the county might have had a reasonable basis for securing the corpse, but Boynton already had dismissed that notion. The giant was a historic statue, but it resided on private property and therefore belonged to Newell. Boynton almost certainly recognized the distinction, but, for the sake of science, hoped to capitalize on Newell's lack of savvy. The lecturer also was not without his own self-interest. After all, the statue represented a monumental discovery, and, by positioning himself as spokesman, Boynton stood to enhance both his profile and his lecture audiences.[19]

The remainder of the day passed without incident. All told, a couple hundred curiosity seekers had come from all over Onondaga County to behold the great wonder. As night fell, quiet once again descended over the farm—the last it would see for quite some time. With reports of the discovery slated to appear in the morning newspapers, Newell's giant was about to become a celebrity.

* * *

On Monday, the giant took the lead position on the local pages of the three Syracuse dailies, with coverage trumping national and international items such as the Congressional debate over bond interest rates and France's war with Paraguay. Under the dramatic headline "A NEW WONDER," the *Standard* hailed recent developments: "Just now this valley is the scene of an excitement, in the finding of a supposed petrifaction of a human being—a giant." The newspaper's correspondent placed himself within the ensuing narrative, describing his initial skepticism upon first hearing of the discovery and noting how seeing the giant had made him a believer. He also cited his newfound popularity as one of the few Syracusans to have laid eyes upon it: "The interest is great in it, insomuch that it has been almost impossible for us to thus disjointedly write about the great wonder, because of the constant interruption by visitors who are anxious to hear from one who has actually seen." Despite interviewing the "quiet and modest" Newell, the *Standard's* correspondent nevertheless botched basic circumstances of the discovery, including making the Cardiff farmer one of the original well diggers. Still,

the *Standard* did put to rest exaggerations regarding the giant's size, publishing the first official measurements:

> From top of head to instep sole—or natural standing height—ten feet two and one-half inches.
> From point of chin to top of head, twenty-one inches.
> Nose, from brow to tip, six inches—across base of nostrils three and a quarter inches.
> Mouth four inches.
> From extreme of shoulders, three feet.
> Hand—Across palm, seven inches; through wrist five inches; second finger, from knuckle joint, eight inches.
> Leg—From hip joint to knee joint, three feet; through thigh, one foot; through calf, nine and a half inches.
> Foot, nineteen and a half inches long.

Much of the *Standard*'s news report concerned the giant's origin. The newspaper reported that most who had seen the giant inclined to believe that it was a petrifaction, but noted that Boynton's "hasty examination" yielded an alternative statue hypothesis. The *Standard* made quite clear its own position with the report's subheadline, "Petrified Giant," but hailed the import of the discovery in either scenario: "In the one case arises the speculation as to a gigantic race of beings that may *have* inhabited portions of this 'new world' hundreds of years before Columbus discovered it, the other as to how long ago the artist did the work, and where came he, or his ancestors, from?"[20]

The youngest of Syracuse's major dailies, the *Courier* would emerge in the coming weeks as a calm and objective voice on giant matters, but one scarcely would have guessed it from the newspaper's dramatic initial report. In an article titled "IMPORTANT DISCOVERY," the *Courier* painted a vivid picture of the hubbub consuming the valley:

> On Saturday morning last the quiet little village of Cardiff . . . was thrown into an excitement without precedent, by the report that a human body had been exhumed in a petrified state, the collossal [sic] dimensions of which it had never been the fortune of the inhabitants of the little village to behold, and the magnitude of which was positively beyond the comprehension or the understanding of the wise men of the valley.

The *Courier* succeeded in capturing full circumstances of the discovery, and, like the *Standard*, outlined both the prevailing petrifaction belief as well as Boynton's statue hypothesis. While reviewing the lecturer's assessment,

The Syracuse Daily Standard's first report on the Cardiff giant, Monday, October 18, 1869. Source: Onondaga Historical Association Museum and Research Center, Syracuse, New York.

the *Courier* acknowledged its own leanings: "We are not disposed to dispute [Boynton's theory], and yet we incline to the opinion that the discovery is *the petrified body of a human being.*" To wit, the *Courier*'s correspondent affirmed his own belief in historical giants, paraphrasing the Book of Genesis: "We know that men of mighty stature have inhabited the earth in days gone by—giants in fact, and who can tell but this may be the body of one of those mighty men, which has lain there for thousands of years."[21]

The *Journal*, the oldest and most conservative of Syracuse's daily newspapers, hit newsstands on Monday afternoon. The newspaper had not sent a reporter to Newell's farm on Sunday, and, as a result, merely rehashed coverage from its rivals. Having not seen the giant firsthand, the *Journal*'s writer refrained from offering any opinion, but the headline, "A WONDERFUL DISCOVERY," affirmed the significance of developments. Even while dramatizing the great wonder, the *Standard* and *Courier* alike dissuaded citizens of Syracuse from venturing to Cardiff, citing Boynton's intent to restrict viewing and ultimately bring the giant to the city. Whether they began their pilgrimage before reading the morning editions or simply disregarded warnings, Syracusans set forth for the tiny village in droves on Monday morning. They

encountered a scene that already differed dramatically from the one set forth in the newspapers.[22]

<p style="text-align:center">* * *</p>

Newell again had awoken to the sound of crowds milling outside his house. This time, however, the Cardiff farmer told curiosity seekers that they would have to wait before seeing the giant, as he had certain matters to address. Newell told his wife Lydia to take their son and head down to his father's house, remaining there until further notice. He then put friends and neighbors to work in enlarging the pit. The men cleared out debris, including the root that extended directly over the giant, while setting up a pump to drain water on a regular basis. Next, Newell instructed the men to build a small wooden railing around the pit and install a white canvas tent procured from the country store. Once the men had finished, Newell explained their new roles. Two would stand on either end of the tent, collecting fifty cents from anyone who wanted to see the giant. Meanwhile, inside, Billy Houghton would answer any questions about the discovery. It was a simple, makeshift operation, but, for now, it would have to do.[23]

The show finally opened at noon. Over the remainder of the day, more than four hundred people, including many from Syracuse, paid to see the great wonder. A half-day's turnout earned Newell a tidy sum of two hundred dollars, or roughly four thousand dollars in modern terms. Given all the newspaper coverage, Newell reasonably could expect a sizable increase the following day, and the Cardiff farmer, flush with optimism and the newfound windfall, purchased his first luxury item that evening. He hired Selah Woodward, a teenage neighbor, to stand guard over the giant, and, for the first time in days, he enjoyed a decent night's sleep. That night, Newell undoubtedly dreamed about where the great wonder would lead him, but the Cardiff farmer's thoughts also focused on George Hull. Where was Hull at that very moment and what was he thinking? More important, how would he have rated Newell's performance thus far?[24]

CHAPTER THREE

~

The Giant Maker

The giant, of course, was neither a petrifaction nor a prehistoric statue, but rather the handiwork of a creator who fashioned it in his own image. At the time of the giant's discovery, George Hull laid low at his home in Binghamton, New York, some sixty miles south of Cardiff. Over the course of the weekend, Hull desperately yearned to know whether his partner Stub Newell successfully engineered the planned discovery and, more important, what the response had been thus far. The giant's discovery did not make the Binghamton papers on Monday, but, over the course of the day, news reached that city by way of the telegraph. A neighbor stopped Hull on the street, and, much to the latter's delight, excitedly related the breaking news from the north.[1]

Hull was a small-time swindler, and not a terribly good one at that. His track record hardly suggested a man who could rival P. T. Barnum in terms of deceiving the American public. Physically, there was at least some promise, as the forty-eight-year-old Hull looked every bit the part of the classic cartoon villain. Even in his middle age, Hull boasted thick, raven hair, which he kept slicked back, and sported a full moustache. Accentuating his dark coloring, Hull typically wore black clothes and a black plug hat. At a time when the average man stood five foot eight inches, Hull was an imposing six foot three, and his unusually large wingspan, often punctuated by a long coat or cape, seemed capable of enveloping acquaintances at any time. Still, what men and women seemed to remember most about Hull were his piercing eyes. One man recalled the effect of those eyes on an entire village: "Those

George Hull. Source: Courtesy of the Broome County Historical Society.

eyes looked right at us, and seemed to pry, and gimlet, and cork-screw their way clear down into the innermost recesses of our souls."[2]

The details of Hull's life derive from a variety of sources, which, like their subject, are suitably complex and at times even shadowy. The best picture arguably comes from a book that Hull commissioned about the giant: *The Giantmaker or The Mist of Mystery*. The book, most likely written by former Binghamton mayor John Rankin, was never published, and only two copies survive today: one in the archives of the Broome County (New York) Historical Society and the other at Cornell University. As an authorized biography, *The Giantmaker* poses conceptual problems for the historian, as Hull could have refrained from discussing parts of his life or even lied to its author. Indeed, he would do both. Fortunately, several business associates furnished insight into Hull's life during interviews with newspapers. Certainly, these

men had their grudges against Hull, but, when balanced against *The Giant-maker*, a reasonable composite of the man emerges. Only with respect to his earliest years does Hull represent the sole source. While the verifiable portions of his story check out, the remainder necessitates trusting Hull—no easy task, to be sure.

* * *

Appropriately enough, even the circumstances of Hull's birth are shrouded in mystery. In *The Giantmaker*, Hull claimed to have been born on April 26, 1821, in Suffield, Connecticut. Over the course of his life, however, Hull told five federal census officials that his place of birth was Massachusetts, citing Connecticut on only two occasions. In Hull's defense, the discrepancy likely stemmed from legitimate confusion. Suffield lies just south of the border between the two states, and Hull spent his formative years there. Unfortunately for the modern historian, Hull's parents failed to register his birth, though few families did in those days. Still, the signs point to Hull's birth in Feeding Hills, a district of present-day Agawam, Massachusetts, located just north of the Connecticut border. In the first half of the nineteenth century, Feeding Hills was part of West Springfield. In the 1820 U.S. Federal Census, John Hull, George's father, appears alongside noted Feeding Hills landowners in the rolls of West Springfield, and, a few months before George's birth, older sister Sally recorded her marriage intentions with the West Springfield clerk, identifying herself as a resident of that town. Along the same lines, Celia Hull, George's younger sister by a few years, identified Massachusetts—and Feeding Hills specifically—as her place of birth.[3]

A native of New Hampshire, John Hull relocated to the Connecticut Valley around the turn of the century. By trade, he was a contractor on bridges and other public works, and the Suffield-West Springfield region certainly held appeal in that regard. The Connecticut River, New England's largest river, snakes its way southward through the area on its way to the Atlantic Ocean, while numerous tributaries abound in the vicinity of the Massachusetts-Connecticut border, including the Chicopee and what then was known as the Agawam River. The first decades of the nineteenth century spawned numerous internal improvement projects in the vicinity, including the Springfield Bridge to connect Springfield and West Springfield. While living in Suffield, John Hull met and eventually married Ruth Olds, who would bear him nine children. The Hulls eventually moved to Feeding Hills, where they lived as tenant farmers along Leonard Pond and where George—one of John and Ruth's youngest children—eventually was born.[4]

Shortly after George Hull commenced schooling, his family's situation changed drastically. According to Hull, his father lost a significant amount of money "by a partner," though Hull did not specify whether the loss stemmed from bad investment advice or some sort of scam. The family's dire financial straits necessitated accommodation. The Hulls moved back to Suffield, possibly to be closer to Ruth's family. At the same time, George Hull, who had completed a term or two of schooling by this point, was forced to give up his education, spending his days instead as a farm laborer to bring in additional income. Hull's labors gained even more import when John Hull soon suffered the loss of his eyesight. George Hull flatly summarized his family's condition during these years: "We all had to put our noses to the grindstone."[5]

Hull's days as a teenager in Suffield roughly coincided with the peak years of America's spiritual rebirth, the Second Great Awakening. The United States became vastly more religious in these years, with denominational affiliation and church attendance increasing exponentially from their early republic levels. French sociologist Alexis de Tocqueville observed in 1835: "There is no country in the world where the Christian religion retains a greater influence over the souls of men than in America." A generally Protestant and specifically evangelical unity emerged from this context, emphasizing personal religious conversion and affirming the Bible as God's revelation to humanity. The evangelical movement, in part, represented a conservative reaction to early republican deism, which promoted reason over revelation and deemphasized the Bible. Of the prevailing evangelicalism before the Civil War, historian Mark A. Noll writes, "Antebellum America was 'evangelical' not because every feature of life in every region of America was thoroughly dominated by evangelical Protestants but because so much of the visible public activity, so great a proportion of the learned culture, and so many dynamic organizations were products of the evangelical conviction." In the years leading up to the Civil War, more than 60 percent of the American population aligned itself with evangelical Protestant sects. Along with Methodists, Ruth Hull's Baptists represented the most popular and influential of these denominations. Evangelical fervor ran particularly high in Suffield, long a pillar of the Baptist faith. Established in 1769, the First Baptist Church was the first such congregation in Hartford County, and, even while living in Feeding Hills, Ruth Hull—and presumably her family—worshipped there. Still, it was not until his family relocated to Suffield that George Hull gained a full appreciation for Suffield's religiosity. He later remarked in *The Giantmaker* that his neighborhood there was filled with "zealously pious people."[6]

As a teenager, Hull found himself at odds with religion, primarily due to his experiences with local clergy. On one occasion, a local deacon hired Hull to drive steers to Blandford, Massachusetts, located roughly thirty miles from Suffield. The deacon promised Hull both good wages and the opportunity to drive back the finest horses in the county. When Hull arrived in Blandford, the deacon instead gave him a heifer. The teenager desperately wanted to challenge the religious man for going back on his word, but refrained from doing so out of deference—and the fact that the deacon still owed him his wages. Back in Suffield, the deacon eventually got around to paying Hull, but gave him only twelve and a half cents—a pittance, even for a teenager. Not only had the deacon lied to Hull, but he had preyed upon the latter's youth. While Hull remained silent, inwardly he seethed.[7]

The second incident involved a Blandford deacon, who hired Hull to plow corn on his farm. The religious man outfitted Hull with a horse, but the animal lacked a saddle, and, consequently, Hull's first hours on the job were exceedingly painful. After a time, Hull slid off the horse for a brief respite. The deacon became enraged at the sight, seizing Hull and placing him back on the horse, all the while swearing that he would flog the teenager if he took another break. Hull resumed his work, but the pain once again proved unbearable. While the deacon otherwise was occupied, Hull dropped from the horse and fled the farm altogether. According to Hull, these two experiences persuaded him "to question appearances, to doubt professions and in short to fear that 'things are not always what they seem.'" At the same time, Hull developed misgivings about religious professionals and religion as a whole: "To these trifling incidents I trace back the distrust of commonly received religious opinions, which too often encourage hypocrisy and cloak wrong."[8]

At this point, Hull began to reconsider the Bible as well. During his youth, his mother forced him to memorize passages from the Good Book, both to inculcate belief and to substitute for lost education, and Hull eventually became quite adept with the minutiae of the text. In light of recent experiences, however, Hull wondered whether the Bible's "marvelous stories" really were true. Among the many parables cited in *The Giantmaker*, Hull noted Elijah's flying chariot in the Book of Kings as well as the Book of Daniel's claim that Shadrach, Meshach, and Abednego walked through fire unscathed. For the most part, Protestants had been reading the Bible for centuries with what one historian called "flat-footed literalness." Whereas their ancient and medieval counterparts generally regarded the Bible as an amalgam of historical fact and allegory, early modern Christians, largely in reactionary response to radical movements and their liberal textual

interpretations, came to accept the Bible's often exotic stories as strictly true. In early nineteenth-century America, literalism both flowed from and reinforced common-man democracy, freeing the Bible from expert theological assessments and placing it within the realm of ordinary human experience. Historian James Turner writes, "Literalism formed part of the larger drive to secure religious belief by making it comprehensible, by keeping it within the bounds of human experience and understanding." Even well into the nineteenth century, many Americans refused to acknowledge that the earth orbited the sun. Pious men and women invariably cited the Book of Joshua and its claim that the Israelite leader commanded the sun to stand still in the skies. Common experience only served to reinforce this belief, with the *Boston Investigator* relating a memorable anecdote along these lines. A devout farmer known to the newspaper refused to accept his neighbor's claim that the earth orbited the sun. On one occasion, the man left a spade standing in the dirt overnight, and, upon noting in the morning that it had not changed position, he excitedly corrected his neighbor, informing him that he had proved the Bible correct. From this episode, the *Investigator* offered a rather damning assessment of literalists and the broader religious world: "They [philosophers] are willing to believe any new fact or new truth, however inconsistent it may be with their preconceived opinions. Christians and other religionists alone are incredulous and superstitious." During Hull's teenage years, Charles Lyell, a Scottish geologist, published multiple editions of *Principles of Geology*, convincingly arguing that the earth was not created in six days, as the Book of Genesis put forth. Lyell's geology was a significant salvo against biblical literalism, but pious Americans for the most part backpedaled, recasting the six days specifically as a symbolic device and positing that God had created the natural world over immense periods of time. In so doing, these men and women largely rescued the Bible's veracity, but also seemingly maintained the harmony between religion and science. In embracing the new metaphorical six days of Creation in *The Christian Freeman and Family Visitor*, Reverend William Fishbough hailed the Bible's victory over its doubters: "We can see no chance for the Infidel's cavil now, except upon the use of the word day."[9]

In *The Giantmaker*, Hull outlined the thought process that led him to dismiss the Bible and embrace a more scientific worldview:

> I thought of Elijah ascending to heaven drawn by a spirited span of horses; of Joshua's great feat in commanding and compelling the sun to stand still, when Nature, as revealed by science taught that the earth revolved around the sun, and that the sun never did move . . . I became a doubting Thomas about many

things, and a firm believer that Nature and Nature's Laws both created and developed the wonderful and phenomenal existence of everything, and produces every change that occurs in the human race, as well as the animal and vegetable kingdom; and that the world might possibly be older than six thousand years, and that it might have taken longer than six days to create it.

The reference to Lyell's geology suggests that the adult Hull, in recalling his earliest years, brought to bear more recent changes in the scientific and religious landscape. In *The Giantmaker*, Hull made repeated reference to the story of Elijah and his flying horse-drawn chariot, and it is likely that the parable's violation of common sense proved far more influential with the teenage Hull. Even without formal education, Hull knew from basic reason and experience that horses—and chariots, for that matter—do not fly. Without any influence from science, Hull easily might have concluded from the Elijah parable alone that the Bible was unreliable. In a sense, Hull was no different than the farmer with his spade, using his own experience to inform a reading of the Bible. In Hull's case, however, perception engendered not belief, but rather skepticism. Still, Hull faced a conceptual roadblock when it came to the subject of miracles. Specifically, most religious believers explained away the incongruities of the Elijah tale by characterizing the episode as a miracle. True, under normal circumstances, horses do not fly, but, in this particular case, divine intervention had allowed the steeds to transcend natural law. On this count, David Hume's philosophy may have helped Hull do away with both the Bible and God.[10]

In an interview with the *New York Daily Tribune*, Hull claimed that, in his early years, he became a voracious reader of Hume and other rational philosophers. Hull's literacy remains a vexing subject, as one business associate claimed that the adult Hull read scientific manuals, while Stub Newell, by contrast, described him as an "illiterate sort of a fellow." Even if he could not read, Hull might well have become acquainted with Hume's philosophy at his mother's church. Though he had been one of Europe's foremost philosophers and historians during the eighteenth century, Hume was widely criticized in the United States, both for his Tory reading of English history and for his religious skepticism, which made him a popular target of evangelicals. In his famed essay "Of Miracles," for instance, Hume argued that, since common experience furnished such a strong counter-proof, no human testimony could render a miracle at all likely. As a result, any religion founded on the basis of miracles—including Christianity—merited skepticism. The *Columbian Star*, a prominent American Baptist magazine, scoffed at Hume decades after his passing: "Mr. Hume denies the possibility of establishing the

truth of a *miracle*, by any evidence whatever . . . Hostility to religion alone could have betrayed so acute a mind as that of Hume, into an absurdity so palpable." The *Vermont Chronicle* likewise characterized Hume—and fellow skeptics Voltaire and Thomas Paine—as morally bankrupt:

> We think it likely the original cause of infidelity in these men was pride of intellect, though their infidelity was doubtless confirmed by moral depravity. Hume felt himself sufficiently flattered, with the prospect of staggering the opinions of the world on the subject of miracles. While all assented, he esteemed it a great feat, it by an ingenious and plausible, yet groundless theory, he could unsettle the minds of the multitude.

The pulpit likewise spawned such polemics, and the teenage Hull easily might have appreciated the degree to which Hume's skepticism rankled religious professionals. More important, Hume's dismissal of miracles offered Hull a counter-argument against those who sought to explain away the Bible's superstitions and questionable science. At some point during these years, Hull became a full-fledged atheist, rejecting not only the Bible and Christianity, but also God himself. In so doing, Hull joined a select group of American unbelievers, and, as Turner notes, "loose use of epithets like 'infidel' and 'unbeliever' obscures the freakishness of out-and-out disbelief in God before the 1860s."[11]

Hull's interview with the *Tribune* likewise cited the *Springfield Republican*, a Connecticut Valley newspaper, as a formative influence upon his young mind. During Hull's adult years, the *Republican* enjoyed a national circulation and prominence within Republican political circles, but, in the first half of the nineteenth century, the newspaper's scope largely was confined to New England, with its weekly edition reaching roughly seven thousand citizens. The newspaper was an organ of the Whig Party, with founder and editor Samuel Bowles assailing Andrew Jackson and the excesses of his common-man democracy. Hull was an ordinary citizen, and in his adult years he aligned himself with the Democratic Party. As a result, he probably identified little with Bowles's politics, instead appreciating the editor's antagonism toward mainstream thought. At the same time, the *Republican*, which early established its independence from area churches, often took occasion to criticize local clergy—undoubtedly another source of the *Republican*'s appeal for the young Hull.[12]

At the age of seventeen, Hull began an apprenticeship under Thomas Pomeroy, a local cigar maker. For decades, Suffield had been a hub of tobacco

production, with the first cigar factory in the United States opening there in 1810. Hull later boasted that, in no short order, he developed into a skilled manufacturer: "I soon thereafter became an acknowledged expert." *The Giantmaker* was full of grandiose claims to invention, and, in this context, Hull would offer his first. He claimed to have manufactured the first ten-cent cigar in the Connecticut Valley—as a teenager, no less.[13]

<p style="text-align:center">* * *</p>

In *The Giantmaker* as well as in various interviews, Hull said little about the next period in his life, doing so with good reason. These years occasioned both Hull's descent into petty crime as well as his estrangement from mainstream society.

Upon Ruth's death in 1845, the Hull family scattered across the Connecticut Valley. An elderly John Hull moved to Westfield, Massachusetts, where he took up residence with son Charles and his family. Older brother Oliver moved to West Springfield to serve as a laborer, while Celia (Hull) King remained in Suffield with her new husband. George Hull himself moved across the Connecticut River, taking up residence in Springfield. Hull reveled in his newfound independence, characterizing the period thusly: "Then I went to work in neighboring towns and became somewhat of a sport. I wrestled, ran, and had a good time generally." Most likely, Hull had taken to wagering on sporting contests, frequently putting his own skills to the test, though he also recalled training young Samuel Day, an aspiring runner. In the 1850 U.S. Federal Census, Hull identified himself as a "trader," which likely bore little relation to mercantile pursuits. If anything, Hull had embraced the distinct American horse trade. Unlike the confidence man or the Yankee peddler who pawned off junk items and then quickly left town, the classic horse trader was a popular and familiar figure about town. Crowds typically would gather to watch traders cleverly underscore a horse's faults during potential sales. The horse trader never lied, but he also offered no more information than was absolutely necessary—the onus was on the buyer to ask all the right questions. If he indeed were trading horses at this point, Hull remained on the up and up, but certainly he had embarked upon a slippery slope.[14]

The ultimate descent into swindle came sometime around 1853. The full extent and circumstances remain unknown, as Hull never publicly confessed to the crime. Former business associate E. J. Cox, however, gleaned the story from Hull and later shared it in his own interview with the *New York Daily Tribune*. According to Cox, Hull devised a new form of marked playing cards

called "star-backs." Along with an unidentified partner—possibly Day—Hull traveled throughout the Northeast, repeating the classic con over and over again. The partner would arrive in town before Hull, selling the cards at local saloons and hotel lounges. Soon thereafter, Hull would show up at these locations, striking up games with unsuspecting locals. During one romp through Broome County, New York, where older brother John Jr. moved decades earlier, authorities got wise to George Hull's scheme and jailed him briefly.[15]

Upon his release, George Hull boarded at his brother's homestead in Chenango. Presumably, it was an opportunity for Hull to get his life in order, and, indeed, during this period, he met the woman who became his wife. The two may have encountered each other previously, but, nowadays, Hull regarded niece Helen much differently. In 1853, Helen Hull was just sixteen, roughly half her uncle's age. The two commenced their love affair, and, according to George Hull, they were married in 1856, though no record of the union survives. The exact date, however, bears significance. The 1860 U.S. Federal Census reported that George and Helen Hull had two children: Nellie, aged four, and Sarah (nicknamed Sadie), aged two. If the Hulls did marry in 1856, as George reported, Helen Hull's pregnancy may well have occasioned not only their union but also the disclosure of the affair to John Hull Jr. As George Hull never addressed the circumstances of his marriage, it is difficult to discern how it affected relations with his brother. The signs suggest that, at least after a time, the two men reached some sort of practical détente, for John Hull Jr. assisted George with business and legal matters, and George even attempted to solicit his brother as a partner in the giant scheme.[16]

In light of their scandalous union, George and Helen Hull moved to cover their tracks. In the 1860 U.S. Federal Census, Helen Hull appeared in the rolls twice—once in her father John's household and once in her husband George's. The couple later took to lying about Nellie's age. For the 1870 U.S. Federal Census, the Hulls reported Sarah's age as thirteen and Nellie's as eleven. In the ten years since the previous census, Nellie managed to age only seven years, effectively recasting her birth year as 1859—a full three years after her parents' marriage. Nellie's gravestone at the Chenango Valley Cemetery likewise records her birth year as 1859—an indication that the modified age persisted throughout her life. Despite the best efforts of George and Helen Hull to make their marriage appear ordinary, Broome County society rejected them as outcasts. According to Cox, the scrutiny became so severe that the newlyweds relocated to a remote farm in the new village of Port Crane. Even the extended Hull family recognized the need for continued oversight. Older brother Oliver, who recently moved to Broome County, joined George and Helen Hull at their new homestead.[17]

George Hull already was an atheist by this point, but recent experiences effectively served to harden him. The *New York Daily Tribune* wrote that Hull took to "arguing all his religious neighbors out of their senses," with the newspaper referring to these harangues as "pyrotechnic" in nature. The salvos against religion reflected not only Hull's long-standing skepticism but also his growing dissatisfaction with the society that shunned him and his wife. Mainstream and religious society were largely one and the same at this point in history, and Hull's atheism fast was taking on a more general misanthropy.[18]

Despite his peripheral existence, Hull nevertheless attempted respectable pursuits. Drawing upon earlier experiences in Suffield, Hull, with help from brothers Oliver and Charles, likewise a recent Broome County transplant, took to raising tobacco on his Port Crane farm. Eventually, he established a small cigar shop along the banks of the Chenango Canal. In many respects, Hull's timing was impeccable. A few miles south along the Chenango River was the emerging village of Binghamton, incorporated only three decades earlier. Binghamton already boasted eight thousand inhabitants, but, more important, the village represented a key transportation hub. Already connected to Syracuse by way of the Syracuse & Binghamton Railroad, Binghamton had secured a position on the Erie Railroad route and emerged as the southern terminus for the Albany & Susquehanna Railroad. The village played a critical role in the movement of Pennsylvania coal, while also routing northern lumber to Philadelphia and Baltimore. With so much emphasis on transportation and trade facilitation, however, Binghamton's own native industries had not yet fully matured. Around the time that Hull opened his shop, the Greater Binghamton region boasted only a handful of cigar manufacturers, who rolled their products by hand, with the aid of only a few assistants. The next few years would change the face of Binghamton. With the outbreak of Civil War, major industries mobilized in the village in an effort to leverage its transportation routes. The Starr Arms Company established a munitions plant there in the early years of the war, bringing to the region modern industrial techniques such as assembly line manufacture. The cigar industry would benefit more directly from the imminent invention of the mold, but, still, local artisans gleaned valuable lessons from new mass production techniques, setting the stage for larger-scale manufacturing. A brief recession would ensue after the war, but Binghamton recovered quickly, and eventually the village would emerge as the nation's second-leading cigar manufacturer, behind only New York City. When the first cannon volleys sounded at Fort Sumter, Hull was on the ground floor of an industry—and a region—poised to explode. Unfortunately, he was too restless to notice.[19]

* * *

Sometime in the early part of the 1860s, Hull turned his attention away from cigars. During a trip back to the Connecticut Valley, he dreamed up a new invention: a modified harness snap for horses. Convinced that the idea would make him rich, Hull put his cigar business on hold and focused efforts on its development. Hull received financial backing from an unidentified partner and promptly set to work on developing the new snap. After its eventual completion, Hull's partner fielded an offer of three hundred dollars for the patent and strongly urged the inventor to sell. Hull assented, and, later, upon the patent's renewal, he received an additional thirty-five hundred dollars. Only much later did Hull find out that the buyers had made hundreds of thousands of dollars from the invention—at least according to him. The experience forever remained a sore spot for Hull: "I ought to have made myself rich, but I didn't." Still, he gleaned valuable lessons from the episode. On one hand, where it concerned partners, Hull had experienced the same ill fortune as his father decades earlier. In the future not only would Hull choose his business consorts more carefully, but he also would make it a point to get the best of them before they did the same to him. More critically, the snap affair gave Hull a boost in confidence. His inventive flair had succeeded in generating a fortune—next time, he would make sure to reap the benefits himself.[20]

Meanwhile, Hull's cigar business rapidly was failing, largely due to inattention. With little other recourse to raise money, Hull resorted to earlier criminal ways. In October 1864, he set fire to one of his tobacco barns, later collecting an insurance claim on the property. The following year, in an attempt to elude creditors and tax collectors, Hull divided his inventory across several businesses and manufactured cigars under a variety of names. Government officials became wise to the scheme, seizing sixty-five thousand cigars from Hull in October 1865. Hull's extended family posted bonds to retrieve the inventory, and he escaped prosecution only by pledging to operate honestly in the future. At this point, however, Hull gave serious thought to leaving Broome County. The end of war had brought economic recession to the area, and, while the cigar industry had made significant strides, Hull had no way of knowing for certain what lay ahead. Perhaps most significant, Hull recognized that, if he stayed in Broome County, the law would scrutinize his every move, and, accordingly, he resolved to head west with his family. Based on conversations with Hull, the *New York Daily Tribune* presented a rather oversimplified picture of this period in his life: "The war was then making men restless, and driving them hither and thither on all sorts of mad errands,

either of fortune or military glory. The Broome County tobacco planter was infected, and taking his family, he started for 'the West.'"[21]

In selecting new outposts for his cigar business, Hull showed attentiveness to larger socioeconomic currents. Decades earlier, the spirit of Manifest Destiny effectively opened the American West, with the subsequent surge of railroad building in the East reflecting the ultimate desire to connect to these new lands and tap their vast resources. Between 1850 and 1860, engineers laid more than twenty thousand miles of track, effectively tripling the size of the national network, though the new lines by and large were concentrated east of the Mississippi River. During the Civil War, President Abraham Lincoln laid the foundation for peacetime development of western lands, authorizing land grants to railroad companies as well as offering cheap homesteads to prospective settlers. With the end of war, the building of the West finally appeared nigh. At a Salt Lake City rally in June 1865, Speaker of the House Schuyler Colfax hailed the coming of the Pacific Railroad: "We hail the day of peace, because with peace we can do many things as a Nation that we cannot do in war. This railroad is to be built, this company is to build it; if they do not, the government will. It shall be put through soon; not toilsomely, slowly, as a far distant event, but as an event of the decade in which we live." In seeking new markets for his cigars, Hull seemingly looked to lands where the railroad recently had come—or soon was coming. Joseph Reed Ogden, husband of Helen Hull's sister Emma and a worker in one of his shops, agreed to establish operations for Hull in Ackley, Iowa. Surveyors plotted this central Iowa village in 1857, anticipating that it ultimately would serve as the western terminus for the Dubuque & Sioux City Railroad. A financial panic slowed early momentum, with the war bringing construction to a halt, but, in the fall of 1865, engineers succeeded in bringing the railroad to Ackley. Along with his family, Ogden moved there in the summer of 1866 and shortly thereafter received multiple cigar consignments and a peddle wagon from Hull. In a similar fashion, Hull selected Baraboo, Wisconsin, as the new home for his own family. Baraboo, located near the Wisconsin River in the south-central part of the state, already played a key role in the local lumber trade. More important, though, negotiations were underway to bring the Milwaukee and St. Paul Railway Company through the region. To secure necessary funds for his family's relocation, Hull set fire to both his Port Crane home and cigar shop on September 7, 1866. He submitted claims for both properties and, over the course of the next few months, received full payment from his insurers.[22]

Not long after his arrival in Baraboo in the spring of 1867, Hull received a disturbing update from Ogden in Ackley. Without going into detail, Ogden

explained that he could not pay Hull for the cigar shipments. Leaving his family behind in Baraboo, Hull headed to Ackley to investigate the situation. He arrived there late in the spring and quickly discovered the source of the problem: the newlyweds had burdened themselves with a heavy mortgage. As he later told it, Hull decided to stay for a while and help the Ogdens out: "I went out there to see about it. I found the farm [Ogden] owned encumbered, and as I thought a good deal of the family, before I left I cleared up the mortgage." Much to Hull's chagrin, however, his visit to Ackley coincided with a religious revival in the area, and, during that time, he made the acquaintance of one Henry B. Turk.[23]

Turk, a native of Tioga County, Pennsylvania, moved to Iowa only a few months earlier. He had enjoyed a long and successful career as a physician, but, these days, the fifty-nine-year-old primarily identified himself as a Methodist preacher. Despite his advanced age, Turk very likely was a circuit rider. These saddlebag preachers played critical roles during the Second Great Awakening, spreading religious fervor to remote areas along the Appalachian frontier and helping Methodism to become the fastest-growing denomination in the United States. Circuit riders were distinct and recognizable characters, traveling by horse and carrying few possessions beyond a Bible. During antebellum settlement of the West, the Methodist Church sent circuit riders to redeem these anarchic lands, with each man typically charged with a wide area—or circuit—of spiritual oversight. Of all the new states and territories, Methodists made especial inroads in Iowa, boasting more churches in that state than any other denomination. With westward expansion recommencing in earnest after the war, the Methodist Church sent still more circuit riders into the field, among them Turk, who settled in Oakland Township, Franklin County. Turk later lived in Ackley, but, in 1867, the village seemingly was not part of his circuit. Rather, Turk made the twenty-mile journey from Oakland Township to assist with the planned revival.[24]

During the revival season, Turk made the rounds in Ackley, meeting with local families and soliciting funds to support his travels. As Hull recalled: "The people were too poor to pay him anything, and [Turk] boarded around." On several occasions, the preacher visited the Ogden homestead, sharing meals with the newlyweds as well as their guest. Hull did not care for Turk from the outset, noting that the preacher showed little regard for the family's financial plight: "He would ask a long blessing; thanking the Lord that they were once more gathered about the table to partake of His Bounty,—seemingly caring little how the family struggled to provide." For the most part, though, Hull remained taciturn, refraining from criticizing the

preacher or challenging his faith. On one occasion, however, Turk stayed overnight at the Ogden household, possibly due to the failing health of Joseph Reed Ogden's father. After dinner, the family and their guests retired to the parlor, with Turk seizing the opportunity to proselytize. *The Giantmaker* described the scene: "He [Turk] was an earnest and a zealous worker in the Lord's vineyard, and after supper he conceived it his duty to engage in a little religious conversation in the family circle more particularly addressing his remarks to the new visitor." Hull took exception to Turk's statements, and, after the Ogdens retired to bed, he launched into a "heated discussion" with the preacher.[25]

The Giantmaker represents the sole record of Hull and Turk's argument. This rather biased source quite clearly favors Hull, but still the book offers insight into Turk's evangelical worldview as well as provides an account of what the two men discussed. According to *The Giantmaker*, Hull, from the outset, attacked the "absurdities" of the Bible, including the statement in Genesis that "there were giants in the earth in those days." "Do you believe that there were men fifteen to twenty feet tall," Hull asked the preacher, with the latter responding: "Yes, I believe there were giants. I don't know how big, but the Bible says that Og's bedstead was nine cubits long and four cubits broad: that would be sixteen feet, five inches by seven feet, four inches. I suppose that he was fifteen or sixteen feet." Turk's literalist affirmation was typical for its day. American Protestants had succeeded in weathering the storm of Lyell's geology, and new German scholarship on the Bible's authorship and dates had made only the most minor waves within the American intellectual community. Religious Americans by and large still affirmed the Bible as a definitive record of history, miraculous stories and all. As Turner writes: "Most Americans appear to have remained unshaken in their conviction of the Bible's historical veracity. Even theologians and Biblical scholars did not attend much to the higher criticism until late in the century." The Bible likewise remained a key source of reference for popular conceptions of science and the natural world. In *Principles of Geology*, Lyell downplayed the role of geological catastrophes such as Noah's Flood in shaping the earth and instead emphasized slow and uniform processes unfolding over time. Still, most Americans maintained their belief in Noah's Flood as a key event in geological history, with only its scope and universality subject to debate. In an entry titled "DELUGE, THE GENERAL," the *Hand-book of Chronology and History* characterized the flood thusly: "The deluge was threatened in the year of the world 1536; and it began Dec. 7, 1656, and continued 377 days. The ark rested on Mount Ararat, May 6, 1657; and Noah left the ark, Dec. 18, following."[26]

In defending the Bible's position on giants, Turk articulated his belief in the text's historicity. To the preacher, oral history represented legitimate knowledge, even if corroborating evidence or documentation was lacking. As the preacher explained: "We don't know that Alexander or Caesar lived, but we believe it because it is part of history handed down, and, if we believe that history, why not believe the sacred history?" Hull objected to this reasoning, arguing that it did not apply in light of the Bible's claim to miracles and divine intervention in human events: "But no one believed that Alexander sat and chatted with the Lord face to face every day or two as Moses and Abraham did." With Hull unable to shake the preacher from his belief in the Bible as a valid source of history, Hull instead focused on internal inconsistencies within the text, hoping to characterize the Good Book as unreliable. To wit, Hull baited the preacher:

> Now you say the Lord is omniscient and omnipresent, he knows everything, but after talking a while with Abraham about Sodom and Gemorrah [sic] the Lord said 'I will go down now and see whether they have done this which has come unto me, and if not I will know it.' The question is, did he have to go anywhere to know anything. It seems strange that the great God, who created the universe and controls everything in the heavens above, and the earth beneath, and the waters under the earth who knows the number of the hairs on the head, and the sands of the sea, should meet persons face to face and chat familiarly with them. The Lord even wanted to know of Abraham why Sarah, his wife, laughed.

As Hull told it, Turk stated erroneously in response that an angel, not God, communicated with Abraham about Sodom and Gomorrah. After correcting the preacher, an emboldened Hull returned to the subject of the Bible's historical veracity. Hull rejected the story of Noah's Flood on commonsense grounds, doubting that the patriarch could have collected animal life from all over the planet and fit all the species aboard an ark of limited size. "If they should tell that story about Caesar we might think his biographer had stretched it a little," Hull joked. After Turk confirmed his belief in the Bible's statement that the deluge covered the mountains, Hull once again brought common sense to bear:

> Hull replied that the Bible said that "The waters prevailed fifteen cubits upwards." That is twenty-seven and a half feet: now, we have mountains in this country fourteen thousand feet high, and some on the continent of Asia, where Noah lived, twenty-five thousand feet high. I don't think that twenty-seven and a half feet of water would sail a craft over them. . . . I think that if

those mountains had been covered it would have taken a little more than a hundred and fifty days for the earth to have dried up.

According to Hull, Turk offered a rather unconvincing response to this latest salvo: "Well, the mountains may not have been so high in those days."[27]

The conversation progressed along similar lines, with Hull and Turk addressing both the parting of the Red Sea as well as Elijah's flying chariot. In the context of the Elijah story, Hull moved beyond simple common sense, bringing newfound scientific knowledge to bear in his rejection of the parable: "This discussion became so earnest that Hull indulged in ridicule, and asked him the distance Elijah had to drive: the distance to the sun, and how many millions of miles it was to the planets Saturn and Herschel [Uranus]: and how many millions of miles astronomers had computed the newly discovered planets to be: and then pointed out that heaven must be beyond all these. . . . Allowing that Elijah did not have to stop to feed and went with whirl-wind rapidity he could not possibly be more than half way there." Of Turk's position on these biblical stories, *The Giantmaker* reported only that the preacher "accepted everything as literally true."[28]

With the debate reaching its climax, Hull levied his final blow against the Bible, arguing that the Good Book's own inconsistent characterization of God assigned him problematic motivations. "Now Mr. Turk," Hull charged, "You believe that God foreordained everything, yet held out the promise to Adam and Eve of everlasting life without evil if they would not partake of the fruit of the tree of knowledge, at the same time God knew that they would partake of it when he created them. He created Adam . . . and then 'cursed the ground and made him eat of it in sorrow all the days of his life.'" The preacher responded that Adam himself had chosen this path: "He [Adam] was a free moral agent. He could eat of [the fruit], or let it alone, as God had instructed him to do." Not satisfied with the preacher's response, Hull again demanded an explanation of God's motives: "He knew from the beginning that Adam would partake of the fruit and bring sin into the world, and misery and death to all succeeding generations. How do you account for the motive of the promise when he possessed the knowledge of the action to be taken beforehand?" Turk nevertheless remained firm: "We have to believe these things, they are in the Good Book." At this point, the argument dwindled to a close, with Hull offering the final summation:

Mr. Turk, I will believe that those incomprehensible statements were written for a good purpose by good men, as men existed in those times, but you must allow me to believe they were mostly allegories or parabolical [sic]: not to be

taken as inspired by the Great Jehovah, and therefore to be believed blindly as literal facts, as the child would believe the mother, although not able to comprehend, or more figuratively speaking, as the young robin opens his mouth for the mother bird, and would swallow a shingle nail as readily as the choisest [sic] morsel.

Both the invocation of Jehovah and the fact that Hull did not explicitly deny the existence of God likely belied the influence of John Rankin, author of *The Giantmaker*. Though Hull affirmed his atheism in newspaper interviews, Rankin kept the full extent of his subject's unbelief out of *The Giantmaker*. The author even apologized to readers before presenting the presumably limited vignette with Turk: "The writer is aware of the unpopularity, even in this day of scientific research and discovery, of entertaining or disseminating a doubt as to any statement whatever contained in the books of the Old or New Testament . . . [The doubts and beliefs of Hull] should not, however, be accepted as an attack upon the doctrines and precepts of that Book which has given such comfort to the weary and worn, and been such a beneficent factor in advancement of the highest civilization."[29]

Taking leave of Turk, Hull lobbed one more salvo at the preacher, scoffing how easy it would be, even in the nineteenth century, to delude men and women with Bible-esque "signs and wonders." Later tossing and turning in bed, Hull returned to Turk's defense of biblical giants: "I lay wide awake wondering why people would believe those remarkable stories in the Bible about giants." At this point, an idea struck Hull, with *The Giantmaker* thusly characterizing the moment of inspiration: "It occurred to his mind that if he could only find one of these giants in some form it would be easy to demonstrate whether the people can be deceived now as well as in former times." The discovery of a biblical giant seemingly would render religious America in ecstasies, with men such as Turk affirming the historical veracity of the Bible's miracles and superstitions. Hull could make religious professionals specifically and believers more generally look like fools, perhaps even striking a blow against religion in the process. A fortune might even be made from exhibiting or selling this giant. Hull had found his ticket to fame, fortune, and vindication from the society that had shunned him. Now, he simply had to figure out how to make a giant.[30]

CHAPTER FOUR

⌒

Cradle to the Grave

Dreaming was easy for George Hull, but the process of making—and hiding—his giant proved anything but effortless. The project consumed Hull for more than two and a half years, taking him through at least four states and costing him thousands of dollars. Hull, for the most part, kept his plan quiet, disclosing the scheme only to a select group of partners and assistants, but, along the way, the budding giant maker raised countless eyebrows both with his suspicious movements as well as his disquieting manner.

When it came to large-scale public deceptions, Hull had numerous templates upon which to draw. In the 1830s and 1840s, penny presses flourished in rising urban centers such as New York City and Philadelphia. These cheap newspapers focused their coverage on local news and popular content, targeting middle-class urban readers as well as the workingman. Sizable urban markets, however, sparked fierce circulation wars, and penny papers such as the *New York Sun* concocted exotic news stories to boost readership. On at least two occasions, the *Sun*'s fictional reportage engendered brief public sensations. In 1834, Richard Adams Locke fabricated a series of items on John Herschel's discovery of furry, winged men on the moon. The vivid scientific reports sparked intense public interest, with one women's group in Massachusetts writing Herschel—an actual astronomer—about the prospect of converting the aliens to Christianity. A reporter from the rival *Journal of Commerce* eventually asked Locke for reprint rights of the original scientific article, at which point the latter revealed the deception. Over the course of several weeks, however, the *Sun* had attained the highest circulation of

any newspaper in the United States, and a pamphlet on the discovery sold more than sixty thousand copies. Bitter that Locke incorporated elements of his story "The Unparalleled Adventure of One Hans Pfaall" into the moon hoax, Edgar Allan Poe later offered his own fictional news story in the pages of the *Sun*. On April 13, 1844, the newspaper promoted his article with a series of eye-catching headlines: "Astounding News! By Express Via Norfolk! The Atlantic Crossed in Three Days! Signal Triumph of Mr. Monck Mason's *Flying* Machine!!!" Poe's report played to public interest in technology, not simply with respect to the achievement in aviation but also by way of the numerous mechanical details on the balloon and its canopy. The *Sun*'s deception lasted only two days, however, as Charleston correspondents reported that Mason—likewise an actual balloonist—was nowhere to be found in that city. Still, the *Sun*'s report succeeded in spawning a brief hubbub in New York City, with the author later recalling: "On the morning (Saturday) of its announcement, the whole square surrounding the 'Sun' building was literally besieged, blocked up—ingress and egress being alike impossible, from a period soon after sunrise until about two o'clock P.M. . . . I never witnessed more intense excitement to get possession of a newspaper."[1]

Museums, of course, elevated public deception into a visual art form, and, in this regard, the great showman P. T. Barnum offered the best recipe for success. Barnum, eleven years Hull's senior, likewise hailed from Connecticut, growing up eighty miles southwest of Suffield in the town of Bethel. The two men shared at least some commonalities in their upbringing. Like John Hull, Barnum's father Philo was a man of modest means, keeping the local store and tavern, while also working as a tailor. Young Phineas Taylor Barnum supplemented the family's income by working on local farms, though he did attend school at every opportunity. During Barnum's youth, Congregationalism remained the established religion of Connecticut, and his family regularly attended Bethel's single house of worship. In an early manifestation of his entrepreneurial spirit, Barnum recalled earnestly memorizing Bible passages in Sunday school, in part because the young boy could redeem reward tickets for new books. Barnum, however, developed a strong personal faith, and, as an adult, he identified with the Universalists, a liberal Protestant sect. Barnum held the local clergy in high esteem, though, in the context of his autobiography, the showman hinted at some early negative experiences with religious professionals: "As the 'best fruit is most pecked by the birds,' so also is the best cause most liable to be embraced by hypocrites; and we all have learned, with pain and sorrow, that the title 'REV.' does not necessarily imply a saint, for nothing can prevent our sometimes being deceived by a 'wolf in sheep's clothing.'"[2]

Over the course of his teenage years, Barnum further honed his entrepreneurial instincts. After watching merchants and customers match wits at his father's store, Barnum sold candy and rum to local militiamen, later hawking lottery tickets to factory workers. Upon the death of his father, he assumed active management of the family's store, but ultimately took to selling lottery tickets again, this time across the state. The experience introduced Barnum to the power of printed advertising and promotion, and, in 1831, he launched Bethel's first newspaper, the *Herald of Freedom*. The experiment proved short lived, however, as Barnum's tendency for exaggeration spawned a series of libel suits. In 1834, Barnum made his critical move, relocating to New York City. It was a particularly wild time in that city's history. With the opening of the Erie Canal, New York surpassed Boston and Philadelphia as the nation's economic hub and preeminent city. Crime, poverty, and class divisions were fast rising, but New York remained a city of opportunity, nowhere more evident than in its attraction of immigrant masses from Germany and Ireland. Anything seemed possible in New York City, and, in the year of Barnum's arrival, the *Sun* staged its legendary moon hoax. The newspaper's artful deception enthralled Barnum, who wrote many years later: "The sensation created by this immense imposture, not only throughout the United States, but in every part of the civilized world, and the consummate ability with which it was written, will render it interesting so long as our language shall endure."[3]

Within a year of his arrival in New York, Barnum established himself in the market for belief. After making the acquaintance of an elderly former slave named Joice Heth, Barnum took to exhibiting her at museums, taverns, and concert halls, promoting her as 160 years old and claiming that she had served as wet nurse to an infant George Washington. Heth became such a popular spectacle that Barnum eventually took her on a tour of New England and various eastern cities. When interest finally waned, Barnum circulated rumors that Heth was a fraud, prompting discerning citizens to return for a second look. Over the next two decades, Barnum replayed this template over and over again. Upon the opening of his American Museum, Barnum exhibited the Feejee Mermaid, a fake specimen with the upper torso of a monkey and the lower half of a fish. A few years later, he scored yet another success with Josephine Fortune Clofullia, the Swiss bearded lady. Clofullia's unusual appearance drew sizable crowds, but Barnum generated still more publicity by circulating rumors that Clofullia was a man and accordingly convincing a customer to sue him on the grounds of fraud.

In Barnum's mind, his deception was morally permissible because it represented a manifestation of humbug, an "almost universal" phenomenon, as the

showman characterized it in *Humbugs of the World*: "I apprehend that there is no sort of object which men seek to attain, whether secular, moral or religious, in which humbug is not very often an instrumentality." According to Barnum, humbuggers differed vastly in nature from swindlers, counterfeiters, and pickpockets, who deceived honest men and women out of their money, offering nothing in return. By contrast, humbuggers stretched the truth and even on occasion lied, but these "glittering appearances" represented their means for attracting public attention, and they always delivered satisfying entertainment experiences in kind. As Barnum reinforced the distinction:

> An honest man who thus arrests public attention will be called a "humbug," but he is not a swindler or an impostor. If, however, after attracting crowds of customers by his unique displays, a man foolishly fails to give them a full equivalent for their money, they never patronize him a second time, but they very properly denounce him as a swindler, a cheat, an impostor; they do not, however, call him a "humbug."

Barnum once reportedly stated that "the people like to be humbugged," and his experiences as a public showman certainly bolstered that claim. As historian Neil Harris argues, Americans returned to Barnum's exhibits over and over again because they reveled in the highly public dance between humbugger and customer: "The manipulation of a prank, after all, was as interesting a technique in its own right as the presentation of genuine curiosities. Therefore, when people paid to see frauds, thinking they were true, they paid again to hear how the frauds were committed."[4]

Despite his public successes, Barnum's future was uncertain at the time that Hull concocted the giant scheme. After recovering from an earlier bankruptcy, Barnum rode out the Civil War years with midget sensation Commodore Nutt, later winning election to the Connecticut legislature in April 1865. Soon thereafter, Barnum suffered a crushing blow, with the American Museum burning to the ground and taking with it much of his renowned collection. A few months later, with the assistance of partner Isaac Van Amburgh, Barnum opened a second American Museum, but the great showman's focus increasingly manifested itself in the political realm. Barnum launched a campaign for Congress in the winter of 1866, but, around the same time that Hull sparred with Turk, the showman lost his election by five hundred votes. Whether Barnum would continue his pursuit of politics at the expense of his showman's career was unclear at this point. Still, with the potential for a void in the humbug market, Hull had every reason to be optimistic.

At the same time, Hull hoped to capitalize on widespread belief in human petrifaction. Reports of the phenomenon had been common in American newspapers for decades, and one 1850 case from Georgia epitomized both the prevailing tone and content:

> A singular petrifaction was discovered in an adjoining county (Chickasaw) some months since—a human body changed to rock. The subject was a woman aged 70, who died in full health five years since, of apoplexy. . . . It appears that her daughter, wishing to remove her remains, caused the grave to be opened, and upon attempting to lift the coffin out, it was found impossible to do so. It was opened, and to the amazement of all, the body was found petrified, and the features so perfect that persons who knew the woman could have recognized her. . . . It required the strength of six men to get the *statue* out, and it was estimated to weigh 600 pounds.

The aforementioned account did not specify causation, but a similar contemporary report from Iowa cited "something in the nature of the soil" as the agent of conversion. On occasion, nature seemingly produced even more exotic transformations, such as the petrified "iron man" discovered in Scioto County, Ohio, in 1847. The *Cincinnati Chronicle* hailed the scientific import of this wonderful discovery: "The body must originally have been petrified in lime; but of this there remains now only the outside incrustation, which will crumble off. What was the man is now iron. By some natural process, the iron must have grown out of the lime. And here is a theme for geologists! How did this change take place? If we are right—and the facts seem to leave no room for doubt—this iron man would afford one of the most beautiful subjects for a geological lecture." Discoveries of human petrifactions became so widespread by the 1850s that one Philadelphia printer collected the most sensational cases for a pamphlet: *A Descriptive Narrative of the Wonderful Petrifaction of a Man Into Stone As Perfect As When Alive.*[5]

Belief in human petrifaction manifested faith in the possibilities of science. Alleged petrifactions invariably arose in environments where elements conspired to produce misleading effects, with citizens mistaking the hard, leathery flesh of corpses for stone. The reports quickly assumed tall tale–like proportions, with citizens and newspapers alike grossly exaggerating the weight of coffins and corpses. Americans were well acquainted with fossils from curiosity museums, having learned along the way that minerals substituted for bone to produce perfect skeletal replicas. Within this context, it was hardly a stretch for believers in the scientifically possible to conceive of minerals similarly hardening and preserving human flesh. The science, of course, was untenable, for soft parts of organisms—muscles, organs, and

flesh—decay from bacteria long before the slow process of fossilization begins. Still, the American inclination to accept quasi-scientific explanations sufficed to make petrifactions one of the most popular manifestations of nineteenth-century pseudoscience. The phenomenon may have enjoyed especial resonance, in part because of the manner in which it brought to life elements of folklore. Greek mythology, a part of antebellum curricula in America, related how men and women turned to stone after laying eyes upon Medusa and the Gorgons.

Still, belief in human petrifactions was by no means restricted to America. In 1845, the *Montreal Times* reported that workers in Berthier, amid repairs to their village church, discovered the petrified remains of a teenage girl, noting: "An attempt having been made to obtain the body for the purpose of exhibition, it has been taken possession of by a relation of the deceased." Two years later, the *Caledonian Mercury* recounted how Edinburgh miners discovered and accidentally broke a petrified human body. That same newspaper likewise reprinted some of the more spectacular cases from the United States, including discoveries of petrified men in Indiana and Texas. In 1866, a collector of curiosities reportedly discovered a petrified aborigine in Australia, bringing the prize all the way back to England and placing it on public auction.[6]

Fervor for petrifactions even spawned parody hoaxes. In 1858, the *Daily Alta California* published a letter from Friedrich Lichtenberger, a Fort Langley doctor, regarding the "strangest [petrifaction] case on record." The physician recounted how Ernest Flucterspiegel had died after drinking from a geode. During the later autopsy, Lichtenberger discovered that Flucterspiegel's insides had turned to stone: "I next made an opening into the cavity of the thorax and . . . discovered the heart *in situ*, and of a natural color, but it was as hard as, and strongly resembled a piece of red jasper, exhibiting here and there those varied colors which give such beauty to that mineral . . . The larger blood vessels were as rigid as pipe stems, and in some cases the petrified blood could be cracked out from the veins, exhibiting a beautiful moulding upon the valves of the latter." The author of the letter never did claim credit for the obvious fiction, but, given that the German "Flucterspiegel" roughly translates to "look at the curse in the mirror," he most likely crafted the letter as a satire on public credulity. Four years later, Samuel Clemens—who had not yet adapted the nom de plume Mark Twain—executed a similar literary hoax in Nevada's *Territorial Enterprise*. He later explained his motivation thusly:

> In the fall of 1862, in Nevada and California, the people got to running wild about extraordinary petrifactions and other natural marvels. One could

scarcely pick up a paper without finding in it one or two glorified discoveries of this kind. The mania was becoming a little ridiculous . . . I chose to kill the petrifaction mania with a delicate, a very delicate satire.

On October 4, the young *Enterprise* editor published a fake report on a human petrifaction near Gravelly Ford. According to Clemens, the local coroner—a nemesis of the young writer—convened an inquest over the corpse, while savants hailed the natural wonder as more than ten generations old. Some newspapers recognized the obvious satire, with San Francisco's *Daily Evening Bulletin* presenting the report as a "Washoe Joke," though both the *Boston Investigator* and *Milwaukee Daily Sentinel* faithfully reprinted the original article. Given that many citizens and newspapers alike regarded the report as legitimate, Clemens initially considered the satire a failure, but the young writer ultimately came to appreciate its success. According to his biographers, Clemens grossly overstated the magnitude of the hoax in later boasting: "I saw that he steadily and implacably penetrated territory after territory, State after State, and land after land, till he swept the great globe and culminated in sublime and unimpeached [sic] legitimacy in the august London *Lancet*, my cup was full, and I said I was glad I had done it."[7]

After his encounter with Turk in Ackley, Hull returned to his family in Baraboo, Wisconsin. He did not divulge his planned scheme to wife Helen and, at least on the surface, renewed his commitment to cigar manufacturing by leasing a small building and employing several workers. Still, thoughts of the giant consumed Hull. Already, he had decided to sculpt his biblical giant from natural material, and, in this respect, his move to Baraboo appeared prescient. Nearby Devil's Lake teemed with quartzite outcroppings, some of the oldest rocks on the continent. Hull made several nighttime excursions to investigate the rocks, and at least one resident characterized his movements as "mysterious" and "circuitous." At the same time, Hull, recognizing his need for material assistance, contacted older brother John about becoming a partner, but the latter declined. Mindful of earlier experiences with business associates, Hull began a careful search for a trustworthy and reliable man. He made the acquaintance of one unidentified local official, who offered to invest in the scheme, but Hull declined the proposition, indicating that he had far greater need for someone to help him with the giant's production. Hull next tried local saloons and hotel lounges, stirring up arguments on politics and religion in his search for a like-minded man. He expounded upon the virtues of New York Democracy, laying wagers that former governor Horatio Seymour would win the presidency the following year—a decidedly unpopular position in Republican Wisconsin. Along the same lines, he

launched into diatribes against religion, avowing his atheism and offering up what local newspaper editor J. C. Chandler sarcastically called "ingenious theological dissertations."[8]

Hull eventually found his man in Vermont native Henry Martin. Martin, who was fourteen years younger than Hull, worked as a blacksmith in Marshalltown, Iowa, but recently arrived in Baraboo to hawk a new agricultural invention. Appreciating Martin's creative flair, Hull revealed the proposed scheme to him. Even though the giant had been his idea, Hull proposed to make Martin an equal partner, with the two men sharing the expenses of the project as well as its eventual proceeds. Martin agreed to the arrangement, and the two men quickly turned their attention to the matter of the giant's composition. Hull outlined his trips to Devil's Lake as well as his thoughts on eventually burying the giant near Baraboo's native earthworks. Martin expressed concern about securing material from the nearby cliffs, opining that, in Iowa, they might find more readily accessible natural material as well as a similar burial context. Hull yielded to Martin on this point, and the two men agreed to meet the following spring in Marshalltown. Martin subsequently left Baraboo, while Hull took steps to do the same. After resolving to move his family back to Broome County, Hull set fire to his Baraboo cigar factory in August 1867, while, hundreds of miles to the west, Joseph Reed Ogden's Ackley shop suffered a similar fate. Within days, Baraboo residents learned that Hull earlier had taken out a twelve thousand dollar policy on the four hundred dollar structure and now was seeking full payout of his claim. The matter eventually landed in court, with Hull receiving only a thousand dollars in damages—well short of the policy's value, but nevertheless a solid profit. With the natives charging "nigger in that fence!" in the unfortunate parlance of the day, the Hulls promptly escaped from Baraboo, heading back east and settling in Binghamton.[9]

Amid the relocation, Broome County officials seized Hull's eastbound cigar shipments as payment for unpaid taxes. Hull's extended family promptly initiated legal action on his behalf, hoping to reclaim the valuable cigars, but, even as his financial situation grew dire, Hull evinced surprisingly little concern. Indeed, his mind was fixed on one thing and one thing only: springtime in Iowa.[10]

* * *

In May 1868, Hull arrived at Marshalltown, a mere forty miles from the place where he dreamed up the giant. In the interim, Martin had shown himself to be a good partner, scouting various rock formations across the state. Upon

Hull's arrival, Martin informed his partner that he had a promising lead one hundred miles to the northwest in the village of Fort Dodge.

Fort Dodge was barely two decades old at this point. In 1850, the United States Army, seeking a strategic position for chasing down deserters as well as monitoring white encroachment upon native lands, established a fort along the banks of the Des Moines River in the central part of the state. The army abandoned the position within three years, but Major William Williams purchased the military reservation and subsequently plotted a village. In 1856, a U.S. Land Office established operations in Fort Dodge to assist with the larger settlement of Iowa, while a railroad survey earmarked the region for a future route between Dubuque and Sioux City. The Civil War stalled momentum for the line, but Fort Dodge nevertheless grew steadily. The population swelled to three thousand, and eastern speculators paid increased attention to the village's abundant natural resources. Heavy timber blanketed the southern and northwest corners of the village, while roughly thirty thousand acres of coalfield offered abundant fuel sources. Still, it was Fort Dodge's gypsum that proved most enticing to investors. Gypsum is relatively common in the United States, with deposits along the Great Lakes, in the Midwest, as well as in several western states. In the Fort Dodge region, native beds extend for more than fifteen miles along the Des Moines River, with prominent outcroppings exceeding more than forty feet in height. Gypsum generally takes a variety of forms, but, in the Fort Dodge region, the mineral is especially soft and chalky—in fact, one can easily scratch it with a fingernail. Early settlers recognized the ease of quarrying gypsum, utilizing it extensively in building projects. State legislator John F. Duncombe built a formidable gypsum mansion atop a nearby plateau, while the German Lutheran church likewise was fashioned from the mineral. Martin visited Fort Dodge's quarries at some point during the winter, and, upon Hull's arrival in Iowa, he took him there for further inspection.[11]

The two men arrived in Fort Dodge on June 6, registering at the St. Charles Hotel. The village already was buzzing, for contractors recently had begun construction of the railroad terminus. Hull and Martin did not immediately make their business known, instead keeping to themselves as they walked about Fort Dodge. The two men cased the local gypsum quarries from afar, while also possibly inspecting the village's mounds. Their suspicious behavior quickly put residents on guard. Bank officials hired additional men to protect their vaults, while owners of valuable horses kept closer watch over their prize steeds.[12]

After a few days, Hull and Martin finally requested a tour of the Lime and Gypsum Works quarry. Owner C. B. Cummings recalled how the two

men spoke in hushed tones during the outing, stopping on several occasions for private conversations. At one point, Hull and Martin even drew out their pocketknives to test the gypsum's softness. At the tour's conclusion, the two men requested a full block, roughly twelve feet by four feet by two feet. Pressed for their intended use of the gypsum, Hull and Martin told the quarry owner that it would form part of an upcoming New York exhibition. While appreciating their business, Cummings explained to Hull and Martin that a block of those dimensions would be next to impossible to quarry. Furthermore, the men faced a daunting task in transporting the block, for the closest rail station was still more than forty miles away—in the village of Montana (later Boone). Hull and Martin, however, remained firm, and ultimately Cummings told the two men that they would have to hire another company. A few days later, Hull and Martin returned to the quarry, pleading their case with Cummings's foreman. This time, the two men gave a different story, claiming that the block would be used in the planned memorial to Abraham Lincoln in Washington, D.C. After getting wind of Hull and Martin's return visit, Cummings told the two men that they were no longer welcome at his quarry.[13]

Hull and Martin did not yet have their gypsum block, but at least they had settled on the giant's material. At this point, their attention turned to its eventual sculpture. The two men had entertained thoughts of fashioning—and possibly even burying—the giant in Fort Dodge, but now the village was out of the question, seeing as they had aroused too much suspicion there. Back in Baraboo, a patent salesman gave Hull the name of a Chicago marble dealer named Edward Burkhardt, who reportedly had connections to a number of sculptors. Hull and Martin resolved to feel out Burkhardt as a partner and shipped him samples of Fort Dodge gypsum in one of Hull's cigar boxes. Hull then headed out to Chicago to track down the marble dealer, while Martin left for Marshalltown to check on his family.[14]

In 1868, Chicago merely was the Fifth City, trailing New York, Philadelphia, Brooklyn, and St. Louis in population. Still, in these final years before the Great Fire, the Garden City—so named for its many wooded parks and shaded streets—was growing at a furious rate. The opening of the Erie Canal in the 1820s shifted commerce toward the Great Lakes, with Cleveland, Detroit, and Chicago accordingly emerging as urban centers. In 1840, fewer than five thousand people lived in Chicago, but, roughly three decades later, 160,000 congregated along the shores of Lake Michigan. Chicago already had emerged as the world's leading market for pork, beef, and grain, while the city boasted numerous iron foundries, machine shops, steam sawmills, and planning mills. One contemporary guidebook noted Chicago's tendency

toward bigness, noting the city's "mammoth hotels, spacious stores, fine ecclesiastical buildings, large public buildings, [and] beautiful residences." Burkhardt was no captain of Chicago industry, but the thirty-four-year-old German immigrant nevertheless had made impressive strides within the stone business. Earlier in the decade, he owned and operated a small marble dealership with James A. Roche, but the two men recently joined forces with Leonard W. Volk, an esteemed local sculptor, establishing the Chicago Marble and Granite Manufacturing Company. This new firm boasted offices on Washington Street in the heart of Chicago's business district as well as two showrooms just north of the river on North Clark Street.[15]

After Hull arrived in Chicago, Burkhardt agreed to meet with him at the Garden City Hotel, on the corner of Madison and Market streets. Burkhardt already was less than enamored with the mysterious stranger, for, upon earlier receiving an unsolicited package of gypsum, the marble dealer was left to pay the entire freight bill. Still, Burkhardt was intrigued as Hull outlined his vision for the giant. He agreed to join the scheme as an equal partner with Hull and Martin, with the understanding that he would furnish two of his workers and his own barn for the project. Hull and Burkhardt proceeded to review the gypsum samples, and the marble dealer endorsed the plan to use the material. Hull then took leave of Burkhardt, pledging to return soon with a massive block of gypsum. Before leaving, however, Hull swore him to secrecy regarding the scheme, though Burkhardt ultimately did confide in his wife.[16]

Along with Martin, Hull arrived back in Fort Dodge on June 25, once again registering at the St. Charles Hotel. Under cover of night, the two men returned to the Lime and Gypsum Works quarry, attempting to obtain the material themselves but quickly proving unsuccessful. Next, they leased an acre of land five miles south of the village, hiring four professionals to quarry the block for them. As Cummings predicted, however, the dimensions proved difficult to secure. Eventually, Hull hired Mike Foley, a local contractor of some regard, to oversee the process. Foley later claimed that Hull made him part of the scheme, but circumstances called the Irishman's account into question. With Foley's assistance, the men at last succeeded in quarrying the five-ton block, loading it onto an army wagon. Several large oxen proved incapable of moving the cargo, however, and several days passed before Foley brought to bear four strong horses, which succeeded in moving the wagon out of the quarry. Foley, however, would not let Hull and Martin take the steeds to Montana, and so the two men faced further delays in finding new beasts that were up to the task. Later seeking sole credit for the giant's production, Hull claimed that a frustrated Martin quit the scheme at

this point, but eyewitness accounts as well as later shipping records confirm the latter's continued involvement in Iowa.[17]

Eventually, Hull—and Martin—hired a new contractor to take the block to Montana. Already, it was the middle of July, more than six weeks after their initial arrival in Fort Dodge. Once again, however, Cummings proved sagacious, as the wagon traveled only a short distance before sinking into a mud hole. The new contractor quit the job, taking his horses with him, and Hull and Martin accordingly hired another man, who pledged to free the wagon and convey it to the rail station. With full confidence, Hull and Martin headed south to Montana, where they waited and waited, but their man never appeared. Returning to the vicinity of Fort Dodge, the two men found the wagon exactly where they had left it, as their contractor had become preoccupied with other projects. Hull and Martin spent eight days searching for a new man. The summer heat was excruciating, and even Hull confessed to thoughts of quitting the scheme. Finally, they hired a man named John Lennehan and located suitable horses at the Wilson family farm in Brushy. Not entirely trusting the two strangers with their prize horses, the Wilsons sent their own teenage son to watch over them on the journey to Montana.[18]

The trip to the rail station proved exceedingly arduous. On one occasion, the wagon fell into a mud hole, at which point Hull employed a local farm's ditching machine to free the carriage from the muck. The wagon also collapsed several times under the weight of its cargo, and Hull and Martin had little recourse but to allow Lennehan to reduce the block's dimensions. The mass now was a more manageable three tons, measuring eleven feet three inches by three feet two inches by twenty-three inches. On the evening of Saturday, July 25, the motley wagon crew finally rolled into Montana. In consigning the cargo at the railway office, Hull and Martin registered its destination as "E. Burkhardt" in Chicago. The shipment headed east two days later. Upon getting wind that Hull and Martin planned to honor the slain president, the *Boone Standard* took occasion to hail the shipment:

> A large block of gypsum, from the quarry near Fort Dodge, arrived at this station on Saturday evening last, and was sent to New York as the quota of this State to the monument, which is to be composed of contributions from each State in the Union. Iowa need not be ashamed of its share. It weighed 6,560 pounds, and was two weeks on the way from Fort Dodge to this point. Those quarries are an immense benefit to Webster county, and will be made the most of.

Boarding an eastbound passenger train together, Hull and Martin undoubtedly enjoyed a hearty laugh at the newspaper's expense. While the long and

lanky Abraham Lincoln was a literal and figurative giant in his day, not even he would have measured up to what the two men had in store.[19]

* * *

The shipment arrived in Chicago sometime during the first week of August. Hull and Martin, having already turned up in that city, conveyed the block from the Water Street depot of the Chicago & Northwestern Railway to Burkhardt's North Clark Street residence, located on the outskirts of Lincoln Park. The formidable shipment escaped general notice, but Hull and Martin did have the misfortune of being recognized by another Garden City sojourner. Benjamin Gue, editor of Fort Dodge's *Iowa North West* newspaper, spotted the two men together several times over the course of his ten days in that city.[20]

From the outset, Martin apparently researched burial locations, ultimately taking leave of Chicago to scout various unspecified sites, while Hull coordinated the giant's sculpture with Burkhardt. Through the marble dealer, Hull met the men who would fashion his colossus. Frederick Mohrmann was a marble cutter at Burkhardt's company, while Henry Salle assisted his partner Volk. In meeting with Mohrmann and Salle, Hull offered the men background on the scheme—naming Martin as an active partner—while also presenting the men with two options for payment. According to Hull, Mohrmann and Salle could accept either a small share in future profits or a one-time payment of seventy-five dollars each. Both men selected the latter option, but Hull paid only forty dollars up front, with every dollar going to the sculptor. In presenting his overall vision to the men, Hull was somewhat vague, an indication that he had not yet decided on the giant's ultimate form. As Salle recalled, Hull initially directed him to sculpt "a monkey, a baboon [sic], or something that would represent a man." Hull later claimed to have told the sculptor to make the giant pass as both a petrifaction and a statue, but this later assessment may well have been revisionist history, informed by the giant's ultimate reception.[21]

Later at the barn, Burkhardt joined the men in a further discussion of the giant's appearance. Practically speaking, whatever species and form the giant assumed, it could have no projecting limbs, for these easily might break during its ultimate shipment. At some point, the men agreed to make the giant human, while accordingly streamlining its posture. Stripping off his clothes, Hull modeled various positions on the floor for Salle, eventually settling on the left leg thrown over the right, with the right arm spreading across the torso. Salle incorporated elements of Hull's own face into his three-foot clay

prototype and eventually into the giant itself. After Hull endorsed the sculptor's model, Mohrmann and Salle stood poised to commence their labors, but first Hull and Burkhardt made sure that their work would remain quiet. To deaden the cutting and chiseling sounds, they lined the walls of the barn with quilts and carpets. Hull also secured large quantities of beer, hoping to keep the men on the premises as much as possible.[22]

The next few weeks were subject to some debate. According to Hull, Mohrmann and Salle disappeared for long stretches at a time, prompting Hull to sculpt the giant himself, with only Salle's manuals to guide him. Of course, Mohrmann, Salle, and Burkhardt offered a much different version. According to these men, Hull left them entirely alone, with Mohrmann and Salle doing all the labor under Burkhardt's direction, working roughly three days a week. Despite the limited schedule, the men presented Hull with the giant after only eighteen days. Upon seeing their handiwork, Hull immediately took exception to the ringlets of hair on the giant's head—a clear indication that he had not overseen their work. After meeting with a local geologist and confirming that hair did not fossilize, Hull ordered Salle to remove the particular embellishment. Along the same lines, Hull told the men that the giant needed to look much older. After some discussion, the men filled a sponge with water and sand, rubbing down the surface to give it a worn appearance. Next, they tried to make the giant look exotic by pouring a gallon of English writing ink over its whitish surface, but succeeded only in giving it a strong blue tint. To mitigate this coloring, the men swabbed the exterior with sulfuric acid, unwittingly arriving at the desired effect. The resulting dingy hue seemingly aged the giant before their very eyes. In one final touch, the men battered the surface with a tool fashioned from a series of pins, giving the giant the illusion of pores. Both Hull and Burkhardt ultimately took credit for these innovations, but, as Mohrmann implied, the process inherently had been a collaborative one.[23]

At last, the giant was finished, but the matter of its final resting place remained unclear. Hull did head eastward at some point, very likely during his assumed absence from the production process. Specifically, Hull scouted various locations in the Berkshires, not far from his childhood home in the Connecticut Valley. Hull visited Salisbury, Connecticut, offering to purchase land upon which a newly discovered cave resided, but the owner's asking price proved too high. Hull also apparently visited Stockbridge, Great Barrington, and Lee, making passing reference to these Massachusetts towns in a later interview. Hull acknowledged especial interest in Great Barrington's soda springs, a particularly exotic milieu, but, for reasons unspecified, he decided against all these locations. Upon his return to Chicago, Hull asked

Mohrmann what he thought about Mexico as a potential location for the giant. Even though the stonecutter endorsed the idea, Hull eventually decided that the distance was too great. In late September, Martin joined Hull in Chicago, his own scouting operations having proved equally unproductive. After some debate, the two men resolved to ship the giant to New York, with Hull pledging to find a suitable location there and arranging for the burial himself. They decided to ship the giant to Broome County, where Hull would have ready access to the cargo, but, rather than Binghamton, they settled on Union, a nearby village where Hull was not as well known. Hull and Martin once again parted ways, but not before another Fort Dodge man—G. M. Hull (no relation)—spotted them together at the Garden City Hotel.[24]

In the final week of September, Hull prepared the giant for its eastbound shipment. He hired local builder Nicholas Strasser to construct a large iron-bound box, and, after the latter's work was complete, engaged contractors Peter Wilson and David Herrman to lower the giant therein with a derrick. Once the giant was secure in its box, Wilson and Herrman conveyed the cargo to the freight yards of the Michigan Central Railroad, located at the foot of Lake Street. On September 24, Hull registered his shipment of "finished marble" with the railroad company, consigning it to "George Olds, Union, Broome County, N.Y."—Olds, of course, being his mother's maiden name. The freight agent weighed the cargo, establishing the box and its contents at 3,720 pounds. The giant departed from Chicago on the first of October. Around the same time, Hull headed east on a passenger train, enjoying a rather memorable ride back home.[25]

* * *

The Giantmaker represents the only source of Hull's eastbound trip. On the surface, the episode comes across as a manufactured tale, one designed to bring symmetry to the narrative. Still, John Rankin, the book's author, not only had Hull to corroborate the developments, but also a second party, who was both a close friend and a business associate. In the case of Hull's giant, truth may well have been stranger than fiction.

During the eastbound train ride, Hull encountered Henry Turk, the Methodist preacher who unwittingly inspired the giant scheme. Turk at once recognized his erstwhile theological foe, and the two men agreed to share a compartment. According to *The Giantmaker*, the two men talked about common acquaintances in Ackley—presumably the Ogdens—but Hull could not help but steer the conversation in the direction of religion. Hull told Turk that he still did not believe all the marvelous stories in the Bible, but, on

one count, he had come around to the preacher's way of thinking. Hull told Turk that he now believed that "there were giants in the earth in those days." According to *The Giantmaker*, the preacher was delighted.[26]

As the train crossed the Michigan state line, a third passenger joined Hull and Turk. His name was David Hannum. A horse trader from Homer, New York, Hannum was a lifelong friend of Rankin, and eventually he would play a major role in the giant's public career. On this occasion, however, Hannum joined the men in their religious dialogue, but soon regaled them with his own lengthy stories about horse swapping. Hull later claimed that, during this lengthy stretch, the giant's freight train passed them on a nearby line.

Turk eventually disembarked at Indiana, leaving Hull and Hannum together. At this point, Hull finally introduced himself to the latter as "Olds." The two men played cards all the way to Buffalo, swapping still more stories. Upon reaching that city, they parted ways, with Hull heading toward Broome County and Hannum continuing on to Syracuse. The two men would meet again roughly a year and a half later, but under far more tense circumstances.

*　*　*

Meanwhile, the giant's freight train, after passing through Detroit, headed east into the Canadian wilderness en route to the Suspension Bridge at Niagara Falls. Six days after its initial departure from Chicago, Hull's cargo arrived at the double-decker overpass, designed a decade and a half earlier by civil engineer John A. Roebling. From there, the New York Central Railroad conveyed the shipment to Syracuse, where it lingered for three days before heading south on the Syracuse & Binghamton Railroad. After arriving in Binghamton, the Erie Railroad carried Hull's cargo to its final destination, reaching the village of Union on October 13.[27]

Hull had arrived back in Binghamton by this point, but made no immediate attempt to claim his cargo. Instead, over the next few weeks, he spent most of his time scouting locations across New York. At some point, Hull turned his attention to Onondaga County, located some sixty miles north of Binghamton. For decades, the county had been the source of numerous scientific discoveries, with Hull specifically recalling newspaper reports of petrified fish and reptiles. The natural dip of bedrock, running south through Onondaga County, offered early paleontologists and amateur bone hunters access to fossils from the Upper Silurian, Upper Devonian, and Lower Devonian periods, while limestone quarries along the eastern ridge of Onondaga Valley, in the vicinity of Manlius and Fayetteville, likewise brought forth remnants of

David Hannum. Source: Courtesy of the Broome County Historical Society.

crustaceans, brachiopods, and other marine life. The digging of the Erie Canal in the 1820s most clearly demonstrated the region's abundance of fossils, with the canal's path traversing and exposing two distinct shales. Early archaeologists and amateur collectors likewise gravitated toward Onondaga County, by dint of its numerous artifacts from the Indian and French settlement periods. In Manlius, residents discovered native beads, rings, and plates as well as French medals, gun barrels, swords, and coins, while, a mile west, in Pompey, a hill known as the Castle yielded similar artifacts. Historian Joshua Clark hailed the county's abundance of artifacts and natural curiosities, writing: "At every plowing something new is brought to light."[28]

One particular artifact spawned exotic theories of the county's early settlement. Philo Cleveland, a resident of Pompey, discovered an inscribed tablet on his farm in 1820, with the stone bearing two clearly discernible markings: "Leo" and "1520." The so-called Pompey Stone engendered debate within the early archaeological community, with Henry Rowe Schoolcraft postulating that a straggler from Juan Ponce de León's expedition had been responsible for the inscription, while Ephraim George Squier argued that it was an obvious fake. In 1868, the origins of the Pompey stone remained unresolved, but, in a clear indication of its broad acceptance, the tablet resided at the New York State Museum, while John Boynton later would speculate that the giant and the stone bore historical connections. Indeed, they did, but in a different fashion than Boynton anticipated. Decades later, a Pompey resident admitted that his relatives fabricated the inscription—just to see what sort of hubbub might ensue.[29]

Beyond its exotic natural and historical context, Hull had a more practical reason for considering Onondaga County as the burial location for his giant. He had a relative in the area by the name of William Newell, or Stub as he was known more commonly. The exact relation of the two men remains unclear. On several occasions, Hull referred to Newell as a cousin. That said, Hull once told a census official that the son of his sister-in-law's sister was his nephew. An investigative reporter later identified Newell as the nephew of Hull's brother's wife, but the maiden name of Newell's mother Epha—the crucial connecting link—appears to have escaped the historical record. No church records survive from the time of Epha Newell's marriage, and she passed away before Onondaga County formally recorded deaths. The death certificates of her husband and children likewise do not make mention of her maiden name. Still, even without this critical piece of information, various genealogical items suggest that Hull and Newell bore no blood relation.[30]

The extent to which the two men knew each other prior to 1868 also remains subject to debate. Hull did know Stub's brother Dennison from the latter's visits to their unidentified shared relative, but a later interview offered the following statement regarding Stub Newell: "He [Hull] never tires of telling about the big stone man . . . and still bears a grudge against the relative to whom he confided his scheme, and who, as he says, 'gave away the snap that lost him a big fortune.'" One could interpret the reference to "snap" in two fashions. On one hand, the term represented contemporary slang for a scheme or plot, and Hull might well have been reinforcing his earlier statement regarding the giant. At the same time, however, Hull discussed his harness snap invention in that same interview, bemoaning his partner's sale of the patent. Read in this light, Hull could have been implying Newell's involvement as a partner in that earlier scheme as well. Within this context, Hull undoubtedly would have been loath to work with Newell again, but, still, his options were somewhat limited at this point.[31]

In early November, Hull headed north to propose partnership to Newell. The two men never revealed details of the discussion or their financial arrangement, but Martin later indicated that, in exchange for burying the giant on his Cardiff farm, Newell became an equal partner with him, Hull, and Burkhardt. As part of the arrangement, Hull told Newell to keep the giant a secret from everyone, including his wife Lydia. After the Cardiff farmer consented, the two men paid a cordial visit to his brother Dennison. Hull then headed back to Binghamton, promising his new partner that he would return soon with the giant.[32]

While he easily might have sent his cargo by rail to Tully or LaFayette, Hull instead envisioned a more stealthy approach, conveying the giant by

wagon through the largely rural area that lay between Union and Cardiff. To wit, Hull hired two new associates. One was twenty-one-year-old nephew John Hull Jr. (the son of John Hull Jr.). The other was Israel Amsbury. Amsbury, a farmer in nearby Fenton, was the brother of John's mother Sophia. He had grown up in Cardiff and was well familiar with the terrain. More critically, Amsbury may have been the connecting link between Newell and Hull. If Stub's mother indeed had been Amsbury's sister, then the earlier assessment of Stub Newell being the nephew of Hull's brother's wife was exactly correct, though again the extant historical record yields no definitive answers. On Wednesday, November 4, "George Olds," accompanied by Amsbury and John Hull Jr., claimed his cargo at the Erie rail station in Union. The three men then proceeded to load the large ironbound box into a wagon, drawn by four horses. At this point, John Hull Jr. and Amsbury began their northward trek, while George Hull pledged to meet up with them in the vicinity of Cardiff.[33]

In contrast to Hull's vision, the wagon journey proved anything but discreet. As John Hull Jr. and Amsbury passed through local villages, residents could not help but take notice of the massive box. By Friday evening, the two men had traveled some twenty miles, reaching Center-Lisle. The next morning, they passed east through Lisle and picked up the Syracuse-Binghamton road. Heading north, they moved through Killawog and Marathon, arriving in the latter village just as hundreds of residents gathered to watch the loser of a bet push the winner around in a wheelbarrow. Residents asked John Hull Jr. and Amsbury what was in the box, to which one of them responded, "Jeff Davis," a reference to the former Confederate president. Later that night, Amsbury and Hull lodged at a State Bridge hotel, roughly thirty miles from Cardiff. While there, a young boy nearly succeeded in exposing the entire scheme. Curious what lay inside the box, the boy bored a hole in its side, but Amsbury managed to stop him before he saw the giant.[34]

Meanwhile, George Hull himself headed north by train. On Saturday night, he arrived in Tully, just south of Cardiff, lodging at the Empire Hotel. When Amsbury and his nephew failed to surface the following day, Hull grew antsy, traveling south to Preble and asking if anyone had seen two men with a large ironbound box. No one had, for, at this point, Amsbury and John Hull Jr. were still a few miles south in Homer. On Monday, November 9, the two men arrived in Preble, where George Hull intercepted them. The three men shared lunch at the Preble Hotel, discussing plans for that day. They were only ten miles from Cardiff at this point, expecting to arrive at Newell's farm sometime in the evening. Hull told them that he had no plans to bury the giant on this night, but rather that they simply would unload

it from the wagon. After the men finished their meal, Amsbury and John Hull Jr. resumed their journey, while George Hull left separately for Tully. Once there, Hull registered at the Tully Hotel, where he stayed during his earlier visit to Cardiff. Hotel proprietor Avery Fellows recalled Hull's rather dramatic and mysterious small talk:

> I said you have got around again; he said yes, I staid [sic] at the other hotel because I found you shut up, and I saw a light when I came back Saturday night, at the other end of town, in Bennett's hotel; I like your style here better, you don't ask so many questions as they do.

Hull then made arrangements with Fellows for a trip to Cardiff that afternoon. With rain expected that evening, he asked the proprietor for a lantern and hat. Fellows did give Hull an old hat, but told him that he would have to buy the lantern across the street—which Hull promptly did.[35]

Between three and four o'clock, Fellows conveyed Hull through Tully Center, later picking up the northern road alongside Bear Mountain. Roughly a mile and a half into their journey, the two men overtook Amsbury and John Hull Jr., but, to George Hull's credit, he pretended not to know them. After passing the men, Fellows asked Hull what he thought they had inside the box, to which the latter responded: "It looks as though they had some kind of machinery boxed up." When the two men got within a half mile of Newell's farm, Hull asked Fellows to leave him there in the middle of the road. Hull then attempted to pay the hotel proprietor, but the latter told him that he could do so back at the hotel. Hull, however, was insistent: "I will pay you for fear anything should happen that I may not come back." Within full view of Fellows, Hull then proceeded to walk the remaining distance to Newell's farm, subsequently entering the small wooden house. On his way back to Tully, Fellows once again passed John Hull Jr. and Amsbury. This time, however, the two men asked Fellows how much further it was to Cardiff.[36]

In the early evening, Amsbury and John Hull Jr. joined George Hull at Newell's farm. By earlier arrangement, the Cardiff farmer himself was not present, instead having taken his wife and child to visit relatives. As night fell, the three men unloaded the giant from the ironbound box, placing it in the vicinity of the barn and covering it with straw and hay. Next, they took farm machinery that Newell had left for them and placed it inside a similar—but smaller—box that the Cardiff farmer had secured. Hull left a note for Newell that they planned to return in a week's time, and, in the meantime, he should secure poles for a derrick—and destroy the original

box. As part of George Hull's plan, Amsbury and John Hull Jr. headed north once again, conveying the new box past the confines of Cardiff. Around ten o'clock, the two men arrived at the Onondaga Reservation, where gate-keeper Daniel Luce briefly chatted with them and took note of their cargo. Later that night, the two men lodged in the vicinity of Manlius. Meanwhile, George Hull headed back to the Tully Hotel on foot, arriving there sometime before daybreak. Upon his arrival, Hull slumped into a chair in the lounge, falling fast asleep. Fellows awoke a short time later, finding the sleeping Hull with his pant legs rolled up, his boots caked with mud, and his overcoat wet. After Fellows roused him, Hull enjoyed a quick breakfast before catching a northbound train.[37]

In either Syracuse or Utica—it is not clear which—"George Olds" hired two local contractors, Charles Wells and Orson Davis. Hull told the two men to meet him later that night south of Syracuse, from whence they would convey cargo to the Black River Canal. Around midnight, under Hull's su-pervision, Wells and Davis took the reins from Amsbury and John Hull Jr., heading east toward the Rome canal. The following day, George Hull met them at the docks, where they unloaded the machinery from the box, placing it upon a boat destined for parts unknown. Once the men completed the job, Hull ordered them to destroy the box, and they complied.[38]

Hull then returned to Binghamton, where he rejoined Amsbury and his nephew. On Saturday, the three men returned to Onondaga County, this time avoiding Tully altogether and arriving at LaFayette. Newell met them at the rail station there, conveying the three men to his farm. As Hull had been adamant that Newell keep the secret from his family, Lydia Newell and young William Jr. almost certainly were absent once again. Around midnight, the men began their work, digging a large pit behind Newell's barn and establishing their derrick over it. In the midst of their digging, the men came across the roots of a tree long since fallen, and Hull decided to use this natural element to their advantage. As the men lowered the giant into the pit, Hull had them maneuver it under the roots, reasoning that men and women might conclude that the giant was older than the tree in question—a hunch that later turned to be out correct. Once the giant was secure in the earth, the men refilled the pit, and the long first chapter of Hull's scheme finally drew to a close. Taking leave of his partner that night, Hull promised to write him once the time was right for the giant's discovery.[39]

Even though eleven months passed before Newell received that fate-ful communication, the Cardiff farmer obviously was not prepared for the excitement to follow. *The Giantmaker* implied that Newell's consternation upon discovering the giant—and even his initial shutdown on Monday

morning—was entirely legitimate. It had taken a sizable offer from D. Lewis Smith, a Syracuse hotel proprietor, to remind Newell of the giant's potential windfall, prompting him to move forward with plans for the tent. Hull, of course, needed no such reminder. From cradle to grave, the giant consumed more than two and a half years of his life, and the investment was more than just emotional. Though Martin pledged to bear half the expenses, Hull claimed that he had borne the entire cost of sculpting and transporting the giant—nearly three thousand dollars, the modern equivalent of sixty thousand. Not even a return to cigar manufacturing in the previous months had put Hull in a better financial position—he desperately needed the giant to deliver. As he sent word to Newell in October 1869, Hull earnestly hoped—in lieu of prayer—that there were a good many Turks out there.[40]

CHAPTER FIVE

~

Big Business

News of the discovery quickly spread beyond Syracuse and Onondaga County. Within days, the LaFayette Wonder, Onondaga Giant, or Petrified Giant—as it alternately was known in these early days—became national news. Stub Newell's homespun production accordingly morphed into big business, with crowds of curiosity seekers swarming to Cardiff and speculators clamoring for a piece of the great wonder.

The giant's quick rise to national prominence owed much to the *New York Daily Tribune*, with the influential newspaper giving the story front-page coverage on Tuesday, the third day after the discovery. The *Tribune*, in company with the *New York Herald*, had done much to revolutionize journalism over the preceding three decades, moving the United States beyond the age of the penny press. While the *Herald* did emphasize crime and scandals in the vein of its predecessors, Editor James Gordon Bennett nevertheless demanded details and investigation, often milking stories over the course of days and weeks. The *Tribune*, by contrast, was an influential purveyor of American ideas, with Horace Greeley tackling the great issues of the day—slavery, industry, and urban excesses—in lengthy editorials. Greeley's penchant for reform influenced the news as well, with reports of crime and violence often carrying moralistic tones and judgments. The *Tribune* and *Herald* succeeded in making American newspapers both informative as well as influential, and, by 1860, the *Tribune*'s weekly edition reached a staggering three hundred thousand people, while the *Herald*—at seventy-seven thousand—enjoyed the highest daily circulation in the world.

As it did so many other aspects of American society, the Civil War dramatically transformed the communications landscape. Whereas newspapers had been merely influential before, now they were indispensable, with reading becoming a necessity of daily existence. During the war, Americans relied upon newspapers for the latest developments on the progress of the conflict. Media historian George H. Douglas argues that this coverage—coupled with new telegraph reports—made Americans more acutely aware of other regions and their news. At the same time, reporting gained even more significance in the context of war. Editors sent correspondents into the field to serve as the eyes and ears of the public, and these men returned telegraph-styled reports, economic in scope but dramatic and picturesque in style. Rising demand for news—and growing urban markets—made newspapers bigger business over the course of the 1860s, with physical editions expanding to accommodate more content and advertisements and with most major cities boasting rival dailies. The stakes for fresh angles on the news, human-interest stories, and, of course, scandals had never been higher. Still, despite unprecedented emphasis on hard reporting, newspaper content in the 1860s often failed to delineate between news and opinion, manifesting the ideas and eccentricities of newspaper leaders, both old and new.

In its Tuesday coverage, the *Tribune* allowed only two other stories to take precedence over the giant: the New York arrival of Charles Loyson, a French priest and Vatican critic, as well as the United States Army's attempt to retake Fort Benson from hostile Indians. The *Tribune*'s Syracuse correspondent opened his account with a taut yet dramatic summation of events: "A remarkable discovery has been made in the town of Lafayette, in this county—a human form of huge proportions, entirely petrified." The writer proceeded to outline the circumstances of the discovery, noting John Boynton's statue hypothesis but also citing the overwhelming sentiment against it and in favor of petrifaction: "The decided opinion of nearly everyone who has seen it—and it has been visited to-day by some of the most highly educated and intelligent people of [Syracuse]—is that its perfection, the material of which it is composed, and the place in which it was found, are against [the statue] hypothesis." While balanced in this particular regard, the *Tribune*'s correspondent nevertheless revealed his own leaning in characterizing the giant as "entirely petrified." The *Tribune*'s pointed headline reinforced this assessment: "A FOSSIL GIANT—SINGULAR DISCOVERY NEAR SYRACUSE." Over the next few days, newspapers across the country circulated the *Tribune*'s report. On Wednesday, the *Philadelphia Inquirer* reprinted the article in full; the *Baltimore Sun* followed suit the next day. On Friday, the *Tribune* article appeared in the pages of the *Chicago Tribune, Daily National*

Intelligencer, and the *Missouri Republican.* It later surfaced in the *Columbus (Ga.) Ledger-Enquirer* and made the front page of the *Daily Alta California,* while the *Louisville Courier Journal* summarized its contents.[1]

Other influential newspapers presented their own coverage of the giant. The *New York Herald,* these days under the direction of James Gordon Bennett Jr., published a letter from an unidentified citizen who had visited Newell's farm: "This forenoon I visited a farm near Cardiff to obtain from personal inspection all that would be of any use to you relating to the petrified giant which has been discovered there." The writer described the landscape and furnished the giant's dimensions, while taking occasion to hail the wonder as "one of the connecting links between the past and present races, and of great value." The newspaper ran this letter under the headline: "A PETRIFIED GIANT." The *Boston Post* cheekily noted that "a fossil man has petrified Syracuse with astonishment," while the *New York Times* offered a more weighty editorial assessment: "The thing seems too ponderous and elaborate for a hoax, and it may turn out to be something of a respectable conundrum for our American archaeologists to exercise their wits upon."[2]

Back in Onondaga County, the giant had become a veritable cause célèbre. The *Syracuse Daily Standard* observed: "The interest in the Stone Giant found at Cardiff increases. Go where you will in this city, and surrounding country, it is the topic. Everybody is talking about it." The following day, the newspaper offered a still more dramatic assessment of the rising fervor in the valley:

> As we said yesterday and the day before, it is the all-absorbing topic with the great mass of our people in city and county. One cannot "drop in" anywhere—at place of public resort, at the social board, or at the fireside gathering, but that "remarkable—how natural—how grand—how distinct this vein or that muscle—fossil, petrifaction, *putrifaction*; Indian, Caucasian—what a monster—statue, work of art—master artist—a thousand years ago—the Jesuits—how possible to get it there—who, when, where, how," and so on, strikes the ear, and will most assuredly resound therein for minutes or hours, as the case may be, unless forced aside by determined effort. But thrust aside, it is, like Banquo's ghost, sure to return again.

Notably, the giant also was inspiring poetry in Syracuse. In "To the Giant of Onondaga," published in the *Journal,* "D. P. P." directly addressed the great wonder, pleading for insight into its mysterious origins:

> Art thou a son of old Polyphemus,
> Or brother to the Sphinx, now turned to stone—

The mystery and riddle of the world?
Did human passions stir within thy breast
And move thy heart with human sympathies?
Was life to thee, made up of joy and hope,
Of love and hate, of suffering and pain,
In fair proportions to thy Giant form?

Tell us the story of thy life, and whether
Of woman born—substance and spirit
In mysterious union wed—or fashioned
By hand of man from stone, we bow in awe,
And hail thee, GIANT OF ONONDAGA![3]

Residents of Onondaga County likewise were clamoring to see the great wonder with their own eyes. Demand for transportation to Newell's farm surged, especially in Syracuse. Curiosity seekers, of course, could take the Syracuse & Binghamton Railroad to Tully or LaFayette, but men and women still needed to secure transport to Newell's farm, more than three miles distant from each station. Enterprising villagers offered round-trip rides within their own wagons, initially waiting upon sojourners to complete their viewing of the giant, but, increasingly, as lines at Newell's farm swelled, made multiple trips in the same time. By and large, though, men and women hired road transport from the outset. At the Salina Street hack stand in Syracuse, curiosity seekers engaged carriages to convey them to Newell's farm. With these buggies only accommodating a few men and women at a time, however, city omnibuses soon commenced their own service to Cardiff. Drivers of these various transports fast became familiar with the route to Newell's farm, but also, as one publication noted, "perfectly acquainted . . . with the leading facts regarding the wonderful discovery"—facts that these men gladly shared with their passengers. The transportation crush eventually grew so great in Syracuse that one jokester was moved to publish a parody advertisement in the *Journal:* "An Omnibus will leave the Syracuse House every fifteen minutes, day and night, to convey visitors to the GIGANTIC PETRIFIED HUMAN STATUARY near Cardiff. Fare for the round trip, $3.00. Same may be secured by remitting the above amount, three days in advance."[4]

With newspaper coverage outside Syracuse on the rise, men and women from all over New York and the Northeast bolstered the ranks of curiosity seekers. Despite what the *Standard* characterized as "extremely unpleasant, uncomfortable weather," residents of Buffalo, Rochester, Utica, Auburn, and Oswego arrived at Newell's farm on Wednesday, while, the following day, one man traveled nearly three hundred miles from York, Pennsylvania.

Over the course of that day, more than fifteen hundred people ventured to Cardiff—roughly four times the number that had done so earlier in the week. A rainstorm belted the valley during the morning hours on Friday, but curiosity seekers were undeterred, with the *Journal* reporting that overall attendance was "much in excess of the visitations of any previous day." On Saturday, the weather grew still worse, but the *Courier* reported a "large attendance," one disproportionately consisting of farmers unable to work the land.[5]

Despite the lack of newspaper coverage over the weekend and three days of bad weather, the giant's first week had been a smashing success. Roughly twenty-five hundred men, women, and children beheld the great wonder, with Newell and his partners earning roughly twelve hundred dollars—twenty-five thousand in modern terms. Put another way, the population of Cardiff had grown exponentially, and, indeed, the very face and tone of the tiny village had changed drastically.

* * *

Both newspapers and individual recollections left a vivid picture of the scene at Newell's farm in these days. One chronicler of note was Andrew White. Four years earlier, White became the first president of Cornell University, a new nonsectarian college dedicated both to liberal and practical studies. Born in Homer, New York, White spent part of his youth in Syracuse, and he was visiting the city around the time of the giant's discovery. White later claimed to have been skeptical of the great wonder from earliest reports, but a local religious professional—most likely Rev. Sherman Canfield—urged him to consider the giant with his own eyes:

> On my return to Syracuse, meeting one of the most substantial citizens, a highly respected deacon in the Presbyterian Church, formerly a county judge, I asked him, in a jocose way, about the new object of interest, fully expecting that he would join me in a laugh over the whole matter; but, to my surprise, he became at once very solemn. He said, "I assure you that this is no laughing matter; it is a very serious thing, indeed; there is no question that an amazing discovery has been made, and I advise you to go down and see what you think of it."

The following morning, White and his brother took a light buggy, speeding through the valley en route to Cardiff. The two men quickly grasped the extent of popular fervor: "The roads were crowded with buggies, carriages, and even omnibuses from the city, and with lumber-wagons from the farms—all

laden with passengers." Upon arriving at Newell's farm, White noted the carnival-like atmosphere: "We arrived at the Newell farm, and found a gathering which at first sight seemed like a county fair. In the midst was a tent, and a crowd was pressing for admission." To capitalize on the large number of curiosity seekers, enterprising local businessmen already had opened a board tavern roughly five hundred feet from Newell's house. A correspondent from the *Standard* offered his own assessment of the scene, likening it to "Pacific gold mining districts, and Pennsylvania oil regions," while also paying heed to the "American 'genius' that quickens to coin a dime." At noon each day, a runner from the establishment raced through the crowds, announcing: "Warm meals right out there—all ready, gentlemen." Soon thereafter, a rival restaurant opened in a shed near Newell's barn, with the *Standard* reporting that this new structure was "less pretentious" than its predecessor.[6]

According to White, curiosity seekers rather rambunctiously pressed for admission into the tent. Once inside, however, the mood shifted dramatically, as visitors crowded around the railing that encircled the giant's pit. White recalled: "An air of great solemnity pervaded the place. Visitors hardly spoke above a whisper." Billy Houghton, Newell's master of ceremonies, allowed a few minutes to pass for solemn reflection before opening his presentation. The *Courier* reported on the storekeeper's attempts to channel the spirit of P. T. Barnum:

> A man stands at the mouth of the excavation to explain the good points of the "giant." He (the exhibitor) "punches" the breast of the statue with a long pole, and tells you tragic words:
>
> "He's holler there!"
>
> You involuntarily listen to see if he does "holler," but no sound issuing from the finely chiseled lips, you listen to the remark accompanying the next punch of the long pole. Thumping the statue near the thigh:—
>
> Exhibitor—"He's solid there! Guess that 'ere is about the biggest leg you ever saw! Why, heavens and earth, a man could hardly reach around that leg!"

Houghton was not privy to Newell's secret, but the latter evidently had told his master of ceremonies to play up the giant's mystery, even if it meant being fast and loose with known facts such as the solidity of the torso. After concluding his presentation, Houghton opened the floor for questions, with the assembled crowd, for the most part, using the time to register its own opinions. White recalled one woman saying, "Nothing in the world can ever make me believe that he was not once a living being. Why, you can see the

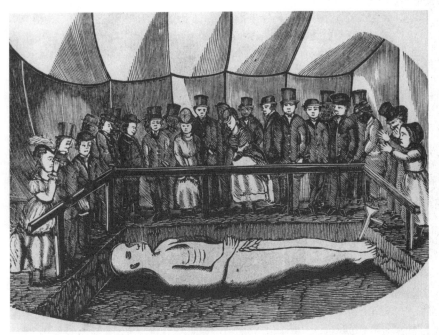

Artist's rendering of the tent scene, from The Onondaga Giant *pamphlet. Source: Courtesy of the New York State Historical Association Library, Cooperstown, New York.*

veins in his legs." Others were more skeptical, such as the one man who exclaimed, "Say, why don't you cut off his legs and show a feller [sic] the marrow of his bones? Then, I'll believe its [sic] a man." The morbid scene spooked others, with at least one man tentatively asking Houghton: "Is—is he dead?" In all of these cases, men and women unwittingly referred to the giant as "he," rather than "it"—a trend that persisted, as Americans became more familiar with the great wonder.[7]

With crowds increasing by the day, the *Courier* reported that the "jam" inside the tent at any given time was "almost unendurable." The density of the crowd likewise made ingress and egress difficult, with the same newspaper noting that "people who had once pressed in could not by any means get out in the same way." Newell and his assistants had little recourse but to raise the sides of the tent, encouraging exit in this fashion, though some curiosity seekers undoubtedly seized the opportunity to sneak inside. Eventually, Newell settled on a more permanent solution, limiting viewing time to fifteen minutes. Of course, men and women who traveled great distances

objected to the new rule, in some cases even refusing to leave the tent. To deal with such rebels, Newell ultimately hired security guards, posting them at both ends of the tent. The *Courier* reported: "They [the guards] were compelled to bring all their powers to persuasion to effect their object." The majority of curiosity seekers, however, took a path of much less resistance. They simply bought more time with the giant by buying more tickets.[8]

* * *

With the giant's popularity soaring, Newell fielded more serious offers from prospective buyers. Of course, from the very beginning, Americans both expected—and hoped—that Barnum would become involved. On several occasions during the first week, the Syracuse newspapers sported references to the "the great 'What-is-it'"—an allusion to Barnum's famed rotating exhibit at the American Museum. On the first Tuesday after the discovery, "Ondiyara," a letter writer to the *Standard*, reported that unidentified Syracuse citizens had communicated news of the discovery to the great showman: "What the lucky Mr. Newell may do with his treasure is not known. It is said he has been offered tens of thousands, and that Mr. Barnum has been telegraphed to [sic]." By and large, though, Barnum resisted the early temptation to bid for the giant, having effectively retired from public life at this point. After his earlier failed campaign for Congress, Barnum had returned his focus to the second American Museum, but that structure suffered the same fate as its predecessor, burning to the ground in March 1868. Soon thereafter, Barnum gave what remained of his museum collection to George Wood, who operated Wood's Museum and Menagerie on the corner of Broadway and Thirtieth streets in New York City. In return for his items as well as his ongoing promotional support of Wood's Museum, Barnum received three percent of the museum's gross earnings—a bitter pill to swallow for the former king of America's entertainment capital. Over the course of 1869, Barnum had written a new autobiography, appropriately titled *Struggles and Triumphs*. The volume would appear in early November, concluding with the rather definitive declaration: "What I can call, without undue display of egotism or vanity, my 'public life,' may be said to have closed with my formal and final retirement from the managerial profession, when my second Museum was destroyed by fire, March 3, 1868." Still, the giant greatly intrigued Barnum, and he would monitor its progress closely over the coming weeks.[9]

In Barnum's wake, Syracuse's most prominent businessmen and citizens moved to acquire the giant from Newell. On the first Monday after the

discovery, hotel proprietor D. Lewis Smith—along with his brother—made an undisclosed offer to Newell, while wealthy farmer Herman Stanton soon followed suit. John Wieting, however, would trump both men. Wieting arguably was Syracuse's most esteemed citizen and philanthropist. He began his career as a civil engineer, but ultimately turned his attention to medicine and popular lectures, earning himself a sizable fortune along the way. In 1850, a Boston newspaper noted Wieting's popularity within that city: "Dr. Wieting has created a perfect furore [sic] of excitement in Boston upon one of the most scientific of all scientific subjects—Anatomy. His lectures at the Tremont Temple are attended by upward of 2,000 people every night." Later retiring from the lecture circuit, Wieting became one of Syracuse's biggest benefactors, endowing the Wieting Opera House in Clinton Square. Many Syracusans feared that a popular entertainer like Barnum might well take the giant from Onondaga County, and Wieting accordingly aimed to make the great wonder his next act of public beneficence. The philanthropist called upon Stub's uncle Justus, a longtime acquaintance, and asked for a personal introduction to his celebrity nephew. On Wednesday, after meeting Stub Newell in Cardiff, Wieting took him back to Syracuse, where the two men spent the remainder of the day discussing terms of sale. A week earlier, Newell was a yeoman farmer who rarely left his property. Now, he was hobnobbing with the elite of Syracuse society.[10]

Fortunately for Newell, he was not entirely without guidance. That same day, George Hull arrived in Cardiff with his wife and two daughters, stopping at the home of Stub's father Daniel. Hull informed the extended Newell clan that he and his family were passing through the area. Dennison Newell, Stub's brother, excitedly asked Hull if he had heard about the giant, and the latter claimed complete ignorance. After sharing the circumstances of the discovery, Dennison Newell offered to convey the Hulls to his brother's farm, and George Hull gladly took him up on his invitation. Later, after beholding the giant inside the tent, Hull took leave of his family, tracking down Stub Newell and pulling him aside for a private conversation. Newell informed Hull about Wieting's arrival and planned offer. Hull, who may have had his own reasons to push an early sale, told the Cardiff farmer not to sell unless he secured thirty thousand dollars—six hundred thousand in modern terms—for a three-fourths interest. In this fashion, Hull and his partners stood to receive an immediate financial windfall, while also maintaining an ongoing share in the public wonder. Hull eventually took leave of Cardiff and headed back to Binghamton with his family, while Newell turned over operations to Houghton, heading north to Syracuse with Wieting. By the time that he returned later that night, Newell had a staggering offer in hand—twenty-five

thousand dollars for complete ownership—though Wieting's bid had fallen short of Hull's stated parameters.[11]

A syndicate of local businessmen soon emerged to challenge Wieting. Amos Gillett, Amos Westcott, and David Hannum were successful entrepreneurs and well-known residents of the valley. Gillett, who lived in Syracuse, was cut from the same cloth as the early Hull, having made his fortune by trading horses and organizing street races. In fact, Gillett would list his occupation in the following year's census as "sporting man." Though one of the city's longest-standing residents, Gillett was not terribly well liked, in part because he was legendarily stingy with his money but also because he sported a formidable temper. By contrast, Westcott was one of Syracuse's most respected and popular citizens. After graduating from the Rensselaer Institute with degrees in natural sciences and civil engineering, Westcott lectured at central New York academies for a time before undertaking dental studies at the Albany Medical College. For close to three decades, Westcott had run a successful practice in Syracuse, helping to found the New York College of Dental Surgery in that city. Westcott's inventive flair led him to improve early dental instruments, and he became one of the first practitioners to utilize adhesive gold foil. For his myriad achievements in the emerging science, colleagues appointed Westcott editor of the *Journal of Dental Science* and elected him first president of the New York Dental Society. In a measure of his wider popularity, Westcott served a term as mayor of Syracuse in 1860, presenting President-elect Abraham Lincoln to the city amid his trip to the capital.[12]

Hannum, who lived further south in the village of Homer, was one of the largest landowners in neighboring Cortland County, amassing a fortune through various entrepreneurial efforts. Hannum and Westcott married sisters, and so the two men early became friends and business partners. At one point, Hannum and John Rankin devised a modified butter churn, but the resulting yield proved too finely grained. At Hannum's urging, Westcott refined their invention, and, from the ultimate sale of patent rights, the three men made more than twenty thousand dollars. Still, Hannum's greater fame and fortune came by way of horse trading. One later biography summarized him thusly: "[He] was known far and wide in central New York as a first-class horse-trader who was very apt to get the best of the bargain. His good nature, however, always stood him in good stead, and many a time the loser went away feeling satisfied just because of Hannum's amusing personality." Hannum's well-known personal creed embodied this combination of savvy and comedy: "Do unto the other fellow what the other fellow 'ud like to do to you, and do it fust [sic]." A popular figure, Hannum frequently held court

at Homer's barbershop, regaling acquaintances with long-winded stories of horse trading. Hull himself could attest to this gift of gab, having shared a passenger car with Hannum roughly a year earlier.[13]

As the giant seemed like an intriguing venture, Westcott contacted Hannum, and, along with Gillett, they visited the great wonder in Cardiff within days of its discovery. Newell recognized the esteemed Westcott, quickly moving to stir his interest as a prospective buyer. One contemporary newspaper rather dramatically summarized the scene several weeks later: "Day after day he [Newell] gave the names of parties who had made brilliant propositions to him, all of which he had rejected. At last he made a point that the Doctor should be one of the company, as he could trust him with anything—with his honor, his life even." Upon returning to Syracuse, Westcott, Hannum, and Gillett gave the matter further consideration, eventually agreeing to place a joint bid of fifteen thousand dollars. The three men, however, soon got wind not only of Wieting's standing offer but also of a rival syndicate, which unwittingly approached Gillett. This two-man group consisted of Simeon Rouse and Alfred Higgins. The former was a prominent produce merchant, while the latter served as principal agent for William Fargo's American Express Company in Syracuse. Higgins's involvement was especially daunting. Years earlier, during a brief stint as a tobacco peddler, Higgins had made Newell's acquaintance, a seeming inside track to the Cardiff farmer. The rival factions sparred briefly, but ultimately resolved to join forces, with the new larger syndicate electing Higgins as its spokesman.[14]

On Thursday, Newell held court with suitors in Syracuse. Remarking upon his arrival in that city, the *Courier* noted that the Cardiff farmer had become a celebrity in his own right: "The proprietor of the Cardiff giant was in town . . . He was regarded with wonder by all the small boys who happened to see him." Over the course of the day, Newell met with a multitude of prospective buyers, including members of the new syndicate, Wieting, as well as Colonel Joseph H. Wood, the Chicago showman who recently opened a second curiosity museum in Philadelphia. Henry Martin also may have been there, having arrived in Syracuse to bid up the price. As expected, offers rose steadily, with Wieting and the syndicate emerging as chief competitors. Finally, the latter group put forth the parameters that Hull earlier set for Newell: thirty thousand dollars for three-quarters ownership. Newell agreed to sell the giant, but on one condition: the syndicate would have to expand to include William Spencer. Newell's move was a curious one, and he undoubtedly acted upon his own accord. Earlier that week, Spencer, a successful wholesale grocer in Utica, returned to his boyhood home in Cardiff, and Newell tried to interest his old friend in purchasing the great wonder.

According to *The Giantmaker*, Spencer evinced little interest, but Newell was relentless. Eventually, Spencer agreed to buy a small share at the time of the ultimate sale. The Cardiff farmer apparently felt obliged to honor this earlier arrangement, and, fortunately for him, the syndicate agreed to include Spencer. After getting wind of the planned sale, the *Courier* humorously reported: "The question, therefore, of 'Who slew the modern Goliah?' has been answered, and Messrs. Westcott, Gillett, Higgins and Hannum will to-day receive the congratulations of their friends for the good fortune that has fallen to their lot." [15]

On Saturday, at the law offices of James Noxon and George D. Cowles, the parties signed a contract to formalize the sale. The giant's overall value was fixed at forty thousand dollars, close to a million in modern terms. Higgins purchased one full quarter share for ten thousand dollars, giving Newell half in cash and a bank note for the remainder. Gillett, Westcott, Hannum, and Spencer equally divided a half share, with each man holding a resulting eighth interest. Gillett, who shared his equity with an unnamed Rouse, provided a certificate of deposit for the sale, while the other men signed notes over to Newell. The Cardiff farmer retained the final quarter share in the giant, but did so—unbeknown to the purchasers—on behalf of himself, Hull, Martin, and Burkhardt. The money transacted must have been staggering to Newell, whose own farm was worth only three thousand dollars. Still, the future held the promise of even greater riches, as Newell and his silent partners enjoyed ongoing equity in the great wonder. It was early, but already giant making had proved far more lucrative than farming, cigar manufacturing, blacksmithing, and marble dealing. [16]

* * *

Even before the sale had been completed, members of the syndicate moved to upgrade the show at Cardiff. First, these men hired Wood to manage the exhibition and serve as master of ceremonies. It was quite a coup for the new owners, for Wood at once was a recognizable commodity and a showman with professional sensibilities. Once the sale was finalized, the new manager moved into action. Despite torrential rains blanketing the region on Saturday, Wood removed Newell's basic canvas tent, mounting a much larger variety that could accommodate more customers at any given time. To add a sense of grandeur, the showman installed a flag at the tent's apex, unfurling the only one currently in his possession: a Union Jack. According to the *Journal*, many patriotic citizens found the gesture distasteful, and Wood eventually replaced the British flag with its American counterpart. [17]

Given widely varying accounts of the giant's discovery and opinions of its origin, the new owners also prepared a pamphlet to serve as a definitive reference guide. *The American Goliah: A Wonderful Geological Discovery*, sponsored by local piano and music emporium Redington & Howe, appeared on newsstands and at local bookstores, selling for ten cents. The fifteen-page booklet recounted the details of the discovery, the giant's dimensions, while also presenting options on transportation to Cardiff. *The American Goliah* likewise offered representative samples of public fervor: "The spectator gazes upon the grand old sleeper with feelings of admiration and awe. 'Nothing like it has ever been seen,' say all who have gazed upon it. 'It is a great event in our lives to behold it,' (is the universal verdict,)— 'worth coming hundreds of miles for this alone.'" Along the same lines, *The American Goliah* offered its own weighty assessment of the giant: "The increasing interest of the public and the constantly enlarging attendance corroborate the previously expressed opinions of the inestimable value of the discovery, and sanction the verdict that the Cardiff Giant is the great wonder of the Nineteenth Century."[18]

The success of *The American Goliah*, which sold ten thousand copies in its first edition, quickly spawned two rival pamphlets. *The Onondaga Giant, Or the Great Archaeological Discovery* offered similar coverage of the great wonder, though this booklet leveraged content from the *Journal*, rather than from the *Standard* and *Courier*. At the same time, in contrast to its predecessor, *The Onondaga Giant* inclined toward the statue hypothesis, accordingly characterizing the great wonder as "archaeological" rather than "geological." Still, *The Onondaga Giant* imparted no less gravity to its subject: "Its like has never been found upon this continent, and it forms interest as one of the most remarkable archaeological discoveries ever made." By contrast, *The Autobiography of the Great Curiosity: The Cardiff Stone Giant* poked fun at all the hoopla surrounding the discovery. In this booklet, possibly the work of Syracuse shoe salesman Edwin A. Bennett, the narrator discovers in Newell's outhouse an ancient manuscript, written by "His Limestonecy" himself. This document outlines the giant's life story, including how a jealous Adam slashed off its ear after seeing it flirt with Eve and how it survived Noah's Flood on account of its swimming ability. The giant eventually comes to New York, turns down an opportunity to work for Barnum, and instead heads west with the Mormons. Despite such allusions, the author seemingly took more exception to excessive public fervor than to the giant's veracity: "I have, since the discovery [of the manuscript], been constantly besieged by 'interviewers,' reporters, and other pests, begging me to allow them to publish it in their respective journals, but . . . I have, with my native magnanimity,

refused them all! So the gullible public can rest assured they are getting the 'only authorized edition,' revised and corrected." The author specifically took potshots at local newspapers, intimating at one point that the *Journal's* editors were roughly the same age as the ancient wonder.[19]

On Sunday, the first day after the sale, the new owners enjoyed the biggest turnout to date. Bad weather prevented many men and women from seeing the giant on Saturday, and, with the workweek looming, curiosity seekers seized the Lord's Day as their best opportunity to visit Cardiff. The *Courier* noted that many men and women set forth for Newell's farm at unusually early hours, hoping to beat later crowds, though too many curiosity seekers ended up employing the same strategy: "Their reasoning, under most circumstances, would have been correct, but too many happened to think in this way. The result was that the exhibitor of the statue had barely time to close his eyes for a few minutes slumber late Saturday night, when he was rudely awakened by a shower of fifty cent postal currency . . . Had the money been anything but paper, the result might have been serious; so many silver half dollars would have killed the poor fellow." The carnival-like atmosphere at Newell's farm reached epic proportions that day, with the *Standard* reporting:

> Sunday was a crusher. The people began to go early, and kept going all day long. From eleven to three o'clock it was a dense mass of people on the Newell farm. Around the house and barns acres were covered with teams and wagons, and the road, for a long distance in either direction was lined with them. It seemed as if such another jam never went to a show before, and it was with great difficulty that the line could be kept so that all could have a fair sight.

In addition to drawing curiosity seekers from all over the Northeast, the crowds on this day included correspondents from the *New York Daily Tribune, New York Herald, Springfield Republican,* and *Harper's Weekly.* By three o'clock, roughly twenty-three hundred people—nearly as many as had visited over the course of the entire first week—paid to see the giant. With coffers containing more than a thousand dollars, the *Standard* reported that Higgins, one of the new owners, was forced to remove the bounty from the property "for safety." That same newspaper reported that the proprietors later sold an additional three hundred tickets, though the *Courier* claimed even greater sales: "But it remained for the later hours of the day to show the grand press of the people. They came and came, and kept coming, until the vicinity evoked like a State fair ground! Horses and carriages, and men and women and children, could be seen in all directions. Up to about four o'clock, good judges say that not less than *four thousand* people had come and gone!" The

Courier referred to Sunday as a "day of harvest" for the new owners, and, indeed, these men earned two thousand dollars in a single day, roughly 10 percent of their overall investment. Sunday also was important for symbolic reasons, with the *Journal* officially proclaiming the giant "much more than a nine days' wonder," the contemporary phrase for a popular novelty. The newspaper further expounded upon this point: "Sunday completed the nine days of excitement and marvelings [sic] over this remarkable discovery, and, instead of an abatement of the popular interest, it would seem that it has but just begun to be awakened."[20]

The giant's local celebrity perhaps was nowhere more apparent than in its overshadowing of the upcoming election in Onondaga County. In the first week of November, New Yorkers would vote on several proposed revisions to the state constitution as well as a separate measure regarding Negro suffrage. Earlier that year, the United States Congress had submitted the proposed Fifteenth Amendment to the states for ratification, with President Grant throwing his full support behind the measure to guarantee equal voting rights for black citizens. During the ratification debate in New York, Democrats objected to the amendment's violation of states' rights principles, though these politicians also feared that newly enfranchised blacks would vote for Republicans en masse. Despite their opposition, the Republican-controlled legislature ratified the amendment in April. By the time of the November elections, however, the Fifteenth Amendment had not yet received the necessary votes to become part of the federal Constitution, and, in New York, citizens would decide whether to maintain existing statewide restrictions on Negro suffrage or establish equal voting rights. Their verdict would serve as a popular referendum not only on the Republican legislature and Negro equality, but also, to some degree, Congressional Reconstruction and the legacy of war itself.

The Democratic *Courier* grasped the import of the upcoming election, and, fearing that the giant might divert public attention from this important matter, interspersed election reminders within its coverage of the great wonder. One such item made manifest the *Courier*'s assessment of Republican policies, both in New York and nationally: "THE RADICAL LEADERS HOPE TO CARRY THE STATE THROUGH THE INATTENTION OF DEMOCRATS TO THE IMPORTANT WORK OF REGISTRATION, FRIDAY NEXT—FELLOW DEMOCRATS! SEE THAT THEY ARE DISAPPOINTED BY ATTENDING THE MEETING OF THE BOARDS OF REGISTRY." Despite the newspaper's best efforts, however, the giant clearly was stealing focus from the election. As the *New York Commercial Advertiser* observed from afar: "Compared with the Cardiff graven image, the election is nowhere in Onondaga county."[21]

CHAPTER SIX

~

Ten Thousand Stories

The giant's popularity was well established at this point, but its specific origin very much remained a mystery. One writer—"UNO" from Cardiff—outlined the salient questions before the public in a letter to the *Standard*: "How long this giant man has lain there, what could have been his age, and what race of humanity did he belong to, if actually human: or if a statue, who carved the stone, and for what purpose, and how came it to be buried in this place without a record or tradition of its existence?" Editors, religious professionals, community leaders, and, of course, ordinary citizens played out this debate in the newspapers, but, in so doing, manifested far less religiosity than George Hull originally anticipated. Instead, men and women ruminated on what the giant said about America's past and, by extension, its present. Lacking a proper framework for judging the giant, archaeologists and scientists broadly steeled this romantic imaging and, in so doing, only furthered the giant's popular momentum.[1]

Toward the end of the first week, the tone and content of newspaper coverage shifted, particularly in Syracuse. While the *Standard*, *Journal*, and *Courier* continued to offer daily news reports on attendance figures, notable visitors, as well as other developments, the majority of coverage focused on the petrifaction-statue debate as well as theories of the giant's origin. The speculation most generally took the form of letters, with typical headlines including "A CORRESPONDENT'S VIEWS," "An Interesting Criticism," and "A SPECULATION BY A VISITOR." The newspapers generally did not discriminate on the basis of class or occupation, as the letters of

common bricklayers ran alongside those of prominent community figures. Still, the selection of letters invariably revealed the newspapers' own editorial bias. By the end of the first week, the *Journal* and *Courier* endorsed John Boynton's statue hypothesis and tended toward letters that supported this position, while the *Standard*, in keeping with prevailing public sentiment, remained squarely in the petrifaction camp. In addition to running letters from petrifactionists—as adherents became known—the *Standard* presented its own evidence in support of petrifaction, including reports of earlier petrified men and mammoth fossils in the valley, while also reprinting content on historical giants from the *English and American Encyclopedia*. The *Standard's* exuberance for petrifaction, in fact, landed its editors in hot water on at least one occasion. The newspaper reported that George Geddes, superintendent of the Onondaga Salt Springs, judged the giant a petrifaction. The following day, the *Standard* ran a letter from an annoyed Geddes, who indicated that he had not yet formed a definite opinion on the great wonder. Citizens outside of Onondaga County likewise took part in the great debate. Metropolitan newspapers, in addition to offering their own unique coverage, ran letters from prominent citizens and passed editorial judgment on the great wonder. Smaller Northeastern newspapers such as the *Norwich Bulletin, Otsego Republican and Democrat*, and *Worcester Palladium* did not send reporters into the field, but these newspapers published the opinions of local curiosity seekers who ventured to Cardiff. More distant newspapers such as the *Chicago Daily Tribune, Weekly Georgia Telegraph*, and San Francisco's *Daily Evening Bulletin*, lacking ready firsthand sources, for the most part reprinted news items and letters from the eastern papers.[2]

From this disparate newspaper coverage, it seems that at least some citizens not only regarded the giant within the context of religious revelation but also considered faith as a means of unlocking the giant's mystery. According to "UNO," one local woman claimed that her family witnessed an earlier manifestation of the giant's spirit at Cardiff: "A lady from the west, who is visiting here, says that while residing in this place several years ago, her two sisters were greatly alarmed by the sight of a giant spectre [sic] on the other side of the creek." Soon thereafter, the *Standard* ran a letter "REFERS IT TO THE SPIRITS," in which author "Q. S." called upon local Spiritualists to convene at City Hall and attempt to communicate either with the spirit of the giant or that of its sculptor—whichever was appropriate: "Let our Spiritualists put themselves in communication with his spirit forthwithly, for we are all anxious." Rev. Chauncey Barnes, a noted Spiritualist from Boston, eventually took up the challenge, presenting a lecture in Syracuse titled "The Mystery of God and the Giant, and How the National Debt Can Be Paid."

The *Standard* characterized Barnes's séance thusly: "To solve the Cardiff Giant mystery he put himself in the clairvoyant state, then commenced in the Indian tongue—we suppose it was, though we have no knowledge—shortly turning into broken English, and talked of when this valley was a part of the great waters; of the red man inhabiting the high lands way back; of the coming of a race, of pale-faces a thousand years ago, &c., and that the Cardiff Giant was one of that race, and a petrified human body."[3]

The Bible proved a more common frame of reference from the outset, with newspapers making frequent allusion to the Good Book and with some citizens even ascribing biblical identities to the giant. The Philistine warrior Goliath became a touchstone for newspaper editors and correspondents, with the *New York Sun* referring to the great wonder as the "American Goliah"—possibly derived from the official pamphlet of the same name—while the *Courier*, in reporting on the sale of the great wonder, offered the headline, "WHO SLEW THE MODERN GOLIAH?" The *Utica Morning Herald* invoked a second biblical giant, Og, when it mused in an editorial: "As Cardiff is of Welsh origin, it may be this chap came from Wales, and, after all, he and Og are old neighbors, if not related to each other." Some citizens went beyond mere allusion, positing that the great wonder was an actual biblical personage. One Onondaga tribesman proffered that the giant was Adam's son Abel, while "UNO" shared with the *Standard* the opinion of an older curiosity seeker: "An old lady, who resides in another town, believes it to be one of Noah's crew, who fell out of the Ark and was drowned." Andrew White likewise quoted a local minister: "Is it not strange that any human being, after seeing this wonderfully preserved figure, can deny the evidence of his senses, and refuse to believe, what is so evidently the fact, that we have here a fossilized human being, perhaps one of the giants mentioned in Scripture?"[4]

Petrifactionists more commonly invoked the Bible when arguing for the existence of historical giants. In one later letter to the *Standard*, Geddes reviewed French naturalist Claude Nicolas Le Cat's paper on modern men and women who exceeded eight feet in stature as well as mammoth bones from the early modern period. With specific reference to the latter cases, Geddes conceded: "The amount of credit we should give to all these accounts is uncertain." By contrast, the Bible represented an indisputable source on the historical phenomenon. In making an early case for the great wonder as a petrified giant, the *Courier* paraphrased the Book of Genesis: "We know that men of mighty stature have inhabited the earth in days gone by—giants in fact." A writer to the *Standard* likewise affirmed not only the Bible's reliability but also the historicity of Greek mythology: "Scriptural and profane

history settles the question of the existence of giants. The former speaks of
the sons of Anak, and the ancients speak of the Cyclops, a giant race who
inhabited the western parts of Sicily." The *New York World* acknowledged
the difficulty in conceiving of living giants, but nevertheless stood by the
Good Book's account: "Many more people would incline to believe that this
'wonder' had once lived and trod the earth, could they fully reconcile them-
selves to the fact that there had 'been giants in those days.' If we believe the
Bible, we must admit that fact." Even statue theorists, in dismissing the great
wonder as a once-living being, nevertheless endorsed the Bible's record of
historical giants. Writing to the *Journal*, Elias Leavenworth, a former mayor
of Syracuse, asserted: "There is no satisfactory evidence that any one person
ever lived in any age or country of this world, of the stature of ten feet, unless
it be Goliah of Gath."[5]

While editors and citizens alike cited the Bible as a definitive source, these
same men and women, for the most part, bypassed the opportunity to hail
the Good Book's veracity or extend the truth of giants to similarly fanciful
parables. Many petrifactionists connected the great wonder to earlier giant
races on the continent, but did not specifically link them to the Bible. The
Standard, upon noting the earlier discovery of mammoth skeletons by workers
on the Cazenovia & Canastota Railroad, stated somewhat vaguely: "These are
proof of a giant race on this continent, and in this part of it; how far back no
one can tell." Extrapolating from sizable bones discovered in Oswego Valley,
the *Fulton Times* similarly opined: "They prove beyond reasonable doubt that
a race of giants at one time inhabited some portions of this continent." Even
religious professionals by and large refrained from invoking the Bible within
the context of the giant. Rev. E. F. Owen, a Baptist minister of Rochester,
traveled to see the great wonder on the first Tuesday after the discovery. Even
while endorsing the petrifaction position, professor Henry A. Ward of Roch-
ester University apparently offered no weightier assessment, for the *Rochester
Democrat* reported only: "It is the opinion of Mr. Owen, and indeed of most
scientific men who have given it an examination, that it is a petrified human
body." Rev. J. G. Bartholomew, a Universalist, endorsed the statue theory in a
letter to the *Auburn News*, but, even in invoking the distant past, the preacher
made no specific reference to the Good Book: "It is wonderful, unexplainable,
immense. We are forced to believe that it is the relic of a by-gone age . . . and
even though he is no petrifaction, he may yet prove to be the connecting link
between the days that are and those long since passed away."[6]

Few Americans regarded the giant as proof of the Bible's veracity, in large
part because there was no ready context for doubt. The Bible weathered the
earlier storm of Charles Lyell's geology, and the Good Book was not under

attack from mainstream religious or scientific sources. After briefly considering the possibility that infidels might employ the giant's antiquity against the Bible, the *Hartford Post* scoffed, "Genesis is still unshaken." For most Americans, the giant simply confirmed what already was known to be true: that the Bible presented a reliable record of natural and human history. While he succeeded in making men and women look foolish for affirming their belief in giants, Hull nevertheless failed to generate the religious response that he desired. In part, the giant maker misjudged the spiritual climate, but he also failed to foresee his creation's wider resonance. Rather than what the giant said about the Bible, Americans seized upon what the great wonder said about America. This romantic response superseded religious reception, and, in large part, helped the giant to succeed beyond Hull's wildest dreams.[7]

* * *

Romanticism emerged in Europe during the second half of the eighteenth century, largely in response to prevailing Enlightenment thought. Over the course of the 1700s, the Enlightenment—made possible by the new knowledge of the scientific revolution—emphasized objective thinking as well as the discovery of universal truths through empiricism, reason, and experience. The Enlightenment transformed nearly every aspect of civil society, most notably politics and religion. Philosophers such as John Locke, in championing freedom and democratic forms of government, established an intellectual framework for later revolutions in America and France, while deists such as Voltaire proved highly influential with Thomas Jefferson and the Founding Fathers in de-emphasizing organized religion and conceiving of God as Creator of a self-regulating universe. Though the Enlightenment generally advanced civilization, the prevailing age was not without its critics. Jean-Jacques Rousseau blamed cold and manipulative civil institutions for corrupting man and leading him away from his noble state of nature. This critique of modern society—coupled with Rousseau's highly expressive and emotive style—proved influential with a new generation of writers and artists. During the final decades of the eighteenth century, the perceived excesses of the French Revolution prompted an intellectual reversal. Romantics such as William Wordsworth, Victor Hugo, and Johann Wolfgang von Goethe rebelled against Enlightenment precepts, arguing that reason alone could not furnish truth and instead championing self-expression, emotion, and spontaneity. Romantics likewise cultivated a high sensitivity for nature and the natural, asserting that humans could find truth about themselves and the larger world by returning to—and contemplating—nature. Romanticism influenced a

myriad of social and cultural forms, including literature, music, visual arts, and philosophy, while also spawning continental revivals of Christianity.

Within their broad aesthetic expression, romantics focused on the past as well as the development of national character. Rousseau's musings on the state of nature and popular sovereignty again were influential, but Johann Gottfried von Herder more clearly defined the emerging dynamic between romanticism and nationalism. In *Materials for the Philosophy of the History of Mankind*, published in 1784, Herder argued that diverse climates and geography spawned specific responses to nature, and, accordingly, each people—or *volk*—had its own unique spirit manifested in language, mythology, and religion. While Herder maintained that each culture merited consideration upon its own terms, later followers promoted the superiority of certain languages and, by extension, people. Early Germanic tribes such as the Normans and Saxons gained particular regard for their heroism and feats of nation building. Early romantics both sought out and created works that expressed this preoccupation with national spirit. The Grimm brothers collected folklore that expanded knowledge and understanding of Germany's past, while Hans Christian Andersen amassed the fairy tales of Denmark. European romantics rediscovered early stories and poems such as the *Nibelungenlied* and *Beowulf*, promoting these works as national epics, while, in Scotland, Sir Walter Scott penned the historical novel *Ivanhoe* about the heroic conflict between Normans and Saxons in early England. The quest for national spirit also informed historiography, with romantic historians evincing what modern counterparts call "a passionate interest in individuals and the heroism of their stories." Martha C. Howell and Walter Prevenier characterized the dynamic between history writing and nationalism during this period: "In the nationalist tradition of history writing that reached an apogee in the later nineteenth century, historians became water carriers for a kind of political nationalism that celebrated the national character and treated the particular culture being celebrated as the end point of a long development toward which some vaguely defined historical forces were striving." Romantic interest in the past also spurred antiquarianism, with cultural humanists conducting early archaeological excavations, but, more commonly, taking up the pen and musing about how the distant past might have looked.[8]

Romanticism was late to bloom in the United States, in part because of the early republic's preoccupation with politics and commerce. Still, by the 1830s, the romantic movement was dovetailing with—and influencing—both common-man democracy as well as the spiritual fervor of the Second Great Awakening. The romantic celebration of the individual—and the arrival at

truth by means other than empiricism and intellectualism—sharpened contemporary attitudes toward science and scientists, while romanticism to some degree reinforced the emotiveness of American evangelism. Within the realm of American arts, the impact was decided. Ralph Waldo Emerson and Henry David Thoreau founded the transcendentalist school, the American counterpart to romanticism that incorporated elements of German idealism as well as Eastern religions. In essays such as *Self-Reliance* and *Nature*, Emerson hailed the values of individualism and self-discipline, while heralding nature as a place of spiritual renewal. Thoreau likewise celebrated the mystical power of nature in *Walden: Or Life in the Woods*. James Fenimore Cooper played a critical role in bringing romanticism to the masses, as the writer explored themes of nature and civilization in his wildly popular novels and thus ensured that romanticism enjoyed an impact far beyond intellectual circles.

Much like their European counterparts, American romantics became preoccupied with national character. During the antebellum years, Americans generally assessed their new nation's progress relative to Old World benchmarks. In 1849, the editor of *De Bow's Review*, a commercial journal, assessed the state of American trade thusly: "We have laid the foundation of cities which occupy rank with the Tyres and Carthages of antiquity, and must rival the Londons of the present day." American writers also measured themselves against European counterparts, especially after the *Edinburgh Review* famously asked, "Who reads an American book?" Patriotic writers not only strived to establish a comparable American literature but also suitable national epics. In *Leatherstocking Tales*, Cooper celebrated the wild and unique American landscape, while likewise casting American Indians as noble savages within the state of nature. Henry Wadsworth Longfellow drew upon American traditions, but contextualized them within classical meters and lines, giving *The Song of Hiawatha*, *Evangeline*, and *The Courtship of Miles Standish* suitable epic sweep. Longfellow himself made light of the pressure to craft a national epic. In *Kavanagh, a Tale*, his blustery Mr. Hathaway demands from a pitiable writer: "We want a national epic that shall correspond to the size of the country . . . We want a national drama in which scope enough shall be given to our gigantic ideas, and to the unparalleled activity and progress of our people!" Still, while the United States rivaled the Old World in terms of commerce and technology, there were concerns that America would not yield a national epic, in part because inherited history did not manifest civilization and progress. "Podrida" articulated this position in *The Knickerbocker*, a popular literary journal: "Perhaps our only materials are in the dreamy traditions of the red men; but they can never win our sympathies, as our own

fathers might have done. We are, consequently, without any epic, save [Joel Barlow's] 'Columbiad,' and that is one only by courtesy. It wants the energy, the sublimity, the living fire of genius."[9]

Not entirely satisfied with the continent's history, Americans worked to reimagine the past. The mounds of the South and Midwest offered the most ready context, since these man-made structures represented some of America's oldest antiquities. From the earliest days of settlement, Americans imagined that a race other than the Indians had fashioned the continent's earthworks. By arguing that natives lacked the requisite artistic and architectural capabilities, Americans reinforced the characterization of Indians as savages and thus justified a program of conquest and removal. As author and clergyman Timothy Flint asserted during one series of lectures: "I am clear, that no person could see the mounds of Grave Creek, on the Ohio, Circleville, on the Scioto, and Cahokia, near the Mississippi in Illinois, without being satisfied, that these immense, though rude erections, were reared by a more laborious and municipal race than the present Indians." The Mound Builder myth reached its zenith during the years of American romanticism, and the identity of this race became a major speculative concern of domestic writers. In his 1833 book *American Antiquities and Discoveries in the West*, Josiah Priest identified ancient Mediterranean civilizations as likely candidates for constructing the mounds: "We are firm in the belief that the Carthaginians, Phoenicians, Roman and Greek nations of antiquity, have had more to do in the peopling of the wilds of America . . . than is generally supposed." After the publication of Carl Christian Rafn's *Antiquitates Americanae* in 1837, Americans increasingly looked to seafaring Northmen—or Vikings—as major players in American prehistory. Rafn, a Danish antiquarian, scrutinized Norse saga to discern the scope and cultural diffusion of early Germanic tribes, corresponding with New England historical societies to connect local artifacts with Viking lore. In *Antiquitates Americanae*, Rafn argued that Vinland of Norse saga represented ancient New England and that Northmen likely sailed as far as the Chesapeake Bay. To this end, Rafn badly misinterpreted native inscriptions as well as colonial structures such as Rhode Island's Dighton Rock. Still, Rafn's publication sparked widespread interest in Scandinavian culture within the United States. Emerson and Thoreau explored Norse language, mythology, and culture in their own writing, while eminent New Englanders such as Jared Sparks, Henry Cabot Lodge, and George Perkins Marsh all embraced the Saxon origins of the continent. American antiquarians also connected seafaring Northmen to inland earthworks. Writing with reference to Pennsylvania mounds in *Traditions of De-Coo-Dah, and Antiquarian Researches*, William Pidgeon asserted: "The circular works of the

Danes and Saxons so frequently found in England in connection with the Pentagon or Doom-ring of Denmark, stretching in a continuous line from Brownsville, in Pennsylvania, through Wisconsin, Canada, Greenland, and Iceland, to Sweden direct, we conceive to be strong evidence of the migration of the Danes, Belgians, or Saxons, at some unknown era in time." The tendency to overstate the scope of Norse voyages—which modern archaeologists maintain did not exceed the Atlantic coast of Canada—proved fodder for at least one literary hoaxer. While waiting for Congress to approve his nomination as Andrew Johnson's private secretary, Pennsylvania native Frank Cowan satirized Rafn, Marsh, and others in a fake news report for Georgetown's *Evening Union*. In the article, a fictional antiquarian discovers a runic inscription along the Potomac River, thus establishing the interior voyages of Northmen as early as 1051. Thoroughly deceived by Cowan's report, the *New York Evening Post*, in light of the discovery, issued a revised timeline of world history.[10]

While some patriotic Americans were content to connect the continent's prehistory with European nations, others more fancifully posited the early existence of an indigenous white race. This culture allegedly fashioned the mounds and established a thriving civilization before savages succeeded in conquering them. The earnest desire to rival—if not surpass—the Old World was manifest in this expression of the Mound Builder myth. After paying homage to the lost white civilization, one writer in *The Knickerbocker* placed America's earthworks on par with the antiquities of Europe and Asia: "While the homage of the world has so long been paid to the monumental piles of transatlantic antiquity, and while voyages and pilgrimages have been performed to far distant quarters of the earth, to obtain a glance at oriental magnificence, and the ruined arts of primitive nations, here we find ourselves surrounded by those of a still more remarkable character. The wondrous cities of Pompeii, Herculaneum, Elephanta, Thebes, and Petra, are not more the subjects of just admiration than are those of our own America." Cornelius Matthews, who fashioned an early epic *Behemoth* about the mysterious Mound Builders, mused in one later essay: "The time may come when the Mound-builders shall be used to point a moral or adorn a tale, as well as Greek or Roman."[11]

The Civil War generally slowed the march of American empire, as did the subsequent conflict between Congress and President Andrew Johnson over the Reconstruction of the South. By November 1868, it was clear that Northerners were growing increasingly dissatisfied with both the Radical Republican program of centralized government and Negro equality as well as the continued military occupation of the South. The *Brooklyn Eagle*

opined: "The soldiers restored the South to the Union . . . Then the Radicals stepped in with their 'reconstruction' policy, and thrust the States out of the Union again . . . The blood of all the slain heroes of the war cries out from the earth against the Radicals, for thus nullifying the victory which our soldiers died to achieve." The election of Ulysses S. Grant that same month was less an endorsement of the Republican Party than a tacit expression of support for the war hero's vague promise of peace. The political and social conflict persisted into 1869, as Congress pushed the Fifteenth Amendment on Negro suffrage, in part to guarantee black political rights but also to reap electoral gains from a legion of new voters. Still, Americans were focusing less on the legacy of war and more on the renewed march of American empire. The opening of the transcontinental railroad in May was a particularly monumental event, with Samuel Bowles Jr., editor of the *Springfield Republican*, crowing: "It is the unrolling of a new map, the revelation of a new empire, the creation of a new civilization, the revolution of the world's haunts of pleasures and the world's homes of wealth." Later that year, Hiram Walker, distiller and railroad owner, hailed the new lines for enhancing America's standing in the world but also succeeding where political Reconstruction had failed: "These roads will cement the interests of the different sections of this Union into one mighty Empire, and give us prestige among the nations of the earth; so that rock-bound New England, with its busy wheels and spindles, the rich alluvial soil of the Valley of the Mississippi, and the golden Pacific slope, may have a common interest in keeping this Government intact through ages to come." Competition with the Old World—and sentiments of national progress and destiny—never fully dissipated during the war years, but they reemerged in earnest by the time of the giant's discovery, and the great wonder—like the Mound Builders previously—stirred romantic passions and pointed to early American grandeur.[12]

It was evident that the giant stirred emotional responses, with petrifactionists especially citing feelings of awe that the natural wonder evoked. The *New York Sun* summarized one conversation with a group of petrifactionists thusly: "They claim that the impression it makes on them is that of a dead body, and that they experience a sensation of timidity (even of fear), such as the bravest men have known in the presence of things deemed supernatural." After listing several common sense objections to the statue hypothesis—including the giant's lack of a pedestal—one man offered his most compelling argument in favor of petrifaction: "No piece of sculpture of which we have any account ever produced the awe inspired by this blackened form lying among the common and every-day surroundings of a country farm yard." "COM," who preferred the statue hypothesis, reported similar feelings to the

Utica Observer: "Gazing down upon the monster in his lowly bed where for ages he has slept, the emotions excited can neither be analyzed nor described. There is a pathos in his mute helplessness, a silent eloquence on those lips, that thrills the heart like a solemn anthem or the dirge of the ocean. It is an epic in stone, a stupendous mystery."[13]

While some citizens supported the giant's connection to Onondaga Indian legend, the vast majority ascribed more exotic origins to the great wonder. Statue theorists, in particular, linked the giant to foreign cultures that allegedly preceded French Jesuits on the continent. In a letter to the *New York Independent*, Jonathan Kneeland, an Onondaga physician, speculated that members of an early Spanish colony had fashioned the great wonder: "Is it not possible that this may have been formed in the 16th century by some sculptor who had seen the Neptune, Mars, and Jove of Rome, and whose type of greatness and goodness was Caucasian in form and feature?" Writing to the *Journal*, "W" reached even further back, suggesting that ancient Egyptians had sculpted the statue: "From the particular shape of the head, I think it is the work of an Egyptian sculptor, and cut from a block of Onondaga limestone." This same writer pointed to a broader Egyptian influence in the New World, opining: "When it was done I cannot guess. It evidently belongs to the people who left the ruins in Central America and the mounds in the west." Among external candidates, however, the Northmen proved most popular. In a clear case where romance superseded revelation, one member of the Oneida community—a group of religious perfectionists borne of the Burned-over District—identified seafaring Vikings as the sculptors of the giant. In a letter to the *Circular*, the community's official newspaper, this man reviewed Onondaga legends of Stone Giants as well as shipwrecked mariners, ultimately concluding: "Now who but the renowned Northmen could have played the role of the shipwrecked mariners and the Stonish Giants in these Indian traditions?" This writer emphasized the heroic nature of these early explorers—"Clad in stout scale-armor, with trusty battle-ax in hand, in search of glory, they sailed the trackless ocean in their frail ships, without a compass, defying the waves and laughing at the storm"—while ascribing similar virtues to the giant's sculptor and subject: "The very magnitude of the statue would indicate that the great-souled Northman was its maker. Its head and limbs seem to be of unmistakable character—the form of a sea-king resting from his toils." Rev. Samuel Calthrop, a Universalist, likewise speculated that the statue represented a dying Northman who clutched his side in pain after being hit by a poisoned arrow. While outlining this particular scenario, Calthrop at once invoked the predestination and inevitability of American empire: "If you had objected that there

was too much mind shining through the features, the sculptor might have answered that the closed eyes saw in prophetic vision that men of his race would one day rule where he had lain down to die."[14]

Romantic images of the past similarly informed theories of indigenous origin. In a letter to the *Standard*, "Ondiyara" invoked a native white civilization, while placing the achievements of this race on par with the great empires of the Old World: "It is not probable that any early French pioneers made it. The Indians could not. It goes back then beyond the Indian age to a race before the Indian, with skill that approaches at least the best of Grecian or Roman sculpture." The *Standard*, which favored petrifaction, characterized the giant as the "eighth wonder of the world," placing the United States in the same context as European and Asian civilizations, while implying that the American continent produced naturally what the Old World could do only by hand. In characterizing indigenous races—either of giants or statue makers—citizens emphasized the civilization and character borne of the unique American landscape. A correspondent from the *New York Herald*, making the case for the statue hypothesis, connected the giant to the Mound Builders, highlighting that race's early capacity for city building and architecture:

> So far as any evidence to the contrary is now apparent this statue may belong to an age when the country near it was peopled by the race whose bones have been taken from numerous tumuli in our own time; when perhaps the further side of this valley was the site of a city and the people made their processions to a temple on the hill, at the foot of which this statue was found.

By contrast, *The Onondaga Giant* and *The American Goliah*, in considering the possibility of petrifaction, speculated on the giant's nature. The former pamphlet ascribed a number of heroic adjectives to the giant, including "manly," "fleet-footed," and "mighty," while the latter characterized the great wonder's countenance in similar fashion: "The expression is calm, thoughtful, almost sweet. The high, massive forehead sets off with grand, yet benevolent dignity . . . Beautiful despite its immensity, it displays a largeness of kindly feeling not commonly surmised from Fairy tales of Giants and Giant deeds." At the same time, *The Onondaga Giant*'s writer wondered whether the giant ruled empires, doing so in autocratic or democratic fashion: "Did he govern nations or turn the destinies of empires? . . . Those hands: have they ever wielded the iron rod of oppression?" "M," a native of Towanda, Pennsylvania, likewise identified the great wonder as a leader of men—referring to him at one point as "the Kingly Giant"—but inclined to

believe that the sovereign was a fair ruler, characterizing him as "the aged, bald headed noble monarch of his race." Of course, by casting the giant as the leader or member of an early white civilization, these men implicitly acknowledged its conquest at the hands of the American Indian. "T. C. C." took an optimistic view of this scenario, suggesting that both past and present American civilizations fulfilled the cycles of history. As the bricklayer explained to the *Standard*: "My theory is that the Indians—or more properly speaking, the savages—for the name Indian was not applied to these barbarians until the discovery of America by Columbus, came from Russia across Bhering [sic] Straits in large numbers and settled the western portion of this continent, and by degrees, spread over the country in bands or tribes, and drove before them and exterminated the civilized race then existing here, as we have since driven them back to their starting point."[15]

One correspondent for the *Milwaukee Daily Journal* perhaps captured the giant's resonance best in noting that curiosity seekers took occasion to "muse upon our past greatness." In this sense, the great wonder was less the Onondaga or Cardiff giant and much more so the American Goliah, a figure that transcended New York and the North more generally and pointed to a broader—and more significant—inherited past, possibly even the stuff of national epics. The giant verily was proof that there had been nations and kingdoms in America in those days, and, as modern citizens increasingly moved beyond sectional differences to focus on transcontinental railroads and telegraphs, indeed it seemed that America might see an empire again—and soon.[16]

* * *

Scientists by and large recognized that the giant was a statue, but, lacking suitable methodology and systematic procedure to discern its age and origins, these men turned to exotic speculation on the past and, in so doing, manifested the same romantic tendencies as their fellow citizens.

Shortly after the examinations of Boynton and the local physicians, the *Standard* reported that unnamed citizens had contacted other prominent scientists. The newspaper's language was noteworthy, conveying the expectation that these new evaluators would confirm the prevailing belief of petrifaction:

> More details bearing on the probabilities of its being a bona fide human petrifaction are at hand, but we defer giving them, in hope of having something decisive within a day or two. Prof. Hall, State Geologist, Prof. Agassiz, and

Prof. S. B. Woolworth, Secretary of the Board of Regents, have been written to, and are expected very soon.

In reaching out to naturalists and paleontologists, who dealt with living organisms past and present, these citizens, of course, revealed their own bias for petrifaction. Though not American born, Louis Agassiz represented a pillar of national science. During his early years, the Swiss naturalist published seminal works on fossil fishes, while also putting forth early theories of glacial activity. After relocating to the United States in the 1840s, Agassiz assumed a professorship at Harvard College and established the Museum of Comparative Zoology. A few weeks before the giant's discovery, though, the sixty-two-year-old Agassiz suffered a cerebral hemorrhage, incapacitating him and precluding any possible visit to Cardiff. Like Agassiz, James Hall was a key figure in nineteenth-century American geology and paleontology. After completing his studies at the Rensselaer Institute, Hall joined the New York State Geological Survey in 1836, and his subsequent report, notable for its early American stratigraphy, became what one scientific historian calls a "classic of geological literature." At the same time, Hall made key observations on the continuity of species within the fossil record, prompting one British publication to hail him as "the great American paleontologist." After relocating to Albany, Hall made the state capital a key location for domestic scientific study, while aiding in the establishment of the state university. While serving as New York State geologist, Hall also led surveys in Iowa and Wisconsin and served as president of the American Association for the Advancement of Science. In 1866, Hall became director of the New York State Museum of Natural History, which, in addition to fossil specimens, exhibited antiquities such as the dubious Pompey stone. Proud Empire Staters may well have reached out to Hall and Woolworth—a university regent who controlled the state's cabinet—as much to strike a deal with Stub Newell as for the state geologist's scientific assessment.[17]

On the first Friday after the discovery, Hall and Woolworth arrived at Newell's farm to examine the great wonder. Given the attendant publicity, the Cardiff farmer cleared the tent for fifteen minutes, allowing the men unencumbered access. The state geologist made three separate forays into the giant's pit, recording the position of the great wonder relative to the points of the compass. Hall likewise consulted with Billy Houghton, advising him not to strike the giant with his exhibitor's pole, for fear of damaging it. At one point, Houghton moved to join Hall in the pit, but the geologist raised his hands and beseeched the Cardiff storekeeper not to hop on the

giant. Houghton heeded Hall's command, and it was well that he did, for the famously ill-tempered geologist kept a shotgun above his desk in Albany. After leaving the tent, Hall refused to make any formal statement to reporters, but when pressed by the *Courier* on the possibility of the giant's modern origin, an agitated Hall thundered: "NO! IT HAS LAIN IN ITS PRESENT POSITION FOR AGES!" Taking leave of reporters, Hall hiked up Bear Mountain to survey the area's geological features, later returning to Albany with Woolworth. He subsequently outlined his thoughts on the giant in a brief letter to the *Albany Argus*. Rather than discuss any possible acquisition, the geologist focused instead on the nature of the great wonder. Hall denied any possibility of petrifaction, confirming Boynton's earlier assessment that the giant was a statue: "The Giant, as already has been stated, is a statue . . . (not a cast), lying upon its back, or slightly inclined to the right side, and in an attitude of rest or sleep." Though he refused to speculate on its origin, Hall nevertheless affirmed the great wonder's scientific import and charged archaeologists with its study: "Altogether, it is the most remarkable object yet brought to light in our country, and, although, perhaps, not dating back to the *stone age*, is, nevertheless, deserving of the attention of archeologists." A few days later, Hall and Woolworth issued a joint statement, reiterating the earlier assessment while stating flatly: "*We do not propose any theory in regard to its origin.*" These letters enjoyed broad national circulation, appearing in the *New York Herald, Philadelphia Inquirer, Chicago Daily Tribune, Columbus (Ga.) Ledger-Enquirer*, and *Daily Evening Bulletin*.[18]

Around the time of Hall's examination, Henry A. Ward also paid a visit to Newell's farm. While he was a professor of natural sciences at Rochester University, Ward was perhaps best known for his museum management. After apprenticing under Agassiz at Harvard, Ward traveled the globe in search of exotic specimens, ultimately founding Ward's Natural Science Establishment at the university. Ward's museum featured legitimate scientific specimens, stuffed and prepared within his own personal laboratory. One contemporary educational journal hailed the museum as well as its founder: "Prof. Henry A. Ward of Rochester University . . . projected a cabinet of geology which should be an epitome of the *entire* science . . . It is an inexhaustible reservoir. The plan of arrangement combines the excellences of all the great European cabinets; and has been heartily endorsed by distinguished *savans* at home and abroad." Agassiz leaned heavily on Ward's laboratory for specimen preparation, as did the American Museum of Natural History, chartered earlier that year. Despite his reputation within American science, Ward gained no special access at Newell's farm, standing shoulder to shoulder with

tral America and the mounds in the west. W.

Scientific Visitors.

THE VISIT AND INVESTIGATION OF STATE GEOL-
OGIST HALL AND PROFESSOR WOOLWORTH—
WHAT THEY SAY.

Professor James Hall, State geologist, and
Professor Samuel B. Woolworth, Secretary of
the Board of Regents, who had been invited to
come from Albany to visit and inspect the great
curiosity, reached this city last evening and were
the guests of the Hon. Richard Woolworth.
They started at an early hour this morning for
Cardiff, accompanied by a number of our citizens
who are interested in the object of their investi-
gation.

On their arrival, these visitors were at once ad-
mitted to the tent, all other spectators being ex-
cluded during the examination. The party con-
sisted of Prof. Hall, State geologist, Dr. S. B
Woolworth, Secretary of the Regents of the
University, ex-Judge Woolworth and Dr. Wiet-
ing, of this city.

Prof. Hall was permitted to get down into the
pit, and make whatever examination he desired.

Although it was understood that any particu-
lar expression of Professor Hall's opinion should
not be made public, yet the general features of
the discovery and its great importance to the
scientific world were fully conceded and freely
canvassed.

The following general summary of the views
of these gentlemen can now be given, and in due
time full details will be presented to the public:

The figure is of great antiquity, antedating the
present geologic period. Its position in the for-
mations of clay and shale is definite and unques-
tioned. It opens up a new and most interesting
field in archeological science, and will rank in
interest with any of the mysterious and wonder-
ful productions of the Aztecs of Mexico.

It is not possible to pronounce at once upon

The Syracuse Daily Journal's October 22 report on the scientific examination of the giant. Source: Onondaga Historical Association Museum and Research Center, Syracuse, New York.

curiosity seekers inside the tent. Upon his return to Rochester, Ward outlined his observations in a letter to the *Rochester Democrat*. He thoroughly rejected the notion of human petrifaction, offering a detailed explanation to that end. The professor noted that, while bones, shells, and hard parts of animals fossilize as a result of mineral substitution, there was "not a single instance on record of fossil flesh; of the fat, muscle or sinew of man or beast changed into stone or any substance resembling stone." Ward refused to speculate on the statue's origin, but acknowledged that the giant gave him the "extremest [sic] awe and profoundest wonder." Like Hall, Ward did not address possible acquisition, though, in his case, it may have stemmed from the fact that the giant was not an item of natural history. In the end, Ward sounded the call for archaeologists, but also recommended the review of sculptors, who might offer insight into the statue's artistic context: "I will leave it upon [sculptors] and the Archaeologist to study and puzzle upon it." Ward's letter appeared in the Syracuse newspapers as well as in *The Onondaga Giant* and *The American Goliah* pamphlets.[19]

In calling for archaeological review, Hall and Ward showed marked confidence in a scientific discipline that very much remained in its infancy in the United States. Over preceding decades, several key individuals and institutions laid a basic foundation for the systematic study of the past. In 1784, Thomas Jefferson excavated the mounds at Monticello in a controlled fashion. Whereas most enthusiasts typically dug quickly through earthworks to find exotic artifacts, the future president paid careful attention to the placement of strata and bones, correctly concluding that the mounds had reached their elevation through a series of succeeding burials. One modern archaeologist has written that Jefferson's excavation "anticipate[d] the fundamental approach and the methods of modern archaeology by about a full century." In 1820, Caleb Atwater, a Circleville, Ohio, postmaster, published *Description of the Antiquities Discovered in the State of Ohio and the Western States*. The work partly was speculative, as Atwater postulated that Hindus fashioned the American mounds, but, still, he took pains to classify and describe artifacts and remains. In 1842, early archaeologists established the American Ethnological Society, a professional organization that encouraged dialogue among practitioners, while, later that same decade, the new Smithsonian Institution assisted in the preparation of what arguably represented American archaeology's first modern text. For the first installment of the *Contributions to Knowledge* series, Joseph Henry agreed to publish the mound surveys of newspaperman Ephraim George Squier and physician Edwin Hamilton Davis, but, prior to publication, the Smithsonian's secretary worked with the two men

to remove much of their speculation from the text, emphasizing instead description and classification. As Henry's biographer has written:

> Henry insisted upon throwing out some of the engravings Squier had prepared which were not "of an original character," and he drew a tight line on the manuscript itself so that "your labours should be given to the world as free as possible from everything of a speculative nature and that your positive addition to the sum of human knowledge should stand in bold relief unmingled with the labours of others."

While the resulting *Ancient Monuments of the Mississippi Valley* did contain references to the Mound Builders as well as belied certain racial assumptions, the text nevertheless was predominantly descriptive. In addition to their painstaking surveys, Squier and Davis offered basic classifications of the earthworks, while looking for patterns that might offer insight into function and use. Their publication represented a departure from previous speculative writings and established an early foundation for the systematic study of the past.[20]

Still, despite such strides and intense interest in the past, American archaeology lagged far behind other scientific professions in 1869. Squier, Wills De Hass, and others had emerged as full-time practitioners by this point, but, with no domestic colleges offering courses, early archaeologists were self-trained. At the same time, many of these men conducted surveys and excavations entirely at their own expense. With the modern framework of social sciences having not yet emerged, early archaeologists competed with earth, natural, and physical scientists for research support of the Smithsonian and the American Association for the Advancement of Science. Even within the American Ethnological Society, archaeologists shared resources with ethnologists and early anthropologists. Most significant, however, American archaeology still was mired in its speculative phase. While *Ancient Monuments of the Mississippi Valley* offered a rough framework for description and classification, the discipline lacked key manuals and field guides for self-trained practitioners. As a result, early archaeologists still largely mused about the past, rather than following the scientific method and looking for patterns across massive amounts of structured data. At the same time, antiquarians still dominated the discipline, frequently eschewing the field altogether and only furthering romantic speculation. The focus of archaeology very much remained on the search for—and interpretation of—singularly exotic artifacts to support pet theories, including the identity of the Mound Builder race.

Perhaps more than any other field, American archaeology suffered the effects of frauds, with hoaxers consuming valuable time and resources while also undermining efforts to establish credibility. One notable case was the Grave Creek stone, allegedly discovered in 1838 amid an excavation in present-day Moundsville, West Virginia. The tablet bore a series of inscribed characters, which antiquarian Henry Rowe Schoolcraft alternately identified as Celtic, Anglo-Saxon, Greek, Phoenician, Runic, and Etruscan, lending credence to theories of early European and Asian settlement. As the owner of the property established an observatory at the mound's apex, modern historians have assumed that the fraudulent tablet was fashioned for commercial benefit. Despite Squier's strong denial of the stone's authenticity, the Smithsonian ultimately assumed possession, though, lacking any framework for establishing its legitimacy, the organization simply made casts and distributed them to interested archaeologists. Indeed, at the time of the giant, many antiquarians still assumed that the Grave Creek stone represented a legitimate artifact and proof of early continental settlement. A similar case emerged in Newark, Ohio, though the archaeological community ultimately succeeded in recognizing the fraud. David Wyrick, an amateur antiquarian, excavated local earthworks to prove his personal theory that the Mound Builders represented the lost tribes of Israel. In June 1860, Wyrick discovered a stone that bore a Hebrew inscription. Given that religious professionals generally had familiarity with ancient languages, local antiquarians enlisted their support in assessing the stone. Rev. J. W. McCarty of Newark identified several modern characters within the inscription, accordingly informing the *Cincinnati Commercial* that the stone represented a recent creation. Several months later, however, Wyrick discovered a second stone, this one bearing an ancient Hebrew inscription of the Ten Commandments. This time, McCarty demonstrated his credulity by characterizing the tablet as a "relic" and informing the *Commercial*: "This matter is no hoax." A committee of the American Ethnological Society reviewed the two stones, considering testimony from New York City rabbis as well as antiquarians. After several months, the committee concluded that the so-called Holy Stones were fraudulent. Most contemporaries assumed that Wyrick perpetrated the deception to advance his own theories of the American past, though the antiquarian never confessed to the fraud and ultimately committed suicide.[21]

With regard to the giant, however, the archaeological community once again revealed its growing pains. Boynton was the first antiquarian to render judgment on the great wonder, and, arriving back at Newell's farm on Monday to secure the statue for science, the lecturer instead found workmen installing a tent over it. An angry Newell approached Boynton, shaking

a copy of that morning's *Courier* at him. The lecturer at once blamed the newspaper for misrepresenting his plans vis-à-vis the statue and eventually succeeded in assuaging the Cardiff farmer. Prior to commencing his show that day, Newell permitted the lecturer to conduct a second examination, and, at this point, Boynton recognized that the statue's material was not limestone, but rather gypsum, most likely native to Onondaga Valley. While practical experience in mineralogy and geology served him reasonably well in this regard, Boynton's archaeological instincts proved lacking. Upon his return to Syracuse, Boynton commenced a letter to Henry Morton, editor of the *Journal of the Franklin Institute*. Boynton further articulated his French Jesuit theory, while also speculating on the statue's function:

> The statue, being colossal and massive, strikes the beholder with a feeling of awe. Some portions of the features would remind one of the bust of [former New York governor] De Witt Clinton, and others of the Napoleonic type. My opinion is that this piece of statuary was made to represent some person of Caucasian origin, and designed by the artist to perpetuate the memory of a great mind and noble deeds. It would serve to impress inferior minds or races with the great and noble, and for this purpose only was sculptured of colossal dimensions.

When he identified the statue as the work of Jesuits, Boynton did so from historical knowledge of French occupation, rather than from any salient characteristics or from comparison to the existing archaeological record. Furthermore, while modern archaeologists would have considered the marks of tools in gainsaying the statue's age, Boynton made no attempt to distinguish between modern and ancient tools. The Syracuse newspapers reprinted Boynton's letter, and his musings proved influential with local editors, as the *Journal* and *Courier* both came to endorse the statue hypothesis. Boynton's speculation received wide circulation as well, appearing in the *New York Herald*, *Daily Cleveland Herald*, and *Missouri Republican*. His profile accordingly rose within the scientific community, as Spencer Baird, the Smithsonian's director, contacted Boynton for more information on the discovery. Baird later avowed that he had no intention of acquiring the giant, but simply hoped to confirm his initial suspicion of fraud.[22]

The giant likewise attracted the attention of De Hass, a critical but ultimately star-crossed figure in the history of American archaeology. A native of Washington, Pennsylvania, De Hass began his career as a physician, but turned to archaeology upon the discovery of the Grave Creek stone in nearby Moundsville. De Hass became a passionate defender of the stone's authenticity as well as a firm believer in the existence of a separate Mound

Builder race. He studied the mounds of the Midwest at his own expense, later emerging as a popular lecturer on American antiquities. At a special session of the American Ethnological Society in February 1858, De Hass challenged Squier's critique of the Grave Creek stone, garnering headlines in both the *New York Herald* and *New York Times*. Two months later, the American Association for the Advancement of Science appointed De Hass the first chairman of a special committee on American archaeology and ethnology. The committee was slated to investigate American earthworks, but the Civil War occasioned its temporary suspension. De Hass himself enlisted with the Union, and, while running a military prison at Alton, Illinois, the antiquarian was introduced to the nearby mounds at Cahokia. After the war, De Hass returned to this region, conducting some of the earliest excavations of the prehistoric mound network. De Hass presented his findings—and musings on the Mound Builder race—at the Association's meeting in Chicago in the summer of 1868. Unbeknown to the antiquarian, however, Hull was elsewhere in the city at the same time, putting the finishing touches on the giant. De Hass later moved to Brooklyn, where he attempted to launch a new archaeological journal. The antiquarian very much was fixated on the professional development of American archaeology. Years later, De Hass offered one of the discipline's first collegiate courses—at Syracuse University—while also heading the Division of Mound Exploration for the new Bureau of Ethnology. Still, De Hass's singular focus on the Mound Builder race ultimately occasioned his professional downfall. When De Hass strayed from his administrative plan to focus on the Grave Creek mound and amass material for a planned manifesto on the Mound Builders, Director John Wesley Powell had little recourse but to dismiss De Hass, replacing him with Cyrus Thomas, the man who ultimately would overturn the Mound Builder myth.[23]

Given his fervent belief in the Grave Creek stone, De Hass may well have hastened his visit to Cardiff after learning of a second discovery. On Monday, October 25, the *Journal* reported that a young boy discovered an ancient coin in the vicinity of the giant's pit. The artifact bore the date of 1091 and featured the inscription "JESTYN AP GURGAN, TYWYSOG MORGANWG," which one local Welshman translated as "Jestyn, son of Gurgan, Prince of Glanmorgan." As the coin received no further press, it must have been an obvious fake, though the perpetrator never revealed whether he meant to tweak wild theorists or advance an ancestral agenda. Within a few days, De Hass arrived at Cardiff, bypassing the coin altogether and conducting an examination of the giant. The antiquarian subsequently presented a lecture on the subject at Shakespeare Hall in Syracuse. From the outset, De Hass acknowledged the giant's grandeur, invoking the Bible for effect: "We

approach the giant with awe and trembling. He is verily a Leviathan in human form, and if Goliah or Og resembled him in stature, or presented such huge proportions, no wonder that he spread terror in his path." De Hass made the standard case against petrifaction, citing the rapid decay of human and animal flesh: "Petrifaction is a slow process; putrefaction a rapid one!" After discussing the statue's artistic qualities, De Hass proceeded to consider its possible origins. The antiquarian denied any connection with the Mound Builder race, reporting that the American earthworks bore nothing of the giant's size, character, and workmanship. As De Hass stated flatly: "It has no counterpart in all the range of American archaeology." In contrast to Boynton, De Hass acknowledged that tool marks might well reveal the giant's age, but claimed that surface erosion precluded any such analysis. On this count, the antiquarian was off base, for sculptors later would note obvious indications of modern tools. De Hass speculated as to some possible sources of the statue: "May not a wandering sculptor have penetrated the valley of the Onondaga or a wave of more advanced civilization settled here in pre-historic times?" Still, in the end, the archaeologist conservatively assigned two centuries' age to the giant—"A safe hypothesis may assign it an antiquity dating back to the earliest historic period in the lake country of North America"—but was much more firm in declaring that the statue was no modern fraud.[24]

Of all the antiquarians who examined the giant, Lemuel Olmstead offered perhaps the most evocative—and quotable—assessment. A former chemistry professor at Dickinson College, Olmstead owned a formidable personal cabinet of American antiquities and arrived in Cardiff at the personal invitation of Amos Westcott, one of the giant's new owners. After examining the great wonder, Olmstead outlined his observations in a letter to the *Albany Evening Journal*. While expressing his doubt that the giant truly was ancient, Olmstead nevertheless fired the imagination of supporters by comparing the statue to works of European civilizations: "As a work of Art, the Cardiff statue is perhaps a better embodiment of the intellectual and physical power of a rock-hurling and mountain-piling old Titan, than Italy possesses." The *New York Commercial Advertiser* and *Daily Cleveland Herald* circulated Olmstead's memorable assessment, while the *New York Daily Tribune* later cited it as one of the more embarrassing expert opinions on the giant.[25]

Even before this point, Hall sensed that the archaeological community might not provide definitive judgment on the giant's origins after all. Already under intense pressure to give his own opinion on the statue's source, Hall ultimately relented and offered his personal speculation in a published letter to Westcott. Stepping outside his realm of expertise, the geologist once again hailed the giant's import, while this time directly linking it to an early civilization whose attainments surpassed even the Mound Builders:

It is certainly a great curiosity, and as it now presents itself, the most remark-able archaeological discovery ever made in the country, and entirely unlike any other relics of a past age yet known to us. . . . The importance of the object lies in its relation to the race or people of the past formerly inhabiting that part of the country. The statue is of far higher order, and of entirely different character from the smaller works of rude sculpture found in Mexico and Central America, or in the Mississippi Valley.[26]

Even though Hall, Ward, and others characterized the great wonder as a monumental archaeological discovery, petrifactionists attacked these men for denying the truth of their position. School superintendent S. B. Howe took occasion to correct Hall in a letter to the *Schenectady Union*: "I notice a remark attributed to Prof. Hall, of Albany, that no flesh was ever petrified. The Professor is mistaken." To wit, Howe recounted how he had handled his grandfather's petrified corpse during a reinterment ceremony, and, indeed, the cadaver had grown so heavy by way of its transformation that several men were required to lift it. In a letter to the *Standard* titled "PROF. WARD QUIZZED," "J" proved far more critical. This writer questioned the basic soundness of Ward's antipetrifaction logic: "A course of reasoning, which is as follows:—1st, There are strata in this figure; 2d, organic remains do not petrify in strata; 3d, organic remains do not petrify at all, therefore this is not a petrifaction—is certainly not a very satisfactory chain of argument to convince an enquiring mind." At the same time, "J" took exception to the fact that the naturalist had not handled the giant, implying that touching—even more so than seeing—might have yielded believing:

He says that he had only fifteen minutes to examine the figure, and was then not allowed to handle it; yet he pronounces it made of gypseous [sic] limestone of the Onondaga group. Now such is the superiority of science over practical experience. Our quarrymen who have worked in our native stone, both limestone and gypsum, for years, declare that they have never seen any such material here.

"M" took a more broad view in defending petrifaction, invoking the possibilities of science against Hall, Ward, and others. Culling material from James Dwight Dana's *Manual of Geology*, the writer contextualized his own vague petrifaction-producing substitution within a specific scientific vocabulary:

Dana and other Geologists say that impressions of the soft parts of animals have been found in the rocks, but they are very rare: but will any one say that under favorable circumstances a fossil man cannot be formed, his corpse forming the mould or pattern, just as we see thousands of plants, trunks of trees, shells, insects, fish, and other objects, which were once imbedded in the

rocks, and have been altered, by the spaces they occupied having been filled with carbonate of lime, quartz, sand, oxide, or sulphuret of iron, carbonate of magnesia, and why not sulphate of lime or Onondaga gypsum? The only condition necessary in the case of a human or other animal body is, that the material to be substituted be supplied as rapidly as the animal matter decays. Geology is quite a new science. It depends on observation, and all that it teaches us is that a Fossil Giant never was discovered until William C. Newell dug his well at Cardiff.[27]

Hall and Ward even faced objections from within the scientific community, specifically from physicians and anatomists. As medical men, these scientists had familiarity with the decay of flesh, but also likely acquired some knowledge of geology and natural history over the course of their broad scientific training. Like ordinary citizens, these men fell prey to the possibilities of science, but, more critically, possessed even more of a quasi-scientific vocabulary to make petrifaction sound plausible. In a letter to the *Norwich Bulletin*, S. B. Bulkley explained how the giant had petrified: "The upper portions of the body . . . are waterworn, and thus partially polished, disclosing the bluish gray limestone cropping up through the yellowish white incrustation of carbonate of lime, with which the body was, at one time, evidently entirely covered. The conclusion is inevitable that at a former period the creek ran along by a low bank, and gradually covered the body with alluvial deposits." Along the same lines, Ashbil Searle, an Onondaga physician, confidently—yet vaguely—identified water and oils as the catalysts of the transformation: "It must be the petrifaction of a human body, being constantly exposed to the contact of water, and a wet alluvial oil, the molecule,—the primary particles of which the body is composed, or the more mature muscles, tendons, ligaments, cartilages, and bones, sooner turned to petrifaction than to putrifaction. There the gasification of the body is intercepted." In a letter to *Scientific American*, George Stone, an appropriately named physician from Warren, Pennsylvania, dismissed the statements of Hall and Woolworth with regard to petrifaction: "Now, Messrs. Editors, the above-named gentlemen may be men of science, in their way; they ought to be, occupying the places they do; but it is plain they are not anatomists, or they would never make the above statement." Stone asserted rather plainly that anatomists represented the best judges of the scientific phenomenon: "One good anatomist is a better judge of the nature of the curiosity in question than a thousand State geologists or Regents of the University." Still, rather than advance a scientific argument in favor of petrifaction, Stone simply cited "well-authenticated" cases in New York, not to mention a petrified human heart that he claimed to have in his possession.[28]

Though belittling Hall and others for denying their beliefs, petrifaction-
ists soon would regard the opinions of scientists much differently. Indeed,
as rumors of fraud began to swirl around the giant, these men and women
cited the romantic musings of scientists in support of the great wonder's
antiquity, amplifying their shortcomings while also setting the stage for
future embarrassment.

* * *

Of course, no man reveled more in weighty pronouncements about the giant
than George Hull. For the most part, the giant maker lurked in the shadows
during this period, offering no blow-by-blow assessments of the popular re-
ception. While occasionally citing his debate with Henry Turk and his origi-
nal plan to undermine religion, Hull, in later years, generally downplayed
the religious aspects of the scheme. On one occasion, a reporter listened
to Hull recount the giant's story at a Binghamton hotel lounge, noting his
stated motivation "to amaze and perplex people in general, but to delight
the antiquarians who found in it an argument to uphold some of their most
cherished theories." Though he did cite the musings of Hall and Boynton,
Hull undoubtedly meant "antiquarians" in the broadest sense of the term,
referencing both scientists as well as ordinary citizens with exotic notions of
the past. If anything, Hull recast his original religious motivations to reflect
the giant's actual reception, appearing savvy in retrospect. Hull's revisionist
history represented still more romantic reimaging of the past, though, in this
case, the giant maker looked no further than himself.[29]

CHAPTER SEVEN

~

Ugly Questions

While most Americans judged the giant a petrifaction or an ancient statue, a small minority regarded the great wonder as a modern fraud. Many of these skeptics simply found the giant guilty by association, the latest in a long line of dubious sensations to emerge from central New York or perhaps a humbug after the fashion of P. T. Barnum. Others based their suspicion of imposture on more tangible evidence, namely the mysterious man and ironbound box seen making their way to Cardiff a year earlier. The best case against the giant, however, stemmed from the actions of Stub Newell and George Hull, who, by the second week after the discovery, nearly gave away their scheme with a series of high-profile blunders.

While religious fervor remained high in 1869, the revivalism of the Second Great Awakening largely had run its course, and Americans accordingly gained perspective on the legacy of the Burned-over District. On one hand, Spiritualism remained an immensely popular domestic religion. The movement boasted several thousand local chapters in the United States alone, and one contemporary magazine placed the overall number of believers in the hundreds of thousands. At the same time, however, Americans generally regarded central New York's other religious movements as great disappointments, if not outright frauds. By this point, Mormon pioneers succeeded in establishing a thriving religious community in the Utah Territory, with Salt Lake City already representing one of the fastest-growing cities in the west. Still, mainstream Americans rejected the foundations of Mormonism as well as the movement's embrace of polygamy. Essayist Ezra Champion Seaman

offered a damning assessment typical for its day: "Mormonism is the grossest, foulest, and most corrupting imposture which has been successfully imposed upon any people, since the age of Mahomet." Along the same lines, the religious perfectionists of the Oneida Community, which boasted roughly three hundred members in October 1869, sparked widespread criticism by abolishing marriage and commencing the practice of free love. One prominent critic denounced the so-called "ethics of the barnyard," and, indeed, angry citizens soon would demand prosecution of the community's sinful activities. Finally, editors of the contemporary volume *Lives of Celebrated Americans* cast William Miller's earlier doomsday movement as an exercise in mass delusion: "In all ages of the world credulity has produced strange shapes in society. The most absurd notions, honestly entertained by deluded persons, or artfully promulgated by wicked impostors, for personal benefit, have found ardent supporters, fired with martyr zeal, especially when the dogma was arrayed in the mysterious garb of a religious necessity . . . In our day, the peculiar doctrines concerning the second personal appearance of Jesus upon earth, known as *Millerism*, have had a more wide-spread and disastrous influence than any other, except that of the wicked and obscene system of Mormonism."[1]

Even beyond the dubious religious sensations borne of the region, western New York's reputation suffered still further from a high-profile hoax that highlighted scientific credulity. For the first half of the century, Silver Lake, situated outside of Buffalo, enjoyed a reputation as a prominent resort town. By the 1850s, however, tourism declined dramatically, and Artemus Walker, a local hotel proprietor, quietly resolved to raise Silver Lake's profile with a newsworthy sensation. In 1855, Walker crafted a large snake from canvas and wire, and, during evening hours that summer, loosed the makeshift serpent upon the lake, controlling it by way of a lengthy rope. The lake monster terrified local residents, but, at the same time, piqued their curiosity. Citizens joined vigilance societies and erected watchtowers to keep tabs on the creature, while local businessmen endowed an experiment company to devise tools for its capture. As word of the Silver Lake monster reached the newspapers, curiosity seekers descended upon the resort town to catch a glimpse of the celebrated creature. With demand for lodging reaching unprecedented levels, local inns and hotels were forced to utilize waiting lists, while enterprising residents converted their homes into boarding houses to accommodate visitors. For two summers, the homemade snake evaded capture, but eventually the fraud became manifest. Some accounts had Walker blurting out the truth in a fit of anger, while other sources reported that residents had discovered the hotel proprietor's contraption while putting out a fire at his establishment. The editor of the *The Knickerbocker* scoffed at

the utter lack of sophistication among New York's country folk, remarking sarcastically on how the *Bunkum Flagstaff* had succeeded in spreading excitement for the "Grate Sarpent."[2]

Earlier cases of credulity did engender at least some initial skepticism with regard to the giant, as newspapers inside and outside of central New York acknowledged the region's history of dubious sensations. In the *Standard's* first article on the great wonder, the newspaper's correspondent admitted that initial reports from Cardiff made him think of the Silver Lake affair. Accordingly, this reporter resolved to assess the giant firsthand before giving it any coverage: "The story was a big one, and not liking 'Silver Lake Snaiks,' [sic] we wanted to see before telling our readers." Of course, seeing yielded believing for this correspondent, and his subsequent report was filled with weighty pronouncements of the giant's scientific and historical import. The *New York Herald* likewise tempered its initial coverage of the giant, juxtaposing news reports with at least one cautionary editorial. In this latter piece, owner James Gordon Bennett Jr., or one of his editors, acknowledged the potential significance of the discovery—"If the report is true the discovery is certainly a wonderful thing, as a work of nature or a work of art"—but nevertheless took note of its highly questionable source: "Western New York, however, is famous for wonderful discoveries." To wit, the author reminded readers how Joseph Smith allegedly located golden plates within the hills of Palmyra as well as how enterprising politician Thurlow Weed conveniently identified the corpse of William Morgan just prior to the 1828 elections. In the end, the editorial writer assumed that the giant was akin to such frauds, though the great wonder unquestionably offered more entertainment value: "The petrified giant no doubt belongs to this class of discoveries; but as it is a harmless sensation we hope it may live through the allotted period of a nine days' wonder."[3]

The earlier humbugs of P. T. Barnum likewise hardened skeptics. One correspondent for the *Auburn News*, expressing his doubts as to the giant's legitimacy, remarked that Newell had "out-Barnumed Barnum as a showman." Mark Twain, who earlier that year published his first full-length book, *The Innocents Abroad*, likewise invoked Barnum in a story for the *Buffalo Express*, a newspaper that the writer owned and edited. In "The Capitoline Venus," George Arnold, a struggling American artist in Rome, needs a financial windfall to impress his sweetheart's father. John Smith resolves to help his boyhood friend, and, after mangling one of Arnold's statues, buries it on a nearby tract of land. Six months later, Smith discovers the statue, which the Italian government embraces as a monumental work of antiquity: "Last night [a government commission] decided unanimously that the statue is a Venus,

and the work of some unknown but sublimely gifted artist of the third century before Christ. They consider it the most faultless work of art the world has any knowledge of." The government issues Arnold five million francs in gold, and the artist accordingly wins the respect of his future father-in-law. At the conclusion of the sketch, Twain cautioned readers to regard the Cardiff giant with skepticism, heeding not only the lesson of the fictional Capitoline Venus but also the legacy of America's great showman: "The Capitoline Venus is still in the Capitol at Rome, and is still the most charming and most illustrious work of ancient art the world can boast of. But if ever it shall be your fortune to stand before it and go into the customary ecstasies over it, don't permit this true and secret history of its origin to mar

SAMUEL L CLEMENS
"MARK TWAIN"

Mark Twain. Source: Print Collection, Miriam and Ira D. Wallach Division of Art, Prints and Photographs, The New York Public Library, Astor, Lenox, and Tilden foundations.

your bliss—and when you read about a gigantic Petrified Man being dug up near Syracuse, in the State of New York, or near any other place, keep your own counsel—and if the Barnum that buried him there offers to sell to you at an enormous sum, don't you buy. Send him to the Pope!"[4]

* * *

Beyond the giant's regional and historical context, skeptics found other reasons to doubt the veracity of the great wonder. In a letter to the *Standard*, James R. Lawrence, a Syracuse lawyer, raised a series of commonsense objections to the circumstances of the discovery. On one hand, Lawrence asked the newspaper why Newell required a second well in the vicinity of his barn when his livestock collection consisted of a mere two cows and a horse and when he already possessed a serviceable well closer to his house. At the same time, Lawrence found it highly suspicious that Newell had instructed Henry Nichols and Gideon Emmons to dig exactly four feet deep. Given the pre-

ponderance of underground streams in the vicinity, the two workers would not have needed to dig that deep to find water, unless, as Lawrence alleged, Newell had wanted them to locate something at that depth. After noting how the Cardiff farmer surrounded himself with workmen on the day of the discovery, Lawrence concluded, "Why, I say, all this show and parade, unless to cover up the real object, viz: *finding a treasure?*"[5]

For the most part, however, local skepticism stemmed from the suspicious activities near Cardiff a year earlier. Residents of Onondaga County apparently made this connection as early as the first Monday after the discovery, for, the following day, the *Journal* noted: "The adjacent country is filled with rumors, by which the presence of the statue is attempted to be accounted for." Still, the newspaper quickly dismissed any possibility of imposture, citing Newell's upstanding character: "By these [rumors] it is insinuated that Mr. Newell was in collusion with parties who seek to impose upon and humbug the public. His good character, the circumstances of the discovery, and the evidence open to the public scrutiny, contradict these rumors."[6]

Rumors of fraud undoubtedly would have persisted in their own right, but the arrival of Hull in Cardiff on Wednesday only served to give them further momentum. While Hull admired his handiwork inside the tent, a fellow curiosity seeker took note of his presence. Avery Fellows, the Tully hotel proprietor who earlier provided lodging for Hull and transported him to Cardiff, recognized the latter immediately and concluded that his movements through the valley had been connected to the giant. Fellows approached Hull, who likewise recognized the innkeeper, and the two men made small talk about Hull's travels as well as the great discovery. According to *The Giantmaker*, Fellows's tone made Hull visibly uncomfortable, and, finally, the hotel proprietor confronted the latter, "Did you really do this?" Hull made light of the allegation, admitting that he had fashioned the giant atop Bear Mountain six thousand years earlier and had carried it down to Newell's farm upon his back. Hull promptly excused himself from Fellows, seeking out his partner for a private conversation. Even with the giant's popularity increasing daily, the conversation with Fellows must have spooked Hull sufficiently, for the giant maker at this point established the terms of sale for Newell. Hull quickly beat it out of Cardiff with his family, but, before Newell departed for Syracuse with prospective buyer John Wieting, Fellows cornered the Cardiff farmer, peppering him with similar accusations of imposture. According to *The Giantmaker*, Fellows erroneously assumed that Newell was the mastermind behind the giant, demanding money from him in exchange for his silence, but the Cardiff farmer steadfastly denied any wrongdoing and refused to submit to Fellows's blackmail.[7]

Faced with no other recourse, Fellows, along with his brother, approached the *Journal* the following day. The two men informed the newspaper that Hull had boarded at the Tully Hotel roughly a year earlier and that Avery Fellows had conveyed him in the vicinity of Newell's farm. On this particular occasion, Hull did not return to Tully until the early morning hours. According to the two men, Hull's visit had been especially memorable, not simply for his mysterious nocturnal movements but also for his debates on religion with other boarders. On Friday, the *Journal* summarized the conversation with the two men, but did not specifically name either them or Hull. The newspaper likewise noted that other citizens recalled seeing a large iron-bound box making its way through the valley around the same time, but did not specifically link these reports to the mysterious stranger: "This is as far as [Fellows's] narrative is authenticated; but further, there are statements made to the effect that on the succeeding day a wagon laden with a very large and heavy box was seen on the road in the vicinity of the locality of the recent wonderful discovery. We do not, however, vouch for the latter statement. The whole story possesses interest."[8]

By the time these reports appeared in the Syracuse newspapers, Newell already had agreed to sell the giant to the local syndicate, and the Cardiff farmer formalized the sale shortly thereafter. Still, Newell needed additional time to process the bank notes from the transaction, and so, to buy his partner breathing room, Hull returned to Cardiff on Sunday. On this occasion, the giant maker introduced himself to reporters from the *Courier* and *Standard* as the "mysterious visitor" in question and pledged to set the record straight about his earlier travels through Cardiff. Hull explained that he had been conducting tobacco machinery through the valley and had stopped along the way to visit Newell, whom he identified as a cousin. Though typically an off-putting character, Hull charmed the reporters on this day, laughing with them about all the commotion that he unwittingly had engendered. On Monday, the *Courier* summarized its conversation with Hull—whom the newspaper did not identify by name—and accordingly characterized the fraud rumors as "exploded." While scoffing at how "lies travel faster than horses," the newspaper further dismissed claims of imposture by citing prevailing scientific opinion: "The story of the statue's being any kind of a swindle or humbug, has received its quietus from the authority of some of the most scientific men of the State." Along the same lines, the *Standard* reported that Hull—again not directly named—effectively had exploded the "Tully story of fraud," relating the circumstances of his earlier visit "to the satisfaction of every one." In its afternoon edition, the *Journal* noted the assessments of the *Courier* and *Standard*, but nevertheless called for a formal

statement from the man himself: "There is but one way to meet and allay the popular suspicions, and this is for the making by Mr. Newell's cousin of a full statement of his visit of a year ago."[9]

That same day, the *New York Herald* emerged with completely new allegations of fraud, which the newspaper presented in a series of evocative headlines: "THE PETRIFIED GIANT," "A STUPENDOUS HOAX," and "The Statue Was Made by a Crazy Canadian." The *Herald* reprinted a letter from Syracuse resident Thomas B. Ellis, who stated his intention "to make an *exposé* of the whole transaction." Ellis noted several suspicious circumstances surrounding the giant's discovery, including not only the impractical planned location for Newell's well but also the apparent ease with which workmen discovered the position of the giant's head. Still, Ellis's common-sense objections merely were prelude to his much larger revelation, culled from dying quarryman George Hooker. While working in Onondaga Valley a few years earlier, Hooker made the acquaintance of Jules Geraud, a native of Canada. Ellis characterized Geraud thusly: "Geraud was a monomaniac. His one idea was that he was an artist destined to rival the fame of Michael Angelo. He was taciturn and of retired habits. He inhabited a secluded shanty, and when not at work in the quarries always retired to it. No person was ever invited into his cabin, and people passing it on the Sabbath always heard the mallet and chisel at full play." After his colleague was absent from work for several days in October 1868, Hooker paid a visit to Geraud's shanty, finding the latter sick with a fever. With Geraud refusing to admit a physician, Hooker tended to his colleague himself, but the artist's condition quickly worsened. With his death seemingly imminent, Geraud decided to reveal his "great secret" to Hooker, instructing the latter to pass behind a screen and behold what the artist described as "the most beautiful statue in the world"—his own representation of Saint Paul. Prior to succumbing that night, Geraud swore Hooker not to reveal his secret labors for at least a week after his death. Five days later, however, the shanty burned to the ground under mysterious circumstances, and Hooker could find no trace of Geraud's statue. He subsequently kept the entire matter quiet, with Ellis later noting: "Beside [Hooker's] superstition, which was actively aroused, he dreaded the laughter of his companions if he revealed the discovery." In October 1869, however, Hooker himself lay on his deathbed, and, after hearing reports of the Cardiff giant, resolved to share the story of Geraud with his physician and Ellis, opining: "I have heard the description of the Cardiff giant, and believe it to be the same statue found lying in the cabin of Jules Geraud at Onondaga." Ellis then proceeded to recount the story of Tully's "stranger," intimating that this man had secured Geraud's statue and conducted it to

Newell's farm. As Ellis concluded thusly: "All other attempts at humbugging sink into insignificance by the side of the 'Cardiff Giant.' Richard Adams Locke's moon hoax and [Edgar Allan] Poe's story, 'Hans Phaall,' are simply moonshine when compared to the cool effrontery of this Cardiff hoax."[10]

In a separate editorial that day, Bennett, or again one of his editors, hailed his newspaper's exposé and similarly likened the giant's successful mass deception to the *New York Sun*'s famed literary hoaxes: "We publish elsewhere to-day a complete exposure of a hoax which surpasses in magnitude the moon hoax of Locke and Poe's story of Hans Phaall." The editorial writer once again belittled the residents of western New York, noting that region's propensity for dubious sensations as well as questionable beliefs. While citing the Morgan affair and Mormonism for a second time, he also extended his criticism to the Oneida Community:

> Meanwhile the whole case adds another to the curious and numerous illustrations of the fact that Western New York is, for some unaccountable reason, a permanent hotbed for the growth of all sorts of humbugs. It was in this "burnt district," as it has been designated, that anti-Masonry had its birth and the Morgan mystery originated. Here Joe Smith dug up the miraculous tablets which form the Book of Mormon, and planted the germ of future troubles at Nauvoo and of the strange society which now peoples Salt Lake City and Utah. Here innumerable communities of comeouters, free lovers and followers of every distorted shape of religious belief and unbelief have flourished.

The writer even intimated that western New York merited blame for the Civil War, noting that John Brown had lived there before commencing his murderous campaign against slaveholders: "Here John Brown hailed from when he set forth on his crusade against the 'peculiar institution,' and initiated the war which has so tremendously affected the destinies of this nation." The author concluded his piece with one final salvo against his western brethren: "Western New York is so extraordinary as the source of some of the wildest delusions and vagaries and enthusiasms that have swept over the national mind that it richly deserves the attention which it claims from philosophical students of American history."[11]

The *Courier*, *Standard*, and *Journal* all acknowledged the *Herald*'s coverage the following day, but only the *Courier* took a strong stance. That newspaper affirmed Ellis's trustworthiness as a source, while taking a jab at the giant's new owners: "A writer for the New York Herald gives the following exposure of the whole affair. The writer is well known to us, and his statements can be relied upon. A friend at our elbow says he would like to obtain a photograph of the owners of the statue, taken after reading the following exposure." The

Courier augmented this coverage with interviews of several local residents who recalled seeing the ironbound box en route to Cardiff, with at least one man affirming that he had seen the wagon drivers with the mysterious stranger. The Syracuse newspaper presented these eyewitness accounts as missing links in the *Herald*'s evidentiary chain: "The statue could have laid in concealment since the death of the sculptor, until it was conveyed by the strangers mentioned above in the heavy iron-bound box drawn by four horses to Stub Newell's farm."[12]

That same day, the *New York Daily Tribune* addressed the *Herald*'s report on its own editorial page. Horace Greeley, who himself had dabbled in Spiritualism, admitted his early hope that the giant was legitimate: "We had some hope that the enormous image recently dug up in Onondaga County would help to illuminate some of the dusken problems which involve anthropology." Referencing the *Herald*'s letter from Ellis, however, Greeley acknowledged: "Late developments indicate that we shall get no luster from that source." Rather than taking occasion to criticize western New York or believers more generally, Greeley instead bemoaned how the hoax's early exposure spared scientists from additional embarrassing assessments: "It is almost to be regretted that the history of its origin should have been made known till Science had broken a few more lances against its stony sides." The *Tribune*'s editor accordingly mused upon what might have been: "The rooks of science would have cawed over it till the air was hoarse with their exegetic clamor. Museums would have competed, naturalists wrangled, and showmen fought for its possession." In the end, Greeley called for a return to normalcy, invoking to that end President Grant's familiar campaign slogan: "The best thing the discoverers can do with it is to bury it again and let us have peace."[13]

Around this time, Newell took steps to distribute the sale money to his partners. After signing the contract with syndicate members on Saturday, Newell deposited cash proceeds at the Syracuse Savings Bank. The Cardiff farmer made a second trip to the bank on Tuesday, the same day that the *Courier* connected Hull to the conductors of the ironbound box. At the bank, Newell immediately raised eyebrows by requesting ninety-four hundred dollars in cash. While *The Giantmaker* portrayed the Cardiff farmer as the village idiot who had no familiarity with finance, Newell may simply have been avoiding a paper trail. The teller informed the Cardiff farmer, however, that the bank did not possess adequate reserves, and, furthermore, it would be unsafe for Newell to carry such large amounts on his person. Newell explained that he needed to give the money to another party, and the teller subsequently informed him that a bank transfer could achieve that

end. When the teller asked for the recipient's name and bank, Newell gave him Hull's information. The entire plan was thoroughly ill-conceived. At the height of fraud rumors, Newell had transacted in large amounts with a third party—just the sort of activity that skeptics were seeking. Furthermore, the third party was a name already well familiar to local newspapermen, as it kept arising in conjunction with the giant. Still, Hull desperately needed the money to satisfy creditors, and, if later reports were accurate, the giant maker kept nearly the entire amount for himself, rather than distribute equal shares to fellow partners Henry Martin and Edward Burkhardt.[14]

Reports of Newell's bank transaction surfaced the following day in the Syracuse newspapers, though reaction generally was mixed. The *Journal*, which earlier called for a formal statement from the unnamed stranger, now asked both Hull—this time named—as well as Newell to address the rising allegations of fraud: "It seems to us that Mr. Newell and his cousin from Binghamton, whose name is said to be Hull, can easily account for the latter's visit of a year ago and the character and destination of the machinery which is alleged to have been transported by the four-horse team. Will they?" At the same time, the newspaper, suspecting that Syracuse had a better read on the prospect of imposture, lashed out at the *New York Herald*'s earlier report: "The flimsy and ridiculous hoax perpetrated by the New York *Herald* . . . has been received as a reasonable and authentic revelation of the origin of the wonder, by the leading New York city journals. . . . We cannot see how intelligent journalists, who have had the accounts of the local papers before them for more than a week, together with the letters of Professors Ward and Hall . . . should reject these and accept the silly tale of an anonymous correspondent." While not directly citing Newell's bank transaction, the *Courier* noted the "ugly questions" currently asked about the giant and called upon its new owners to restore faith in the discovery. Rather than acknowledge possible imposture, the *Standard* actually stepped up its defense of the great wonder. The newspaper flatly dismissed the Tully story of fraud, intimating that Hull already had resolved that matter, while also taking residents to task for providing useless affidavits of what they earlier witnessed: "The 'Tully Story' is not new—it is old. But it is being made new by the efforts of a morning paper [*Southern Onondaga*], and sundry affidavit makers, who swear just what is wanted." The *Standard* also questioned the veracity of the *Herald*'s hoax report, noting that its own reporters had interviewed several local quarrymen, none of whom had heard of Geraud. As the *Standard* dryly noted with regard to the lurid deathbed confession: "We expect to hear that the witness, physician, and writer are all dead before this is in print." Finally, the *Standard* cited the lofty pronouncements of John Boynton, Henry A. Ward, and

James Hall in defense of the giant's veracity, even though these same men had dismissed the newspaper's petrifactionist position: "The scientific men—Dr. Boynton, Prof. Ward, Prof. Hall, and others, agree that [the giant] is of great antiquity—not less than two hundred years, perhaps hundreds on top of that. This is certainly proof enough as against the disappointed croakers."[15]

Amid its spirited defense of the giant, the *Standard* accused unnamed local businessmen of conspiring against the great wonder, and the newspaper was correct in this regard. According to *The Giantmaker*, John Wieting, D. Lewis Smith, and Herman Stanton became embittered after failing in their attempt to purchase the great wonder and soon established an antigiant clique in Syracuse. This group ultimately would come to include Ezra Walrath, a former *Courier* editor who operated a real estate and loan business in the city, as well as the newspaper's current publisher D. J. Halsted. These men met regularly at the Syracuse House, a city hotel, and groused generally about the great wonder that they now perceived as a fraud. At the same time, these wealthy men paid ordinary citizens to speak ill of the giant in public places, while supporting investigation of the fraud angle. To this latter end, the clique engaged Wills De Hass, who earlier lectured on the giant at Shakespeare Hall. According to *The Giantmaker*, De Hass's lecture was a failure, and, needing a quick financial boost, the archaeologist suspended belief and agreed to investigate Hull's activities in Binghamton.[16]

After reports of Newell's bank transaction reached the newspapers, the new owners of the giant angrily confronted the Cardiff farmer about rumors of imposture. Newell defended the bank transfer, claiming that he owed Hull for the care of a shared relative in Binghamton, but members of the syndicate were unmoved. As a sign of good faith, Newell made these men an offer. If the new owners succeeded in proving that the giant was a fraud, then the Cardiff farmer pledged to refund all their monies from the original sale. The syndicate members agreed to the arrangement and forced Newell to sign an amendment to the original contract. The parties set January 24, 1870—three months from the syndicate's first full day of ownership—as the deadline for establishing fraud, while likewise defining imposture as the giant's deposition on Newell's farm prior to April 1, 1867—the date that the Cardiff farmer assumed ownership of the land. Though unclear whether Newell acted with Hull's advisement, the Cardiff farmer assumed little practical risk with the deal. On one hand, tort law had not yet broadened to include such concepts as emotional damages or injury to reputation, and thus Newell faced no threat of reprisal in this regard. The law protected parties only up to their original investments, and, at worst, Newell would have to return money that had not belonged to him—and his partners—in

the first place. Even that scenario was unlikely, for caveat emptor—let the buyer beware—certainly seemed to apply to fossil giants, and, furthermore, given the great wonder's continued popularity, it would be only a matter of time before the new owners recouped their purchase money. By no means was Newell a legal scholar, but common sense—and possibly the advice of friends in confidence—served him well.[17]

At this point, the owners of the giant engaged in damage control. Members of the syndicate collected affidavits from those men who were present at the time of the great wonder's discovery, including Henry Nichols, Smith Woodmansee, and John Parker. Even though he had discovered the giant with Nichols, owners did not seek the testimony of Gideon Emmons, possibly because of the latter's reputation as the village drunkard. At the same time, Newell visited the offices of the *Standard* and the *Journal*. The Cardiff farmer defended himself against allegations of imposture, while explaining the fraud proviso to editors of these newspapers. Crucially, however, Newell portrayed the clause as part of the original contract, rather than a response to recent developments, thus emphasizing his integrity from the outset. Newell's efforts—coupled with those of the syndicate members—proved influential, for the tide indeed shifted the following day. The *Standard*, in citing the fraud proviso as proof of Newell's upstanding nature, overstated the legal ramifications that the Cardiff farmer assumed: "In a conversation with Mr. Newell yesterday, he seemed anxious to satisfy all reasonable public enquiries. He has already stipulated in his bill of sale that Saturday, the 16th, was the first he ever saw or knew of the giant; that he had no knowledge whatever of it before that time. This laying him liable in fraud, if not true, ought to be sufficient explanation on his part." The *Standard* likewise trumpeted the forthcoming affidavits, claiming that these documents would "clear away the doubt." Meanwhile, the *Journal* offered its readers similar assurances: "Mr. Newell's bill of sale to the present owners of the statue affirms that the first he knew or saw of it was on the 16th day of October, when it was exhumed on his farm, and that he had no prior knowledge of it. This provision would lay him liable to prosecution for fraud, if the contrary was shown."[18]

On Saturday, October 30, still more storm clouds dissipated, as a local physician confessed to fabricating the Geraud story. This man—who identified himself only as "W"—told the *Courier* that, after tending to a dying stonecutter of French origin, he dreamed up the fanciful tale of Geraud, Hooker, and the giant. Upon returning to his office, "W" shared the story with colleague Elijah Vandewarker, who proposed submitting it to the *New York Herald*, possibly to tweak that newspaper for its bias against western New York: "[The story-telling] suggested the idea that it would be well

enough to reward the enterprise of the New York Herald with a revelation."
Vandewarker assumed the role of Thomas B. Ellis—the combined names of
two prominent Syracuse bankers—and subsequently submitted the letter to
the *Herald*. As "W" explained to the *Courier*: "No one was more surprised
than ourselves" at the success of the literary hoax. Of course, the *Courier*
looked exceedingly bad for earlier affirming the fictional Ellis's trustwor-
thiness, and, at a most auspicious time for Hull and Newell, the Syracuse
newspaper lost credibility as a giant critic. The *Herald* did not acknowledge
the Geraud fiasco in its subsequent report on the giant, and, in fact, the
newspaper's correspondent scoffed at the possibility of imposture: "Please
do not credit the statement that the statue was brought in a wagon and
buried a year ago by the light of a 'dark lantern.' Nobody who has seen the
figure as it lies there in all its majesty believes the yarn."[19]

The *Standard* and *Journal* published a series of affidavits that same day, the
two-week anniversary of the giant's discovery. Nichols, Parker, and Wood-
mansee recounted the circumstances from the morning of Saturday, October
16, affirming no signs of suspicious activity or wrongdoing. Barzilla Coleman,
Billy Houghton, Volney Houghton, Robert Park, and Nathan Park—among
the first to arrive on the scene that day—attested that they saw nothing un-
usual at Newell's farm, save the giant itself. The owners of the great wonder
likewise furnished affidavits from Newell's family and friends—including
wife Lydia, father Daniel, father-in-law William Wright, and nephew Barzilla
Wright—all of whom attested to Newell's upstanding character. In perhaps
the most anticipated affidavit, Newell himself swore that that "*never until the
16th of October had [he] any knowledge or information whatever that said stone
giant or any other image was lying at the place where the same was discovered.*"
The Cardiff farmer, of course, was lying, but assumed little or no risk in doing
so. He did not make the affidavit in conjunction with a court case, and thus
the document was completely extrajudicial, with Newell not making himself
liable to perjury. Again, the Cardiff farmer either was more savvy than his
contemporaries portrayed him, or he received sound advice from someone
like Coleman, his uncle by marriage who had been assisting him with the
Cardiff exhibition and who, as a notary public, would have grasped the legal
distinction. By contrast, Hull refused to make any formal affidavit, with the
owners characterizing his alleged rationale thusly: "The person implicated
in the story about the four-horse team and wagon containing a mysterious
iron-bound box, is Mr. George Hull, a tobacco dealer of Binghamton, whose
testimony could not be obtained at the present time for obvious reasons . . .
The box contained heavy machinery for manufacturing tobacco (which had
been used at Binghamton), and doubtless a quantity of contraband tobacco,

which the owners were desirous of concealing from the scrutiny of officers of the Government."[20]

Both the *Standard* and *Journal* hailed the documents for settling the matter of fraud. The *Standard*, which earlier dismissed affidavits of Tully residents as extrajudicial, failed to make the same distinction for these new statements, with the newspaper informing the public that the affidavits "effectually dispose of the theory of fraud." At the same time, the *Standard* invoked scientific opinion, noting that the weighty assessments of Hall, Ward, and Boynton already should have satisfied doubts: "The opinions of Profs. Hall, Ward and Boynton, as to the impossibility of a recent deposit of the statue, where found, ought to have been satisfactory." The *Journal* similarly hailed the new affidavits, affirming that fraud now was impossible unless all in-volved parties had colluded—clearly, a faulty assumption. Only the *Courier* noted the irrelevance of the new documents in fixing Newell's integrity: "The affidavit is extra judicial, and amounts to no more than would his word upon the subject. In making it, Mr. Newell does not perjure himself." Still, the *Courier* failed to make headway with the masses, in part 'because the newspaper still suffered the effects of the Geraud hoax. At the same time, public attention already was shifting away from rumors of fraud and toward new developments. On November 1, two days after the publication of the affidavits, the *Journal* ran a letter from Samuel Woolworth, the State University regent who earlier visited Cardiff with Hall. After noting that "[his] belief in regard to the statue has not wavered since the day [he] looked on it," Woolworth proposed to Amos Westcott a group examination of prominent scientists and learned citizens, with possible visitors including Hall, sculptor Erastus Palmer, Judge George William Clinton of Buffalo, ethnologist Lewis Henry Morgan, and State University Chancellor John Van Schaick Lansing Pruyn. Westcott not only agreed to the planned examination, but, as the *Journal* reported, the giant's owner sent out his own personal invitations to Ward, Boynton, Andrew White, as well as Rochester University President Martin Brewer Anderson. As the *Standard* mused: "It has proved more than a nine days' wonder, for to-day the Cardiff Giant is just beginning to attract the attention of men of science and wise men all over the country; and they are coming here to see for themselves."[21]

Despite having successfully evaded exposure, Hull and Newell neverthe-less took stock of the future at this point and decided it best to cash out. Accordingly, Newell shopped the quarter share that he held publicly on behalf of his silent partners, doing so quietly, for fear that a public sale might rekindle suspicion of imposture. Newell ultimately found an interested party in Alfred Higgins, the syndicate leader and old acquaintance who purchased

a quarter interest back on October 23. Higgins must have considered the giant a worthy investment regardless of legitimacy, for he sounded no alarms regarding Newell's actions. The two men discussed terms of sale, but never did succeed in consummating a deal. It must have been a trying time for Hull, Newell, Martin, and Burkhardt, for, even though in principle they all continued to reap their share of the box-office bonanza, the proceeds from the original sale remained subject to the new fraud proviso. These men would need to keep America believing in the giant through January 24, the deadline for establishing imposture, for then and only then would they realize their full payday. From the vantage point of early November, with crowds increasing daily and with the syndicate poised to take the giant on the road, America seemed only too willing to comply.[22]

CHAPTER EIGHT

~

The Conquering Hero

Not long after acquiring the giant, members of the syndicate began making plans for its removal from Cardiff. In part, the decision was borne of necessity. Winter was looming in the valley, and the weather fast was becoming inhospitable. The grounds at Stub Newell's farm had turned frosty, and, fearing that the elements would wreak havoc on their prize investment, the new owners looked to move the giant indoors. At the same time, however, these men had a new business plan to enact. To date, curiosity seekers had been traveling vast and inconvenient distances to see the giant at its remote country outpost. The syndicate members instead envisioned taking the giant to them, first touring the great cities of the Northeast—New York City, Boston, Philadelphia—then heading south and west to New Orleans, Chicago, and San Francisco. The railroads would allow them to exhibit the great wonder in metropolitan markets all over the country—as well as every stop in between—and even Europe and the Far East eventually might beckon. Still, for all the exotic and faraway destinations planned for the giant, the owners settled first on Syracuse, the so-called City of Salt. It was, after all, their civic duty.

Though no Empire City, Syracuse nevertheless represented a significant market. The city experienced rapid growth during the antebellum years, and, by 1869, it was the twenty-ninth-largest city in the United States, boasting forty-three thousand inhabitants. Among cities in New York, Syracuse ranked seventh in population, trailing only New York City, Brooklyn (not yet consolidated into Greater New York), Buffalo, Albany, Rochester, and

Troy. The emergence of Syracuse was noteworthy, especially in light of one historian's claim that "no city in the United States was founded in such a dismal spot." During geological times, Onondaga Creek formed marshy lowlands along Onondaga Lake and the central portion of present-day Syracuse. The environment inhibited the growth of trees, and only shrubbery and saplings took root within the impenetrable swamp. The Onondaga Indians bypassed the grim area altogether, settling further south in the more hospitable climes of present-day LaFayette and Pompey, and early white pioneers followed suit. By the dawn of the nineteenth century, frogs represented the primary residents of present-day Syracuse. A few miles north, however, a different story unfolded. After the conclusion of the Revolutionary War, white settlers commenced the manufacture of salt at Onondaga Lake. Beyond its flavoring, salt held critical importance in daily life, as men and women used the mineral to cure and preserve meats and fish. With workers mining deposits from deep within the earth, the manufacturing of salt generally was a dangerous, time-consuming, and expensive venture, though, at Onondaga Lake, the process proved much easier. Native springs naturally brought salt to the lake's surface, and manufacturers needed only boil the water to extract the mineral. State legislators early recognized the lake's vast economic potential and accordingly secured its rights from the Onondaga Indians in 1795. Within two years, surveyors cleared and plotted the lake's uplands, and a new village—appropriately named Salina—was born.[1]

Over the next two decades, Salina thrived as a salt-producing center, while the lands further south generally remained untouched. During this period, however, forward-thinking politicians forged ahead with a plan for a statewide canal to connect the Hudson River with Lake Erie. The project would represent an unprecedented feat of manpower and engineering—digging a massive ditch across 350 miles of varied terrain—but the prospect of connecting New York City to the Great Lakes and interior trade routes proved tantalizing. In 1808, Joshua Forman, an assemblyman from Onondaga County, proposed a survey to review potential routes, and the legislature subsequently appointed James Geddes, another Onondaga resident, to lead the effort. Both Geddes and Forman ultimately lobbied for an interior route that would take the canal through their county, but, rather than passing through Salina, the two men proposed to run the channel through Onondaga Lake's marshy lowlands, where construction would prove less taxing and where Forman owned significant tracts of land. Legislators approved the plan, and construction began in earnest during the second decade of the nineteenth century. Forman, who envisioned that a prosperous city would emerge along the canal's route, promptly incorporated the new village of Corinth, a nod

to the Greek city where ancients once attempted a man-made channel. Federal postal authorities, however, rejected the name, citing its current use elsewhere within the United States. A subsequent meeting of early settlers brought forth a new appellation: Syracuse. The name was fitting, for the Syracuse of Sicily not only possessed native salt springs, but also boasted a village named Salina to its north. In 1820, the New York legislature officially recognized the new village, and, that same year, engineers completed the stretch of canal between Utica and Syracuse.

The Erie Canal eventually opened for business in 1825, and the waterway dramatically transformed American commerce. The canal offered cheap and efficient means for shipping grain and other agricultural products through the East and Midwest, while consumers benefited from correspondingly lower prices. Farming became increasingly profitable in Ohio, Michigan, Indiana, and Illinois, and great new cities emerged along the Great Lakes, including Cleveland, Detroit, and Chicago. In New York, the Empire City surpassed Boston as the nation's preeminent port, while Buffalo and Rochester emerged as key points of domestic trade and production. At the same time, just as Forman predicted, the canal transformed the village of Syracuse. Hotels, shops, and factories emerged along the waterway, while salt manufacturers and farmers enjoyed ready access to a massive trade network. Engineers completed a ditching project to drain the nearby swamp, and the newly hospitable village promptly drew settlers at an exponential rate. While only 250 people inhabited the village in 1820, that number increased to twenty five hundred a decade later, and, by 1850, Syracuse boasted a population of more than twenty-two thousand. The arrival of the railroads, beginning with the Auburn & Syracuse in 1839, cemented Syracuse's role as a transportation and business hub for central New York, and, in a clear sign of the village's emergence, Syracuse subsumed Salina in 1848, roughly assuming its modern metropolitan scope.

The progress of Syracuse, however, stalled during the 1860s. As it did in many other Northern cities, the end of war brought about an economic downturn. Still, emerging competition within the salt industry represented the primary cause of Syracuse's recession. In the early years of that decade, Michigan emerged as a major producer of the mineral, while foreign manufacturers likewise penetrated domestic markets. Spurred by advances in mining technology, a booming rock salt industry also was emerging in the western part of the state, while, by contrast, manufacturers in the City of Salt did not even know the location of their native beds. Proud Syracusans suffered the indignity of watching rival salt pass through the city on the canal, and, toward the end of the decade, the Onondaga Salt Company reluctantly

began negotiations to merge with Michigan's Saginaw and Bay Salt Company. Indeed, by 1869, it seemed that the so-called City of Salt was confronted with something of an identity crisis.

In the wake of the giant's discovery, at least one rival city wondered whether the great wonder was a calculated maneuver to boost Syracuse's sagging economy. As the *Troy Times* observed: "Immense salt deposits were discovered in Canada recently, and Syracuse feared that its salt had lost a part of its value, prospectively, if not in savor. Therefore it was found necessary to start a new sensation." Such charges, of course, were baseless, though the giant did bolster Syracuse's businesses and industries, even while lodged in Cardiff. The majority of foreign curiosity seekers passed through the city en route to Newell's farm, utilizing its railroads, stages, and omnibuses, while also patronizing its shops, restaurants, saloons, and hotels. Local retailers capitalized on intense public interest by referencing the giant in newspaper advertisements, hoping not only to catch wandering eyes but also to align their businesses with the ever-popular wonder:

> The last sensation is the discovery of the mammouth [sic] 'What is it,' in the valley of the 'Onondagas.' Some say that the monster which has been exhumed and is now on exhibition at a half a dollar per head, is a petrified man of huge proportions. Others say it is a piece of statuary, while many believe it is to be only the remains of a figure seen in front of tobacco and cigar stores. There is no doubt, however, in regard to what the people see in the great Dry Goods House of Milton S. Price . . . Go and see the great sensation at PRICE'S.

> The very latest discovery in connection with the all absorbing topic of conversation, the Cardiff Giant is one of the identical shoes and gloves worn by his majesty long before the flood. (We mean the flood in which Noah's Ark figured so extensively.) They are now on exhibition at the Syracuse Boot and Shoe Store, No. 3 Wieting Block. There are at present a large number employed in search of the trunk and satchel that his wife used to travel with and which we hope soon to have on exhibition. Admission free.

> THE ONONDAGA GIANT!—Although Professor Hall has not made known his opinion in regard to the Stone Man, many scientific men have examined the *Baltimore Oysters*, kept by Roberts, and pronounce them *equal in size* and as much of a wonder as the Giant. They are on exhibition daily (*Sundays excepted*) at the corner of the Myers Block.

Other businesses devised still more exotic means of attracting curiosity seekers. On October 29, the *Courier* reported: "Alex D. Behan has on exhibition at his saloon a very correct likeness of the Cardiff Giant. The painting is in

oil and is just the size of the Giant. Those who have not seen the Giant can form a good opinion of it by seeing this painting." The giant's impact on the Syracuse economy compared favorably—if not entirely outpaced—earlier sensations. While the imprint of P. T. Barnum's humbugs prove difficult to discern because of his museum's constant presence in New York City life, the giant's broad and intense impact upon the Syracuse economy mirrored the transformative effect of the Silver Lake serpent. The giant's magnitude, of course, was greater, a function not only of its wider social resonance but also Syracuse's size and accessibility.[2]

Despite the fact that the giant had been borne of Cardiff, Syracuse citizens by and large regarded the great wonder as their own. After all, Syracuse represented the closest city to Cardiff, and it was the seat of Onondaga County. The giant early became a touchstone of civic pride in Syracuse. On October 21, the *New York Commercial Advertiser* noted the effect of the great wonder on the larger city ego. Writing with reference to Buffalo's grain economy as well as Rochester's rare *Agave americana* plant, which blooms only once a century, the *Advertiser* observed: "The Syracuse people hold their heads higher than ever now that their ancestors are found to be so imposing. The conceit of the century plant is quite taken out of Rochester, and Buffalo no longer boasts of its grain elevators." From the outset, Syracusans lobbied the owners to bring the great wonder to Syracuse, and, in the first week of November, these men finally granted them their wish.[3]

* * *

The giant's final days in Cardiff indeed proved noteworthy. The planned group examination of the great wonder took place on Wednesday, November 3. Not all of the invited dignitaries made the trip to Cardiff, among them Louis Agassiz, ethnologist Lewis Henry Morgan, as well as sculptor Erastus Palmer. Still, the great wonder attracted a cross-section of scientists and prominent New Yorkers. James Hall, Henry A. Ward, John Boynton, as well as several area surgeons all were present, as were Andrew White, State University Chancellor John Van Schaick Lansing Pruyn, regent Samuel B. Woolworth, Judge George William Clinton of Buffalo, Judge Alexander S. Johnson of the New York Court of Appeals, former Syracuse mayor Elias Leavenworth, along with city ministers Rev. Sherman Canfield and Rev. George Morgan Hills. The group ultimately arrived at no definitive conclusion, but the prevailing sentiment remained that the giant was a legitimate archaeological wonder. As the *Journal* reported: "For the present, it must suffice for us to know that the charges of imposition were utterly rejected by

the investigators; that the statue is of gypsum, the exact character of which is to be compared with the gypsum deposits of the vicinity; that it is a remarkable work of art, without the known counterpart in the world, and that the wonder and marvel of the scientific visitors were increased the further their examinations were prosecuted." In fact, the *Courier* quoted White—who later claimed never to have wavered in his skepticism—as saying: "My notion formerly has been the humbug theory, but I must confess that belief has been very much shaken!" Still, at least one newspaper grew weary of all the sound and fury emanating from the expert community without any definitive judgment on the giant's origin. Shortly after the examination, Tully's *Southern Onondaga* satirically published the twin headlines "Scientific" and "Official Report of the Recent Scientific Examination of the Stone Giant." A blank column followed.[4]

The general election also coincided with the giant's final days in Cardiff. While the national political landscape changed little as a result of the November vote, primarily because it was not a Congressional election year, the states did register shifts within public opinion. While Republicans maintained control of Massachusetts, Democrats made key gains in Maryland as well as in New York. In the Empire State, Democrats won control of the legislature, and, already possessing the governorship and the New York City mayoralty, the party thus gained ascendancy within state politics. The *New York Herald* hailed the political triumph of Democrats in New York and beyond as the "most important political victory they have achieved since the election of [President James] Buchanan in 1856." According to the newspaper, the election confirmed that Democrats were "in harmony with the sentiment of the country," but also manifested the public's disaffection with "the issues of the war" and the "dead past" that Republicans continually invoked.[5]

Significantly, New Yorkers rejected the opportunity to remove voting restrictions on black citizens. While many Northerners supported Negro suffrage on the grounds that it might hasten Reconstruction's end, New Yorkers refused to make any practical concessions on the matter. Prior to the election, the *Brooklyn Eagle* correctly predicted that citizens would oppose the measure on racial grounds: "Thus doubly the question, are you willing to declare by your vote that you are exactly and precisely the equivalent of a negro, neither more nor less? is presented to the voters of this State. There cannot be much doubt of the result. The vast majority of the people will vote down the negro property qualification requirement, and by electing Democratic Senators and Assemblymen will vote down the Fifteenth U.S. Constitutional Amendment also." In the November election, New Yorkers indeed rebuffed the Negro suffrage measure by a margin of 282,403 votes to

249,802. The *Herald*, which earlier hailed the Fifteenth Amendment as the final act of Reconstruction, charged Democrats with restoring America's attention to both the present and the future: "In this view of the revolution accomplished, and the new epoch about to open in our political history, we call again upon the Sachems of Tammany Hall to look about them and shape their programme to the new order of things, including the nigger and the South, and for the campaign, not of 1860, but of 1872."[6]

In invoking Tammany Hall, the New York City political machine, the *Herald* pointed to the November election's other notable legacy: the consolidation of political power in William M. Tweed. Tweed had been a force in New York City politics for more than a decade, using his position on supervisory boards to establish cronies within key city posts. During the early years of war, Tweed directed Tammany's general committee and thus effectively controlled all Democratic nominations within New York City, including judges on the state's Supreme Court. Tweed gained election to the state senate in 1867, and, in the following year's election, engineered Democratic gains within the legislature. Colleagues at Tammany responded in kind by appointing him Grand Sachem, ruler of New York City Democracy. Over the course of 1869, Tweed reaped the spoils of his newfound power, steering the Erie Classification Act through the legislature to benefit corrupt railroad owners Jim Fisk and Jay Gould, all the while securing himself bribe money and a lucrative company directorship. With Democrats having gained control of the legislature, Tweed now presided over a much more powerful statewide machine, and Washington seemingly lay on the horizon. With reference to Governor John Thompson Hoffman, a Tweed ally, the *Herald* observed: "Tammany has her eye upon the next Presidential contest, and she has her candidate in the foreground. From and after the first of January the eyes of New York, and even of Delaware, will be upon the Wigwam and upon Governor Hoffman at Albany."[7]

The giant emerged within various contexts of election coverage. Albeit humorously, the *Troy Times* invoked the great wonder while hailing the overall Democratic victory. The newspaper linked the giant to the Hard-Shells, an antebellum faction of traditionalist Democrats: "There can be no doubt about it at all, and we refer to Prof. Hall as our authority—the stone giant is nothing more or less than the Great Founder of the Hard-Shell Democracy!" Reports likewise surfaced that Democrats of Onondaga County had cast votes for the giant in state and local elections. Desperate for political capital in the wake of the election, the *Rochester Democrat*, a Republican organ, cited the behavior as befitting uncritical Democrats: "This was perfectly appropriate with the practices and traditions of that amiable faction, who heretofore

have guiltlessly voted the ticket, 'Jackson straight.'" As a bastion of Republicanism, Onondaga County resisted the larger Democratic groundswell, but Syracuse, in particular, rejected Negro suffrage. Observers, however, did note unusual voting patterns. In Syracuse, voter turnout decreased by a staggering 25 percent from the previous election. The *New York Herald*, in noting how Republicans and Democrats alike in Onondaga County voted for a judicial reform measure, attributed this odd behavior to the giant: "Very few votes are cast against the [Judiciary Article] in Onondaga county, where the majority for it is eleven thousand, both parties voting for it almost *en masse*. So much for the gypsum giant." The *Journal* later objected to the allegation, asserting: "The New York Herald thinks the all but unanimous vote for the Judiciary Article in Onondaga County was owing to the gypsum giant. What next will be laid to the giant's account?" Still, the *New York Commercial Advertiser* observed how the great wonder entirely superseded the recent election in Onondaga County newspapers: "The papers cut down the returns and crowd their columns with speculations and views about the statue which still lies on its side in the mud, where it was first discovered."[8]

The great wonder did not remain in the earth much longer, however, as owners established Friday, November 5, as the date of its removal from Cardiff. Around eight o'clock that morning, a large delegation arrived at Newell's farm from Syracuse. Along with the owners, members of the press made the trip from the city, as did Boynton, Woolworth, and Hall, with the state geologist slated to provide scientific oversight on this day. Calvin O. Gott, who operated a studio in Syracuse, likewise arrived in Cardiff, as the owners had engaged the Canadian immigrant to take what would be the first official photographs of the giant. Finally, the group included the men tasked with raising the great wonder from its grave: J. E. Sweet and A. A. Sweet of the steel-making firm of Sweet, Barnes, & Co. as well as Christopher C. Bradley Jr. of C. C. Bradley & Sons, which manufactured mowing and reaping machines.[9]

Upon his arrival, Gott snapped several photographs of the largely empty farm as well as members of the Syracuse delegation milling outside the exhibition area. Newell and several workmen then proceeded to take down the tent, exposing the great wonder to the light of day for the first time in weeks. The giant's imminent departure legitimately saddened the Cardiff farmer, who had grown accustomed to his newfound celebrity. As *The Giantmaker* reported:

> Newell moved among them distraught and uncomfortable: it was no slight thing to sever from him the object which had given him fame and celebrity,

and to bear away to an unknown destiny this rare and precious product of his heretofore unprofitable farm. It was not strange that he shed a tear or two, but a visit to a bureau drawer in the house and a glance at certain notes, which [stood to represent] a value of $20,000, speedily soothed his agitated nerves.

Shortly after composing himself and helping the men to remove the exhibition railing, Newell posed for several photographs with his extended family. Meanwhile, despite prior announcements that the exhibition would be closed, more than five hundred curiosity seekers descended upon the farm, eager to watch the raising of the giant.[10]

The work commenced promptly at nine o'clock. After roping off the area surrounding the pit, Sweet and Bradley's men enlarged the northeast bank, and, in so doing, exposed more of the roots that originally extended over the giant. Even though the great wonder's position relative to the limbs had been well established by this point, *The Giantmaker* reported that members of the crowd nevertheless buzzed upon seeing the commonsense indicator of the giant's significant age. Even at this late stage, George Hull's improvisation continued to pay dividends. Once the men finished enlarging the cavity, Gott requested a few moments, staging a stereoscopic view of the giant, while also taking close snapshots of its surface for scientific scrutiny. The workers dug further around the giant's legs, and, with a large trench emerging, Gott positioned Henry Nichols directly alongside the great wonder, capturing the original discoverer as he leaned upon his shovel. In a nice bit of symmetry with the original deposition, the workers then constructed a derrick over the pit, triangulating three poles and establishing a pulley system. Using a thick iron chain, the men suspended a large beam directly over the giant, and, with an inch-and-a-quarter-thick rope, secured the great wonder to the dangling beam. Recalling the tense mood as workers made their final preparations, one amateur rhymester mused:

Take him up tenderly,
Move him with care,
Doing no harm,
For he's worth more to-day,
Than Stub Newell's farm.[11]

At half past eleven, the men began turning the pulley's wheel, slowly raising the giant from the earth. As the great wonder passed above ground level, Hall and several of the owners clamored into the pit to inspect it from below, seemingly oblivious to the fact that a ton and a half of gypsum dangled overhead. After raising the great wonder to a height of four and a

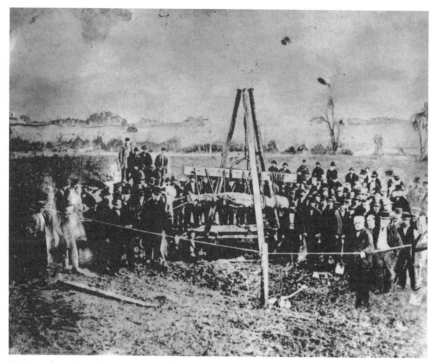

Raising the giant from the grounds of Stub Newell's farm, November 5, 1869. Source: Courtesy of the New York State Historical Association Library, Cooperstown, New York.

half feet, the workers locked the pulley system and allowed Gott to stage another photograph. The latter stationed several key figures within the ropes and pit, among them Hall, Woolworth, Boynton, the owners, the original discoverers, as well as Newell and his extended family. Gott then positioned members of the press and workmen behind the giant. With the eastern wall of the valley serving as his backdrop, Gott snapped one of the more enduring images of the giant and its locale. An artistic rendering of the photograph, along with several others from this day, later appeared in *Harper's Weekly*, the nation's preeminent news and literary journal. The caption for this particular image read matter-of-factly: "THE CARDIFF GIANT—HOISTING THE STATUE FROM THE PIT."[12]

After Gott secured his photograph, the assembled crowd erupted in cheers. The historic day was proceeding swimmingly, and workers quickly moved to finish the task at hand. After raising the giant eight additional feet above ground level, the men placed several planks over the pit and subsequently moved a large wagon into position under the giant. The workers

then successfully lowered the great wonder into a sand-filled box that rested within the bed. Before the workers commenced their northward journey to Syracuse, however, one of the owners—not identified in subsequent newspaper reports—slapped a label on the side of the giant's container. In a clear indication of the good humor and spirit that prevailed on this day, the homemade tag read: "THE IRON-BOUND BOX."

* * *

The wagon bearing the giant arrived at Bradley's Syracuse factory later that day. Over the course of the evening, his workers carefully cleaned the great wonder, while weighing the wagon and its contents. Having earlier noted the weight of the empty wagon, Bradley thus provided the Syracuse newspapers with the first assessment of the great wonder's weight: 2,990 pounds.

The following morning, Syracuse citizens congregated outside of the factory, hoping to catch a glimpse of the great wonder en route to its final destination. At nine o'clock, the wagon rolled into the streets of Syracuse, and a cheering crowd followed the conductor down Marcellus Street. A marching band already had assembled to hail the giant's arrival and promptly launched into a rendition of Handel's "See, the Conquering Hero Comes." The wagon conductor soon turned left onto Warren Street, leading the makeshift parade north into Clinton Square, along the banks of the Erie Canal. The square—named in honor of former New York governor and canal visionary DeWitt Clinton—represented the heart of the Syracuse community. The Wieting Opera House and Syracuse House both resided there, as did major banks and the county courthouse. The square was perhaps best known, however, for one of the most significant events in city history. In October 1851, in accordance with the new Fugitive Slave Law, federal marshals arrested runaway slave William "Jerry" Henry and detained him at the county jail. At the time, Syracuse was hosting an abolitionist convention, and, along with earnest reformers, outraged citizens stormed the prison and freed Henry. More than twenty-five hundred men and women took part in the so-called Jerry Rescue, and, over the next few weeks, Syracusans successfully spirited Henry away to Ontario, where he spent the remainder of his days in freedom. As one chronicler of Syracuse history observed: "This act was a bold defiance of law and its results were heralded throughout the North; the anniversary was celebrated annually for several years in Syracuse."[13]

The giant's new exhibition space was on the opposite side of the square from the site of the Jerry Rescue. The Bastable Block, located at the intersection of Warren, East Genesee, and East Water streets, housed several

businesses, including the First and Second National Banks of Syracuse, as well as Shakespeare Hall, which hosted plays and popular lectures, including Wills De Hass's earlier presentation on the giant. The ground floor boasted a large arcade for special exhibitions and public presentations, and, earlier in the week, the owners secured this space to showcase the great wonder. By the time the wagon and its followers arrived at the Bastable, another large crowd already had assembled to see the giant. Indeed, despite earlier announcements that the exhibition would not open until Monday, Syracuse newspapers reported that more than a thousand citizens took to the streets that morning just for a glimpse of the giant. With large crowds scrutinizing their every move, workers established an inclined plane at the rear of the wagon. After sliding the giant's container onto a rolling platform, the men wheeled the great wonder into the arcade. As the *Journal* later observed: "Not a break, nor scratch even, was caused in the removal."[14]

Over the course of the weekend, Colonel Joseph H. Wood prepared the arcade for the Monday opening. Though Wood earlier placed his imprint on the Cardiff show, the Bastable exhibition more clearly manifested his sensibilities as a professional museum manager. The Chicago showman established the giant as the focal point, situating the great wonder in the center of the room atop an oblong square six to eight inches in height. In similar fashion to the Cardiff exhibition, Wood ordered the construction of a railing around the giant, though, for effect, he draped the enclosure with damask and lined the interior with dark matting. Wood further instructed workers to build a six-foot tall platform along three sides of the arcade. After visitors entered from the Water Street side, Wood planned to have them ascend a short flight of stairs to the platform. After walking along the structure and gazing down upon the exhibition from various perspectives, curiosity seekers then would descend a second flight of stairs and follow a Brussels carpet to the dais. There, in the center of the room, men, women, and children would ponder the great wonder for a few minutes before ushers escorted them to the exit. In the coming days, Wood also installed a mirror at the dais, allowing curiosity seekers a better view of the hand behind the giant's back.[15]

The opening of the Bastable exhibit proved a resounding success. More than a thousand paying customers—many of whom presumably already had seen the giant at Cardiff—streamed into the exhibition space over the course of the day. The Syracuse newspapers reported a slight change in ticket pricing, noting that children now could gain admission at twenty-five cents, or half the adult price. Over the course of that week, the crowds increased on a daily basis. On Thursday, roughly fourteen hundred curiosity seekers attended the exhibition, with the overall number increasing by another hun-

dred the following day. On Saturday, November 13, more than two thousand people passed through the arcade, approximating the high-water mark at Cardiff. As expected, the giant's more accessible location attracted remote visitors, as the *Standard* reported that half of the curiosity seekers now were coming from outside Onondaga County.[16]

Meanwhile, debate over the giant's nature and origin continued to rage in the newspapers, with still more men of science coming forward with their opinions. After defending petrifaction in the *Rochester Express* and sparking a subsequent rejoinder from Ward, Ira Brown, a Weedsport physician, criticized the scientific community for losing its objectivity: "Must we close our eyes . . . because Prof. Boynton hastily jumped to the conclusion that what he saw was a statue? Must evidence be twisted to sustain this view? Scientific men sometimes make fools of themselves, and I tell them that in spite of their idle speculations, the Cardiff Giant remains the wonder of the world, and will so remain, be it what it may." In a letter to the *Fulton Gazette*, J. J. Brown, a chemistry professor at Cornell University, offered a potential compromise between the statue and petrifaction camps. The chemist suggested that the great wonder was the cast of a living being, akin to the forms discovered in the Roman city of Pompeii: "Suppose the man to have been drowned by a flood, which also buried the body in silt or mud . . . Before decomposition would begin under such circumstances possibly a thin film of mineral matter may have been formed around the body, retaining all the outlines at least of the exterior surface. Then as the body decomposed the cavity was subsequently filled with mineral matter by the slow process of infiltration." By contrast, Lewis Henry Morgan, who did not attend the earlier scientific examination at Cardiff, shared his skepticism with the *Albany Evening Journal*. Morgan, who began his career as a lawyer, had become a recognized expert on ethnology, and his writings on kinship and cultural evolution established the foundations for the modern social science of anthropology. Drawing upon published descriptions of the giant and its Caucasian features, Morgan flatly dismissed the possibility of American Indian construction. At the same time, the ethnologist reviewed the placement of art and sculpture within the development of civilizations, ultimately concluding: "I submit it is wholly impossible that this effigy was the work of a people in this State anterior to our own of the European epoch. Had any people lived in this State, or in the United States east of the Mississippi, capable of sculpturing this statue, they would have left stone walls and building sculptures as well upon the surface of the land, equally indestructible witnesses of their existence." Despite its allegations of fraud, Morgan's letter did not receive as wide circulation as the letters of Boynton and Hall, in part because ethnology lacked the

popular cachet of geology, natural history, and the study of antiquities. At the same time, Morgan's decision not to examine the giant firsthand served to undermine his credibility. The *Standard*, for instance, declined to run the letter, noting: "The gentleman would speak with better understanding if he had seen the great wonder; theorizing upon hearsay is all well enough, but theories based upon actual observations are better."[17]

Meanwhile, petrifactionists renewed their earlier salvos against men of science. Clifton Wiles, a Freetown merchant, reminded readers of the *Cortland Standard* that sexton Thomas Hovey had dealt with numerous petrified corpses at the local church graveyard. After listing several instances, Wiles sarcastically asked Ward and scientists more generally how they would assess such cases: "Is this petrifaction, or is it not? If not, what should it be called? When doctors disagree, who shall decide? The people generally wish for information on this subject; if those who contradict the petrifaction theory will explain, perhaps we all may be edified." While citing its own local instances of petrifaction, the *Albany Knickerbocker* likewise took aim at the Rochester naturalist: "We see it stated that Professor H. A. Ward, of Rochester, has declared 'that there is no single instance on record of fossil or petrified flesh.' The Professor has neglected to read the Albany papers. In removing the remains in the old burying grounds to the Rural Cemetery, among them were those of a man noted years ago for his obesity. In life he weighed 400 pounds. His remains were found turned to stone—petrified."[18]

A week after the opening of the Bastable exhibition, the *Journal* reported that the owners planned to keep the great wonder in Syracuse for only a few more days: "The giant will only remain on exhibition in this city during this week, as the demand for its removal to the eastern and larger cities is strong. It is designed to exhibit the wonder in Albany next week, and then it will be removed to New York city." In light of the newspaper's announcement, the Bastable saw its biggest weekly turnout to date, and the following day, attendance neared two thousand once again. The *Courier*, in assessing overall fervency, noted that many individuals had purchased multiple tickets, with one particular man avowing, "I am going to look at that thing, over and over and over again." That same day, the newspaper reported that some customers were taking advantage of their newfound proximity to the giant, reaching out and touching its surface. To curb such behavior, Wood placed placards in the vicinity of the great wonder, but some curiosity seekers refused to heed the warning. Wood caught one elderly man in the act, with the latter exclaiming in defense: "But you see I did want ter [sic] lay my hand on the old fellow jest once, so that I could tell the folks at hum [sic] that I'd touched him!"[19]

During the giant's waning days in Syracuse, the civic-minded owners reached out to the community. On Thursday, November 18, the proprietors opened the exhibit one hour early, offering a free private showing to children and administrators from the Onondaga County Orphan Asylum and the St. Vincent de Paul Orphan Society. Though it was Thanksgiving, more than fifteen hundred curiosity seekers attended the exhibit that day. The giant's civic dimensions were even more manifest on Friday. On this occasion, Mayor Charles Parsons Clark received a delegation from Rochester, Syracuse's rival city. The group included current mayor Edward Smith as well as former mayor Michael Filon. As the *Rochester Democrat* reported: "The ostensible object of their visit was to see the Cardiff giant, but we think they also wished to test the hospitality of the city of Syracuse." Over the course of the day, Clark and other prominent citizens of Syracuse gave the Rochester delegation tours of Syracuse's salt springs, a local high school, a new savings bank, and, of course, the Bastable exhibit. The *Journal* noted that the giant's owners warmly received the Rochester delegation, offering them ample time to behold Syracuse's wonder: "They visited the giant, and were afforded the best possible facilities to gratify their curiosity." Later, during a banquet at the Globe Hotel, Mayor Smith offered his thanks, both to the city of Syracuse and to the giant. As the *Journal* reported:

> Mayor Smith responded in behalf of the Rochesterians, stating that for some time the Rochester city officials had contemplated a day of recreation, and the wonderful Cardiff Giant had at last afforded a suitable excuse therefore . . . After speaking in a complimentary manner of the various localities and buildings visited, and also of the wonderful giant; Mayor Smith said he hoped that the present visit of the Rochester people would not be the end of corporate courtesies between the two cities, but that these municipalities, whose interests are so inimical will become better acquainted and that a better social understanding may exist henceforth.

After the banquet, Smith and the remainder of the Rochester delegation returned to the Bastable for one final look at the great wonder before returning home. During the waning hours of the exhibition, the Rochester men watched as the final curiosity seekers filtered through the arcade. Over the course of that day, more than four thousand men, women, and children had visited the great wonder—the largest showing to date.[20]

With the end of the giant's stay in Syracuse nigh, leading citizens and businessmen asked the owners to reconsider their plans. In a formal appeal published in the *Standard* and *Courier*, these men cited the large numbers of

local men and women who still yearned to see the great wonder: "The time has not yet arrived when the curiosity of those in our immediate vicinity has been sufficiently gratified." At the same time, the writers cited the great wonder's positive influence upon the Syracuse economy and asked the owners to consider keeping the giant in the city as long as it remained profitable: "We suggest to you, as to those interested, as citizens of long standing, in the prosperity of Syracuse, that you consent to such an extension of the time originally determined upon as the limit of the 'Giant's' residence among us, which will, while remaining sufficiently remunerative to yourself conduce to the welfare of the community in which we all as citizens are interested." The signers of the petition included some of the most familiar names in Syracuse, including former mayor Elias Leavenworth, Syracuse House proprietor Oliver E. Allen, Onondaga Salt Springs superintendent George Geddes, and Thomas B. Fitch, president of the Syracuse & Binghamton and New York Railroads. Still another signer was Benjamin W. Baum, president of the Second National Bank and father of L. Frank Baum. The younger Baum visited the Bastable exhibit during these days, and the giant made a decided impression on the future author of *The Wizard of Oz*. Two years later, the young writer would offer the poem, "The True Origin of the Cardiff Giant," in his self-published *Rose Lawn Home Journal*. The efforts of the elder Baum and his fellow petitioners proved somewhat successful, for Amos Westcott announced on Saturday, November 20, that the giant would remain in Syracuse for part—if not all—of the following week.[21]

While planning the giant's upcoming tour, Westcott and the other owners fielded numerous offers from parties seeking to invest in the great wonder. A few weeks earlier, William Spencer sold half of his eighth share to Benjamin Son, a Utica merchant, for five thousand dollars, fixing the giant's overall value at eighty thousand—or double the assessment at the time of the original sale. During the giant's exhibition in Syracuse, the *Rochester Express* reported that Alfred Higgins rejected an offer of twenty-five thousand dollars for an eighth of his interest, implying an overall market value of at least two hundred thousand dollars—a 150 percent increase from just a few weeks earlier. Around the same time, Stephen Thorne, a Utica brewer, purchased Simeon Rouse's sixteenth share for fifteen thousand dollars, establishing the giant's overall worth at two hundred forty thousand dollars—or roughly five million dollars in modern terms.[22]

Around this time, Newell finally found a ready buyer for the quarter share that he held on behalf of Hull and his other silent partners. John Rankin, who later authored *The Giantmaker*, was only thirty-four years of age in 1869, but the successful entrepreneur already enjoyed a comfortable

John Rankin. Source: Courtesy of the Broome County Historical Society.

semiretired existence. A native of Providence, Rhode Island, Rankin spent his earliest years in New England, later relocating with his family to Cortland County in New York. While studying at the Cortland Academy, Rankin made the acquaintance of a young David Hannum, and the two became lifelong friends. After a brief stint as a bookkeeper, Rankin studied the law and briefly clerked in the Wisconsin legislature, later returning to New York. There, Rankin reconnected with Hannum and joined the horse trader in several successful business ventures, among them the sale of the butter churn patent, during which time Rankin became acquainted with Westcott. After a brief stint in Syracuse, where he taught at a local business college, Rankin relocated to Binghamton during the Civil War years, and the young entrepreneur quickly established himself as one of the city's elites. After acquiring the great wonder, Hannum and Westcott asked their friend to assist with its management, and, accepting their offer, Rankin became an eyewitness to nearly all developments and events involving the owners. The experience also enamored Rankin of the great wonder, for, after getting wind of Newell's desire to sell, the Binghamton entrepreneur offered twenty-five thousand dollars for the quarter share. Though the bid was well below market value, the Cardiff farmer nevertheless agreed to the terms, and the two men formalized the arrangement on the first of December. The contract included no fraud protection clause—a sign either of Rankin's faith in the giant or his belief that it was a sound investment regardless. Fearful that the public might interpret Newell's divestment as a sign of fraudulence, Rankin and the Cardiff farmer kept the sale quiet, and, indeed, the transfer escaped the notice of the Syracuse newspapers.[23]

After closing the exhibition at the Bastable, the owners finally shipped the giant east on Friday, November 26. During its final days in Syracuse, the great wonder attracted daily crowds between fifteen hundred and two

thousand curiosity seekers. After six weeks in Onondaga County, the giant had attracted roughly sixty thousand paying customers. The number was significant, for it implied that, expenses notwithstanding, the owners finally had recouped their original investments. With New York City on the horizon, they now were in position to enjoy pure profits. Before heading to the Empire City, however, these men bowed to public pressure and agreed to exhibit the great wonder in the state capital, a far less lucrative market. The decision would prove extremely costly, for, just as these men shipped the great wonder to Albany, skepticism was renewing in earnest, and the case against the giant became significantly stronger.[24]

CHAPTER NINE

~

The Naked Giant

Even while crowds stormed the Bastable in Syracuse, fraud allegations once again had begun to swirl around the giant. Men of science further scrutinized the great wonder's gypsum composition, while citizens of Fort Dodge and a scientist seeking redemption collected evidence of George Hull's earlier movements in Iowa and New York. While most Americans gradually came to accept the circumstantial case against the giant, Hull and his partners, still hoping to collect money from the original sale, refused to make any formal confession of guilt or present the final pieces to the puzzle. Hull, in particular, held his tongue as best he could, all the while laying the groundwork for his next project—a tell-all book.

During the final week of October, the insights of one man in particular had been lost amid the broad allegations of imposture. Fillmore Smith, a twenty-four-year-old mining engineer, wrote a letter to the *Courier* and *Journal* regarding the properties of gypsum. A recent graduate of the University of Michigan's mining program, Smith brought his practical experience to bear in assessing the great wonder. Specifically, Smith reported that the properties of gypsum precluded the giant's lengthy burial. As the engineer explained, gypsum becomes highly soluble in large quantities of water, and, given all the underground streams on Newell's farm, the giant could not have withstood more than a year or two in those conditions. The great wonder's surface already bore signs of dissolution, and, as the engineer ultimately concluded: "We are thus reduced to the necessity of believing that the statue has been placed there within a very recent period,—say one or two years,—or that the

men of science and other less pretentious observers have made a prodigious blunder in pronouncing the statue to be gypsum. Of the latter alternative, there is an exceedingly small chance, and the little cloud of suspicion which has been gathering in the horizon, suddenly begins to loom up with a dark and frowning aspect." Though lacking extensive field experience, Smith nevertheless demonstrated command of gypsum's material nature. More critically, the practical realities of the statue's burial context seemingly presented a real opportunity to overcome the shortcomings of the archaeological community. Still, the newspapers and public largely were unmoved, with supporters of the giant actually leveraging earlier scientific opinion against the young engineer. In a letter to the *Standard*, "M. E." scoffed at Smith's seemingly singular insight: "Now let me ask, do not all the scientific men who have made an examination of this wonderful object and made their conclusions public, say that, while it is beyond doubt composed of gypsum, it is also *of great antiquity, and given evidence of long inhumation?*" Smith's letter also suffered from poor timing. One day later, the *Standard* and *Journal* published the affidavits of Stub Newell and others, and momentum accordingly shifted away from skeptics.[1]

Still, Smith's perspective proved influential with John Boynton. After reading the engineer's letter, the latter conducted his own experiments, confirming Smith's assessment of gypsum. Boynton at once recognized the folly of his earlier speculation, concluding that the great wonder was a modern fraud. On November 12, he expounded upon his change of heart in a letter to Spencer Baird, the Smithsonian director who earlier contacted him for information on the discovery. The lecturer acknowledged that, from the outset, he held high hopes for the giant: "When I first saw it lying in its mucky grave and nearly covered with water, I hoped it was a monument that would throw some light on the shadowed history of the German, Spanish, and French settlements in the Onondaga Valley . . . But I fear that we are not to be enlightened much, for my veneration for the high antiquity of the Onondaga Giant is fast waning to a taper." While not directly acknowledging Smith's earlier hypothesis, Boynton described his experiments on Onondaga gypsum to the Smithsonian director. Extrapolating from the solubility of his sample, Boynton confidently postulated that the giant's burial had taken place 370—or 371—days earlier, with the lecturer's specificity—only a month off—stemming more from Hull's known movements in the valley. Boynton also vowed to collect further evidence of the giant's recent deposition and thus establish its fraudulence for the public: "I am going to make out a full report of the entire history, proceedings, discovery, resurrection, and journey of the Giant to its present resting place." Boynton bravely forwarded

a copy of his letter to the *Courier* and *Journal*, and both newspapers reprinted the lecturer's correspondence on Wednesday, November 17. Given concurrent coverage of the Rochester delegation, however, Boynton's letter did little to sway public opinion. Still, owners of the giant did not take kindly to the lecturer's allegations. According to *The Giantmaker*, the ill-tempered Amos Gillett subsequently accosted Boynton at a Syracuse bank and threatened the lecturer with bodily harm if he further slandered the giant.[2]

Skepticism emerged from other sources as well. On the evening of November 16, Erastus Palmer, who had not attended the earlier group examination at Cardiff, inspected the giant at the Bastable. The noted sculptor, who hailed from nearby Pompey, arrived in the company of H. K. Brown, a fellow artist from Newburgh, as well as James H. Armsby, anatomist and cofounder of the Albany Medical College. According to the *Courier*, Palmer scrutinized the giant's legs and chest, and, in stark contrast to archaeologists such as Wills De Hass, detected obvious signs of modern sculpting tools. While Armsby merely affirmed that the great wonder was a statue, Palmer quickly concluded that it was of recent origin and little artistic value. Unlike earlier specialists such as James Hall and Boynton, however, Palmer refrained from any official statement, later citing his reluctance to embarrass Amos Westcott: "That gentleman is so wealthy, so gifted, so amiable, so full of scientific knowledge and all good qualities, that opposition is dumb in his presence. His delusion with respect to the statue has made it a success, for that it is a success is absolutely certain." Palmer certainly could not have been pleased, then, to see a summation of the examination as well as off-the-record comments on the giant's fraudulence appear in the following morning's *Courier*. The *Standard* also summarized the examination, but offered a much different overall assessment: "These gentlemen hold the Giant a work of art, [a] remarkably good one, and of very ancient date." The *Standard* further noted a recent conversation between Palmer and "one of [Syracuse's] first families." According to the newspaper, a young woman informed the sculptor that many city lawyers adhered to the ironbound box story, with Palmer allegedly responding: "That giant work was done long before any of your lawyers were dreamt of—it has been there for ages." Indeed, with the *Standard* and *Courier* both offering radically different assessments of news and opinion, Syracuse citizens were left to wonder which newspaper represented the more reliable source on giant matters.[3]

As allegations of imposture resurfaced, Westcott, in particular, grew increasingly conflicted. A *New York Sun* correspondent characterized the giant's owner thusly: "It seems that [Westcott] is like a man in love with a low girl, who is determined to think well of her, and yet has aching twinges

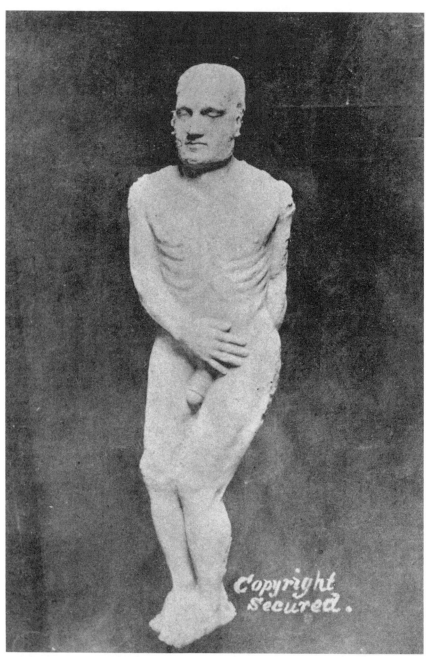

Photograph of the giant at the Bastable in Syracuse. Source: Courtesy of the New York State Historical Association Library, Cooperstown, New York.

of mistrust." At least publicly, though, Westcott remained an outspoken supporter of the great wonder. In late November, *Scientific American* published a letter from the Syracuse dentist, who identified himself as "an old subscriber (I have the SCIENTIFIC AMERICAN from its first No. to the last one)" and "an admirer of the great truthfulness, candor, and intelligence which have always characterized your opinions and expressions." In his letter, Westcott addressed an earlier report in the journal on Jules Geraud, the fictional Canadian sculptor. While taking pains to dismiss that fanciful literary hoax, Westcott scoffed at the persistent ironbound box story, arguing that the entire premise violated common sense:

> I will simply say, that any theory involving the idea that a stone statue, weighing 2990 pounds, was brought in an ordinary wagon, from nobody knows where, and deposited some three or four feet below the surface, and partially under a large limb of a tree, by two men, is so entirely ridiculous, that no sensible man, who is in the least acquainted with the surroundings, can possibly give it a second thought, and any belief, either in this, or the crazy Canadian or Geraud story, requires a stretch of credibility far greater that necessary to regard it a very ancient statue, or even a petrified Giant.

Westcott likewise took aim at *Scientific American*'s "all-wise" letter writer, noting that "men of sense and wealth"—himself included—had deemed the giant "a reality of sufficient magnitude to make it an object to pay a large sum of money to possess it."[4]

Petrifactionists similarly defended the giant by offering still more cases of the natural phenomenon, while renewing their attacks upon scientific investigators. After citing an instance of human petrifaction in Monroe County, one writer in the *Rochester Express* asked, "Now, without expressing any opinion relative to the 'Cardiff giant,' as to whether it be the 'work of art' or really petrified flesh, and laying aside the variety of opinions touching the petrifaction of flesh, I inquire, if the body referred to was not *stone*, or in other words *petrified*, *what was it?*" A *New York Sun* correspondent related a similar case in Richmond, Virginia, with the *Journal* noting that the author believed Henry A. Ward's antipetrifaction stance was "strangely subversive of the truth in many well authenticated cases." After reporting on the recent discovery in Canada of a petrified human head—replete with tongue and eyes—the *Standard* mused: "While the men of science protest against any such thing as flesh petrifaction, cases continue to come to the surface."[5]

Despite the best efforts of giant supporters, skeptics gained even more momentum in the final week of November. On Monday, November 22, "BOZ"

summarized new gypsum experiments in a letter to the *Courier*, now clearly the preferred forum for giant critics. William St. John, a foreman at C. C. Bradley & Sons, recovered a fragment of the giant during its removal from Cardiff, and, after reading Boynton's letter to Baird, commenced his own experiments into the solubility of gypsum. The foreman discovered that, in just one day, running water dissolved more than a third of his sample. Though consistent with Boynton's earlier findings, St. John's results nevertheless were significant, as the latter tested the giant's own gypsum rather than local samples, which did not match the great wonder's exact composition. An emboldened Boynton stepped up his attacks on the giant that evening in a lecture titled "Giants! Geology!! And Fossil Men and Women!" The crowd, having braved a snowstorm to hear the presentation, proved in no mood for antigiant polemics, and, as *The Giantmaker* reported, Syracusans generally dismissed the lecturer as a turncoat. The following morning, the *Standard* did not offer a full summary of the lecture, even though it had done so for Wills De Hass's earlier presentation. As the newspaper stated rather matter-of-factly: "The Doctor frankly confessed that he had changed his views as to some things in regard to the Giant, and it was quite evident he is down on Old Gypsum . . . To give a fair sketch of the lecture would occupy more room than we can spare this morning. Anything short of a full sketch might be unjust, and we therefore pass it by." Two days later, the *Courier*, of all newspapers, undermined Boynton's cause by reprinting the following critique from the *Worcester Spy*: "Dr. Boynton not a high authority, has given up the hypothesis which he first used to explain the mystery . . . His reasons, however, are not satisfactory; for the soft gypsum used in his experiments is not like the material of which the statue is made."[6]

The gypsum camp needed a more forceful spokesman, one not tainted by earlier endorsements of the great wonder. Skeptics soon found their man in O. C. Marsh, whose background differed markedly from other scientists involved to date. Indeed, Marsh stood at the forefront of a new guard. Like many other younger men of science, Marsh, while studying at Yale, had benefited from increased emphasis on laboratory instruction. Upon his graduation in 1860, Marsh pursued further studies in mineralogy, natural history, and geology at the Sheffield Scientific School, ultimately earning a master of arts. In the United States, however, the advanced degree remained—as one contemporary termed it—"notoriously no certificate either of application or attainment." Marsh accordingly pursued true advanced training in Germany, and, in this respect, anticipated what soon would become the norm in American higher education. The modern university, for the most part, already had emerged in Germany, and, in scientific fields, educators emphasized research

and new contributions to knowledge. The laboratory, of course, was the focal point for undergraduate and graduate instruction, with historian Burton R. Clark observing, "Within [the university laboratory], training procedures were developed and effected; there, specialist qualifications were established which certified scientific competence." Within the context of seminars, master professors taught research methods and techniques, reinforcing investigative protocol while disabusing students of speculation. Perhaps most significant, however, German universities downplayed contributions across a variety of scientific fields and instead emphasized defined and clearly developed areas of expertise. At universities in Berlin, Breslau, and Heidelberg, Marsh received advanced training specifically in invertebrate paleontology. After his return to New Haven in 1866, the thirty-four-year-old Marsh became the youngest professor of paleontology in American history, and, within two years, he would make his first foray into the American West, where he later earned celebrity for discovering dinosaur fossils. Colleagues identified Marsh as a rising star who might lead American science into a new and more professional age, and, indeed, the young paleontologist showed little deference for the old guard, challenging even Louis Agassiz on his fossil identifications.[7]

On Tuesday, November 23, Marsh passed through Syracuse en route to Rochester. A friend had been urging the paleontologist to examine the giant, and, even while assuming the great wonder was a fraud, Marsh nevertheless hurried over to the Bastable during his layover. After receiving clearance from the owners, Marsh directly approached the giant, circling it several times and stooping down for a closer look. After only a few minutes, Marsh pronounced his examination complete and, taking leave of the Bastable, returned to the rail station. Later that night, the paleontologist wrote a letter to his friend from Rochester, sharing his thoughts on the great wonder. Marsh did not even acknowledge the possibility of petrifaction, citing numerous tool marks on the surface as evidence of the giant's man-made nature. He then advanced the familiar practical argument against the statue's antiquity, noting the high solubility of gypsum in water. Marsh's assessment hardly represented a triumph of specialization, for the paleontologist, to some degree, had ventured into the realm of archaeology, while leveraging earlier experience with mineralogy. Still, in contrast to earlier scientists such as Hall and Ward, Marsh had approached the subject coolly and objectively from the outset, refusing to acknowledge the giant's emotive power or indulge in its romantic possibilities. Instead, he assessed it systematically, adhering closely to the scientific method. By this point, the paleontologist's arguments hardly were new, but Marsh's most important contribution to the antigiant cause was his vigor. Unlike previous skeptics, the paleontologist made his case in strong and

unequivocal terms, affirming that the great wonder was "of very recent origin, and a most decided humbug." This terse and memorable phrase ultimately would circulate in newspapers all over the country, the nineteenth-century equivalent of a sound bite. At the same time, Marsh endeared himself to newspaper editors and the public alike by scoffing at his own colleagues: "Altogether the work is well calculated to impose upon the general public, but I am surprised that any scientific observer should not have at once detected the unmistakable evidence against its antiquity." The *Buffalo Courier* published Marsh's letter on Monday, November 29, and, within days, it surfaced in the *Syracuse Daily Courier, New York Herald,* and *New York Sun.*[8]

The tide clearly was shifting at this point. Around this time, the *New York Commercial Advertiser* imagined that the great wonder was laughing at the American public: "It is now said that when the giant is alone at night, he removes his right hand from its customary position, and placing the thumb on the end of his nose, vibrates his fingers in the air." The *Courier* likewise observed: "The impression that his giantship is a fraud is becoming a settled conviction outside of Syracuse." Even within the City of Salt, where belief ran strongest, the skeptic camp made key converts. In a letter to the *Journal,* former mayor Elias Leavenworth retracted his endorsement of the great wonder, stating with reference to earlier ironbound box stories: "I see no reason to doubt the truth of the facts above stated, and notwithstanding my former convictions to the contrary, I see *very strong reasons* for doubting the *antiquity* of the giant."[9]

In the wake of these salvos, Hull was squirming. Given the recent sale to John Rankin, the giant maker and his partners no longer possessed equity in the great wonder, but still needed belief to persist through January 24 to collect monies from the original sale. Beyond the obvious financial incentive, Hull wanted to keep details of his scheme out of the newspapers, saving them for a tell-all book of which he recently conceived. After successfully duping Americans, Hull envisioned still more profits by publishing the full story of his humbug. Around this time, the giant maker made his first commitment to the planned publication, though it came amid an unexpected confrontation. Ezra Walrath, a Syracuse real estate and loan officer, kept the books for Hull's cigar-manufacturing business. The former *Courier* editor became a prominent member of the antigiant clique and, in late November, confronted his client over allegations of imposture. The giant maker actually admitted his complicity, sharing the full background of his scheme with Walrath, but, in so doing, proposed a deal. If Walrath refrained from giving the newspapers sufficient detail to establish fraud, Hull would make him partner and author of his planned book. The latter agreed to Hull's deal, but

did tell the newspapers what he could. On the first of December, the *Courier* reported: "It is said that a certain person, whose name we are not at liberty to publish just at present, but who is connected with the history of the giant, has made a full confession of the birth, origin, life and history of the giant, which will shortly be given to the public in a book. Until this confession is made public, and for obvious reasons it is withheld at present we shall withhold from the public certain facts in our possession which would throw additional light upon the question." Around the same time, the *New York Commercial Advertiser* noted: "We are informed by a gentleman who knows, that the giant was made in Chicago."[10]

Meanwhile, the great wonder attracted throngs of curiosity seekers at the State Museum in Albany, where Hall had furnished free exhibition space. The opening in that city drew between five hundred and a thousand paying customers, and the *Standard* reported that attendance increased over ensuing days. Despite all the allegations of imposture, the giant remained as popular as ever, and, indeed, it appeared that the great wonder once again would ride out the storm. Then, much to the chagrin of owners and supporters of the giant, all hell proceeded to break loose.[11]

* * *

News of the giant's discovery first reached Fort Dodge in late October. As it did in most every American locality, reports of the great wonder shocked and intrigued villagers, but the matter merited no special attention until Hall's letter appeared in local newspapers. Residents of the Iowa village thought that the geologist's description of the statue's composition sounded a great deal like their own native gypsum. It did not take villagers long to link the giant conceptually to the two men who visited their quarries in the summer of 1868.

Despite their suspicions, Fort Dodge residents refrained from making any allegations until they had visual confirmation of the gypsum. Fortunately, Galusha Parsons planned to visit relatives in Onondaga County, and the village lawyer, who himself had witnessed Hull and Henry Martin en route to Montana a year earlier, promised to attend the exhibition and discern whether the giant consisted of Fort Dodge gypsum. Parsons reached Syracuse sometime during the middle of November, and the lawyer joined curiosity seekers at the Bastable exhibit. After laying eyes upon the giant, Parsons immediately recognized his village's native gypsum, later recalling: "It made me *scream* outright. They have hardly cut the corners off of this 'Fort Dodger' enough to disguise the block since I saw it on the road to Montana. How intelligent people can

be so humbugged as they appear to be, I cannot conceive." From the Syracuse telegraph office, Parsons sent word to Benjamin Gue, editor of Fort Dodge's *Iowa North West* newspaper: "I believe [the giant] is made of that great block of gypsum those fellows got at Fort Dodge a year ago."[12]

With Gue spreading the word through Fort Dodge, villagers moved into action. Several leading citizens sent letters to eastern newspapers, with these communications appearing in print shortly after Marsh's scientific broadside. On Saturday, December 4, the *Journal* ran a letter from city marshal W. H. Wright, who recalled how two men quarried a large block of gypsum in Fort Dodge and shipped the material east. Though Wright's timeline was fuzzy— he situated the events in the summer of 1867—the city marshal's conclusion was clear: "My opinion is, your giant was made out of it." Three days later, the *New York Herald* published a similar letter from physician John McNulty. While describing the unique and easily identifiable properties of Fort Dodge gypsum, McNulty recalled the two men and, crucially, identified one as Hull—a name well familiar to followers of the giant saga. As McNulty wrote: "The citizens of this place believe that the giant, said to be found in Onon-daga county, N.Y., and hundreds of years old, was made from an immense block of gypsum . . . taken from here a year ago last June or July." Finally, N. M. Page, the village postmaster, identified both Hull and Martin in a letter that ultimately appeared in the *Chicago Daily Tribune* and *New York Daily Tribune*. In his letter, Page further speculated that Colonel Joseph H. Wood was involved in the "sell," seeing that the notorious Chicago showman was managing the exhibition.[13]

Meanwhile, Gue interviewed various citizens who had come into contact with Hull and Martin during their stay in Fort Dodge. The editor scrutinized local hotel registers, while also requesting shipping records from the Montana freight agent. On Thursday, December 9, Gue published the first of several exposés in the *Iowa North West*. This initial report established the dates of Hull and Martin's lodging in Fort Dodge, while also recounting unusual behavior and demands during their tour of C. B. Cummings's quarry. From an interview with Mike Foley, Gue likewise described how Hull and Martin ultimately secured the sizable block. Despite not yet receiving shipping records from Montana, the editor correctly surmised that Hull and Martin sent the block to Chicago. After all, both Gue and G. M. Hull (no relation) had seen the two men in that city. While the puzzle remained incomplete, Gue's exposé filled out the picture considerably.[14]

Around this time, Hull's partners began to scramble. Edward Burkhardt's name had not yet surfaced in the newspapers, so the Chicago marble dealer remained quiet. By contrast, Martin came forward, publicly denying any

wrongdoing in an interview with the *Marshalltown Times*. According to the blacksmith, he did quarry gypsum with Hull in Fort Dodge and later shipped it to New York, but claimed that the block had no connection whatsoever to the giant. For what purpose, then, the two men had quarried the gypsum, Martin did not make clear. In the end, the *Times* characterized the local blacksmith thusly: "Mr. Martin seems to feel quite indignant at the imputation that he had a hand in the resurrection of this—as we believe—giant humbug." Despite being the figure most associated with the giant, Stub Newell did not respond to allegations of imposture, but, still, his actions spoke louder than words. The *Standard* reported that the Cardiff farmer was negotiating the sale of his property—a clear sign that Newell was not long for the region.[15]

By contrast, Hull wanted to have his cake and eat it too. Despite growing consensus of fraud, the specific case remained circumstantial, as no one actually had witnessed the giant's burial. Indeed, it would take a formal confession from Hull or one of his collaborators to establish the imposture beyond question. Given the leeway, Hull took credit for the scheme in informal conversations. On Friday, December 10, the *Journal* noted that Hull broadly acknowledged the fraud to several local residents. James R. Lawrence, a city lawyer and early giant critic, reported that Hull stopped short of providing details and instead trumpeted his upcoming book. In point of fact, Hull was forging ahead with plans for publication. After meeting with Walrath in Syracuse, Hull headed out to Chicago with his author, hoping to introduce him to key locations in that city. Walrath later shared an anecdote from the trip west:

> While on the cars going there we overheard a couple of Chicago bankers talking about the wonderful giant. One of them remarked that "He had paid fifty cents to see the giant, and he would give a dollar to see the man that made it." Hull, who was sitting by my side, nudged me and said, "I guess I had better take that dollar." But I advised him to keep still.

During their time in the Garden City, Hull and Walrath met with Burkhardt, discussing the sculpting process while also visiting the latter's barn. To date, Burkhardt had not yet seen any profits from the sale or gate receipts, but Hull reassured his partner that funds soon would be forthcoming. At the same time, Hull met with Henry Salle and Frederick Mohrmann, neither of whom had been paid in full. The giant maker purposely withheld payment at this point, hoping to keep his erstwhile workers invested in the great wonder until the bitter end. During his trip, Hull also visited the offices of the *Chicago Daily Tribune*. The giant maker introduced himself as the man behind the

imposture and pledged to give the full story soon—possibly a ploy to keep the newspaper from doing its own digging in that city. That same day, the *Tribune* informed its readers: "The man who carved the man out of the block of gypsum is in Chicago to-day, and nothing but his pecuniary interest in the stone gentleman prevents him from exposing the entire joke. He is a clever workman, and a smart fellow generally, and without a humorous being. He laughs in his sleeve at the world, and the commotion he has kicked up. He wonders, no doubt, that men are so easily gulled, and thinks the public has not cut its eye-teeth yet."[16]

Meanwhile, Boynton already had made considerable strides in tracing the progress of the ironbound box. Over the preceding two weeks, the lecturer traveled the countryside, interviewing eyewitnesses while also collecting affidavits. During his conversation with Martin Strail, a Tully blacksmith, Boynton learned that Newell requested an iron hoop for his tub earlier that summer. The Cardiff farmer had given the blacksmith a template, and Strail kept the unusually large ring. Boynton later showed the item to an Erie freight agent, who confirmed that it came from the infamous ironbound box. Boynton likewise scoured the railroad's records, tracing the shipment all the way back to Chicago and thus confirming Gue's earlier suspicion. His affidavits and documentary evidence appeared in the *Journal* and *Courier* on Saturday, December 11.[17]

A few days later, "DETECTIVE" offered a series of "suppositions" in a letter to the *Journal*. Based on Boynton's research and the published reports from Fort Dodge, this writer presented a rough timeline of events from 1868, including the assumed Chicago sculpting, which investigators still had not confirmed. In speculating on various details of the giant's shipment and deposition—most of which the public already had before it—the writer noted that Hull fashioned the giant's surface pores with a makeshift tool, a detail implying the writer was present for one of the giant maker's off-the-record confessions. At the same time, while extrapolating from two Fort Dodge letters, "DETECTIVE" made a wild accusation. Both McNulty and W. H. Slauson speculated that Hull and Martin received assistance in Fort Dodge from a third man, with both giving his name as Glass. According to McNulty, Glass was a "stylish" man from Syracuse who visited Fort Dodge in the company of his wife. For his part, "DETECTIVE" identified Glass as "John R——, of Binghamton." The writer, obviously lacking knowledge of Rankin's investment and association with Hannum and Westcott, incorrectly interpreted his presence as a sign of quiet oversight. In *The Giantmaker*, Rankin possessed every opportunity to claim credit for partnership with Hull, but, in fact, never did. At the same time, in later confessing his own role in the

scheme, Martin did make reference to Rankin, but as one of the many public investors, not as a partner. Rankin's complicity necessarily would have made Westcott and Hannum conspirators, and both a later court case and subsequent life events make that supposition altogether unlikely. Glass very probably was an innocent bystander—a fact that Gue seemingly acknowledged in a later pamphlet. He excised the reference to this man from McNulty's letter, while framing his entire narrative around Hull and Martin.[18]

Amid rising allegations against the giant, petrifactionists and statue theorists alike grew quiet, or, if these men and women did present stirring defenses, newspapers generally refrained from printing them. In Syracuse, the *Journal* and *Courier* focused nearly all coverage on the fraud investigation, with the *Oswego Advertiser* observing from afar: "The *Courier* makes a clean breast of [the giant], and always considered it a disgraceful imposition . . . while the *Journal* goes down on its knees in sackcloth and ashes, and eats humble pie for having assisted to gull the confiding public." By contrast, the *Standard*, the great wonder's foremost supporter to date, dropped coverage to a minimum, seemingly hoping that the story would disappear. As the *Advertiser* noted: "The *Standard* stands afar off and hesitates to stir it even with a ten-foot pole, it smells so putrified [sic]."[19]

By the middle of December, the giant fast was becoming a national joke. While the *Courier* cited the "disgrace and stigma" that the great wonder had wrought upon America, most newspapers interjected humor within coverage of the fraud allegations. The *Chicago Post* joked that the giant was William Morgan, whom New York Freemasons allegedly murdered decades earlier. Referencing a popular pugilist, the *New York Evening Post* reported: "Mc-Coole has heard of the Cardiff giant, and dares him to come to St. Louis and fight for $5,000 a side." The *New York Commercial Advertiser* claimed that the giant failed its audition for *The Marble Heart*, a contemporary play about a sculptor, because "it was not perfect in every part." On at least one occasion, the *Journal* reprinted some of the best jokes from newspapers across the country, including the following item from the state capital: "The *Albany Express* refers to the giant as the biggest piece of imposition ever attempted in this country, and says it is thought nothing can ever match it, unless hereafter somebody discovers a woman giant of equal dimensions." Several humorous bits linked the giant to national politics as well as New York state governance. The *Louisville Journal* juxtaposed the great wonder with the failures of radical Reconstruction: "We have on one or two occasions expressed the conviction that after Gen. Grant, the next best man for the Radical party to nominate for the presidency in 1872, is *the Cardiff giant*. The assurance from the New York papers that the Cardiff giant is a humbug, only serves

to deepen our conviction." Though not identifying a party, the *Southern Onondaga* nominated Hull for the upcoming presidential election, noting: "Our country stands ever ready to reward the prowess of heroes. We now have a batch awaiting the laurel crown with which one encircles the brow of genius." Other New York newspapers joked about the giant in the context of state politics, demonstrating awareness of rising political corruption. In early December, the *Rochester Democrat* speculated on the giant's possible affiliation with William M. Tweed's Tammany Hall: "It has been suggested that the man from Cardiff would make a very solid speaker for the lower house, but there are so many ambitious Democrats in the Assembly that this cannot be permitted. His antecedents are so uncertain it would not be altogether safe; no one could tell whether he belongs to the Tammany 'ring' or to some other branch of the party." Before the giant even arrived in the state capital, a skeptical *Albany Evening Journal* opined that only the newly elected Democratic legislature would exceed the great wonder in its corruption:

> The Cardiff Giant is a curiosity, whatever may have been his origin. He will soon be here, as will also another and still more singular institution. This latter, which will certainly more than rival the Giant as a curiosity, will doubtless also far exceed it as a humbug. It is Governor [John T.] Hoffman's honest Legislature. There is a difference between the two, also. One has a real existence, even though its origin is not mythological. The other is a figment of the imagination.[20]

The hubbub surrounding the giant bemused at least one foreign observer. Goldwin Smith, a British-Canadian historian, presented a lecture in Buffalo on "An English University," drawing laughs for his invocation of the giant:

> We, in the old world, with our *effete* civilization, have nothing but our antiquities, and even in our antiquities you will soon whip us if you go on finding Cardiff giants. [Laughter.] I may say for myself that during the whole of the Cardiff giant affair I have had unshaken confidence in the intelligence of the American people. If the thing had happened in the old world there might have been some doubt or hesitation about it, but I never felt, myself, the slightest doubt, that the nation which had produced wooden nutmegs, and Mr. Barnum, could also produce the Cardiff giant.

The reference to P. T. Barnum was not without context. Indeed, while allegations of fraud fueled many jokes about the giant, concurrent events in New York City brought the entire affair into the realm of farce. Barnum finally had emerged from the shadows, and, in the great showman, the owners encountered a foe more formidable than the truth itself.[21]

CHAPTER TEN

~

War of the Stone Giants

New York City residents did not lack for newsworthy distractions in December 1869. For weeks, newspapers had been recording Charles Loyson's every statement on religion during his public lectures and meetings with city clergy, and, in the first days of December, the French priest was wrapping up his high-profile tour of the Empire City. Political intrigue abounded, as city editors accused Tammany Hall of voting fraud in the December charter election, while likewise speculating that the new state legislature might rescind New York's earlier ratification of the Fifteenth Amendment. A scandalous murder unfolded at the offices of the *New York Daily Tribune*, where a deranged man named Daniel McFarland shot his ex-wife's lover, journalist Albert D. Richardson. But, beyond the headlines, the city was abuzz. In a matter of weeks, engineers would begin construction on a massive new suspension bridge to connect Brooklyn and New York. The *Brooklyn Eagle* hailed this planned project as a "blessing," citing not only anticipated "physical contact and access," but also the "actual union" to emerge between the two colossal cities. Amid all these developments, a giant did command public attention, with newspapers and citizens alike hailing the arrival of a "distinguished visitor." New Yorkers believed that the Cardiff giant had arrived in their midst, but, in reality, P. T. Barnum foisted an imitation upon them, partly for reasons of revenge, but more to remind the world that no one out-Barnumed Barnum.[1]

In the first few weeks after the giant's discovery, Barnum resisted all entreaties to visit Cardiff, preferring instead the quiet retirement of his

Bridgeport, Connecticut, home. Still, in monitoring daily headlines and gauging public fervor for the great wonder, Barnum could not help but feel nostalgia for his own past successes. At the same time, Barnum may have felt a twinge of jealousy, having once planned a giant-inspired humbug that never came to fruition. Decades earlier, Barnum settled upon a fossil giant as the follow-up to his wildly successful Feejee Mermaid exhibit. After collecting exotic animal bones from all over the world, Barnum commissioned workers to construct an eighteen-foot human skeleton. As the *Boston Chronotype* later reported: "His plan was a novel one. The skeleton once completed he intended having it removed with great secrecy to the west and buried thirty feet under the ground in the centre of a big prairie, where after it had reposed for a few months it might *accidentally* be discovered by a party of miners, and the wonderful discovery heralded to the newspapers. It would then be ready for exhibition and no doubt yield a golden harvest." In this case, however, Barnum proved his own worst enemy, boasting about the scheme at a "convivial" party in New York. According to the *Chronotype*, a "shrewd Yankee" overheard the plan and resolved to outwit the great showman. As workers fashioned Barnum's fake fossil, the self-identified Mr. Smith contacted him, relating the fictional discovery of an eighteen-foot skeleton in Alabama and offering to sell the scientific wonder to the American Museum. As the *Chronotype* characterized Barnum's reaction: "Barnum read the letter over twice in utter astonishment. He could hardly believe his eyes. The impudent scoundrel! he exclaimed not satisfied with 'stealing my thunder,' the fellow tries to palm the d----d humbug off on me." A local newspaper eventually revealed Smith's deception, including how the latter had gotten wind of Barnum's plan in the first place. According to the *Chronotype*, the revelation of the gag bemused the great showman, who reportedly "laughed till the tears ran down his cheeks," but, with all the details before the public, Barnum lost any opportunity to execute the humbug. By the time that George Hull concocted his own scheme, the public—and almost assuredly the giant maker himself—had forgotten this exceedingly minor event in the showman's career, but, still, the episode remained with Barnum and undoubtedly resurfaced in the wake of the Cardiff giant's discovery.[2]

On Wednesday, November 24, curiosity finally got the best of Barnum. While traveling to Auburn with friend and spiritual advisor Rev. Dr. E. H. Chapin, the great showman stopped over in Syracuse, visiting the exhibition at the Bastable. Despite Barnum's celebrity, his arrival attracted hardly any attention, as newspapers and citizens alike focused instead on the giant's imminent departure from Syracuse. As the *Standard* reported rather matter-of-factly the following day: "Among the visitors . . . were the Rev. Dr. Chapin

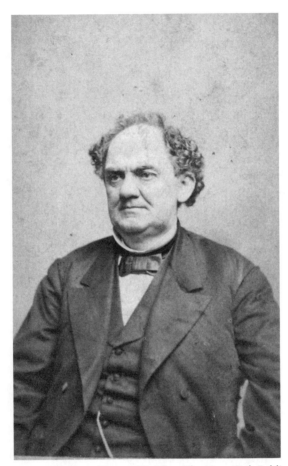

P. T. Barnum. Source: Billy Rose Theatre Division, The New York Public Library for the Performing Arts, Astor, Lenox, and Tilden foundations.

and Mr. P. T. Barnum of New York, who being en route for Auburn, stopped over to see his stone majesty." Many years later, Barnum recalled his initial thoughts upon seeing the great wonder: "I went there to see it, and found a figure in the form of a huge human being, possibly a petrifaction showing seams and scars resulting from exposure to the elements for centuries; or, it might be the rough chisel work of men's hands. I confess that I was puzzled, and, at first, was inclined to believe that it was what it was represented to be." After contemplating the giant for a few minutes, Barnum excused himself from Chapin, seeking out the owners for a private discussion. According to John Rankin, the great showman acknowledged from the outset the

giant's grandeur as well as its scientific import: "He expressed the profound satisfaction which he had experienced in the contemplation of the greatest marvel of the age, a satisfaction which every friend of science and student of the secrets of archaeology could not fail to share." After trumpeting his own track record in bringing science to the masses—"It was a source of pride to him and would be until the day of his death, that he had been the humble instrument of disseminating some little knowledge upon heretofore recondite and obscure points in natural science, and fostering an interest in that elevating study"—Barnum got down to business, offering the owners fifty thousand dollars for a quarter ownership share.[3]

As the owners huddled over the offer, Amos Westcott emerged as the leading voice against the sale and Barnum's involvement more generally. Amid all the fraud allegations, the dentist argued, the public likely would interpret any sale as a sign of cashing out as well as possible complicity, and Westcott, for one, would not risk any injury to his sterling reputation. While admitting some misgivings about the giant, Westcott nevertheless affirmed his faith in the great wonder's veracity and warned colleagues that they would regret parting ways with it. Finally, Westcott, as a man of science, disparaged Barnum's track record of humbugs, articulating what *The Giantmaker* termed a "radical difference in the policy" of the two parties. Whereas Barnum often aligned himself with frauds, Westcott argued that the syndicate was sharing a legitimate scientific wonder with the masses. True, Westcott and his colleagues personally profited from "innocent curiosity," but, unlike Barnum, these men neither vigorously pursued the public dollar nor diminished the sanctity of science with crass publicity and promotion. While Westcott's colleagues might not have shared his high-minded passion for science—or his exceedingly narrow view of Barnum's career—his arguments nevertheless proved influential. At the same time, the men all agreed that they simply did not need Barnum's name or promotional expertise. After all, the giant had drawn massive crowds in Cardiff and Syracuse without any involvement from the great showman, and undoubtedly would do the same in other cities. After only a few minutes of consultation, the men rejected Barnum's initial offer as well as several subsequent ones to lease the giant for Wood's Museum in New York City.[4]

Despite the rejection, Barnum nevertheless took the high road at the Bastable. As Rankin recalled: "In taking leave he was good enough to wish that the proprietors might make ten million dollars out of their prize." Barnum, though, "delicately submitted the suggestion" that the men speedily dispose of the four-horse team—a reference to the familiar ironbound box story and a clear indication that the showman had been following the giant's

saga closely. Barnum's comment also revealed his awareness of imposture at the very time that he sought to acquire the great wonder. Indeed, Barnum would have cared little for the giant's legitimacy, as long as it delivered full entertainment value—which very clearly it did. From his own experience, Barnum also knew that the giant would hold value even after the establishment of fraud. Men and women would visit the exhibition in light of new information, scrutinizing the giant and attempting to discern how humbuggers had fooled them. The owners themselves may have factored this long-term appeal in deciding not to sell to Barnum. Save Westcott, many of these men already may have come to terms with the giant's fraudulence, conceiving of it at this point only in terms of profits.[5]

Before leaving the City of Salt, Barnum paid a visit to the Holland Street studio of Carl Franz Otto. The showman again demonstrated his awareness of giant-related developments, for, in recent days, Syracuse newspapers updated their readers on the sculptor's current project. For some time, petrifactionists had been dismissing the statue hypothesis on the grounds that no sculptor could fashion such an evocative and lifelike figure. Otto, who regarded the great wonder as a statue and specifically the work of seafaring Scandinavians, resolved to prove them wrong by fashioning a perfect replica. As the *Journal* noted: "He was led to make this attempt by hearing it asserted, with great positiveness, that such a thing could not be done. He had so much confidence in his own mechanical and artistic skill, that he determined to see what he could do in this direction." Three local businessmen—druggist Nicholas Lehnen, tailor Harmann Bushmann, and distiller Leonard Woods—offered the sculptor two hundred dollars upon completion of the project, with these men envisioning a later exhibition at the Bastable or possibly even the Atlantic Gardens in New York City. The sculptor agreed to the terms, and, during the first two weeks in November, the eccentric German immigrant—who typically donned a scarlet fez—carefully studied the giant's features and posture during several trips to Newell's farm and the Bastable. The availability of Calvin O. Gott's photographs greatly facilitated his work, and, by the middle of November, Otto successfully fashioned a large clay model. After casting a mold, the sculptor filled it with plaster of Paris, marble dust, as well as other unidentified ingredients. With the figure thus rounding into form, Otto applied treatments to match the original giant's hue, while also digging similar erosions on the surface.[6]

By the end of the month, the sculptor nearly had completed his work. According to the *Journal*, while the imitation weighed less than the original giant and was not as soft to the touch, the naked eye otherwise could discern no difference between the two giants: "The imitation of the original is very

perfect." The various newspaper reports actually impeded the final stages of the sculptor's work, as Otto fielded a steady stream of curiosity seekers and admirers, among them John Boynton. On the day of Barnum's arrival in Syracuse, the *Courier* reported: "Dr. Boynton, Monday, visited Mr. Otto's studio, and pronounced the giant there a complete facsimile. All who have seen it united in this testimony." Like the Syracuse lecturer, Barnum was suitably impressed with Otto's work, and, as "SENEX" ultimately reported to the *Standard*: "P. T. Barnum on Wednesday visited the studio of Mr. Otto and complimented him on the success of his efforts, and expressed great surprise that with so meagre opportunities he had been enabled to do so well."[7]

Later that day, at the rail station, a conductor asked Barnum his thoughts on the hubbub in the city. The day's events obviously made the great showman reflective, for, in acknowledging the great wonder's success, Barnum mused upon his own place in the entertainment universe: "They must not call me the Prince of Humbugs after this. That beats out anything I ever did in my life." As train wheels later churned furiously en route to Auburn, the showman's mind raced equally fast, hearkening to past successes and missed opportunities, but also to the electricity and excitement of the Bastable show. According to biographer A. H. Saxon, the giant "fanned into life again" the showman in Barnum that never had gone completely dormant. Barnum also reflected upon his negotiations with the Syracuse syndicate, growing increasingly miffed that these small-time businessmen had not accorded him proper respect. Decades later, and one year before his own death, Barnum recalled how he decided upon his ultimate course of action. The showman's memory clearly was failing, for, in the volume *Funny Stories*, Barnum placed Cardiff in Pennsylvania, while identifying Albany as the site of his meeting with the owners. The showman also dramatically recast the tone of earlier negotiations:

> I therefore approached the proprietors, and said, "I will give you fifty thousand dollars for your Cardiff Giant, as it is. If, then, you will get a committee composed of Palmer, the sculptor, who lives here in Albany, and two or more physiologists and anatomists from the Albany Medical College, and, if they, after careful examination and proper tests, will make affidavit that your stone man is a genuine petrifaction of a once living human being, upon such published affidavit, I will give you an additional five thousand dollars for it."

According to Barnum, when the proprietors refused his offer, he became convinced that the great wonder was a "swindle," nobly resolving to "punish the perpetrators" by hiring a sculptor to craft an imitation. The show-

man quite clearly was engaging in revisionist history, as the "perpetrators" in question actively were engaging in humbug, providing men and women with full entertainment value. In truth, Hull's scheme was something more sinister than humbug, as the giant maker settled grudges at the expense of the public and sold the great wonder under false pretences. Still, Barnum knew none of these elements in November 1869, and it seems that, even decades later, lacked the full story. In retrospect, Barnum simply wanted to come across as heroic, claiming to have commissioned Otto's imitation to "fight fire with fire," when, in fact, the sculptor completed his work before the showman even entered the picture, and Barnum, of course, cared little for the original giant's veracity. If anything, Barnum was jealous of the great wonder's success and did not want to acknowledge this fact in retrospect. On that train ride from Syracuse to Auburn, the competitive juices flowed within him once again, and, indeed, it was time for America's great showman to get back in the game.[8]

* * *

Upon reaching Auburn, Barnum sent word of his plan to George Wood, with whom he enjoyed a profit-sharing arrangement at Wood's Museum. After agreeing to exhibit the imitation giant, Wood dispatched his museum's manager, Albert Parkes, to Albany. In the state capital, Parkes made one final offer for the original giant, but the owners rebuffed him. Parkes, who later dubiously claimed credit for discovering Otto's imitation, then departed for Syracuse, where he met the sculptor amid rather fortuitous circumstances. By this point, Otto finally had completed work on his imitation, but a full-blown ownership dispute threatened its ultimate exhibition. A few weeks earlier, after failing to secure a needed advance from his original investors, Otto worked out a separate deal with real estate broker Alonzo Smith, who purchased a 50 percent share at five hundred dollars. Smith promptly sold a third of that share for a thousand dollars to John Redington and William Case, who crafted and sold musical instruments in Syracuse. Otto promptly reneged on his arrangement with Smith and instead dealt directly with the latter two men. After Redington and Case announced plans to exhibit the imitation at the Bastable, two of the original investors—Lehnen and Woods—served them with an injunction. Arriving amid all the uncertainty, Parkes pledged to free Otto—and his giant—from the ownership quagmire. In addition to buying out Redington and Case, Parkes offered the sculptor one hundred dollars a week for three months, along with free board at a fine New York City hotel—all in exchange for his giant. As Otto weighed the

offer, Parkes enlisted the aid of John Wieting, a personal friend and influ-
ential figure in Syracuse. Even if Parkes did not divulge Barnum's scheme to
Wieting, the latter undoubtedly sensed what was afoot and, as a leading critic
of the giant, heartily endorsed the plan. At Wieting's urging, the sculptor
agreed to Parkes's deal, and the two men soon formalized a contract. After
working out a separate arrangement with Redington and Case, Parkes gave
his new partners shipping instructions and promptly returned to New York
City, where he began preparations for the giant's arrival.[9]

On Thursday, December 2, Otto, Redington, and Case moved the imita-
tion giant to the New York Central Railroad depot, but, later that evening,
Lehnen and Woods secured a last-minute injunction to stop the shipment.
Redington and Case posted bonds the following afternoon and temporarily
freed the cargo, while agreeing to appear in court at a later date. To avoid any
further incident with the original investors, the men quietly moved Otto's
giant to the Syracuse & Binghamton Railroad, and the freight train departed
for New York City later that day. The timing was noteworthy, for, in less
than twenty-four hours, the first Fort Dodge letter would appear in the pages
of the *Journal*.[10]

* * *

The shipment arrived at the Cortlandt Street station in Jersey City on
Saturday, but Barnum and his cohorts did not immediately move the cargo,
instead preferring a high-profile parade on Monday. That morning, Parkes
arrived at the station with twelve Flanders horses, a wagon, as well as one
hundred hired men. After placing the imitation giant in the wagon's bed,
Parkes slowly conveyed the vehicle up Broadway, with his hired men march-
ing alongside. The odd spectacle garnered attention, with Parkes observing
that the street quickly became "packed for its entire length with sightseers."
Of course, the New York citizenry believed that the wagon bore the cele-
brated Cardiff giant, for a large sign on the side read: "The Petrified Giant
for Wood's Museum." Crowds grew ever larger as the procession neared its
destination, and, as the museum manager later noted: "In the vicinity of
the museum the throngs were so dense that Captain Petty, of that precinct,
was on duty with the reserve platoons to keep a passage-way open for the
mournful procession, which had occupied nearly three hours making the
transit from Cortlandt Street." At Wood's Museum, located at Broadway and
Thirtieth, curiosity seekers watched closely as the laborers, over the course of
a full hour, deliberately conveyed the giant into the building.[11]

Rather than open the exhibition immediately, Barnum and Wood instead worked the city press over the course of the day. The two men staged a private showing for editors later that evening and, as *The Giantmaker* alleged, used the opportunity to bribe these men for positive press. If city editors were aware of Barnum's imitation ploy, they certainly did not make the gambit manifest in the following day's editions. The *New York Commercial Advertiser*, in its "City Intelligence" section, reported that "among the distinguished arrivals is the Onondaga Giant," while likewise citing the "Cardiff giant" in its theatrical notes. The *New York Sun* noted the arrival of the "Cardiff colossus" at Wood's Museum, while the *New York Evening Post* reported that the curiosity came from Albany, indeed the last known location of the original giant. The *New York Herald*, while acknowledging the multiplicity of giants, nevertheless refrained from judgment, citing instead broader allegations of imposture: "We forbear to distinguish between these giants or to decide which is the greater of two humbugs." Meanwhile, Barnum and Wood broadened existing newspaper advertisements to include information on the new exhibition: "A MOST IMPRESSIVE MYSTERY! THE PHENOMENON OF THIS CENTURY, THE STONE MAN OF ONONDAGA!" Barnum and Wood likewise invoked the successful "What is it?" marketing ploy from the old American Museum: "What is it! Is it a Statue? Is it a Petrifaction? Is it a Stupendous Fraud? Is it the Remains of a former Race?" They also emphasized that curiosity seekers could witness this "most stupendous wonder"—and everything else at the museum—all for the standard admission fee of thirty cents.[12]

The public exhibition opened in conjunction with these first press items, and, despite bad weather, hundreds beheld the colossus at Wood's Museum on Tuesday. Even the exhibition space borrowed liberally from the original giant's show, as Otto's imitation rested on a pyramid-shaped dais in the center of the room, while an elevated platform offered customers multiple vantage points. Like Colonel Joseph H. Wood, Barnum and George Wood (no relation) created a solemn atmosphere by draping the railings and woodwork in black, while these men also placed dark green globes over the gas jets to mute the lighting. To complete the funereal effect, the exhibitors pumped solemn organ music into the space, while directing ushers to wear slippers, thus preserving the eerie stillness.[13]

Within a few days, additional city newspapers acknowledged the existence of multiple giants, but, like the *Herald* previously, generally refrained from passing judgment. On Saturday, the *New York Commercial Advertiser* noted: "Truth is mighty and must prevail, therefore should we not be daunted by

the fact that while the Cardiff Giant is delighting the gaze of thousands who crowd Wood's Museum to look upon his stony features, he is also on exhibition in Albany . . . Between these two the public, which pays its money, is at full liberty to make its choice." The *New York World*, likewise referencing the Albany exhibition, similarly refrained from exposing Barnum's imitation: "We shall reserve our opinion of its archaeological merits until we hear further from another Cardiff giant now said to be in Albany. If the original has been duplicated, and Cardiff giants are to be furnished to all the museums in the country, we prefer to confine our attention to the more animating, if not more aesthetical zoological show." While referencing the multiplicity of giants, the *New York Daily Tribune* wryly observed: "It makes no difference. An imitation hoax is just as good as a real one, especially if you can't tell them apart." The public seemingly agreed with the *Tribune*'s assessment, for Parkes later claimed that "the rush was simply tremendous." The presentation did succeed on several levels. On one hand, the exhibit attracted multitudes that maintained their faith in the great wonder and believed that Wood's Museum possessed the original giant. At the same time, skeptics wanted to discern how the vaunted Cardiff giant had deceived scientists and the public alike. Finally, more savvy citizens, who realized that the original giant still was in Albany, nevertheless attended the exhibit, curious to learn how Barnum had bested the original humbuggers.[14]

Still, Barnum and Wood faced intense criticism from various circles. The *Albany Evening Journal* sharply denounced the museum's actions: "The imposture is contemptible. Whatever may be the character of the Cardiff Colossus, the proprietors are entitled to the benefit. Even if it is a humbug, Wood's caricature of it is no better, and he has but stolen and counterfeited the invention of another." The owners of the original giant also arrived in the city, filing an injunction with the New York Supreme Court to stop the exhibition. The court was notoriously corrupt, having been aligned with Tammany Hall for years, and, in previous elections, judges brazenly naturalized thousands of citizens to boost the Democratic voting base. In recent years, the court had abetted William M. Tweed's rise to power, with Judge George Barnard admitting the untrained politician to the city bar, while issuing favorable injunctions in his dealings with the Erie Railway ring. Barnard's actions represented payback, for, years earlier, Tweed secured his appointment to the court, even though Barnard—according to his own brother—knew as much about the law as a "yellow dog." The judge showed utter disdain for the legal process, generally whittling sticks of wood and drinking brandy during court cases. Perhaps fittingly, the injunction against Wood's Museum landed on his docket, with Rankin recalling the scene in court that day:

That functionary [Barnard] did not happen to be in an enjoining humor. Without listening to the whole of the long document that the lawyer proposed to read to him, he refused to grant the injunction prayed for. He said that he had been doing a great deal in injunctions lately, and felt disposed to "Shut down": this was a fight between Cardiff Giants, and he was not inclined to interfere. He subsequently informed Attorney Davidson [attorney for the plaintiffs] that there was no reason why an injunction could not have been granted in the case: but he did not explain why he had refused to grant one.

The *New York Sun* later offered a more damning assessment, noting that Barnard simply "laughed" at the request for an injunction. As the newspaper recalled: "Judge Barnard . . . utterly scouted the affidavits and affirmations of the Cardiff party. He would grant no injunction. He characterized the whole thing as an audacious fraud."[15]

The owners, faced with no other recourse, took on Barnum and his cohorts. On Monday, December 13, three days after the *Syracuse Daily Journal* noted Hull's informal confession, the owners published a letter in several New York City newspapers. The signers of the letter included Westcott, Amos Gillett, David Hannum, and Stub Newell, with the Cardiff farmer's name undoubtedly affixed for appearance only and not reflective of his active involvement. As the letter read:

> We desire to inform the public through your columns that the statue now on exhibition at Wood's Museum is a plaster cast taken from the original by Mr. Otto, an artist of Syracuse, without our knowledge and consent. The Cardiff giant is now at the State Geological Hall, in Albany, where a room was placed at our disposal by the authorities of the State. It will shortly be in New York, and when open for exhibition the announcement will duly be made in your advertising columns.

In referring to the great wonder as the "Cardiff giant"—as they likewise did in an accompanying advertisement that day—the owners sought to distinguish themselves from Barnum and Wood, who cleverly had been utilizing Onondaga-related appellations in their advertisements, since, truthfully, the imitation did come from that county. During this period, the frequent invocation of the "Cardiff giant" did much to establish that nickname in popular consciousness, and, indeed, this designation would be the one to accompany the great wonder into history.[16]

In their haste, however, the owners made a critical mistake. In their letter, the men accused Otto of fashioning the imitation giant from a plaster cast of the original. Of course, the sculptor had done no such thing, instead

crafting a clay model and then taking a cast from that reproduction. Barnum and Wood seized upon this gaffe in subsequent letters to city newspapers. In one item, Wood issued a challenge to the so-called Albany Giant showmen. If these men could prove that the Wood's Museum colossus derived from a plaster cast of their giant, Wood pledged to give a thousand dollars to the New York Association for Improving the Condition of the Poor. He also scoffed at attempts to defend the Albany giant: "The attempt of the Albany Giant showmen to attach respectability to their statue simply because the owners of a hall in Albany generously let them have it *rent free*, strikes me as novel." In a nice bit of symmetry with earlier affidavits in defense of the giant, Wood offered a sworn statement from Parkes, who cleverly affirmed the Onondaga origins of the Wood's Museum colossus:

> On my way to Syracuse I saw the so called stone giant exhibiting in Albany, and not relishing the pretensions of the showman exhibiting it, but desiring to give satisfaction to our patrons—the public—I proceeded to Syracuse, and there engaged at a very large cost the great "Onondaga giant," and that I know that the statement made by the Albany giant showmen that the great Onondaga giant at Wood's Museum is a CAST taken from the original is groundless and UNTRUE, to the best of my knowledge and belief.[17]

The battle between the two giants garnered coverage in newspapers all over the country, contributing to the overall glut of giant-related content. The *Daily Cleveland Herald* noted the owners' initial plans for an injunction, while the *Chicago Daily Tribune* reprinted their letter in full. A *Philadelphia Inquirer* correspondent made light of the brouhaha in the Empire City: "The New Yorkers have been thronging to Wood's Museum during the past few days to look at the Cardiff giant, which, however, turns out to be only a plaster cast made of the original. It is rather rich that we should be victimized by such a fraud upon a fraud." In Syracuse, the *Journal* defended the owners' obvious misstatement regarding the cast—"This statement is wholly incorrect . . . but we do not believe it was intended by the authors to make a misstatement"—but nevertheless scoffed at the two giants: "It is quite certain that both are genuine wonders, each in its own peculiar line."[18]

The original giant finally arrived in the Empire City on Friday, December 17. Amid all the distractions and fraud allegations, the great wonder's three weeks in Albany largely had been a disappointment, with the State Museum exhibition drawing only sixty-six hundred customers—roughly one week's turnout in Syracuse. Still, the owners forged ahead with their show, ensconcing the great wonder at the Apollo Hall, located only two blocks

from Wood's Museum. Over the weekend, Westcott, Hannum, Rankin, Gillett, and Cardiff's Billy Houghton prepared the exhibition space, though the men lacked for time as well as Colonel Joseph H. Wood's professional touch, with the Chicago showman already giving up on the giant and returning to the Garden City. At the Apollo Hall, the great wonder once again lay upon a dais, but, this time, the room lacked even the simplest adornments. In preparation for the opening, the owners secured major advertisements in New York City newspapers. In one such promotion, the men excerpted the *Syracuse Daily Journal*'s earlier coverage of Otto's giant, while characterizing the sculptor's work as "a spurious imitation of this marvel of the nineteenth century." Hannum and Gillett signed a joint affidavit, affirming their accompaniment of the "ACTUAL CARDIFF GIANT" all the way from the tiny hamlet, while the owners more broadly took aim at Barnum and Wood: "[The proprietors] may also unequivocally state that it was only subsequent to the failure to obtain the original statue from its proprietors for the purpose of exhibition, that the present exhibitor of this incomplete duplicate entered into an arrangement to obtain the counterfeit for the purpose of anticipating their arrival in this city." In conclusion, the owners offered a list of all the "distinguished individuals" who examined the giant and "share[d] the amazement of the public," among them James Hall, Samuel Woolworth, Andrew White, Henry A. Ward, Lemuel Olmstead, and Erastus Palmer. The *Courier* later criticized the owners for using these names, asserting: "We are at loss to know how their consent has been obtained for the use of their names in defrauding the public, and giving a show of respectability to an exhibition, which has no parallel in the line of humbugs."[19]

At least one city newspaper predicted a reasonable competition between the two giants. As the *New York Commercial Advertiser* observed: "Two men of gypsum are in town, each claiming to be the original Simon pure Cardiff wonder. Already the monsters are hurling paper pellets at each other through the press. By-and-by they may come to blows, and then the consequences will be fearful to contemplate. And in this view (while wishing the prospective candidates a safe deliverance) we can but use the motto made use of on a memorable pugilistic field in England, 'may the best man win.'" The Apollo exhibit, however, proved a failure from the outset. On Monday, the opening attracted what the *New York Sun* described as a "fair attendance," but, the following day, the exhibit drew only fifty curiosity seekers during the morning and afternoon. Though the owners soon expanded their advertisements to include excerpts from Newell's existing affidavit as well as earlier statements by Hall and Ward, attendance remained light. By contrast, the Wood's Museum exhibit drew sizable crowds, reportedly attracting more

than five thousand visitors on Christmas Day. Around this time, the *Sun* proclaimed Barnum the obvious winner of the so-called War of the Stone Giants. As the newspaper opined: "Barnum has thus completely triumphed. He has checkmated the opposition completely and routed them ignominiously." The *Sun's* broad summary of the strange affair in New York City received wide circulation in the coming days and weeks, appearing in the *Cleveland Daily Herald* and *Chicago Daily Tribune*, and with both the *New Hampshire Sentinel* and *Idaho Statesman* summarizing its contents.[20]

Even Barnum fell prey to imitations, with entrepreneurs quickly attempting to duplicate the great showman's success. Over the course of December, Otto received several orders for new imitations, and the sculptor soon began manufacturing Cardiff giants at a frenzied pace. Russell R. Lewis purchased Otto's second imitation for five thousand dollars, exhibiting the giant in his native Utica. On December 20, the *Journal* reported that Otto sold yet another imitation for three thousand dollars, and this giant eventually cropped up at Colonel Joseph H. Wood's museum in Chicago. Still another replica played to crowds at the Bastable over the holidays, and, over the next few weeks, non-Otto imitations surfaced in Springfield and Worcester, Massachusetts, as well as in Philadelphia and Des Moines. In noting the appearance of a giant—fittingly enough—in Binghamton, the *Journal* wearily asked, "How many are there?" A few weeks later, after reporting on the shipment of an Otto imitation to Montreal, the newspapers noted that the sculptor had a standing order for six additional giants.[21]

In the wake of the War of the Stone Giants, Mark Twain presented a new sketch that emphasized the specific episode's farce but also more generally the hoax's foolishness. On January 15, 1870, the writer published "A Ghost Story" in the *Buffalo Express*. In the sketch, Twain's anxious narrator awakens to strange and frightful noises in his Broadway flat. After rising from his bed, he soon encounters the source—the ghost of the Cardiff giant: "Stripped of its filmy housings, naked, muscular and comely, the majestic Cardiff Giant loomed above me! All my misery vanished—for a child might know that no harm could come with that benignant countenance." The spirit attempts to sit with the narrator, but rather pathetically breaks multiple chairs in the process. The narrator accordingly changes his tune, charging: "Confound it, haven't you got any judgment at all? Do you want to ruin all the furniture on the place? Here, here, you petrified fool." At the climax of the story, the spirit sadly explains its dilemma: "I am the spirit of the Petrified Man that lies across the street there in the museum. I am the ghost of the Cardiff Giant. I can have no rest, no peace, till they have given that poor body burial again." At this point, the generally unsympathetic narrator reveals

the spirit's obvious mistake: "Why you poor blundering old fossil, you have had all your trouble for nothing—you have been haunting a *plaster cast* of yourself—the real Cardiff Giant is in Albany! Confound it, don't you know your own remains?"[22]

Hull, of course, did not find Barnum's antics nearly as funny. In an interview years later, the giant maker acknowledged the folly of not involving the great showman earlier: "P. T. Barnum, the showman, taking advantage of the furore [sic] it had created in the scientific world and widespread interest it had awakened . . . exhibited the imitation. . . . I made many mistakes in the management of my scheme." In late December, Hull personally surveyed the damage in New York City with Ezra Walrath. At the Apollo Hall, the two men somehow escaped the notice of the owners, though admittedly their visit was brief. According to Walrath, a curiosity seeker remarked on how much the great wonder resembled Hull, and, at this point, the giant maker and his author beat a hasty retreat from the exhibition space. The day when Hull could confirm fully the giant's fraudulence and revel in his own masterwork was drawing nigh, but, to receive his sale money, he would have to keep owners and the public believing for at least a few more weeks.[23]

CHAPTER ELEVEN

~

Hubbub

At the beginning of January, the owners forced the issue by calling fraud and demanding cancellation of the bank notes from the original sale. George Hull, however, refused to give up, with the giant maker employing one final trick to see his long-anticipated payday and possibly give the great wonder new life. Still, while impressing key figures in its new exhibition space at the Hub of the Universe, the giant's days as a public sensation nevertheless were drawing to a close.

The constituency of the ownership group changed amid the December firestorm. A disgusted Alfred Higgins quit the syndicate altogether, demanding that Stub Newell return his cash from the original sale, while also canceling his bank note for the remainder. The Cardiff farmer, perhaps owing to his acquaintanceship with Higgins, surrendered the note as well as some of the money, though the parties eventually required a court case to sort out the repayment terms. With Higgins's interest reverting back to Newell, the Cardiff farmer promptly resold that quarter share for fifteen thousand dollars to another Syracuse syndicate, this one headed by prominent bankers Thomas B. Fitch and J. M. Ellis. Still, Newell and his silent partners saw no immediate windfall, for the *Courier* reported that these purchasers paid nothing up front—which earlier may have been true for John Rankin. These latter two parties now owned half of the great wonder, while Westcott and Hannum maintained a 25 percent interest from the original sale. Along with late-stage investors Stephen Thorne and Benjamin Son, original purchasers Amos Gillett and William Spencer shared equally in the giant's final quarter share.[1]

Though others held greater equity, Westcott remained the group's leader as well as the giant's foremost public defender. Amid all the December allegations, Westcott vigorously maintained the giant's veracity, all the while belittling critics in increasingly petty fashion. Elias Leavenworth, who retracted his endorsement of the great wonder in late November, became the dentist's primary target. After reading the former mayor's statement in the newspapers, one Fort Dodge villager wrote Leavenworth about Hull and Henry Martin. Leavenworth forwarded this communication to the Syracuse newspapers, and a furious Westcott retaliated with his own letter, published in the *Journal* on December 16. The dentist challenged Leavenworth's objectivity, noting that the latter held "landed interest" in the vicinity of Fort Dodge and implying his collusion with the gypsum industry there. At the same time, while expressing doubts about the Fort Dodge allegations, Westcott snidely called upon Leavenworth to leverage those interests in putting the matter to rest:

> These letters have more the appearance of being written to get up a sensation than to express important facts. I not only suspect that *the gypsum found at Fort Dodge is quite unlike that composing the Cardiff Giant*, but . . . I believe these parties either innocently or maliciously misrepresent the facts . . . Now, General, as it will be quite easy for you to be instrumental in settling this whole matter by showing us the kind of gypsum procurable at Fort Dodge . . . we feel that it is not asking too much, when we ask you to get us a good-sized block from said quarry.

In concluding his letter, Westcott once again sounded the commonsense argument against the ironbound box story: "If it should turn up that the somewhat famous spot could furnish none of the proper material of which to make *Cardiff* giants, there would be no necessity showing the absurdity or rather impossibility of transporting over a common wagon road a stone weighing *over ten tons* or making Hull turn sculptor to lighten it by the way side." At one point in his letter, while scoffing at the Fort Dodge origins of the gypsum, Westcott recalled how one Onondaga quarry owner mistakenly thought that the material originated in central New York. A. F. Wilcox, who operated a quarry in DeWitt, objected to Westcott's characterization, stating flatly in a published rejoinder: "I made the assertion that I had blocks of gypsum large enough for a dozen giants, and never at any place or on any occasion have I admitted that in this I was mistaken." Westcott rather pettily refused to let Wilcox have the final word, and, in a letter to the *Journal* on December 23, chided the quarry owner: "You regard it ridiculously strange

that experienced geologists should decide 'instantly' on seeing specimens of gypsum, whether they were like or unlike some other specimen with which they were familiar. Is there in fact anything strange about this? . . . Would you not regard a doubt as to your own capacity thus to discriminate between two varieties of gypsum next to an insult?"[2]

Still, amid his spirited public defenses of the giant, Westcott once again was waging an internal war. The *New York Sun* observed that the dentist left the Apollo Hall exhibition shortly after its opening, returning to Syracuse "sick alike in mind and body." Shortly thereafter, Westcott quietly commenced his own investigation into Hull's background. After learning that the cigar manufacturer once lived in Baraboo, Wisconsin, Westcott requested information from the postmaster of that village. His letter, dated Christmas Eve, read, in part: "Has the man Hull alluded to in the inclosed slip ever lived in your town? He is said to have figured there as a manufacturer or dealer in tobacco, or both. Any information you can give of him, the time he was there, his surroundings and conduct, will be thankfully received."[3]

By the first days of January, Westcott seemingly had come to terms with the giant's fraudulence. The dentist demanded that Newell cancel his bank note from the original sale, with Hannum, Spencer, and Son soon following suit. Newell, however, no longer held title to the notes. In late November, the Cardiff farmer conveyed his rights over to George Bartlett, Hull's lawyer in Binghamton, setting the stage for both the giant maker's ultimate payment as well as his avoidance of creditors. After Newell alerted Hull to the owners' demands, the latter decided to confront the situation directly. Bartlett assigned the giant maker power of attorney over the notes, and Hull promptly departed for Syracuse, where he met Westcott at the law offices of Noxon & Cowles. The dentist reiterated his earlier demand, while noting that Hull's presence that day seemingly confirmed what he and the others long suspected—that the cigar manufacturer was the man behind Newell and the giant. In his defense, Hull maintained that the infamous ironbound box had not contained the giant, but rather illicit tobacco machinery. Westcott, however, was unmoved, and, at this point, Hull offered him a deal. First, in a sign of good faith, Hull would give up his claim to the notes, which carried a value of fifteen thousand dollars. He then would furnish the owners with proof that the ironbound box had contained machinery. If the men accepted Hull's evidence, they would give him forty-five hundred dollars and a portion of their equity; if not, they owed him nothing. Hull clearly was hedging his bets. In angling to receive forty-five hundred dollars, the giant maker sacrificed more than ten thousand in potential profits, but, faced with the possibility that clear evidence of fraud might emerge before the January 24

deadline, it was better than nothing. At the same time, if Hull succeeded in restoring public faith in the great wonder, the renewed equity would more than offset these losses.[4]

Westcott fell for the giant maker's seemingly earnest plan, and, in subsequent communications with Hannum, Spencer, and Son, strongly urged his colleagues to consider the proposed deal. Unlike Westcott, who so desperately wanted to believe in the giant and conceived of Hull's plan as validation, the others simply may have endorsed efforts to prolong the exhibition and expand their profits accordingly. Though not involved in Hull's deal, late-stage investors—Rankin, Thorne, Fitch, and Ellis—also may have pressured their colleagues to accept the arrangement, as none of them had yet reaped any box-office windfall. After a few days of discussion, the parties formalized a contract on January 8, with Hannum later signing the document from New York City. Before retreating into the mist once more, Hull advised the owners to prepare for the giant's comeback, and foolishly, they did just that.[5]

* * *

For the giant to succeed once more, the owners needed to put New York City—and P. T. Barnum—behind them. They would require a large urban market, but, more important, one that played to the great wonder's strengths. To date, much of the giant's success owed to science and collective musings on the distant American past, and, accordingly, the owners settled on Boston—the American scientific capital and the Mecca of romanticism—as the place for the giant's comeback.

During the antebellum years, Boston surpassed Philadelphia as the nucleus of American science. As historian Robert V. Bruce has argued, the city's age, stability, and overall quality of life attracted prominent scientists, but, more critical, Boston supported science and learning like no other city in America. Boston led the way in the establishment of public schools and colleges, with Harvard in nearby Cambridge an institution on par with the Old World's finest. The wealthy elite endowed both individual research efforts as well as early professional organizations, and, by the 1840s, Boston boasted no fewer than fourteen scientific societies, including the Boston Society of Natural History and the American Academy of Arts and Sciences. The city's many private and public libraries likewise proved a boon to scientists and scholars more generally. At the same time, however, Boston and New England fostered a broader culture of—and enthusiasm for—science. "Love of science is inherent in New England," two foreign sojourners observed. These same

writers likewise noted the manner in which science permeated Boston society: "In London or in Paris many more celebrated men of science may be found; but these capitals are of such immense extent, and so many different interests divide and split people into sets and coteries, that the literary and scientific element is entirely diluted: whilst in Boston it forms one of the principal features of society."[6]

Still, for all of its scientific attainments, Boston perhaps was best known for its writers and philosophers, with The American Travellers' Guides hailing the city as "the literary capital of the Western world." Over preceding decades, Boston and New England writers such as Ralph Waldo Emerson, Henry David Thoreau, Nathaniel Hawthorne, Herman Melville, Henry Wadsworth Longfellow, James Russell Lowell, and Oliver Wendell Holmes, while drawing upon European romanticism as well as other Old World influences, nevertheless established a uniquely American literature. Boston and New England had given rise to transcendentalism, the romantic school that broadly celebrated nature and the individual, while musing specifically upon America's landscapes, traditions, and distant past. Indeed, nowhere did Carl Christian Rafn's writings on early Viking voyages enjoy greater resonance than with New England writers and intellectuals. Decades later, in the wake of war, a new style of writing slowly was emerging from the West, with Mark Twain and Bret Harte emphasizing rugged realism over romantic sentimentality, but, still, the old literary guard remained active and influential. Over the course of 1869, Emerson had prepared Society and Solitude, a collection of essays that at once celebrated time-honored romantic themes, but also took aim at an increasingly materialistic American culture. Along the same lines, Lowell soon would publish "The Cathedral," a reflective poem that contrasted medieval courage and virtue with the gross materialism of modern society.[7]

The great wonder arrived at the so-called American Athens on Saturday, January 22. That morning, workers blocked traffic for more than an hour, as they moved the giant into its new exhibition space, an empty storefront at 113 Washington Street. The offices of the Boston Morning Journal lay directly across the street, and the owners may have selected the new location in part to capture the newspaper's attention. Over preceding months, the Journal, Boston Post, and Boston Herald generally offered sparing coverage of the great wonder, summarizing developments such as James Hall's examination, the Jules Geraud hoax, as well as the allegations from Fort Dodge. While possibly skeptical, city editors did offer accurate summations, and therefore these men may simply have waited for definitive judgment to emerge before extending significant coverage. Still, even with their advantageous location, the

owners did not receive anticipated headlines upon the giant's arrival. The *Journal* noted only that "the Cardiff Giant blocked up Washington Street nearly an hour Saturday morning in getting into his quarters," while the *Post* observed: "A big thing—the Cardiff Giant, at 113 Washington Street." The *Boston Daily Evening Traveller*, much to the chagrin of the owners, mistakenly reported that an imitation giant had arrived in the city: "A model of the Cardiff Giant arrived in town this morning."[8]

Prior to opening the exhibition, Hannum and Rankin—the only owners still traveling with the show—extended invitations to prominent intellectuals and scientists, hoping to elicit endorsements of the giant. On Tuesday, January 25, a formidable delegation arrived at the exhibition space for a private showing. The city newspapers did not record the names of the attendees, but, according to *The Giantmaker*, the group included Emerson, Holmes, geologist Charles T. Jackson, surgeons and anatomists John Barnard Swett Jackson, Winslow Lewis, James Clarke White, and Charles Eliot Ware, sculptors Edward Brackett and Cyrus Cobb, painter William Morris Hunt, and humorist Benjamin Shillaber. The men closely scrutinized the great wonder, with Jackson and the anatomists utilizing scientific instruments. Nonscientists such as Emerson leveraged these same devices, supplementing their visceral reactions with attempts at empiricism. As *The Giantmaker* characterized the philosopher's examination:

> Emerson walked around and around the Giant in his rapt manner, but with keen eyes scrutinizing every point in the mysterious object. With a microscope he repeated his inspection, and made himself so far as he could, master of every feature and detail of the Giant. But when asked for his judgment, he simply replied: "It is beyond the depth of my philosophy, very wonderful and undoubtedly ancient."

Shillaber concurred with Emerson's judgment of antiquity, while invoking the grand and inscrutable American past: "It is a remarkable and antique image, and opens up a volume as yet never read—a hitherto sealed book of the antiquities of the continent." Despite his long-standing fascination with human giants, Holmes, like the other examiners, judged the giant a statue. Though the anatomist-poet was vague with regard to the great wonder's origins—"It is an immense statue cut from stone by unknown hands. Its anatomical developments are very wonderful"—*The Giantmaker* reported that the other examiners considered the statue of significant age and decidedly legitimate. Cobb, for one, reportedly charged: "The man that calls that a humbug simply leaves his autograph that he is a fool."[9]

If *The Giantmaker* painted an accurate picture of the examination, the question remains why these eminent intellectuals and scientists endorsed the giant at a time when most Americans agreed on its fraudulence. On one hand, seeing invariably produced believing over the course of the giant's existence, and these men were not immune to the great wonder's evocative power. At the same time, Bostonians were beholden to newspaper coverage, and, in the American Athens, the enormous burden of proof against the giant had been distilled into a few sentences—the same amount earlier given to the Geraud story, which the men knew had been proven false. The city newspapers themselves remained noncommittal on the matter of fraud. The *Boston Daily Evening Transcript*, for instance, characterized the giant's origin as an unsolved mystery: "The Cardiff Giant is a stupendous—what? That is the question about which the scientific and the common people alike are puzzled." The *Boston Morning Journal* similarly observed: "Our readers are familiar with its history and with the controversy that has arisen in regard to it. They have now a chance to decide whether it is a 'humbug' or not. We can only say that if it is a humbug it is the most artfully devised one which has ever been exhibited. We advise all to see it, for the leading question of the day will be, 'Have you seen the giant?'" While the city newspapers again only summarized the group examination—"Yesterday scientific gentlemen gave close scrutiny," noted the *Post*—the exhibition nevertheless enjoyed a decent opening the following day. Somewhere between four hundred and a thousand curiosity seekers beheld the giant—a far cry from salad days in Cardiff, Syracuse, and even Albany, but still dramatically outpacing its New York City performance.[10]

A few days earlier, Hull had resurfaced in Syracuse, furnishing Westcott with evidence of the ironbound box's contents. Over preceding weeks, Hull returned to Chicago, mollifying an increasingly agitated Frederick Mohrmann while also collecting affidavits from Nicholas Strasser, who built the container, as well as from David Herrman and Peter Wilson, who packed the box and moved it to the rail station. Either Hull falsified the statements, or paid the men off, for the trio collectively attested that the ironbound box contained illicit machinery and measured only nine feet in length— a full foot and a half shorter than the great wonder. Later returning to Binghamton, Hull secured affidavits from Israel Amsbury and nephew John Hull Jr. According to the men, they conveyed a nine-foot box from Union to Syracuse, but denied changing its contents along the way. Westcott fell for Hull's ploy completely and promptly commenced a triumphant letter to the newspapers. The dentist opened this communication by mocking Leavenworth's earlier statement that "the giant [was] dead." Referencing Charles

Dickens's *A Christmas Carol*, Westcott noted that, despite his death, Marley still haunted his erstwhile partner: "It would verily seem that the *ghost* of the Cardiff giant had been on the rampage, bothering in a very unaccountable manner some of its early friends and admirers. Ungrateful ghost his!" Along the same lines, Westcott revisited earlier endorsements from Samuel Calthrop, Henry A. Ward, Lemuel Olmstead, and John Boynton, observing that the initial statements of these men should have been "wholly sufficient to exculpate both Mr. Leavenworth and the purchasers of the Cardiff giant from the charge of being simpletons, because they all alike regarded the statue both of great merit and antiquity, and as being wholly free from any just imputation or fraud." The dentist then proceeded to the crux of his communication, heralding new evidence against allegations of imposture: "We *now* have ample *proof* that the fraud theories are without the least shadow of foundation in fact, and that these *theories* are the 'stupendous fraud and humbug.'" With reference to the deadline for establishing fraud, Westcott announced that none of the owners would seek cancellation of their notes: "The knowledge now in possession of the purchasers of the giant has constrained the conclusion that they could not, if they were so inclined, resist the payment of these notes—nor is any one of them, so far as I know, as a matter of *policy*, disposed to EXCHANGE HIS INTEREST IN THE GIANT FOR THE NOTE REPRESENTING IT." The public was unaware that that the January contract with Hull superseded the original arrangement, but Westcott capitalized on public knowledge of the January 24 deadline, publishing his letter in the *Journal* on that same date. For the most part, however, Westcott's communication met with stunned silence. While the *Standard* did reprint his letter two days later—the day that the Boston exhibit opened—the Syracuse newspapers offered no commentary, and the letter received barely any national circulation.[11]

While awaiting payment from the owners, Hull, now seemingly an equity holder once again, collected additional affidavits to bolster the giant's case. In Utica, the giant maker took statements from Charles Wells and Orson Davis, who helped him unload the box at the Black River Canal, as well as from Hattie Bishop, an Onondaga resident who saw Amsbury and John Hull Jr. conveying the box north of Cardiff. On Saturday, January 29, Hull's affidavits—juxtaposed with previously published shipping records—appeared in the *Syracuse Daily Journal*, and, a few days later, in the *Standard* and *Courier*. The newspapers largely refrained from commentary, with the *Standard* mustering only a halfhearted introduction: "A plausible connection of 'Fort Dodge' and the 'box' by means of affidavits greatly elated the believers of fraud as to Old Cardiff. The proprietors of the Giant think that they have

thoroughly exploded that 'connection,' and all theories of fraud based on that mysterious four horse team and iron bound box by the following affidavits." Critically, the affidavits received little or no coverage in Boston. In its entertainment section, the *Post* noted that new affidavits had exploded the allegations of fraud, but Hannum and Rankin may well have paid for this quasi advertisement.[12]

While failing to receive the anticipated boost from the affidavits, the exhibition nevertheless drew decent crowds in Boston. Over the course of the giant's first two weeks in that city, newspapers estimated an average daily attendance of four hundred curiosity seekers, with the great wonder drawing more than a thousand on a couple of occasions. At the same time, the giant still enjoyed currency within the scientific and intellectual community, and, on Friday, February 4, several members of the initial delegation returned for a follow-up examination. While the *Boston Traveller* reported the presence of Jackson, Brackett, Lewis, White, and Ware, *The Giantmaker* claimed that Emerson—Jackson's brother-in-law—also returned for a second visit. After commencing the examination, the men asked Hannum and Rankin for permission to bore a hole into the giant's head. While the two men debated the efficacy of the action, Hull conveniently arrived at the exhibition in the company of nephew Linus Bliss, who actually was the giant maker's senior. Hannum, who over preceding months had not crossed paths with Hull, at once recognized him as Olds, his erstwhile traveling companion. The giant maker corrected Hannum, identifying himself as the infamous Hull and rendering the horse trader bewildered and angry. Hannum demanded a full interrogation, but, first, seeing as how Hull knew so much about the giant, asked him how to handle the scientists' request. Hull told him to let the men bore their hole—after all, they would find only gypsum. The giant maker then ascended to the balustrade and bemusedly watched the surgery. After some time, the men finished their examination and, taking leave of the owners, promised a forthcoming report in the newspapers.[13]

At this point, Hull and Hannum launched into a long and tense conversation, which Rankin recorded in *The Giantmaker*. From the outset, Hull acknowledged that the giant was a fraud, explaining how their other traveling companion—Henry Turk—unwittingly inspired the entire scheme. According to Hull, he earlier recognized Hannum's name in the newspapers and thus avoided the giant's owner at all costs. Hannum reportedly was shocked by the truth about the giant, but more he was livid at Hull for swindling him and ruining his reputation. A defensive Hull charged back that it was no swindle—after all, the giant earned Hannum a pretty penny. At the same time, Hull reminded the horse trader that scientists and other men put forward all the grandiose

claims about the giant—not the owners themselves—and therefore Hannum's reputation would not suffer. The mood gradually softened, and the two men even shared a laugh about Twain's "A Ghost Story." Still, as the giant maker took leave of Hannum, the horse trader's mood was anything but jovial. He promptly departed for Syracuse to apprise colleagues of developments, all the while wishing that the giant simply would go away. Stubborn supporters, however, would not let it go so easily.[14]

* * *

Members of the follow-up delegation—sans Emerson—convened at Jackson's home on Saturday to discuss the giant. Earlier, upon hearing of the planned meeting, the Boston Traveller scoffed: "They meet this afternoon to talk together in conclave, and we doubt not that they will arrive at conclusions, causing the wise to wag their sagacious heads and filling the common people with wonder." By contrast, the Boston Morning Journal presented a more balanced assessment: "A committee of scientific gentlemen yesterday afternoon 'viewed the body' of the Cardiff giant. Among their number were gentlemen prominently known by our citizens and practically conversant with anatomy, mineralogy, and sculpture. Their verdict, which will be a carefully prepared report from a scientific point of view, will be looked for with curiosity." Over the course of the day, the men debated the great wonder's origins, all the while preparing their public statement. On Monday, the Boston Daily Advertiser ran the assessment as a news story, while Rankin, perhaps begrudgingly, offered it as an advertisement in the Boston Morning Journal. The statement, in part, read:

> Dr. C. T. Jackson and Mr. Brackett expressed the opinion that the material is natural, stratified gypsum, or plaster stone, and bears marks of erosion by water, which could have been effected only in a long period of time. The statue is of decided artistic merit, and appears to be the work of some one who has never studied antique models. We are satisfied that there is no deception about it.
>
> The other gentlemen thought it a work of great interest as a statue.[15]

That Brackett and Jackson emerged as the primary spokesmen hardly was surprising, for both men tended toward fervent belief. Brackett, who was both a sculptor and a commissioner on land fisheries, was a devout Spiritualist, frequently staging séances to communicate with the dead. In a later book titled Materialized Apparitions, Brackett would claim, for instance, that a spirit once condensed into human form in front of him, asking: "How do you do?"

What do you think of this?" Jackson was far more unstable and arguably even dangerous. The state assayer firmly believed that he had been the first man to use anesthesia in surgery, and, for decades, waged psychological warfare on the true innovator, William Thomas Green Morton, whom he eventually drove to an early grave. Jackson also had accused Samuel Morse of stealing his idea for the telegraph. In February 1870, the geologist was drinking heavily, and at least one historian has suggested that Jackson was suffering from schizophrenia. In fact, he soon would suffer a complete mental breakdown while visiting Morton's grave, ending his days in a mental institution.[16]

For the most part, newspapers across the country ignored these latest scientific pronouncements in favor of the giant. Where editors did pick up the story, the tone typically was less than charitable. The New York Commercial Advertiser, for instance, reprinted the Traveller's earlier report under the headline: "The Savans Bore a Hole in His Head and Hold a Solemn Conclave—Results Thereof." The giant had remained a national joke, partly because Barnum and Wood still played the imitation game for laughs. At the beginning of February, the two men, who maintained their exhibition during this entire period, secured a second imitation. Wood's Museum accordingly took to promoting its "two original Cardiff giants." Still other newspapers simply pined for the end of giant mania. As the Syracuse Daily Journal observed: "And who is not tired of hearing of giants to right of them, giants to left of them? And who does not earnestly wish for the return of 'Jack, the giant-killer?' Yet the 'original and only Cardiff giant' has his fascinations for Bostonians, who by hundreds daily pay him homage."[17]

Midwestern newspapers soon would grant the Journal's giant-killing wish. On February 2, two days prior to the follow-up examination in Boston, the Chicago Daily Tribune published an exposé of Hull and Martin's activities in the Garden City. Henry Salle was the source, though the newspaper did not name the sculptor directly. After furnishing insight into the production process, Salle joked that the giant hardly represented his best effort: "Well, they hurried me like thunder—any baker could make as good a thing out of dough." After reviewing the Tribune's report, the Sauk County Herald came forward with details of Hull's suspicious activities in Baraboo, culled from interviews with local residents. After noting earlier meetings with Daniel Webster, Andrew Johnson, Henry Ward Beecher, and Barnum, the Herald's editor joked that none compared to the esteemed giant maker: "Insignificant on the tablet of our recollection shall be all these, when we consider that George Hull, with the ingenuity adequate to dupe, diddle, defraud and gull a whole continent, did nevertheless once lend us a dollar! George, come back now and we'll pay you."[18]

The crushing blows came on February 10 and 11. On the former date, Salle and Mohrmann published a joint letter in the *Chicago Daily Tribune*, identifying themselves thusly: "We, the undersigned, desire, through the medium of your columns, to state to the public that we are the makers of the so-called Cardiff Giant." As the two men explained, while they still held a "pecuniary interest in the genuine Cardiff," they had been "disappointed by the men who engaged us to do the job"—a clear indication that Hull never paid the workers in full. More damningly, Salle and Mohrmann indicated that they had evidence of their involvement. In his own letter the following day, Mohrmann specifically identified this proof as the Chicago derrick as well as its associated bands, though Salle also may have retained his clay models. Mohrmann reiterated the basic elements of the sculptor's earlier account, while noting his own recent interactions with the giant maker: "Hull was in Chicago about two weeks ago, and told me that he had sold his interest, and had received notes therefor [sic]." According to Mohrmann, he subsequently reached out to Martin, but the blacksmith gave an entirely different story, one reflective of Hull's misinformation: "I wrote to Martin about it, and he replied that Newell, another interested party, had the notes and had run away with them." Mohrmann made no reference to Edward Burkhardt, presumably to maintain their business relationship, and, indeed, the marble dealer entirely escaped scrutiny during this period. In conclusion, Mohrmann effectively dared Hull and others to deny the truth of his and Salle's statements: "If Hull, or the parties now in possession of the giant, deny the truth of what I say, Salle and myself are willing to make affidavit that the facts given are true. Affidavits of other persons who are familiar with the circumstances connected with the making, will also be procured, and the giant proven to be what it is, as every intelligent person knows—a humbug and a swindle." The *Syracuse Daily Journal*, *Syracuse Daily Standard*, *New York Commercial Advertiser*, *Daily Evening Bulletin*, *Daily Cleveland Herald*, and *North American and United States Gazette* all reprinted the *Tribune*'s items, and, for most Americans, the naming of the sculptor finally settled the giant's fraudulence once and for all.[19]

At this point, the owners removed themselves from active management of giant affairs. A thoroughly embarrassed Westcott washed his hands of the matter, giving Hannum his share and attempting to renew his dental practice. The other owners retained their interests, but empowered Calvin O. Gott, who earlier photographed the giant at Cardiff, to manage the exhibition on their behalf. Upon his arrival in Boston, Gott announced that the great wonder would remain there only a few days longer, while promptly commencing a search for future exhibition locations.[20]

Though crowds dwindled by the day, a few Bostonians stubbornly maintained their belief in the giant. In a published letter to the owners, Jackson scoffed at the recent claims of Salle and Mohrmann: "I was amused last evening on reading a statement in the Transcript, that certain men in Chicago claim to have made the Cardiff Giant . . . I would as soon believe that Bathylius wrote Virgil's famous lines, as that they could do such work. Challenge them to do it, and offer a high reward. You can do it with the most perfect safety." Brackett invoked the celebrated William Morgan affair in dismissing the Chicago claims: "I see by the papers that two men in Chicago claim to have made the Cardiff Giant in seventeen days. Secure them at once, and put them on exhibition with the Statue, for they have performed a feat more wonderful than that attributed to Morgan, who, in order to escape the vengeance of the Masons, sculled up over Niagara Falls in a pot-ash kettle, with an iron crowbar." Meanwhile, the giant remained an item of interest in Boston intellectual circles, most notably the Thursday Evening Club. The club was a veritable who's who of the Boston intelligentsia, with members including Harvard scientists Louis Agassiz and Asa Gray, Harvard President Charles Eliot, Massachusetts Institute of Technology founder and first president William B. Rogers, Reverend Phillips Brooks, and author-clergyman Edward Everett Hale. At a meeting on February 17, club members discussed the giant over dinner, though, lacking minutes, it is uncertain whether any members maintained belief or if all simply shared a laugh over public credulity.[21]

Around this time, Hull finalized arrangements for his planned tell-all book, but did so unbeknownst to Ezra Walrath and with a completely new partner in Rankin. For the latter, the book represented a new entrepreneurial venture, but also an opportunity to recoup any earlier giant-related losses. Still, given the manner in which Hull duped him and his associates, Rankin must have possessed a strong sense of humor—or an incredibly single-minded business sense—even to consider working with Hull. The entrepreneur's admiration for Hull's business savvy did manifest itself in *The Giantmaker*, as Rankin, the literary character, compliments him on the "wonderful achievement of getting up such a production, and the great skill manifested in it." Still, Rankin's primary motivation for involvement in the book project may have been to recast his own role in the historical episode—which indeed he would do in earnest. The two men formalized their arrangement on February 25, agreeing to share equally in expenses and profits. Three days later, they made a separate deal with Samuel Crocker, an editor from Lexington, Massachusetts, who soon would launch *The Literary World*, a Boston journal. The latter agreed to write the history of the hoax at

eighty-five cents per word, along with royalties. While Crocker commenced his research and writing, Walrath did the same, completely unaware that Hull had struck a better deal with others.[22]

An angry Martin, to some degree, upstaged Hull in March, offering up a full confession, while also claiming credit for the original idea. On Sunday, March 13, Martin arrived in Buffalo from Boston, where the blacksmith presumably had attended the giant's exhibition. After registering at the Continental Hotel, Martin requested a newspaperman, for "he had something of importance to communicate," and a correspondent from the *Buffalo Courier* promptly arrived on the scene. Upon learning that Martin's subject was the giant, the reporter scoffed that "considerable had already been said on the subject," but soon recognized that the blacksmith was an insider. The *Courier* characterized Martin's motivation thusly: "He gave as a reason for making the revelation that the 'giant' had with him been a failure, and that his partner, George Hull, had not dealt fairly with him." The blacksmith recounted his activities with Hull in Fort Dodge and Chicago, while referencing his trip to Syracuse to bid up the sale price. As Martin described subsequent developments, including arrangements with the purchasers, the blacksmith got several details wrong—an indication of how Hull had shared enough detail to keep him onboard, while masking the true financial situation. Martin criticized the giant maker for stiffing his partners, noting that he had received only a thousand dollars, Newell two thousand, and Burkhardt nothing. Martin did not know Hull's exact profits, but clearly sensed that they had been far greater, and, to exact revenge, he claimed credit for the idea of the giant, casting Hull only as a man "recommended to me for his shrewdness and enterprise." As the blacksmith further articulated: "I knew the American people liked to be humbugged and would pay well for it. I wanted to beat Barnum." Martin also cited his plan to discover the giant's mother in the vicinity of Newell's farm—which never came to fruition because Hull allegedly made "a d——d fool of himself." In conclusion, the blacksmith vowed to deceive the public again: "I will humbug the American people within two years, and the Cardiff giant will be a wooden nutmeg affair." Martin, of course, would do no such thing, while Hull, who did perpetrate a second hoax, made his former partner pay dearly for these statements. Over the course of ensuing decades, Hull effectively would write Martin out of the historical episode altogether.[23]

Martin's statements received wide national circulation, appearing in the *New York Herald*, *New Hampshire Patriot*, *Charleston Courier*, and *Daily Evening Bulletin*. In light of this first full confession, the *New York Daily Tribune* took occasion to reflect on the entire affair. Horace Greeley began

his editorial in joking fashion, scoffing at the missed opportunity to see the giant's mother: "The behavior of the miserable Hull, in making a d——d fool of himself, is therefore to be deeply regretted." At the same time, the *Tribune's* editor sarcastically noted the giant's earlier scientific defenders, wondering whether any of these men even would acknowledge Martin's statements: "This confession of the gentleman who 'got up' the giant will perhaps draw forth a few remarks from the gentlemen who gave it various scientific recommendations." While maintaining his snide tone, Greeley concluded the brief item by launching into the community of experts that failed to recognize the humbug:

> We of course understand that the eminent professors, geologists, antiquaries, and authorities on art and anatomy who vouched for the authenticity of the statue, are "not up to small deceit or any sinful games;" but we should like to hear from the intelligent savants who declared, some that it was a real petri-faction, some that it had evidently been in the earth at least 200 years, some that it was "stamped with the marks of ages," one that "only the ancient Greek school of art was capable of such a perfect reproduction of the human form," and one that Italy possessed nothing which embodied so perfectly "the intel-lectual and physical power of a rock-hurling Titan."

Indeed, ever since the December revelations of fraud, Americans had been making scientists the scapegoats of the hoax. The *Syracuse Daily Journal* scoffed that men of science needed to brush up on the properties of gypsum, while the *Albany Evening Journal* nicknamed Hall "Dr. Fossil." In a letter to the *Courier*, "SKEPTIC" called for the state geologist's early retirement— "Why Professor Hall is not a fossil and why he should not be carefully laid away?"—while the newspaper itself demanded Hall's resignation, charac-terizing the geologist as a "vulgar fraud." The proud Hall, of course, would do no such thing, and, in the pages of the *Courier*, the geologist reminded readers that he had referred the matter to archaeologists and withheld his own opinion on the giant's origin. Conveniently, however, Hall ignored both his endorsement of the giant's scientific value as well as his speculation regarding an early white civilization. Hall's protestations notwithstanding, scientists had been the clear losers of the affair—ironic in light of Hull's own love for science. In a high-profile episode, American scientists did little to convince the public that they were better arbiters of scientific matters, and, amid efforts to professionalize the community and establish an expert class of citizens, scientists lost still more credibility in the public eye. The affair also rather dramatically highlighted the growing pains and failings of prepro-fessional science. Despite the State University's best efforts, most scientists

had assessed the giant independently and in an uncoordinated fashion. Geologists, naturalists, mineralogists, antiquarians, chemists, and anatomists all put forth their opinions, and, with amateur enthusiasts already crowding the field, the result was a scientific din. The specific failings of archaeology also proved critical. Early practitioners lacked methodological tools to assess the great wonder and instead resorted to speculation and romantic musings about the past. In crossing over into this realm, Hall and other scientists demonstrated even less facility. American science obviously required a mature archaeological discipline, but it also would need specialization. American colleges produced men with generalized scientific knowledge, hence the familiar hyphenated personas of nineteenth-century American science: the geologist-paleontologist, the naturalist-physician, and the mineralogist-chemist. A true expert profession would necessitate smaller and deeper areas of specialty, placing scientists in better position to seek truth while also inhibiting them from straying into other domains. While emerging as a cautionary tale for overzealous scientists, the giant, in a way, also offered one for science at a critical juncture. In giving shape to the modern profession, good scientists would build upon earlier successes, but, perhaps more critically, they also would learn from past mistakes.[24]

While harsh in its assessment of science, Greeley's editorial conveniently ignored the role of newspapers in the affair. A few weeks earlier, the *Chicago Daily Tribune*, while blaming scientists for the humbug's success, also faulted its own brethren: "If the owners of the giant who perpetrated the joke on the *savans*, and a goodly portion of the people of the country, and that their swindle is in any way interfered with by this expose, let them secure the services of some influential newspaper, and some more affidavits and opinions of the wiseacres of science, and they may be able to sell some more stock in their enterprise." The giant affair quite clearly manifested the weaknesses of an emerging American press. Editors and reporters freely had mixed news and opinions, while sometimes failing to corroborate even the most basic facts. More damningly, newspapers misrepresented individuals to advance their own editorial beliefs, as in the case of the pro-petrifaction *Standard*, which recast the opinions of George Geddes and Erastus Palmer. Greeley's own colleagues in New York City likewise were not exempt, having allegedly accepted bribes from Barnum in exchange for positive press. The public, in large part, relied upon newspapers for facts, and, in the context of the giant, their record was spotty at best. Still, the problem was much broader in scope. Newspapers offered information on giants and the ancient past, but so did science, local history books, encyclopedias, and, of course, the Bible. In a rapidly growing America, men and women enjoyed unparalleled access to

information, and the commercial stakes in presenting that information never had been higher. Still, across these disparate sources, scientific and historical information all too often was inaccurate, inconsistent, and biased. Many Americans accordingly followed their personal impulses, becoming their own best experts, but, still, these men and women fell prey to their own fervor, superstition, and prejudice—all of which played equally significant roles in the success of the hoax. In coming decades, the rise of experts—coupled with the professionalization of key fields—mitigated some of these information issues, but, at least in the case of newspapers, things would get significantly worse before they got any better.[25]

The timing of Greeley's reflection was noteworthy, as it roughly coincided with the adoption of the Fifteenth Amendment into the United States Constitution. The measure received the requisite votes for ratification in February, but Secretary of State Hamilton Fish did not formally acknowledge its passage until March 30. In a letter to Congress, President Grant hailed this momentous measure:

> A measure which makes at once four millions of people voters who were heretofore declared by the highest tribunal in the land not citizens of the United States, nor eligible to become so, with the assertion that at the time of the Declaration of Independence the opinion was fixed and universal in the civilized portion of the white race, regarded as an axiom, in morals as well as in politics, that "black men had no rights which white men were bound to respect," is indeed a measure of grander importance than any other one act of the kind from the foundation of our free Government to the present time.

Still, ratification had been a difficult and divisive process. Several states rejected the measure outright, including California, Kentucky, Delaware, Georgia, Maryland, Tennessee, and Ohio, though the latter state ultimately did change its vote. In New York, just as political observers predicted, William M. Tweed sponsored a resolution to rescind the state's ratification, and the new Democratic legislature followed his lead. In New York and other states, legislators weighed partisan and practical concerns amid the ratification debate, but, for the public, the primary issue had been race. Since the waning days of war, Northern and Southern citizens alike voted down Negro suffrage in popular referenda, refusing to admit full racial equality. In 1869, the New York popular vote manifested similar concerns and drew clear lines on the social legacy of war. At the same time, however, opposition to Negro suffrage at this stage reflected growing disdain for the radical party as well as its platform of war issues. New Yorkers and Americans more generally were looking forward, and astute Republicans soon would commence in earnest

what, to some degree, already had begun: the retreat from Reconstruction. It was time to renew the march of commerce, progress, and empire, and, in its own small but also very big way, the giant briefly fed this desire, invoking broader American impulses and contributing to the emerging practical reunion. Soon, political and social Reconstruction would give way completely to a period that would make America a thoroughly modern nation. The giant also foreshadowed the costs of this coming age, highlighting not only cracks in an ever-growing system but also identifying the individuals who might exploit them.[26]

* * *

The giant eventually traveled the Northeast, but it was hardly the victory tour once envisioned. In May, the exhibition left Boston, with Gott taking the great wonder to Portland, Maine. Though the manager promoted the giant's origins as an ongoing mystery, the exhibition drew only a smattering of believers, with the great wonder mainly attracting men and women who wanted to scrutinize the humbug. A few weeks later, Gott brought the great wonder back to Massachusetts, establishing the exhibition at Lowell. To generate enthusiasm, he offered reduced admission to scholars, while boasting about significant female attendance to the *Lowell Daily Citizen and News*, but, still, the manager's efforts proved for naught, as the great wonder attracted only handfuls of curiosity seekers. By the summer months, the giant's own drawing power had diminished so drastically that Gott took to exhibiting it as a sideshow at county fairs. The giant made appearances in Worcester, Massachusetts; Saratoga Springs, New York; as well as in several Vermont towns. As the year drew to a close, the exhibition moved to Springfield, Massachusetts, fittingly enough only a few miles from where Hull spent his youth.[27]

In the new year, Gott sought full ownership, and shareholders proved more than willing to oblige. In January, the photographer bought a five-eighths interest from Hannum for four thousand dollars, with the overall share most likely covering not only the latter's equity but also that of Westcott, Rankin, Spencer, and Son. A month later, Gott bought a quarter share from Newell, who by this point had moved to Syracuse. The interest likely was the Fitch-Ellis share, which reverted to the farmer sometime in the wake of the Chicago reports. In March, Gillett sold his sixteenth share to the photographer, and Simeon Rouse did likewise upon reclaiming his interest from Thorne, who defaulted on his payments. Thorne was one of the true victims

Upper portion of an advertisement for the county fair tour. Source: Courtesy of the New York State Historical Association Library, Cooperstown, New York.

of the hoax, having mortgaged his farm to purchase equity in November 1869. The Utica brewer never did enjoy a box-office windfall, and, though a court forgave part of the debt, the giant ruined him financially.[28]

While resolving ownership claims and relocating his own family to Fitchburg, Massachusetts, Gott turned the exhibition over to Billy Houghton, who, as an earnest believer, followed the giant from its days in Cardiff. The

storekeeper exhibited the great wonder in New Haven, Connecticut; Green-field, Massachusetts; and Troy, New York, before finally delivering it to Fitch-burg in the fall of 1871. At last, it seemed that the giant's nomadic days had drawn to a close. The new digs, however, hardly befitted the erstwhile public sensation. The giant once regarded as a founder of American civilization—or the artistic handiwork of a lost race—took up residence in a lockbox in Gott's yard—a rather inglorious end to the first chapter of its public career.[29]

CHAPTER TWELVE

~

At His Old Tricks

Giant matters commanded George Hull's attention in the immediate aftermath of the hoax, as he filed a lawsuit, sold an ownership share, as well as coordinated his planned manifesto. Still, Hull very much was fixated on his next move. Given American expansion and the booming economy, contemporary businessmen and entrepreneurs were making vast new fortunes seemingly overnight, and Hull's own cigar-manufacturing trade finally had flourished in Binghamton. Still, while looking ahead at the future, Hull could not help but look back. The Cardiff giant had not succeeded in undermining religion, and, while the scheme earned Hull significant profits, a few subtle changes might have garnered him an even greater windfall. In the end, rather than undertake respectable pursuits, Hull chose the path of imposture once again, conceiving of and plotting a sequel hoax. This new scheme, however, would prove a bitter disappointment—the first in a series of misfortunes for the giant maker during this period.

In the waning months of 1870, Hull still had not received payment from Amos Westcott and David Hannum, per their January arrangement. In the strictest sense of their contract, Hull indeed had satisfied the owners with his earlier affidavits, with Westcott even saying as much in the *Journal* and *Standard*. Of course, Westcott and Hannum conceived of the situation much differently now, with subsequent reports from Chicago establishing the fraudulence both of Hull's affidavits and the giant. The matter came to a head in October, as Hull sued the two men for monies owed: fifteen hundred dollars each, plus interest. John Hull Jr. filed the suit on his brother's behalf,

allowing him to avoid the scrutiny of creditors. In their subsequent answer, Westcott and Hannum thoroughly rejected the giant maker's claim to the money, while charging both Hulls with imposture:

> George Hull and plaintiff [John Hull Jr.] well knew that said giant was placed upon the farm of said Newell and both said George Hull and plaintiff had an interest in said giant and both knew the said giant was contained in said box and both assented to transport and deposit the same on said farm and both were guilty of imposing upon the public and of designing to defraud the said defendants.

In their legal brief, Westcott and Hannum erred in one obvious respect, assuming that the plaintiff had assisted in the transportation and burial of the giant, when, in fact, it was his son, who shared the same name. In plotting their defense, the two men identified John Boynton, Henry Salle, Frederick Mohrmann, Henry Martin, and Fort Dodge quarry owner C. B. Cummings as key witnesses to establish imposture, but, seeing as most of these men lived outside New York, Westcott requested and received temporary deferment in December 1870. The dentist also had more pressing concerns, as his health declined drastically around the time that Hull and the giant resurfaced. Newspapers characterized the affliction as hypochondria, which, at the time, connoted specific digestive ailments as well as vague melancholia-producing sickness. Mental illness ran within Westcott's family, and the dentist likely was suffering from some form of depression. Not relishing a protracted legal battle, the ailing Westcott, along with Hannum, settled the matter out of court, as Broome County shows no further record of the case. The dentist subsequently gave up his practice, recuperating in Europe during the summer months of 1871. Upon returning to Syracuse, Westcott sought further treatment from a Utica doctor, but still could not restore the normalcy that had prevailed before the giant affair. On July 6, 1873, after sharing breakfast with his family, Westcott closed the door of his bedroom, drew a pistol from a drawer, and shot himself in the neck. He succumbed before the first physicians arrived on the scene. Mental illness obviously played the most significant role in Westcott's death, but, still, in interrupting the dentist's professional career and causing him severe embarrassment, the giant quite clearly contributed to his rapid decline.[1]

In the wake of the settlement, Hull supplemented earnings by selling his remaining ownership share to Calvin O. Gott. The giant maker assumed renewed equity on the basis of the January arrangement, and Westcott and Hannum had not even seen fit to address the matter in their earlier affidavit.

Hull's interest was entirely redundant with shares previously acquired, but still Gott purchased the equity, valuing the resolution of all outstanding claims. With the recent transactions, Hull had realized the final direct profits from the scheme. He did not reveal specific earnings around this time, but, years later, the giant maker told reporters that the scheme netted him twenty thousand dollars. *The Giantmaker* offered a similar assessment, placing profits from the giant's sale and gate receipts between fifteen and twenty thousand dollars—or roughly ten times what Hull's equal partners had enjoyed.[2]

With Samuel Crocker still developing his history of the hoax, Hull faced a critical decision about his future. Even with recent earnings, the giant maker lacked the means to retire, and earlier creditors stood to collect a large portion of profits derived from his scheme and book. At least the prospect of renewing his cigar trade held greater appeal these days. Mass production techniques and newly invented molds had transformed cigar manufacturing in Binghamton, recasting the traditional craft as big business. In truth, American industry was booming everywhere, with new fortunes and wealth concentrations fast emerging. As Rev. Hugh Miller Thompson, a professor and newspaper editor, observed: "Wealth is accumulating in these United States enormously. There are fortunes more than regal in them at present, and these fortunes are rapidly doubling. There are more millionaires than in any population of the same numbers in the world." Railroad expansion, in particular, spawned many of these new fortunes, as speculators benefited from unprecedented demand for new companies and lines. From the end of war, the existing railroad network had doubled, with the period between 1870 and 1872 representing peak years. Engineers laid nineteen thousand miles of new line during this stretch, with new roads blanketing the western wilderness, including the Denver Pacific, Kansas Pacific, and a portion of the Atchison, Topeka and Santa Fe Railroad through Colorado. In an 1871 book optimistically titled *Saint Louis: The Future Great City of the World*, L. U. Reavis mused on the contemporary railroad boom: "The same indomitable spirit of energy and enterprise which had settled a wilderness, felling forests, fencing fields, and fighting savages, in its onward course, was equal to the emergency of building railroads. And it will soon happen that the American Union will be covered with a grand network of railways, penetrating not only every State, but almost every county and township in this vast territory." At the same time, future titans of industry were laying the foundations for corporate empires. John D. Rockefeller incorporated the Standard Oil Company in 1870, and, a few years later, Andrew Carnegie would open his first steel mill.[3]

For some Americans, the relentless pursuit of wealth—and the means to that end—had become cause for concern. In 1871, Henry Barnard, a

prominent American educator, perceived increasingly misplaced priorities: "As a nation we have increased so rapidly in wealth and power, have so far exceeded anything the world ever saw before in mental and material development, and as a people have become so engaged in the race for riches, as almost to forget our duty to art, science, and literature, to which we are indebted for so much that has made us great and powerful." At the same time, newspapers highlighted questionable business practices, graft, and political corruption with alarming frequency. Americans already had become familiar with names like Jay Gould, Jim Fisk, Daniel Drew, and Cornelius Vanderbilt, who, in the absence of government regulation, inflated railroad assets and profitability at the expense of stock purchasers. The public also learned the stunning degree to which William M. "Boss" Tweed had been beating the system. In April 1870, the powerful politico succeeded in passing a new charter that effectively gave him control over New York City's treasury. The *New York Times*, in a series of reports the following year, cited numerous insider contracts, kickbacks, and other forms of graft, noting, in one particularly memorable instance, how the Tweed Ring paid a plasterer three million dollars for his work on the city courthouse. Modern historians estimate that Tweed and his cronies bilked taxpayers to the tune of two hundred million dollars. Within months, reformers secured Tweed's arrest, but similar graft and corruption soon emerged in Pittsburgh, Chicago, Milwaukee, and Philadelphia. At the same time, the earlier Gold Ring would prove mere prelude to the vast corruption that plagued President Grant's second term, as journalists linked several key insiders to bribes and speculation schemes. The newspapers, though, turned a blind eye to scams within their own pages, as owners and editors sold more than a quarter of newly expanded advertising sections to patent medicine companies and hucksters. Mark Twain and Charles Dudley Warner soon would commence a novel about the emerging ethos of wealth, corruption, and materialism in America. The book, titled *The Gilded Age: A Tale of Today*, ultimately would give the new age its enduring name, at once invoking the shiny veneer of American progress but also the overall flimsy material—and the seedy underbelly that it shielded.[4]

Amid the shifting value landscape, Hull faced a defining choice. He could establish himself once again within the cigar business, seeking riches by conventional means, or he could revisit earlier imposture. In these years, Hull ruminated on his missteps in the giant scheme, particularly his ill-advised interactions with Avery Fellows and his failure to reach out to P. T. Barnum. It seemed within Hull's reach to perfect his methods, earning equally vast, if not greater, fortunes, all the while satisfying his own longstanding grudges. On the surface, Hull assumed respectable appearances, putting his windfall

toward a new Binghamton home and city block for a new large-scale cigar facility. Beneath this gilded exterior, however, Hull busily hatched plans for a new and even greater hoax.[5]

* * *

While religion remained at the forefront of his mind, Hull first desired a broad scientific conceit for his new scheme. Given how scientists fueled his earlier hoax, the giant maker sought a context to spark scientific exuberance as well as set the stage for endorsements. In some respects, the scientific landscape had changed little in the intervening years. On one hand, the older generation of scientists endured, and the overall community still consisted of amateur enthusiasts, self-trained practitioners, and, of course, outright quacks. The public still largely followed its own scientific impulses, as evidenced by the continued popularity of petrifactions. The giant did little to undermine belief in the phenomenon, with the public regarding the great wonder's fraudulence as a separate matter. In February 1871, newspapers across the country carried reports of a spectacular case in Milford, Ohio, where the petrified remains of Nancy Buggs weighed more than seven hundred pounds. The Mechanics' Institute Fair, held in San Francisco in August, promoted a petrified human heart from Storey County, Nevada. As the *Daily Evening Bulletin* dryly commented on the persistent petrifaction mania: "Now, says some genius, why not mark these petrifying localities, and plant dead heroes, statesmen, divines, or others, whose forms we wish to transmit to posterity, in appropriate attitudes, and let them petrify. Then dig them up and set them up; saving the cost of stone cutting, and adding to the meritorious deeds of the statue's lifetime the last, of 'Sculpting' himself."[6]

Still, the scientific landscape changed dramatically in at least one respect, as Darwinian evolution became a matter of public discourse. Charles Darwin published *On the Origin of Species* a full decade before the giant's discovery, but the English naturalist's observations on evolution largely remained confined to intellectual circles. In 1871, Darwin published *The Descent of Man*, more boldly asserting that man, apes, and monkeys shared a common ancestor. The theory eventually would polarize the religious world, with conservatives maintaining the Genesis story of Creation, moderates increasingly downplaying biblical literalism, and still others quitting their faith altogether. Still, in these early years, the popular imagination fixated more on the notion of the missing link, a gross oversimplification of Darwin's theory. The public believed that the fossil record soon would reveal evidence of an early transitional figure that was part man, part monkey. According to

business associate E. J. Cox, Hull read several scientific books during this period—an indication of his basic literacy—but became particularly obsessed with Darwin's theory. The missing link at once embodied Hull's religious and scientific goals. In the case of the giant, Hull had taken aim at the Bible in roundabout fashion, initially offering validation of its literal word. By contrast, a missing link fossil, in establishing the fact of evolution, would target the Bible and the Creator directly from the outset. Darwinian evolution eventually might undermine religion anyway, and so the giant maker merely would hasten the process by giving scientists the first true evidence, all the while capitalizing on their exuberance. Hull himself never spoke about the scheme, as it ultimately proved a disappointment, but Cox characterized his motivations thusly: "He used to say if he could get the scientific men quarreling over the origin of man, and throw the religious world into a hurly-burly of doubt and controversy, he should be perfectly satisfied and win great fame. He declared that he would spend the rest of his life in working a humbug which would explode the truths of the Bible and electrify the scientific world." Hull may well have been the first man to conceive of a missing link hoax, anticipating England's Piltdown Man by two and a half decades.[7]

After settling on his new scheme, Hull took steps to lower his profile, placing the book project on hold. Ezra Walrath earlier completed his writing and submitted the manuscript to Hull, but the giant maker either destroyed the text or shared it with Crocker, all the while telling Walrath that publishers simply had shown no interest. By the fall of 1872, Crocker may have completed his own text, but Hull nevertheless halted publication plans. As Cox recalled: "Hull went to Boston, saying he had made arrangements with a publisher to issue a history of the Cardiff Giant, and wanted to stop the publication, because, as he said, he had perfected himself, so that next time he shouldn't make a failure in that kind of business." While Hull showed concern for trade secrets, in reality, the public already knew most of the details of the giant scheme. After Edward Burkhardt followed up Martin's confession by claiming credit for sculpting innovations in *The Lakeside Monthly*, Hull himself consented to an interview with the *New York Daily Tribune* in September 1871. Over the course of that discussion, Hull not only recalled his early descent into atheism, but gave an overview of the entire hoax, including his original argument with Henry Turk, whom he did not name directly. While mentioning Burkhardt and his colleagues, Hull nevertheless took credit for the majority of the sculpting work. At the same time, the giant maker omitted Martin entirely—undoubtedly as retribution for earlier comments—while casting Stub Newell as the scapegoat for all his failures.

Hull rather ridiculously claimed that the scheme failed because the Cardiff farmer could not keep a secret: "I believe Newell blowed on me."[8]

Around this time, Hull concealed his financial assets and went "away from mankind," as he later termed it. Given the recent purchase of a new house and cigar factory, Hull's creditors only had multiplied in the wake of the giant hoax. For his new scheme, Hull needed time, focus, and money. First, the giant maker transferred twelve thousand dollars in capital assets and tobacco machinery to Israel Amsbury, his longtime friend and collaborator. The latter promptly reestablished the business in his name at Elkland, Pennsylvania, near the New York border. Given this framework, Hull could derive funds for his scheme through the cigar business, all the while escaping the notice of creditors. The giant maker further distanced himself from these men by declaring bankruptcy in the waning months of 1872, reporting overall liabilities of more than thirty thousand dollars. In January, Hull moved his family to Elkland, including his "invalid" wife, as one newspaper described her. Helen Hull never spoke publicly about her husband's activities, and the only clue to their relationship comes from Cox, who characterized the marriage as "not . . . the good terms that ought to prevail between husband and wife."[9]

In Elkland, Hull rented three hundred acres under the guise of establishing a farm, and, that summer, constructed an icehouse on the property. Hull envisioned the building as his workspace for experiments and soon thereafter installed a brick kiln within the structure. Despite hopes for a low profile, Hull's reputation clearly preceded him. Young boys greeted the giant maker in the streets: "Helloa, Cardiff Giant!" At the same time, the icehouse afforded little privacy, as neighbors soon heard the giant maker clanging away at all hours. Hull's nocturnal activities even quickly became a running joke around town. "Where's Hull?" one would ask. The standard response went: "Hull's gone into his hole. I guess he'll be out in the morning." As ever, Hull also acted indiscreetly, garnering attention for receiving a shipment of blood from Corning, New York. Hull's maniacal intensity during this period also registered with his business associates. Cox, who did not know the particulars of the scheme at this point, recalled how the giant maker developed severe cramps amid a trip through New York. Convinced that he was dying, Hull exasperatingly exclaimed: "Must I die and let those ———— fellows get the best of me? No I can't; I've got too much to live for. I won't die! I've got to stay!"[10]

During his first two and a half years in Elkland, Hull developed numerous prototypes within the icehouse, but did not come close to realizing the missing link. In August 1875, creditors became wise to the giant maker's

earlier financial maneuvers, alerting a U.S. commissioner in Syracuse. The official promptly issued a warrant for the giant maker's arrest in Binghamton, and, upon Hull's return there in December, authorities briefly jailed him. The giant maker posted bonds for his release, pleading not guilty to charges, but ultimately paid dearly for his transgressions. Upon his eventual return to Elkland, Hull had no remaining funds for the scheme and accordingly searched for investors. While Hull may have targeted Barnum from the outset, the giant maker did not approach the showman at this point, instead working out a deal with Theodore Case, owner of the Elkland Hotel, for seven hundred dollars.[11]

Flush with new investment money, Hull hired an assistant to facilitate the modeling process. In February 1876, the giant maker enlisted the services of a man known only as Fitch, who ran an artificial stone factory in the northern part of New York. One of Hull's relatives, Charley Babcock, worked at the Elkland cigar factory and agreed to serve as the model. After some time, Hull and Fitch successfully fashioned the legs, using Babcock's long and skinny limbs as their guide, but, still, the latter quit the project before the men completed the entire sculpture. Accordingly, the barrel-chested Hull served as the model for the torso, creating a stark contrast between the upper and lower body. Hull and Fitch took separate casts of the two sections, filling each mold with a mixture of Portland cement and metallic brown coloring. The men also placed human bones within the setting mix, establishing an internal skeletal framework. After forging the casts within the kiln, the men joined the two sections together for an upright sculpture. Still, while attempting to move the heavy item, Hull and Fitch broke the figure, forcing them to repeat the entire process. After completing the second sculpture, Hull, in a nod to his earlier giant, pricked the surface for the illusion of "goose flesh." In stark contrast to the solemn and dignified Cardiff colossus, however, the new giant was a monstrosity. The humanoid figure, which measured more than seven and a half feet tall and weighed over six hundred pounds, sported completely disproportionate limbs as well as an unusually large skull. More notably, a four-inch tail protruded from the new giant's backside. In March, Hull revealed his handiwork to Cox, who assumed operations of the cigar business from Amsbury and invested ten thousand of his own money to keep the enterprise afloat. After pledging to give Cox a share of the proceeds, Hull proudly crowed over his creation: "That tail alone is worth a million." According to Cox, Hull was "in ecstasies."[12]

Around the time that Hull finally finished his new giant, America effectively completed a chapter in its own history. In the earlier November presidential election, Samuel Tilden defeated Rutherford B. Hayes in the

popular vote and held an advantage within the Electoral College, though Democrats and Republicans still disputed results in Florida, Louisiana, and South Carolina. As the inauguration date loomed, America still had no president-elect, and eventually party leaders forged a compromise behind closed doors. In exchange for Democratic support of Hayes's presidency, Republicans agreed to remove the final federal troops from the South. For the most part, Republicans already had abandoned efforts in favor of full black equality, with legislators failing to enforce the promise of the Fifteenth Amendment. In the compromise of 1877, Republicans finally ceded the race question to the South, sounding the final death knell for Reconstruction. As the *Brooklyn Eagle* affirmed: "The negro problem, as it is called, it is for the South to solve." The wholesale disenfranchisement of blacks soon commenced in the South, and the age of Jim Crow dawned. In a sense, North and South finally had achieved full reunion, but did so at the expense of black citizens, rendering Reconstruction—in the words of one historian—"America's unfinished revolution."[13]

At the same time, Hull's own efforts remained unfinished, for the giant maker had exhausted all remaining funds, without engineering the new giant's transportation and burial. At this point, Hull reached out to Barnum, once again America's preeminent showman. In the wake of his success with the imitation Cardiff giant, Barnum commenced his second career in public entertainment. In 1871, the showman launched "P. T. Barnum's Museum, Menagerie, and Circus," a traveling show that soon became known as "the greatest show on earth." Along with partner William Cameron Coup, Barnum leveraged the rapidly expanding railroad network, recasting the circus from a wagon affair into a flatcar fleet that brought enormous animals and exhibits to cities and towns all over the map. The *New York Times* hailed the traveling show as the "most extensive and various affair of the kind ever organized," while the *Brooklyn Eagle* marveled at the mammoth undertaking: "The show, in a word, was an immense thing . . . It would take an entire Eagle to hold a catalogue of the articles; suffice it to say that if there be anything which a man would specially like to see he is pretty sure to see it, or something like it in Barnum's Menagerie." Within a few years, Barnum's enterprise would grow even larger, as the showman joined forces with James A. Bailey for the familiar Barnum & Bailey Circus. In March 1877, Barnum received Hull at his Bridgeport estate, listening to the giant maker outline his latest creation. The men once again boasted entirely different aesthetics, with Barnum holding the public in high regard and looking to entertain men and women, while Hull mainly sought to exploit them. Still, in supplicating Barnum, Hull most likely played up the scheme's humbug aspects,

and the intrigued showman, careful not to "buy a pig in a bag," dispatched agent George Wells to Elkland to review Hull's handiwork. Wells ultimately approved of the giant maker's creation, and, after telegraphing word to Barnum, the two men shipped the new giant to Bridgeport. On March 26, after returning to the showman's estate, Hull established a joint stock company with Barnum, Wells, and Case, and the showman specifically pledged to give the giant maker two thousand dollars, while also covering transportation and burial expenses.[14]

After finalizing the terms of their deal, Hull and Barnum discussed possible burial locations. In his own mind, Hull already had settled on Wethersfield Cove in the vicinity of Wethersfield, Connecticut. Over preceding decades, brownstone quarries in the general region had yielded countless fossil specimens, including prehistoric bird and dinosaur tracks. Prior to his first trip to Bridgeport, Hull had secured a turkey, impressing the bird's footprints into a tablet cast from his new giant's mixture. Hull subsequently buried the tablet at the cove, establishing a fossil context for the giant's eventual deposition. Barnum, however, did not endorse the giant maker's plan, fearing that his own strong association with Connecticut might engender skepticism from the outset. The great showman instead lobbied for the Rocky Mountains, and Hull deferred to Barnum's judgment. The latter already had a longtime associate, William Conant, in Colorado Springs, and the great showman at once sent for his erstwhile colleague, who now worked as an agent for the Atchison, Topeka & Santa Fe Railroad. After shipping the cargo to New York City, Hull returned to Elkland, where he forged additional salmon trout and turtle fossils in the kiln. He then proceeded to the Empire City, meeting Conant there on the April 8. The two men shipped the freight to Pueblo under the consignment of George W. Williams and promptly boarded a separate passenger train for Colorado Springs. Upon their arrival in that city, Conant introduced his companion as George W. Hall, a traveling acquaintance.[15]

Over the next two weeks, Hull and Conant scouted various locations within the Rocky Mountains, though the giant maker again acted indiscreetly, remarking to a guide at one point about how "he wouldn't be surprised if they found a petrified man there some day." On April 22, the two men reconvened in Pueblo with Doc Allen, a friend of Conant's and a man familiar with the surrounding terrain. Two days later, the trio finally settled on a burial location in Beulah, some sixteen miles southwest of Pueblo. On May 8, Hull, identifying himself as Williams, claimed the alleged shipment of machinery. With the assistance of Allen, the men conveyed the new giant to Beulah, partially burying the specimen at the foot of a low sloping hill. Before taking leave of the region, the men also deposited Hull's other fake fossils.[16]

At this point, Hull headed back to Elkland, as Barnum was abroad, and the discovery would have to wait for the showman's return. In June, Cox expressed his displeasure about Hull's recent arrangement with Barnum, noting his own exclusion from the joint stock company. Hull reassured his business associate, stating in his own defense that he had not wanted Barnum to think any additional men were privy to the new giant's existence. Cox, however, correctly surmised the giant maker's plan to box him out of the scheme, later recalling: "I told him I would have my pay or wash my hands of the whole business, and when he got ready to bring the giant to the surface, he would need to keep an eye on me." In August, Barnum returned from Europe and promptly established himself at his Colorado ranch. Around this time, Hull returned to Colorado Springs, and, in addition to identifying himself as George H. Davis, the giant maker took drastic steps to conceal his true identity. Hull cut his hair and shaved his moustache, while also donning heavy spectacles to cover his memorable eyes. While the giant maker lodged at the Crawford House, Conant alerted him to a recent communication from Cox, who threatened to expose the scheme with a published affidavit. Hull and Conant both sent reassuring letters to Cox, but the giant maker took no chances, securing an eastbound train to the latter's home in Hornellsville, New York, where he arrived on September 4. As Cox later recalled: "I met him on the street, but should not have known him if he had not spoken to me; he was cleverly disguised. I refused to have anything to do with him, and sent him to my attorney. Before the latter he brandished a revolver and threatened to shoot me." At gunpoint, Hull forced Cox to sign an arrangement that limited the latter's claims to a one-twenty-sixth share, and, once the deal was done, the giant maker beat a hasty return to Colorado, where plans for the discovery already were afoot.[17]

With Hull finally back in the fold, Conant staged the discovery on Sunday, September 16. That morning, the freight agent arrived in Pueblo along with his son Will. The Conants secured a horse and buggy and told

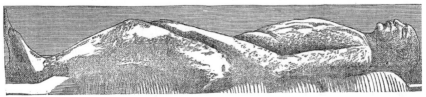

Artist's rendering of the Colorado giant that appeared in the Daily Inter Ocean, *December 13, 1877. Source: From Gale.* 19th Century U.S. Newspapers. *© 2008 Gale, a part of Cengage Learning, Inc. Reproduced by permission. www.cengage.com/permissions.*

local residents of their plan to look for exotic stones and petrifactions in the nearby mountains. At Beulah, the Conants saw the new giant's toes sticking out of the ground and promptly commenced its excavation, though, amid their digging, they inadvertently broke its neck. That evening, the Conants returned to Pueblo, bringing word of their wonderful discovery, but sharing no details of its grotesque appearance, for fear of warding off potential helpers. Despite Will Conant's announcement the following morning that his father had discovered "the devil," the elder Conant recruited a group of hardy souls—Hull included—and these men succeeded in bringing the new giant to Pueblo, placing the figure at the Nyberg & Rickers stables.[18]

News of the discovery soon circulated throughout local newspapers. The reception showed marked similarity to earlier coverage of the Cardiff giant, with editors quickly dividing into petrifaction and statue camps and freely interjecting editorial opinion into news reports. The *Pueblo Democrat* informed its readers: "We do not entertain a scintilla of a doubt but that it is a petrifaction." By contrast, the *Pueblo Chieftain* regarded the Colorado giant as a statue, but similarly affirmed its veracity: "There is considerable excitement here over the discovery, and a general desire on the part of all to hear the opinion of some scientist with regard to the origin of this curious work of art. There can be no question about the genuineness of this piece of statuary." A correspondent for the *New York Daily Tribune* later noted the prevailing theories in Pueblo, including the assessments of local physicians: "There are many who think it was made by the Indians centuries ago. This belief is strengthened because the discovery was made in a spot where many other petrifactions have been discovered. The majority of medical men have declared it to be genuine. This is the opinion of the prominent physicians of Pueblo. Here the doctors are divided: The one part declares it to be a statue and the other a human petrifaction."[19]

After a few days in Pueblo, Conant and Hull moved the new giant to Colorado Springs. Within two weeks of the discovery, one local correspondent estimated that a thousand people had traveled from all over the state to see the curiosity, while the *Chieftain* reported "several thousands." Still, in a departure from the Cardiff giant, Conant and Hull initially refrained from charging admission, thus shielding the freight agent from accusations of imposture. On September 23, Barnum arrived at the exhibition, similarly focused on making Conant appear honorable. As the great showman later informed the *New York Daily Tribune*:

> My first offer, after seeing the giant, was $20,000 cash ("pig in a poke") and I gave the proprietor three hours to make his decision. He declined my offer,

and I then offered $25,000, provided upon looking into the figure and giving it a close examination, Professor [O. C.] Marsh, of Yale College, or any other equally competent scientist should pronounce it a petrifaction. The owner, Mr. Conant, positively declines to sell more than three-quarters of his "find" at any price, and also declines to sell at all until such scientific examination has been thoroughly made.

The invocation of Marsh, the erstwhile giant killer, was ironic, but Hull, in particular, did hope to attract prominent scientists and spark their enthusiasm for Darwinian evolution. Still, most leading scientists, mindful of the Cardiff giant, assumed fraudulence from the outset and stayed away, allowing newspapers, ordinary citizens, and amateurs to run with the subject. Within the camp of believers, some editors and citizens did play into Hull's hands by invoking Darwinian evolution. The *Chieftain* excitedly portrayed the Colorado giant as a missing link, but did not dwell on the religious implications: "At the end of the backbone is a tail about two or three inches long, strongly suggestive of the truth of the Darwinian theory." E. W. Keyes, a member of the local Board of Education, assigned similar gravity to the apparent petrifaction: "I will put upon record my belief, that it will excite greater interest in the scientific world than any discovery history has ever recorded, and eventually be pronounced upon by minds competent to judge—not a modern humbug, but the connecting link which shall establish the theory of Darwin." Others evinced some concern for the Bible. L. R. Lancaster, a lawyer and newspaper editor, would not commit to petrifaction, but nevertheless acknowledged the potential consequences of that assessment: "If we accept it as the remains— yet more strangely preserved—of one who lived while yet the race was young, we must place him so far back in the world's history that logic will hardly reach him; and our cherished dogmas of original creation must vanish like mist. We must have a revised revelation, or give way to Darwin." Still, rather than attack the veracity of Hull's fossil—and Darwinian evolution more generally—conservative Christians largely remained outside the public fray.[20]

The reality, however, was that Hull's missing link did not generate near the public hoopla or newspaper coverage of the Cardiff giant, in part because the conceit seemed too similar, and editors and citizens alike recalled earlier lessons. The *New York Daily Tribune* presented its report under the headline: "Is It Another Cardiff Giant?" The *Syracuse Daily Journal* dryly noted: "We have always felt confident that the Cardiff Giant had relatives somewhere, and it was a mystery that none of them came forward to speak in his behalf during the anxious days of the establishment of his identity." In relating circumstances of the discovery, the *Journal* even referred to Conant as "the

Stub Newell in this case." On September 28, in a conciliatory letter to Cox, Hull himself cited the many invocations of his earlier giant: "FRIEND COX: Had bad luck, broke thing. On exabiction [sic] 2 days, is doing very well. The people cry C.G. (Cardiff Giant) think, can over cum [sic] that, will write again in a fue [sic] days."[21]

With New York City as their ultimate destination, Conant and Hull took the Colorado giant on a train tour, playing to small crowds in Denver, as well as in Omaha, Nebraska, and St. Joseph, Missouri. In the latter city, the two men hosted an examination, but their scientists lacked significant cachet. One was E. R. Paige, an amateur naturalist from Council Bluffs, Iowa, while the second examiner was J. K. Taylor, a Bridgeport chemist and longtime Barnum associate. The examination, of course, was a complete sham, with Taylor informing Hull in advance that he required oxidized iron crystals to establish the Colorado giant's organic nature. Hull secured the particles, and, over the course of the examination, used sleight of hand to mix them into collected samples. In a subsequent published report, Taylor, of course, hailed the proof of petrifaction: "I have, therefore, argued from the appearance of its physical structure, as here described, that there are points which no sculptor would have conceived, while there are others he could not have executed, no matter how thorough his knowledge of anatomical structure. I am therefore compelled to arrive at the decision, that the figure that formed this mould was ONCE A LIVING ANIMAL ORGANISM." Paige fell for the gambit completely, affirming along similar lines: "The matter taken from the head yielded to chemical tests unmistakable evidences of iron, accounting for the oxidized crystals. Therefore the Colorado petrified man will take his place at the head of the long list of rare discoveries in natural science." The naturalist further argued that the fossil contradicted Darwinian evolution, with its apparent age and upright posture challenging the notion that "man ever walked on all fours."[22]

The exhibition made subsequent stops in Kansas City, Missouri, and Hannibal, Missouri, before arriving at Quincy, Illinois, during the first week of November. The Quincy Whig hailed "the greatest curiosity ever exhibited in this city," while likewise endorsing the petrifaction position: "We have ourselves examined this subject with great interest, and can see no earthly reason to pronounce it other than a genuine petrifaction." With New York City on the horizon, Hull and Conant decided to repair earlier damages, hiring a sculptor named G. Fabrisco Sala. Amid Sala's repairs, Hull and Conant received a communication from Barnum, who instructed them to proceed to the Empire City posthaste. The showman had arranged for a high-profile scientific examination at the New York Aquarium.[23]

The Colorado giant received a mixed reception upon its arrival in New York City. The *New York Daily Tribune* once again invoked its predecessor: "It would be well to hunt up the Cardiff giant—which must be somewhere about—and put it alongside, for the sake of comparative anatomy." Still, having now witnessed the Colorado giant, the newspaper tempered its skepticism somewhat, acknowledging: "What more could anybody ask of a missing link?" With reference to the upcoming examination, the *New York Times* proved far more cynical: "The autopsy is expected to result in the unanimous verdict that it is a worthy successor of the Cardiff giant." On December 7, Barnum hosted the scientific examination, but prominent geologists, naturalists, and archaeologists stayed away, leaving chemists, physicians, and anatomists as the primary scientific voices. The attendees on this occasion included Robert Ogden Doremus, professor of chemistry and physics at the City College; his brother and fellow chemistry lecturer Charles A. Doremus; homeopathic surgeon S. L. Moses; Fordyce Barker of the Bellevue Hospital Medical College; and local sculptor Wilson McDonald. These men likewise heeded earlier lessons, as the *Times* noted that examiners proved loath to share their opinions. Only McDonald offered a strong assessment, as the sculptor hailed the Colorado giant as proof of Darwinian theory: "Mr. Mc-Donald, who is an enthusiastic Darwinite, considers that the figure is either the petrifaction of an animal partaking of the qualities of both a man and a monkey, or a representation of such an animal, made thousands of years ago. In either case, it is, he says, a proof of the truth of the Darwinian theory. He intends to write a full description of the figure for the information of the great English naturalist."[24]

Over the next few weeks, the Colorado giant played to small crowds at the Aquarium, as Barnum, Hull, and partners shared in gate receipts. One promotion for the exhibition identified the subject as the "Wonderful Colorado Stone or Petrified Man," while alleging that the specimen was a "puzzler to the scientists." Later, the men moved the exhibition to the New York Museum of Anatomy on Broadway. During this period, the giant acquired a bevy of nicknames, including the Colorado Petrified Giant, Muldoon Man, and Solid Muldoon, with the latter two nicknames referring to Edward Harrigan's popular song, "Muldoon the Solid Man," about a boastful and beloved Irish-American politician.[25]

The Colorado giant's run ended in January, as Cox finally confessed the scheme to the *New York Daily Tribune*. A correspondent from the newspaper met the latter man in Hornellsville, and Cox furnished him with affidavits as well as earlier communications from Hull and Conant. Over the course of a wide-ranging interview, Cox outlined Hull's activities in Elkland, while,

at the same time, disclosing personal details about the giant maker, including circumstances of Hull's marriage and his earlier playing-card swindle. At Cox's urging, the correspondent visited Elkland, surveying evidence of Hull's work in the icehouse, while also confronting Amsbury and Case, both of whom denied any knowledge of the scheme. On the other hand, Louis W. Fenton, who assisted Hull during the giant's removal, confessed to his involvement. The *Tribune*'s exposé, published on January 24, 1878, exposed the fraud, and, in ensuing days, the *Colorado Mountaineer* fleshed out particulars from the Colorado side.[26]

Hull's sequel hoax had been an utter failure. The giant maker devoted the better part of a decade to the scheme, and, according to Cox, spent more than ten thousand dollars of his own money—more than three times what he had for the Cardiff giant. At the same time, even lacking financial details, the Colorado giant clearly did not yield significant box-office returns, with the *New York Daily Tribune* observing at one point: "As a show, the 'stone man' has thus far been little but a failure." Furthermore, while the new giant sparked some enthusiasm for Darwin's theory, Hull once again failed to explode the religious world. Broke and embittered, the giant maker finally returned with his family to Binghamton, but the next years would bring him only further misfortune and embarrassment.[27]

* * *

Upon returning to Binghamton, Hull tried in vain to reestablish his cigar business, but clearly the giant maker had missed his opportunity. Several large companies now dominated the city's cigar trade, including Hull, Grummond & Company, which his own nephew John founded in 1876. The young man once associated with the ironbound box quickly was emerging as one of Binghamton's leading citizens and elite businessmen.

During the spring of 1879, George Hull's already checkered reputation suffered even greater injury, as the giant maker unwittingly found himself in the middle of a lurid scandal. In November 1878, Colonel Walton Dwight, a former Binghamton mayor and celebrated war hero, died at the age of forty. Reporters soon discerned not only the extent of his financial debts, but also that the former mayor purposely destroyed his health in the months and weeks prior, swimming in the icy Susquehanna River and also refusing food. During this period, Dwight took out numerous policies with leading insurance companies, neglecting to disclose his failing health. The former mayor actually rebounded over the course of November, but, on the evening of the fifteenth, died suddenly at his home. A subsequent autopsy showed no signs

of suicide, and rumors soon spread that Dwight had been murdered—perhaps at his own direction. Dwight's wife was asleep at the time of his death, and the only other person in the house was lawyer Charles A. Hull, George's nephew. In May 1879, insurance companies reviewed Dwight's case, ultimately referring the matter to the courts. Still, representatives commenced character assassination of Dwight in the press, hoping to sway popular opinion in their favor. One unidentified insurer speculated that Dwight actually was alive, with a partner substituting a fake corpse at the autopsy. This representative, drawing upon earlier published reports of Charles A. Hull's presence in Dwight's home, either mistakenly or purposely identified that partner as the architect of the Cardiff giant hoax. Though evidence to the contrary readily was available, newspapers nevertheless circulated the connection of Dwight to George Hull and the Cardiff giant. As the *Syracuse Daily Courier* reported: "The suspicion which has been created within a day or two that Col. Walton Dwight, the Binghamton millionaire, payments on whose life insurance policies is being opposed on the ground of suicide, still lives is being widely noticed throughout the State. This remarkable case has a local aspect, inasmuch as Hull, of Cardiff Giant fame, is Col. Dwight's attorney, and is also credited with the origin of the plan for spiriting his principal away and supplying his place with a bogus corpse."[28]

Within weeks of these reports, Helen Hull, then only forty-two years of age, succumbed to consumption. Though their marriage had not been a good one, it was another blow to George Hull, and, in deference to his wife's faith, the giant maker consented to funeral services at the local Methodist Episcopal Church. At this point, Hull became increasingly withdrawn from society. In October, desperate for income, Hull took to what the *Standard* of nearby Windsor termed "bounty-hunting." The giant maker began reporting cases of unlawful fishing, aiming to collect the local game association's meager $12.50 reward. In one instance, Hull accused two prominent citizens of breaking the law and took them to court for the bounty, though the men ultimately were acquitted. As the *Standard* wrote dismissively of Hull: "This would seem to shut the giant man out of his fun and stop the chances of his getting rich without working."[29]

The Dwight case persisted into the new year. Perhaps recognizing the earlier mistaken identity, newspapers eventually dropped the matter of Hull's collusion, but insurers still leveraged the giant in their attacks on Dwight's reputation. In a January interview with the *New York Star*, an unidentified representative accused Dwight of shady business dealings, citing the Cardiff giant hoax among his ventures: "Col. Dwight was a broken-down adventurer; he had seen many up and downs in life, being rich one year and poor the

next. He was mixed up in several doubtful schemes, among which were the bogus Cardiff giant and a $500,000 Canadian forest swindle." Though no admirer of Hull, the *Binghamton Republican* scoffed at these latest attempts to connect Dwight to the giant maker and his creation. With reference to the former mayor's autopsy, the newspaper mused: "When the Colonel got ready to consummate his plot, [Charles A. Hull] had the giant brought up and placed in [Dwight's] bed, and he skipped out. The reason Dr. Swinburn failed to find any trace of disease was that there was nothing the matter with the giant." The Dwight case spawned numerous trials and appeals over the next few years, but insurance companies eventually honored the claims of his beneficiaries. Still, the affair proved as much a character assassination of Hull as Dwight, and, indeed, allegations followed the giant maker into the grave. In 1943, *The American Weekly*, the Hearst Corporation's sensationalist newspaper, published a retrospective piece on Dwight's death titled "Mystery of the Bankrupt Mayor." *The Weekly* showed little tact—or historical research, for that matter—in placing Hull at Dwight's bedside and juxtaposing the giant maker with various scenarios of foul play. Still, the episode proved only the beginning in terms of Hull's difficulties with both newspaper sensationalism and shoddy reporting.[30]

The newspaper landscape changed drastically around this time, with New York City dailies once again leading the way. The *Herald, Sun, Tribune, Times,* and *Evening Post* already had become massive businesses by this point and mirrored larger economic trends by buying out competitors and capitalizing on technological advances. The invention of the Linotype was a revelation, offering much faster typesetting and production. Still, given huge capital investments and advertising revenues, these leading newspapers actually became somewhat conservative, avoiding controversial materials for fear of offending readers. In 1883, however, Joseph Pulitzer acquired the *New York World*, and his bold style of journalism shook the newspaper world, for better or worse. Pulitzer revived the sensationalism of the earlier penny press, presenting spirited daily news for all classes, while emphasizing gossip, scoops, and scandals. In ensuing years, William Randolph Hearst would acquire the rival *New York Journal*, and fierce circulation wars spawned "yellow journalism" and the age of fictional and manufactured news.

A disgusted Hull had left Binghamton sometime during the 1880s, heading west with daughter Sadie and her husband Charles Gates. The family settled for a time in California, but ultimately relocated to West Superior, Wisconsin, just across the bay from Duluth, Minnesota. Gates was a cigar salesman, and Hull supported his son-in-law's trade in Duluth and Madison. In December 1890, shortly before the giant maker's winter trip to Binghamton with his

family, the *Chicago Herald* erroneously reported that Hull had died. According to a later newspaper report, the giant maker simply ignored the false reporting: "He was seen upon the streets [of West Superior] after the publication of the article and just previous to his arrival in [Binghamton], but claims to have paid no attention to it because it would be contradicted by his friends." Upon Hull's arrival in Binghamton, however, the story gained further momentum. Charles Gates made a brief trip to Elmira, and, while intoxicated, the cigar man lost twenty-five hundred dollars in a robbery. Given the known connection of Gates and Hull, newspapers speculated that the theft was a context for fraud. On Christmas Day, local newspapers reported a conversation with Hull, who, far from dead, defended his son-in-law's honor, noting that, while Gates previously had been "addicted to occasional sprees," he was "pretty steady" these days. At the same time, Hull reported that nineteen hundred dollars of the stolen money had belonged to him. As reports of the robbery spread, Hull's alleged demise assumed entirely new dimensions, with newspapers now linking his death to the lost funds. As the *Milwaukee Daily Sentinel* noted on December 29: "Reports received as to the manner and cause of his (Hull's) death are conflicting, one stating that he took his one [sic] life and another that death occurred the day after the robbery of his son-in-law." A day later, the *Chicago Daily Tribune*, thinking Hull dead, offered a retrospective article on the Cardiff giant hoax, with the *Binghamton Evening Herald* later reprinting the same piece. Even after the Associated Press issued a dispatch confirming that Hull indeed was alive, newspapers and old friends alike took occasion to belittle the giant maker. In possibly his only published interview since the hoax, Newell dismissed his erstwhile partner—"He was an illiterate sort of a fellow, who made a good deal of notoriety for himself. He was a big talker"—while stating flatly with regard to his earlier involvement: "I havn't [sic] got anything to say. If I knew anything about [the hoax], I would tell you. The newspapers every once in a while have something, but none of them have the correct story." Walrath, no longer in Hull's loop, told newspapers that he would not be surprised if Hull himself circulated reports of his death to support a new scheme. One newspaper even linked Hull to a recent petrifaction in California, though offered no evidence to support the claim.[31]

The bizarre episode did occasion some reflection on Hull's part, with reports of his demise reminding the sixty-nine-year-old giant maker of his own mortality as well as the limited time that he had remaining. During this period, the Cardiff giant had remained very much alive in popular consciousness, and it seemed that the creation would outlast the creator. In his final years, Hull would fight vigorously to preserve his own legacy, while seeking to achieve everlasting life through his giant.

CHAPTER THIRTEEN

~

A Tall Tale

Even while languishing in Calvin O. Gott's front yard, the Cardiff giant never left the popular mind. The hoax remained in the headlines, with the erstwhile great wonder still attracting outspoken believers and with reporters often mistaking Carl Franz Otto's imitations for the original. At the same time, the giant spawned new imitators, not the least of whom was George Hull, with his Colorado missing link. Amid news reports as well as standard retrospective pieces, the story of the Cardiff giant emerged as somewhat of a twice-told historical tale, with the facts of the affair suffering in accordance. Hull himself had been diminishing the role of his partners for years, but, in his own waning days, sensational newspapers and men with their own agendas gradually shifted the focus away from the giant maker. Indeed, Hull would devote the final years of his life to reclaiming his own place in history.

In the aftermath of the hoax, one antiquarian maintained his faith in the giant and staged a spirited public defense of its antiquity. For decades, Alexander MacWhorter, a resident graduate at the Yale Divinity School, believed that Phoenicians once explored the lands of western New York. Upon visiting Stub Newell's farm, MacWhorter perceived the giant as evidence of his romantic speculation. Even after revelations of fraud, the antiquarian refused to yield his position, much to the chagrin of New Haven colleague O. C. Marsh. Amid the giant's subsequent tour of county fairs, Gott received MacWhorter at the exhibition and became aware of his fervent belief. To stoke the antiquarian's exuberance and create attendant publicity, Gott inscribed a series of symbols and characters on the giant's right arm. During

a later exhibition at New Haven, MacWhorter discovered the inscription, hailing the definitive proof of his Phoenician theory. Fittingly enough, Hull may have been present for MacWhorter's examination. During his later interview with the *New York Daily Tribune*, Hull noted his attendance at the New Haven exhibition, citing concurrent business in that city. As the giant maker recalled, an unidentified scholar was examining the giant when a customer announced his arrival. With reference to the claim that Hull fashioned the giant, the scholar reportedly scoffed: "Never! That is, unless he is more than 1200 years old!" Over ensuing months, MacWhorter prepared an article on the inscription, keeping a bemused Yale faculty abreast of his scholarship. In July 1872, MacWhorter's manifesto, "Tammuz and the Mound-Builders," appeared in the *Galaxy*, a literary magazine whose contributors included Mark Twain and Rebecca Harding Davis. The antiquarian interpreted Gott's symbols of flowers, crosses, and stars as a consecration to Tammuz, the Phoenician shepherd god, while translating the characters as "LORD TAMMUZ OF THE HEAVENS. THE BAAL." Some newspaper editors actually praised the antiquarian's scholarship in subsequent items. The *Daily Evening Bulletin* characterized the article as "remarkably ingenious," while the *Milwaukee Daily Sentinel* acknowledged the strength of MacWhorter's physical evidence—"however absurd it may seem to many of us." The *Congregationalist*, a religious magazine, however, offered a more representative assessment, citing the article as the "funniest thing" in that month's *Galaxy* and scoffing at how the giant now boasted a calling card on its arm. In Europe, where scholars and the public had less familiarity with the hoax, MacWhorter's article received a much more favorable response. On September 29, 1874, Konstantin Schlottmann, secretary of the German Oriental Society and professor of Hebrew at the University of Halle, introduced the antiquarian's paper to the German Philological Congress and put forth his own theory that the giant was connected to alleged Phoenician inscriptions in Brazil as well as the lost continent of Atlantis. After getting word of Schlottmann's presentation, the *Albany Journal* speculated that the scholar was an "American swindler in disguise," while broadly bemoaning the hoax's persistence: "It is none the less a ridiculous swindle, and the fact shows not only how firm a hold falsehood may obtain in the world, but that popular credulity has no geographical limits." To capitalize on foreign interest, entrepreneurs soon brought one of Otto's imitations to Germany, though Andrew White, then the U.S. Minister to Germany, apprised Schlottmann of his error. One colleague noted that MacWhorter eventually recognized his own folly, observing: "It was the great disappointment of his life, and he did not survive it long." Upon the antiquarian's death, the

Independent remarked that his scholarly work told a cautionary tale: "Without cool, sound judgment, enthusiasm leads a scholar terribly astray."[1]

Around this time, a case of mistaken identity involving the giant actually spawned a court case. On November 30, 1873, the *Boston Herald* reported on the sale of the original giant in New Orleans, noting that purchasers paid a scant eight dollars for the erstwhile great wonder. Of course, this giant was one of Otto's imitations, but the report nevertheless impacted Gott, who was then in negotiations to sell the original. According to the photographer, his prospective buyer originally offered thirty thousand dollars, but retracted his bid upon seeing the *Herald*'s report. Gott sued the newspaper for libel, and the matter came before the Boston Superior Civil Court in October 1875. Over the course of his testimony, Gott affirmed his belief in the giant, while also endorsing MacWhorter's theory of Phoenician origin. At one point, members of the jury even traveled to Fitchburg, beholding the subject of the controversy. While the jury found for the *Herald*, Gott appealed the decision, though the giant's owner eventually dropped the case due to rising legal costs.[2]

During this period, entrepreneurs followed P. T. Barnum's earlier lead, exhibiting imitations in cities such as Cincinnati, Denver, and Worcester, Massachusetts. Newspaper reporters and editors generally showed little facility in distinguishing Otto's giants from their predecessor. The *Missouri Democrat*, for instance, reported that a local sheriff seized the original giant to satisfy a debt and recorded the owner's corresponding trauma: "Oh! My giant! My Cardiff! My darling Cardiff! What will my wife do without her giant?" Two entrepreneurs even spawned a new hoax with their imitation giant. After altering the sculpture to augment its length and accommodate a sixth toe on one foot, the men buried the imitation at Giant's Causeway in Ireland. Upon the subsequent discovery, Irish newspapers identified the petrifaction as Finn McCool, the causeway's mythological builder, and as one publication observed: "So great has been the throng of sight-seers that admission is charged to the public." In America, newspapers scoffed at the hubbub abroad, with the *Congregationalist* remarking: "So that's what's become of our Cardiff friend, is it?"[3]

The Cardiff giant hoax also spawned several new imitators who broadly followed Hull's template in crafting allegedly ancient petrifactions. In October 1875, William Ruddock of Thornton, Michigan, manufactured a figure from water-lime, sand, and gravel, though financial limitations constrained his handiwork to four feet in height. Ruddock buried his creation within the gravel pits of Pine River, and, upon the discovery, local newspapers hailed the figure as a petrified child. A dramatic report titled "A PETRIFIED BABY"

soon appeared in several prominent newspapers, but nevertheless failed to spark a wider sensation. Four years later, John Thompson of Trumansburg, New York, leveraged the example of the Cardiff giant, but also employed elements of Hull's recent Colorado hoax. With Ithaca-area tourism declining, the hotel proprietor planned a local sensation to drum up business, engaging ironworker Ira Dean to sculpt a giantlike figure. The final product stood more than six feet and weighed several hundred pounds, and, though roughly humanoid, the figure also sported an apelike nose and hooves. After staging the discovery in July 1879, Thompson brought the Trumansburg giant to his hotel and charged curiosity seekers ten cents admission. Newspapers reacted rather tepidly, recalling lessons of Hull's earlier giants. The *Inter Ocean*, for instance, offered the headline, "Another Stone Man—Something to Amuse the Professors of Cornell University During the Vacation," while the *Galveston Daily News* scoffed: "A smart detective will soon find out who was the sculptor of the stone man. For variety's sake it should have been a woman this time." A dissatisfied partner revealed Thompson's scheme in September, and, as local folklore goes, angry residents threw the Trumansburg giant into Cayuga Lake.[4]

Amid the imitations and imitators, however, the story of the original remained in circulation, with the *New Englander and Yale Review*, *New York Daily Tribune*, and *Popular Science Monthly* all offering significant retrospectives. Over the course of the decade, the tone of these pieces changed markedly, in large part reflecting growing dissatisfaction with Gilded Age ethos. In 1871, for instance, the *New York Daily Tribune* lauded Hull's ingenuity: "The world must confess that it was never humbugged so brilliantly as it was a year ago last Summer by the discovery of the petrified man near Syracuse, N.Y. The Cardiff Giant was the work of no ordinary genius. The man that could conceive and successfully carry out such a masterpiece of jugglery is a character for history." A mere ten years later, however, the *Cleveland Daily Herald* offered a vastly different assessment, criticizing Hull's lack of capitalistic scruples. After interviewing Gott in Fitchburg, the *Herald's* correspondent remarked: "I mused upon the accomplishments of human originality and the credulity of the human mind. To accomplish success is a great thing, even in the case of a successful humbug. As I contemplated this generally regarded as the most gigantic humbug of the 19th century, I felt that I could proscribe no limitations to American ingenuity in the pursuit of (filthy) lucre."[5]

Despite its increasingly unfavorable reputation, Gott nevertheless proudly promoted his giant, and, on at least one occasion, brought the erstwhile great wonder out of the shadows. In the wake of his lawsuit, the giant's owner purchased a house in Fitchburg's Railroad Square, converting the structure

into a hotel. While the giant remained in the lockbox, Gott nevertheless featured it prominently in advertisements. At the same time, the giant's owner purchased a pedestrian track, christening the course as Cardiff Giant Park. In 1881, Gott commenced renovations on his hotel, primarily to build a new exhibition space for the giant, and, during this time, the owner stored his prize possession at neighbor Sumner Lawrence's barn. With debts mounting, however, Gott finally brought the giant out of hiding in 1883, staging a public exhibition at a Fitchburg opera house. A prospective buyer from Europe soon commenced negotiations with Gott, but the two men never completed the sale. Within a few years, Gott defaulted on payments to David Hannum, but, having recently lost his fortune through farmland speculation, the horse trader made no immediate attempt to claim the giant. Though embarrassing him and indirectly occasioning the demise of friend Amos Westcott, Hannum nevertheless maintained a sense of humor about the hoax. On one occasion, for instance, a young man demanded that the horse trader yield his seat on a passenger train: "My name is Sloan, and my father is president of this road." Hannum, refusing to budge, retorted: "My name is Dave Hannum, and I'm the father of the Cardiff Giant." In the wake of Gott's death, Hannum did travel to Fitchburg in 1890 with John Rankin, his longtime friend and current creditor. Though the giant remained in Lawrence's barn, Gott's widow had relocated her family to Cambridge, where the two men eventually tracked her down. Lou Gott lacked funds to pay Rankin and Hannum, but urged them to repossess the giant. Hannum explored possible exhibition at the upcoming World's Fair in Chicago, but died before any plans came to fruition. The giant remained in limbo in Fitchburg, and, upon Hannum's death, Rankin became sole owner.[6]

While Gott's activities in Fitchburg generated press, cases of mistaken identity only increased over the course of the 1880s, possibly due to the passage of time, but also a manifestation of rising sensationalism and generally lax reporting. In 1881, newspapers reported that a "baptism of fire" consumed the original giant at Hannah Hollow, near Hudson, New York. According to the *Syracuse Daily Journal*, local boys had finished off the giant: "The fire inflicted considerable damage upon the Giant, and irreverent boys of the neighborhood have well nigh finished his strong existence." Four years later, newspapers similarly reported that the giant had been "cremated" amid the burning of a show house in the Dakotas. Most notably, the *Buffalo Express* later informed readers that the dilapidated and decaying giant resided within a chicken-wire cage at an El Paso beer garden. Amid all these reports of Cardiff giants, the fate of Barnum's imitation became increasingly unclear. In 1871, the *Syracuse Daily Journal* noted that the

showman's menagerie included a "*fac-simile* of the questionable petrified monster," though this imitation easily could have been the second one that Barnum acquired. Many years later, the *Springfield Union* reported that the "original and genuine" giant lay beneath Daly's Theater, the former site of Wood's Museum: "When the museum was converted into a theater, the Cardiff giant was one of the high-priced curiosities, but it was so heavy that it wouldn't pay to cart it away, and so a hole was dug under the building and the alleged petrifaction was buried without ceremony." The *Union*, of course, erred in characterizing this giant as the original, but, still, the item leaves open the possibility that Barnum's first giant never left the Empire City—and, in fact, may still be there.[7]

Of all the retrospectives and news reports during these years, one item was particularly noteworthy. In 1883, residents of Hardin County, Iowa, prepared a local history volume, outlining the settlement of villages such as Ackley, while also amassing biographies of notable citizens. One such subject was Henry Turk, who then resided in nearby Wright County, near Walled Lake. The preacher's entry appeared in a section on local physicians and contained no information on his religious work. By this point, Turk's name already had surfaced in connection with the giant, as Hull divulged the preacher's last name in an interview for the *New Englander and Yale Review*. With reference to the hoax, local historians portrayed Turk as the mastermind of the scheme: "In ancient history [Turk] was authority. He is given the credit of having conceived the idea of manufacturing the celebrated 'Cardiff Giant' that deceived so many so-called scientific men in this country. . . . Knowing the nature of [Fort Dodge] gypsum, Dr. Turk believed it would make a good giant and deceive some of the most knowing ones." Editors of *The History of Hardin County, Iowa* innocently may have misinterpreted published references to Turk's inspiration of the hoax. At the same time, however, the men easily could have been saving face for their esteemed neighbor, or, perhaps most likely, enhancing Ackley's role in the historical episode. Hull may never have seen the publication, but nevertheless the book foreshadowed the final years of his life, when the story of the giant increasingly slipped away from him.[8]

* * *

During the 1890s, Hull returned to Binghamton, as the giant maker always seemingly did, taking up residence there with daughter Nellie. Hull had a major health scare in December 1897 at the age of seventy-six. While the specific nature of the illness was not disclosed, newspapers did characterize

it as "severe." At this point, with death seemingly imminent, Hull wanted to share the story of the giant one final time and accordingly requested a reporter from the *New York Sun*. For the most part, Hull's deathbed narrative mirrored the one from the *New York Daily Tribune* decades earlier, but, this time, the correspondent largely allowed the giant maker to tell the story in his own words. Hull recalled his parents and youth in Suffield, while making only scant reference to his marriage and avoiding the playing-card swindle altogether. In discussing the origins of his hoax, Hull cited the theological argument with Turk, while affirming his lifelong atheism. In the subsequent account, Hull omitted both Henry Martin and Edward Burkhardt—both of whom long since had passed—while claiming credit for most of the sculpting. With reference to Newell, Hull hinted at the farmer's connection to the harness snap invention, but more directly blamed his erstwhile partner for the hoax's failure. As the *Sun* summarized the giant maker's statements: "Newell became so puffed up with the importance of the secret that he could not contain himself, and told it to several of his relatives and friends. Hull saw that the secret would soon leak out, and he decided to realize at once and quit." Despite the somewhat damning reputation that his scheme acquired over the years, Hull made no attempt to justify earlier actions, simply relating the facts of the affair. In reprinting the interview, the *Syracuse Daily Journal* largely refrained from judgment, though, while referring to Hull as an "inventor of some enterprise," did note his "cunning plans" at one point and broadly referred to the scheme as an "imposition."[9]

Hull recovered from his illness, and the ensuing months witnessed renewed interest in the hoax. Still, the giant's newfound popularity owed less to Hull's musings and instead to the publication of a novel, *David Harum*. Edward Westcott, son of Amos, based his homespun tale on the life of Hannum, whom he came to know intimately during the giant affair. The book included many of Hannum's celebrated horse-trading stories, while painting a memorably quaint portrait of Homer, New York. As the giant affair remained a sore point for his family, Westcott, a banker by trade, made no mention of the episode in the novel, though he did ask Hull for his recollections of the horse trader. Westcott passed away prior to his novel's publication, and so the author never knew how much his writing resonated. The public reveled in the charming and humorous novel, and, within two years, *David Harum* became one of the best-selling books in American history. Westcott's novel spawned contemporary theatrical productions, children's books, and even a dedicated publication of its Christmas vignette. Over the next several decades, the novel inspired both silent and sound films, with Will Rogers portraying Harum in the latter. The success of *David Harum* also sparked

intense interest in its real-life subject. Rankin, who himself gained celebrity for inspiring the novel's John Lenox, obliged the public with "The David Harum I Knew," published in *Home* magazine. Rankin also contributed to a full-length companion biography titled *The Real David Harum*. The volume featured biographical information on its subject, but also shared stories that had not appeared in the novel, including an entire chapter devoted to the Cardiff giant. In this section, editors reprinted the text of Hull's recent interview, while noting Hannum's involvement as an investor: "Hannum was one of the first who saw the possibilities of money-making in the Cardiff Giant, and he secured an interest, in partnership with Dr. Westcott, father of the author of the novel." Rankin likewise recalled how his friends and associates purchased shares in the great wonder:

> Dr. Westcott, father of the author of "David Harum," was one of the many from Syracuse to visit Cardiff, and he was very much taken with the discovery, and believed it to be a genuine giant and not a hoax. When Hannum next went to see him, which he did every few days, Westcott took Hannum with him, and as Hannum was governed somewhat by Westcott's judgment in the matter, they, with four other gentlemen from Syracuse, purchased a thirty-thousand dollar interest.

Without referencing his own acquisition of an ownership share, Rankin instead offered a dubious claim, namely that, based on rumors of fraud in November 1869, he had advised Hannum and Westcott to sell their interests.[10]

Despite *The Real David Harum*'s clear assessment of Hannum's role, several newspaper interviews laid the groundwork for an emerging mythology: that the memorable horse trader had been in cahoots with Hull from the outset or even that the hoax was entirely his doing. The characterization partly was romantic—namely that the scheme seemed appropriate fodder for the shrewdest of horse traders—but also stemmed from honest misinterpretations of the word "owner." For instance, when recalling Hannum's presence at the Bastable decades earlier, one man painted a misleading picture for the public: "Mr. Hannum was constantly hanging around the crowd with the object in view of sensing the opinion of the people as to whether the stone image was a genuine petrifaction. . . . It was not generally known at that time that he was one of the chief owners of the humbug." At the same time, Alfred Merrill, an elderly acquaintance of Hannum and Rankin, shared personal recollections of the two men with the *Milwaukee Daily Journal*. In giving the newspaper lesser-known facts about his friends, Merrill mentioned the giant affair, but his vague word choice left room for misinterpretation: "Hannum was a char-

acter and no mistake. You doubtless remember something about the 'Cardiff Giant.' Well, Hannum and John Rankin, who, as you know, was John Lennox [sic] of the novel, participated in the big hoax and made quite a little money out of it. . . . Hannum and Rankin exhibited the stone at Albany and a lot of other places and made money out of it and had a lot of rich sport." In the coming decades, many newspaper retrospectives on the giant omitted Hull altogether and cast either Hannum or Barnum as the originators, since the latter two men were much more familiar to the public.[11]

The success of *David Harum* spawned its own imitators, and, in 1901, Syracuse newspaperman Charles Reginald Sherlock published *Your Uncle Lew*. The subject of this homespun novel was D. Lewis Smith, the city's own version of Hannum. An early bidder for the great wonder, Smith ultimately had joined the antigiant clique in Syracuse. Accordingly, Sherlock devoted several chapters in his novel to the affair, drawing not only from the public record but also from earlier recollections of Smith and possibly Ezra Walrath as well. In the novel, Lew hosts a shady individual named Lull at his hotel, with the latter unsuccessfully attempting to interest him in a vague show-business scheme. Lull resurfaces in the wake of the giant's discovery, and a suspicious Lew enlists a *Harper's Weekly* correspondent to investigate the giant. At one point, a drunken stonecutter visits Syracuse, and the two men coax the truth out of him, but do not go public with the information, due to the manner in which they obtained it. Upon reading *Your Uncle Lew*, Hull was infuriated. Obviously, Sherlock had taken dramatic liberties with the historical narrative, but the giant maker also was annoyed that the author was making money off his story. As Sherlock recalled, Hull contacted his publisher and demanded royalties on the grounds that "the Cardiff giant episode was the property of his family." The publisher, however, would ignore the giant maker altogether.[12]

To Hull's chagrin, still others had begun directly profiting from his giant once more. Earlier that year, Carleton White, a Buffalo lawyer, approached Rankin about exhibiting the erstwhile great wonder at the city's upcoming Pan-American Exposition. The giant owner showed little inclination along these lines, but finally consented after White recruited a new member for his syndicate: Hannum's nephew Theodore. In April 1901, Rankin sold the giant directly to Hannum for one hundred dollars. During the summer months of 1901, the giant made its highest-profile appearance since the heyday of the hoax. The syndicate exhibited the curiosity in a special building on the north midway, and, according to the *Syracuse Herald*, promoted the giant's origins as an unsolved mystery: "They say it's a hoax. If it is, it's the most scientific that was ever perpetrated. If it is real, which it undoubtedly is, it is

most wonderful." Correspondents reported that roughly 10 percent of fairgoers attended the exhibit, an indication that the giant still possessed drawing power. Admittedly, though, a much more significant event at the exposition drew attention away from its comeback: the assassination of President William McKinley. At the exposition's conclusion, syndicate members restored the giant to Lawrence's barn in Fitchburg. In a farcical aside, Galen O. Wood, a Syracuse horse trader, purchased an imitation giant prior to the exposition, erroneously assuming it was the original. The horse trader brought the giant to Buffalo, but exposition organizers denied its exhibition on the grounds that they already possessed the Cardiff giant. Undeterred, Wood established a tent outside the fairgrounds, and, in an unwitting nod to Barnum, exhibited his giant as the original.[13]

With others reaping notoriety and financial gain from his giant, Hull finally took action. The giant maker reconnected with Rankin, hoping to rekindle their earlier book project. In the intervening years, Rankin largely had shifted his focus from entrepreneurial efforts to public service, serving a term as mayor of Binghamton as well as assisting in the administration of the Binghamton State Hospital. Still, Rankin agreed to assist the giant maker in publishing the book. The status of the text at this point was entirely unclear. The two men already may have possessed significant material from Samuel Crocker and Walrath, both of whom were now deceased, though, in identifying himself as sole author, Rankin may have commenced the writing from scratch. At the very least, Rankin and Hull updated and expanded the text. A new maudlin introduction offered context to address recent developments. The elderly giant maker sits with a young woman and discusses *David Harum*, *The Real David Harum*, and *Your Uncle Lew*. Hull references his communication with Edward Westcott, noting that the author had personal reasons for excluding the giant from *David Harum*. At the same time, Hull dismissed *Your Uncle Lew* as a false representation of the affair: "It is not a true history. There are some truths in it about the discovery and the excitement it created, a fairly correct statement in regard to crowds of people who went to see it, and the large sums of money made, but it is mostly fiction." After the giant maker bemoans how a lack of education prevented him from writing the history of the hoax, the young woman offers to help him, segueing into the heart of the book. Rankin likewise added a final chapter that chronicled ownership changes over recent years as well as the recent exhibition in Buffalo. Within this context, the author noted how most participants in the affair had passed in recent years, and, indeed, at this point, Alfred Higgins, Stub Newell, and Lydia Newell were the only other survivors. A reflective Rankin also took occasion to dedicate the book to Amos Westcott, his fallen friend.[14]

At the same time, Rankin enhanced and changed certain characterizations within the text. Recognizing potential sales appeal, the author expanded Hannum's presence within *The Giantmaker*. While adding a front matter page titled "David Harum's Aphorisms," Rankin sprinkled previously unpublished horse-trading stories throughout the text, most notably during Hannum's two encounters with the giant maker. Rankin also concealed his own purchase of an ownership share, presumably out of embarrassment. When referencing the sale of Newell's public interest, Rankin noted rather cryptically: "About this time, W. C. Newell disposed of his remaining quarter interest to a new purchaser for a considerable sum, who, strange as it may seem, never appeared in the management of the Giant affairs." Along the same lines, the author mused in the final chapter: "Where is the person who holds intact the Newell reserved one quarter? No answer!" Rankin also removed his own involvement in Syracuse, New York City, and Boston, writing himself out of the narrative. More significantly, following up his claim in *The Real David Harum*, Rankin added a section about his alleged investigation of Hull in November 1869. In this chapter, Rankin emerges as the heroic skeptic, successfully enlightening Hannum to the fraud, but failing to convince Westcott. For the most part, however, the chapter fails to dovetail with characterizations of Hannum during the Boston exhibition.[15]

Upon completing his revisions, Rankin asked Leon Mead to review the manuscript. In a letter to Rankin in March 1902, the writer hailed Rankin's work and predicted great success: "I predict for it a sale that will cause 'David Harum' to 'go way back and sit down'—to use a pat phrase of the day. If crisp diverting dialogue, wholesome philosophy, an absorbing and dramatic story and sunny glimpses of life and of nature are not out of date—and I have yet to hear that they are—it will prove a great popular success." At the same time, however, Mead encouraged the author to articulate his own relationship with the historical characters, citing Rankin's lifelong friendship with Hannum, his association with Westcott, and his acquaintance with "the Cardiff Giant projector." Rankin accordingly prepared a new preface, informing readers that he had been well acquainted with two of the owners and that "the most prominent in the management of the Giant affair" was an "early and valued friend." At the same time, the author noted that "the originator of the most remarkable and successful deception of the age" had been a fellow townsman. Perhaps in a nod to recent confusion in the press, Rankin also took occasion to delineate the roles of Hull and Hannum in the affair: "George Hull made the Giant in secret and David Hanum [sic] exhibited it in public; each in turn was the central figure on the stage, but to the latter has come the greater fame through the genius of the gifted Westcott who

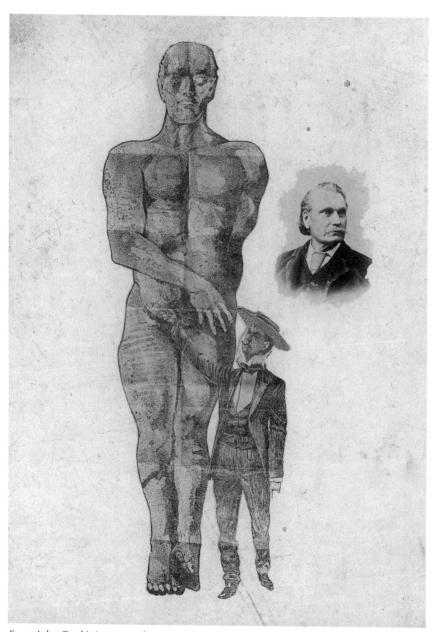

From John Rankin's personal papers, an illustration presumably planned for The Giant-maker. *Source: Courtesy of the Broome County Historical Society.*

has made 'David Harum' a familiar name throughout the continent." Rankin still did not divulge his own investment, instead offering a vague explanation of how he became an eyewitness to history: "At the time the incidents in this volume occurred the author was thrown in almost daily contact with the individuals who figure prominently in the narrative." Finally, the writer acknowledged his own literary license within the text: "The author has not drawn upon his imagination to supply a lack of memory: with one exception not a scene is represented but what actually occurred." The scene in question almost certainly was Rankin's investigation, rather than Hull's eastbound train ride with Hannum and Turk. Other possibilities—including Rankin's role in the original scheme, as "DETECTIVE" alleged decades earlier—require many more scenes and characterizations to be untrue.[16]

Amid Rankin's revisions, Hull fell gravely ill, and the giant maker was confined to his daughter's home after February 1902. During the summer months, a newspaper report sparked a vigorous rejoinder from the giant maker. While selling one of his sculptures in San Francisco, G. Fabrisco Sala told local reporters that he had fashioned the Cardiff giant for Barnum in Quincy, Illinois. Sala, of course, had confused his giants, having performed that work on the Colorado colossus, but still the sculptor made no mention of Hull over the course of his interview. Given the similarity of Sala's name to that of Henry Salle, newspaper reporters and editors simply assumed that his statements were accurate. In July, Hull sent for a Binghamton reporter and addressed the recent publication. Hull's own memory clearly was failing, as the giant maker could not remember Salle's name—which actually had been the case for some time—but also did not make the obvious connection to the Colorado giant. As Hull noted: "I worked for months on the job and was assisted at times by a man named Sala, who was very irregular, as he got drunk and wouldn't show up for weeks. Maybe this is the same man who is now claiming to have carved the statue, but I don't think so." The giant maker then gave one final version of the familiar narrative, once again omitting Martin and Burkhardt while mistakenly referring to Stub Newell as Shorty. In the end, a reflective giant maker observed: "I made many mistakes in the management of my scheme or today I would have been a rich man."[17]

Over the next two months, Hull did not leave his bed, and, on the morning of Tuesday, October 21, 1902, the giant maker finally succumbed. He was eighty-one years of age. Two days later, Nellie Wilcox hosted a service at her home. Perhaps in an attempt to save her father's lost soul, Wilcox invited the pastor of the local Methodist Episcopal church to officiate, and assembled friends and family sang "Peace, Perfect Peace" and "Sweet By and By." John Hull Jr., George's nephew, served as one of the attendants, bearing the

giant maker's coffin just as he had the ironbound box decades earlier. George Hull's family ultimately laid him to rest at the Chenango Valley Cemetery, alongside wife Helen and granddaughter Dora. The simple gravestone lists the names of the three, but makes no mention of the Cardiff giant.[18]

The Giantmaker did not surface over the next two years, and Rankin himself passed away in July 1904. In his obituary, the Binghamton Press noted that the former mayor secured an injunction to prevent the book's publication until a later date and that his widow possessed the only copy. With reference to Rankin's motivation, the Press referred only to sensitive "secrets" within the manuscript. As The Giantmaker really offered no new information, the author must have had concerns for how survivors would respond, a theme that Rankin did sound within the preface: "Not until now, however, when the leading actors in the comedy, with scarcely an exception, have vanished from the scene, and no tinge of chagrin or regret can touch a sensitive cord [sic], has [the author] concluded to give to the public the full and truthful history of the Cardiff Giant." Rankin obviously was being cautious, waiting for Newell and others to pass and thus protecting his family from any possibility of libel suits. Still, given that The Giantmaker offered no new characterization of the Cardiff farmer beyond what already existed on the public record, the decision was a poor one on the author's part. Predictably, The Giantmaker was forgotten and consigned to the dustbin of history.[19]

* * *

The timing of Hull's death was significant, broadly coinciding with the peak years of American growth. The final decades of the nineteenth century had seen Colorado, North Dakota, South Dakota, Montana, Washington, Idaho, Wyoming, and Utah all join the Union, and, in fact, westward expansion proceeded so rapidly that historian Frederick Jackson Turner already ruminated upon the "closing of the frontier." Still, a restless and growing America no longer could confine itself to contiguous borders, a trend that began even before the Cardiff giant with the acquisition of Alaska. In the final years of Hull's life, the vast continental nation sought new frontiers, emerging as a protectorate of Hawaii, waging war with Spain over Cuba, and reviewing the annexation of the Philippines. For Hull, the expansion over the course of his life must have been truly staggering. At the time of his birth, the West still broadly connoted places such as Ohio and Illinois. But the growth of America had been something far greater than geographic. Hull had been born prior to the opening of the Erie Canal, and, for much of his youth, America remained a rural nation. In the years leading up to the

hoax, however, America became much wider in scope, with an extensive railroad network blanketing the North and South, massive cities such as New York City, Brooklyn, and Philadelphia emerging, as well as with mass-market newspapers and the telegraph binding citizens all over the country. But it all had been prelude to what came after the Civil War, when the scale of America increased exponentially, and the United States became a thoroughly modern nation. In the final decades of his life, Hull and other Americans saw the advent of the metropolis and the skyscraper as well as the telephone and the electric light bulb. J. P. Morgan incorporated America's first billion-dollar corporation, and fellow trust titans John D. Rockefeller and Andrew Carnegie ruled entire industries. The growth of commerce and the accumulation of wealth had been staggering. As early as 1885, Rev. Josiah Strong, a clergyman and author, observed: "The most remarkable point . . . is the fact that European wealth represents the accumulations of many centuries, while the greater part of ours has been created in twenty years." In nearly every respect, America became in these years what Carnegie called a "giant nation." In *Triumphant Democracy: Sixty Years' March of the Republic*, the steel magnate mused upon recent American growth as well as the promise of the future: "What will [the young republican] not be able to do ere his second century of national existence closes! Already the nations which have played great parts in the world's history grow small in comparison. In a hundred years they will be as dwarfs, in two hundred mere pygmies to this giant; he the Gulliver of nations, they but Lilliputians who may try to bind him with their spider threads in vain."[20]

The Cardiff giant, arriving on the cusp of this great leap forward, pointed to the growing pains of American institutions. The American system was enlarging rapidly, and, foreshadowing the Gilded Age, Hull exploited institutional cracks on a grand scale. Barnum earlier capitalized on some of the same failings of American science and journalism, but none of his singular humbugs matched the scope of the giant. At the same time, Barnum's innocent curios actually belied his reverence for the public. By contrast, Hull's affair, while humbug in its delivery of entertainment, possessed a much darker side, settling grudges at the expense of the public, while fleecing earnest businessmen. In this regard, Hull's hoax belonged more to the Gilded Age than Barnum's antebellum America. In fact, Westcott's death virtually ensured that the giant never could be just a laughing matter. Still, in some ways, the giant had left America a marginally better place. As the examples of the Colorado missing link and other subsequent hoaxes demonstrated, Americans—scientists included—became a little more skeptical after the Cardiff giant. Like so many other manifestations of the Gilded Age, the giant, in

exposing the failings of the American system, pointed the way to reform. Around the time of Hull's death, men and women finally were catching up with American growth, launching a progressive reform movement that truly capped America's modernity. While correcting the excesses of the Gilded Age, these men and women also placed American institutions on better footing. This new generation of reformers emerged from the increasingly modern American university, targeting corrupt city bosses, noncompetitive business practices, as well as the exploitation of labor. Muckraking journalists targeted medical quacks and patent medicine salesmen, prompting the emergence of a new Food and Drug Administration to regulate and monitor pharmaceuticals. Progressive reformers likewise established new professional organizations that at once limited access to their ranks, while providing familiar and recognizable affiliations. These groups included the American Historical Association, the U.S. Chamber of Commerce, and a reorganized American Medical Association. Along the same lines, progressive educators established specialized graduate programs to standardize training and provide recognizable benchmarks of attainment such as the doctorate. Harvard awarded the first graduate degree in prehistoric archaeology in 1894, and, by the first decade of the twentieth century, a new generation of professional archaeologists had commenced their study of the past. Educators also launched new professional schools, with the Missouri School of Journalism and the Columbia University Graduate School of Journalism training students on the systematic collection of facts, while also reinforcing standards of ethics and objectivity. Professional specialization—coupled with a new emphasis on critical thinking—also toppled time-honored founts of knowledge during these years. Under the auspices of the new Bureau of Ethnology, Cyrus Thomas finally exploded the myth of the Mound Builders in 1894, properly attributing native earthworks to the American Indian. At the same time, new biblical scholarship from Germany resonated, and Americans increasingly recognized that the sacred text was the product of human writers from different periods, rather than the infallible word of God. While many Americans still prefer to read the Bible literally, the combined influence of Darwinian evolution and higher criticism have led most men and women to conclude that there were not, in fact, giants in those days. In addition to biblical reconsideration, progressive reformers standardized and systematized knowledge so that Americans would possess reliable sources of reference on fossil giants and other subjects. Indeed, the age of experts and expert knowledge finally was dawning in the United States. Americans always will enjoy a complex relationship with expert authority, and, of course, fringe knowledge

endures, but, still, men and women today rely upon experts in a fashion that forbears could not conceive.

The Cardiff giant was just one of many episodes in Gilded Age America to inspire reformers, but, in a sense, its familiarity imparted significance. The best cautionary tales, of course, are the memorable ones, and the final decades of the nineteenth century illustrated the extent to which Americans remembered the affair and heeded its lessons. No less a progressive giant than Theodore Roosevelt recalled the hoax and invoked it within the context of his early conservation and environmental reforms. In encouraging broad public appreciation for nature, Roosevelt took aim at "nature fakers," namely those writers who embellished the natural world unnecessarily and at the expense of truth. These writers included now-marginal figures such as Ernest Thompson-Seton and William J. Long, but also more familiar names such as Jack London. In September 1907, the sitting president launched into these sham naturalists in an article for *Everybody's Magazine*. Invoking the Cardiff giant, Roosevelt wrote:

> No man who has really studied nature in a spirit of seeking the truth, whether he be big or little, can have any controversy with these writers; it would be as absurd as to expect some genuine student of anthropology or archaeology to enter into a controversy with the clumsy fabricators of the Cardiff Giant. Their books carry their own refutation; and affidavits in support of the statements they contain are as worthless as the similar affidavits once solemnly issued to show that the Cardiff "giant" was a petrified pre-Adamite man. There is now no more excuse for being deceived by their stories than for being still in doubt about the silly Cardiff hoax.

It was a damning assessment, to be sure, but entirely consistent with contemporary attitudes toward the giant. The sober and critical tone persisted through the early twentieth century, but later writers eventually rescued some of the hoax's humor and made it easier for men and women to bring the giant back into public life for good.[21]

CHAPTER FOURTEEN

~

Coming Home

Over the course of the twentieth century, ownership of the giant changed several times, as boosters from Syracuse and Fort Dodge proudly asserted local connections to the great American hoax. While originally dismissing the affair as something of a blight upon history, Americans more generally, by the midpoint of the century, not only showed a willingness to laugh about the episode, but even recast the giant as a symbol of innocence, setting the stage for its ultimate commemoration at a New York museum. In the final decade of the twentieth century, two rather bizarre retrospectives emerged and broadly hinted at how modern Americans judge the affair as well as how they continue to learn from it.

After the Pan-American Exposition concluded in the fall of 1901, Theodore Hannum returned the giant to Sumner Lawrence's barn in Fitchburg, and the latter's family held the erstwhile great wonder for the next ten years. With unpaid storage bills mounting, Frances Lawrence, Sumner's widow, finally took action in 1912, filing a lawsuit for $893 against Hannum as well as the estate of Calvin O. Gott. "CARDIFF GIANT IN TROUBLE AGAIN," the *Boston Globe* dryly observed. Neither defendant claimed ownership, and, accordingly, the Police Court of Fitchburg placed the giant on public auction to satisfy Lawrence's claims. On September 12, the "certain statue, image, or relic called the 'Cardiff Giant'"—as Fitchburg's sheriff identified the item—sold for a scant two hundred dollars. The purchaser was Ralph Lawrence, son of the plaintiff. The new owner did not retain the giant for long, however, selling the novelty item the following spring to Edwin Calkins, a Syracuse-area hotel proprietor.

Lawrence commanded only a few hundred dollars, but Calkins included stock to inflate the overall numbers for publicity. The latter informed newspapers that the actual purchase price had been $16,100.[1]

Upon completing the sale, Calkins announced plans to exhibit the giant at the Panama-Pacific International Exposition, planned for San Francisco in two years. In the interim, however, the hotel proprietor brought the giant back to Onondaga County. Calkins believed that the giant was a legitimate fossil and even sued one railroad company for designating the shipment as a statue, which carried higher rates. He ultimately won the case and received a rebate from the company in question. During the summer of 1913, in a nod to the past, Calkins conveyed the giant through the valley on a wagon, making exhibition stops in Tully as well as Cardiff. In Syracuse, the hotel proprietor exhibited the former conquering hero at the Bastable, dubiously claiming four thousand paying customers on one occasion. Newspapers, however, gave the overall impression that the comeback was a failure, with the Syracuse Herald noting that Calkins ultimately exhibited the giant at a midway sideshow, which also featured two-headed calves and fireproof men. As the newspaper snidely observed: "The great and only Mr. Goliath of Cardiff is too dernèd cold and stiff to associate with the other fakes; he flocks by himself up a different street, near the horse building and the coughing and spitting ensilage cutters. . . . Testimonials to his divine origin and the sweetness of his smile by Ralph Waldo Emerson, Oliver Wendell Holmes, and sundry sculptors and antiquarians who bit hard on the old Dutch stonecutter's gypsum masterpiece, are stacked up beside him."[2]

Amid the Syracuse exhibition, one of the giant's most ardent supporters resurfaced. Billy Houghton, then eighty-two years of age, had served as Stub Newell's master of ceremonies back in the day and followed the giant at every exhibition stop between 1869 and 1871. Despite the enormous burden of proof against the great wonder, the elderly storekeeper nevertheless affirmed its veracity. With his own days waning, Houghton offered an affidavit, sharing an insider's perspective while also alleging a broad conspiracy: "I am telling this true story for the benefit of the rising generation, who will no doubt have many arguments over the different and conflicting stories that have been told about it, the same as their parents and grand parents have done." According to Houghton, John Boynton, having failed to acquire the giant, launched a campaign in collaboration with the newspapers, downplaying obvious evidence of the giant's antiquity, including the roots that extended over the great wonder. Sadly, if Houghton had access to The Giantmaker, the storekeeper would have realized that George Hull deposited the giant in that position to elicit just such a response. In conclusion, Houghton denied

ever believing that the giant was a petrifaction, instead endorsing Alexander MacWhorter's theory of Phoenician origin: "Personally, I have never believed it was a petrifaction; I believe it was a Phoenician God and Prof. McWaters [sic] of Yale, after looking up the image, found that there was a race of people who lived here years ago who worshipped stone Gods and it is possible that it was one of these."[3]

Despite such earnest support as well as his own personal belief, Calkins nevertheless sold the giant later that year, presumably owing to the poor performance in Syracuse. The purchaser was J. R. Mulroney of Fort Dodge, with the sale price again dubiously reported at ten thousand dollars. The *Iowa Messenger* characterized Mulroney as a civic booster: "Mr. Mulroney has had his heart set on owning or at least in bringing back to Ft. Dodge, the great fake which put Ft. Dodge on the map many years ago." To commemorate the hoax, Fort Dodge residents already had christened Hull and Henry Martin's quarry as Cardiff Glen, and as one Iowa historian observed of the giant's unexpected economic impact: "From [the hoax], Fort Dodge gypsum gained renown and in 1871 the first mill for its utilization on a commercial basis was built, the beginning of one of the state's important mineral industries." After acquiring the giant, Mulroney hinted at the upcoming San Francisco exhibition, but nevertheless affirmed his ultimate plan to establish the giant in Fort Dodge. Still, a lackluster performance at the Iowa State Fair in August 1914 may have changed the new owner's mind, for Mulroney soon traded the giant to Hugo Schultz for two hundred acres of Minnesota farmland. Even after relocating to South Dakota, Schultz kept the giant in Fort Dodge, storing it within a local warehouse. The giant remained there for several years, with Schultz allowing access on only a few occasions. In May 1921, the Associated Advertising Club of Iowa staged a gala event at the warehouse. In light of recent industry reforms, club members took occasion to mock the erstwhile great wonder. As the Associated Press observed: "Symbolicant of the new order of truth in advertising, a wake was conducted for the Cardiff Giant." The theme for the evening was "The Last Remains of Fake Advertising," and, for these men, the giant, perhaps even more so than patent medicines and other false promotions, symbolized an earlier system that rogue individuals and companies had exploited.[4]

Around this time, one American writer similarly regarded the giant as an embodiment of excess and immorality, leveraging the iconic figure in a rather heavy-handed personal crusade. After years tending to tuberculosis patients in Baltimore, Ellen La Motte served as an army nurse during World War I, later traveling throughout Asia. Based on her experiences in the Far East, La Motte later wrote several books on the dangers of opium addiction.

For her collection of short stories *Snuffs and Butters*, La Motte offered "The Cardiff Giant," which invoked the familiar image within the broader context of drugs and creative decline. La Motte's showman Phillips thrilled crowds in the United States and Europe with the giant, but derived his creative flair and genius through artificial means. Phillips ultimately renounces his methods, but, in so doing, becomes a shell of his former self. The showman travels with the giant—these days looking rather "second-hand and second-rate"—throughout the Far East, simply preying upon the innocence of natives. Drugs allowed Phillips to reach creative heights and professional success, but, at heart, like the giant, he was just an empty sham.[5]

Boosters ultimately rescued the giant from its limbo, as several Fort Dodge men purchased the curiosity for twenty-five hundred dollars in the spring of 1923. The men subsequently worked out an arrangement with the Hawkeye Fair & Exposition Company to construct an exhibition building at its fairgrounds. The syndicate members would float part of the construction expenses and ultimately share in initial gate receipts. The men also pledged to assign ownership to the Fort Dodge Chamber of Commerce upon recouping their original investments. After the opening of the exhibition, residents once again hailed the gypsum wonder, with one Iowa newspaper remarking: "The Fort Dodgers are very proud of [the giant]." Still, local interest represented an exceedingly limited market, and syndicate members did not come close to realizing their investments. In 1934, the men leased the giant to the Syracuse Chamber of Commerce for one year at fifteen hundred dollars. The latter organization planned an exhibition at the upcoming New York State Fair. After the parties finalized the arrangement, the *Syracuse Herald* announced the giant's imminent return: "Cardiff Giant Coming Home To Syracuse for State Fair." Indeed, for some of the chamber members, the great wonder not only was a part of local history, but also family history. As the *Herald* reported: "Harold M. Day, manager of the convention bureau of the Chamber of Commerce . . . shakes his head as he recounts how his father walked 40 miles from his farm to where the hoax was disinterred, paid 50 cents to look at precisely the same sort of rock he had on the farm at home, and then walked 40 miles back home again." In August, the chamber staged a parade through the streets of Syracuse, while employing the giant in several promotions for the fair. The exhibition's attendance, however, proved underwhelming, and, just as the chamber was looking for additional revenue, United Artists Studio contacted members with questions about the hoax. The studio was filming *The Mighty Barnum* about the life of the great showman, and screenwriters unwittingly had written the giant as a human character. After learning that the original colossus was not, in fact, animated, the

studio leased the giant for a thousand dollars to reshoot scenes, though, in the final release of the film, R. E. "Tex" Madsen still played the Cardiff giant. Prior to its return to Syracuse, the studio utilized the great wonder in a brief promotional tour for the movie.[6]

The Syracuse Chamber of Commerce declined its own second-year option and arranged for the giant's return to Iowa. At this point, however, the Fort Dodge syndicate reneged on its earlier arrangement with the local chamber, selling the giant instead to a private buyer. Gardner "Mike" Cowles Jr. was the publisher of the *Des Moines Register and Tribune* as well as a noted collector of historical oddities. Cowles paid the syndicate fifteen hundred dollars and pledged to share any gate receipts during his first five years of ownership. In August 1935, the publisher exhibited the giant at the Iowa State Fair, but subsequently removed the colossus to his home in Des Moines. He installed it within his den, lining the walls with posters from earlier exhibitions in Syracuse and Albany. The unusual display attracted the attention of *National Geographic*, which featured the giant in an article titled "Iowa, Abiding Place of Plenty." A photograph showed two young women perched on the great wonder's lap, with one laying her hand on its head. The newest member of

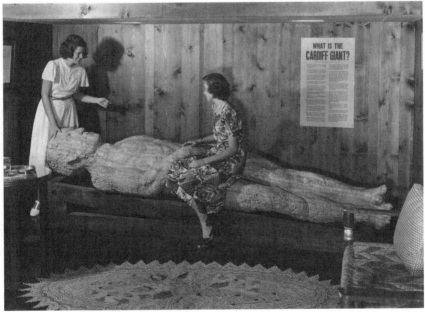

The Cardiff giant in the home of Gardner "Mike" Cowles Jr. Source: J. Baylor Roberts/National Geographic Image Collection.

the Cowles household may well have sparked jealousy with its popularity. As the publisher later recalled: "One day, my seven-year-old son and two of his playmates decided it would be great fun to smash the giant's penis with a hammer. They succeeded in breaking off the tip. I was enraged—perhaps a little more than the occasion warranted—at the mischief. Eventually, I found a craftsman who cemented the tip back on."[7]

During these years, Cowles's most prominent visitor was H. L. Mencken, the journalist and noted social critic. In 1938, Mencken requested a weekend visit at Cowles's home, and, as the publisher recalled, regaled him with bawdy stories and serious reflections upon American society. After some time, Mencken revealed the true nature of his visit, namely to gauge interest in a new hoax. Specifically, the journalist envisioned exhibiting the giant at the upcoming World's Fair in New York, and, during that time, staging the discovery of a female colossus in New Jersey. The men would exhibit the two giants together, and, as Cowles recalled, Mencken crowed: "We'll have the biggest love story known to man! I'll write the publicity, and we'll have a hell of a time!" Still, Mencken's vision hardly was all fun and games. According to Cowles, the journalist manifested his "notoriously low opinion of the American public, its stupidity, greed, and gullibility," while opining that the new hoax would prove once and for all that Americans would "swallow any 'bunk' . . . that was foisted upon them." Mencken regarded mainstream society in much the same manner as Hull, and, on religious matters, the two men shared even greater commonality. For years, Mencken had mocked contemporary fundamentalists, who, in response to higher criticism and Darwinian evolution, fiercely maintained the authority of the Bible. The journalist himself had been present at the Scopes "Monkey" trial and bemoaned how evangelicals still adhered to the literal word of Scripture. Once, with reference to a writer's persistent belief in miracles, Mencken wrote, "By what route do otherwise sane men come to believe such palpable nonsense? How is it possible for a human brain to be divided into two insulated halves, one functioning normally, naturally and even brilliantly, and the other capable only of the ghastly balderdash which issues from the minds of Baptist evangelists?" Mencken never would realize his planned hoax, however, for, upon returning to Baltimore from Iowa, the journalist suffered the first in a series of debilitating strokes.[8]

By this point, though, Mencken very much was the exception, as most Americans cast the original historical episode in a more understanding and favorable light. Rather than regarding the affair as a manifestation of Gilded Age ethos or the general stupidity of the American public, many contemporary writers embraced the hoax not only as a symbol of simpler times and

innocence, but also, hearkening back to initial reaction in December 1869, a humorous gag. The second decade of the twentieth century had given rise to a broad nostalgia movement in the United States. In the wake of World War I, race riots and the Red scare sparked concern that America had lost its essential purity. Amid modern industrialization, urbanization, and the moral decay of the Jazz Age, Americans increasingly associated this purity with the virtue and innocence of the rural, small-town, and predominantly white past. The Great Depression, which many Americans regarded as a failure of modernity, sharpened nostalgia for simpler times. The spiritual yearning revealed itself in agrarian movements, but also in Hollywood films such as *Mr. Deeds Goes to Town* and *Meet John Doe*. These years also occasioned broad interest in American history, but, more specifically, Americana, as manifested in a wave of local history books, antique collecting, folklore volumes, as well as community pageants. Many writers invoked the giant within this context, recasting the affair as a humorous expression of earlier innocence and purity. In *Listen for a Lonesome Drum*, a folklore volume published in 1936, Carl Carmer depicted Gid Emmons and Hank Nichols as classic wide-eyed rubes upon discovering the giant: "[Gid] and Hank thought it was just a rock at first but pretty soon they realized it was a lot bigger than most rocks you find around there and they got sort of curious. . . . By God, he *was* stone, so far as anybody could tell, although there wasn't any rock like what he was made of in York State." After reviewing how "people got to speculating" and how "scholarly-looking" fellows arrived on the scene, Carmer characterized reaction to fraud thusly: "The whole country bent just about double over Stub Newell's giant and how he fooled the professors—and six million people went to look at him." The only Americans who ended up looking bad in Carmer's story were the scientists, and even these men merely were embarrassed: "[York State folks] laughed and laughed while the professors and geologists got red in the face and looked straight ahead or tried to explain just what they had meant a few months before." Along the same lines, in *Heroes, Outlaws and Funny Fellows of American Popular Tales*, Olive Beaupré Miller related the affair from the perspective of Mike Foley. From the outset, the blissful quarryman sings a song about a young man who committed the "worst crime known to Iowa": refusing to hoe his corn. Soon, two "slick-looking city dandies" arrive at Foley's farm, and the latter helps them to secure a block of gypsum. Foley ultimately forgets about the two men, focusing once more on watching "corn gr[ow] up straight and tall" and "more little white farmhouses . . . springing up in the land." Once word of the giant's discovery reaches the newspapers, Foley does not make an immediate connection to Hull and Martin, instead marveling at how Holmes—"one o' the most knowin' and wisest men in the

East"—bore a hole in the giant's head. After revelations of the hoax, Foley at last realizes that the two men fashioned the great wonder from his gypsum and ends up "laugh[ing] in a series of loud guffaws." Finally, for the seventieth anniversary of the giant's discovery, A. M. Drummond and Robert E. Gard, founders of a New York State playwriting project, staged *The Cardiff Giant: A New York State Show* with the Cornell University Theater. The production was replete with homespun dialogue and accents, juxtaposing Hull and other historical figures alongside stock characters such as Erie Canawlers and Cracker-Box Politicians. A bevy of songs reinforced the overall lighthearted feel, as did a production directive to avoid burlesquing characters.[9]

Within this broad nostalgia for simpler times, the New York State Historical Association made efforts to acquire the giant. The organization opened the Farmers' Museum in Cooperstown in 1943, with the facility recreating the look and feel of an early agrarian community. The main barn, a two-floor stone construction, provided space for a series of old-time shops, while the 1845 Village area grouped a series of nineteenth-century structures, among them a tavern and a blacksmith's workspace. As Clifford Lord, director of the association, articulated the museum's aims: "To reestablish contact between the present generation and their forebears, lineal or spiritual . . . to recreate something of the spirit of the Yorker of a century and more ago, who fought under [George] Clinton, pushed the frontier westward, brought the land under cultivation, built the Erie Canal." Administrators believed that the giant belonged within this context, and the association successfully acquired it from Cowles in 1948. On May 19, the exhibition opened following a mock funeral, with the giant lying in an open grave upon the museum grounds. James Taylor Dunn, the association's librarian, hailed the event in a subsequent publication: "It is appropriate that this American belly laugh in stone, the greatest sensation ever known on a New York State farm, should end its days at The Farmers' Museum, which seeks . . . to portray every aspect of life in this state."[10]

Cooperstown was a fitting location for the giant's final resting place, as the town strongly was associated with romantic images—true or not—of the American past. William Cooper originally founded the town, but his son, James Fenimore Cooper, became its most notable resident. The latter based his early novel, *The Pioneers*, on his boyhood experiences there, and the popular novel established familiar themes that ran throughout his later works: the dichotomy between civilization and wilderness as well as the passing of the American Indian. Cooper did not invent a mythic past or look beyond America's true natives, but nevertheless romanticized the noble

savage, while celebrating the heroism of American Indians and white set-
tlers alike. More critically, Cooper characterized the American landscape as
powerful, sublime, and awe-inspiring, and his novels cultivated a curiosity for
the continent's unique nature. The novelist also made the American wilder-
ness a source of pride as well as a point of competition with the Old World.
As Cooper wrote of the Mohawk region in *Wyandotté, or The Hutted Knoll*:
"Still, this particular region, and all others resembling it—for they abound
on the wide surface of the twenty-six states—has beauties of its own, that
it would be difficult to meet with in any of the older portions of the earth."
By delivering romantic themes to a broad audience, Cooper, one of the most
widely read American authors of his time, indirectly contributed to the
cultural context that made the giant's success possible. He also very much
belonged to the fervency of the times. In June 1850, Cooper was one of the
prominent writers and intellectuals who engaged in a séance with Kate and
Maggie Fox, the founders of Spiritualism. According to Horace Greeley, the
novelist was exceedingly impressed with the response of the spirits.[11]

In modern times, Cooperstown emerged as the specific locale for another
romantic myth. In the early years of the twentieth century, Albert Spalding,
the former baseball player and famed sporting-goods manufacturer, inaugu-
rated a committee to determine the origins of America's national pastime.
During this time, nationalism ran high, as the United States had begun
imperial forays into the Pacific Ocean. Uncomfortable with the notion that
baseball developed from the English game of rounders, Spalding sought proof
of uniquely American beginnings. In 1907, the sporting-goods manufacturer
furnished a letter from a mining engineer, who claimed that Abner Double-
day had drawn the first baseball diamond and established the basic rules
of the sport at Cooperstown in 1839. The dubious claim at once invoked
powerful symbols. Cooperstown, of course, represented an idyllic rural loca-
tion, but also was the home of Cooper, whom many considered America's
national novelist. At the same time, Doubleday had been a decorated war
hero, having served the Union during the Civil War. Baseball administra-
tors accepted Spalding's evidence, and, in 1939, the centennial anniversary
of Doubleday's alleged innovation, established the National Baseball Hall
of Fame in Cooperstown. As Stephen Jay Gould later observed, the baseball
myth was "more parochial but no less powerful for many Americans than
the tales of human beginnings that gave life to the Cardiff Giant." Skeptics
eventually disabused most Americans of the Doubleday myth, but the Hall of
Fame and giant still endure in Cooperstown—twin monuments to unbridled
American romance.[12]

* * *

The Farmers' Museum exhibit spawned at least some renewed interest in the hoax in ensuing years. In 1955, the popular television program *You Are There*, hosted by Walter Cronkite, staged a reenactment of the historical episode, with actor Tyler McVey portraying Hull. Four years later, Clarence Budington Kelland published a serial, "The Cardiff Giant Affair," in the *Saturday Evening Post*, staging a melodramatic romance amid nineteenth-century Cardiff. In 1966, Gwen Kimball published a richly illustrated children's book on the hoax, and four other juvenile titles have appeared over ensuing decades.

For the hundredth anniversary of the historical episode, the Fort Dodge Historical Foundation and the National Gypsum Company collaborated on a project to honor the village's role in the hoax. After securing a large slab of gypsum from Cardiff Glen, Clifton Adams, a Fort Dodge sculptor, fashioned a new imitation giant. The foundation ultimately exhibited this replica at the Fort Museum, which, like its New York counterpart, recreated the village's frontier days. The museum consisted of various structures, including a trading post, livery, and blacksmith's shop, and the giant's exhibit resided within a modest log structure.[13]

The final decade of the twentieth century spawned two unusual and entirely novel invocations of the hoax. Harvey Jacobs deconstructed and rebuilt the historical episode for his novel *American Goliath*. The author's story included Hull, Newell, and P. T. Barnum, but also injected new characters as well as other notable nineteenth-century personages such as General Tom Thumb and Jay Gould. The fantastical tale loosely followed the timeline of the historical affair, but, notably, Jacobs's giant possessed cognitive ability, with readers gleaning its thoughts at various points. At the same time, Jacobs fashioned bizarre dreamlike sequences. At one point, Helen Hull makes love to the great wonder, and, in another scene, the original and imitation giants square off in a boxing match. In his review of the book for *Time*, R. Z. Sheppard made note of the novel's moral ambiguity and how the author seemingly treated "bunkum and hypocrisy as endearingly ambivalent national traits." The Beau Jest Moving Theater, a New England theatrical company, made this equivocation even more manifest in *The Naked Giant*, staged at the Massachusetts College of Art in Boston. The playwrights recounted the story of the hoax, but juxtaposed it with modern cases of public deception. Members of the company at one point portrayed Gulf War soldiers, launching Patriot missiles at Iraqi targets. Even though the weapons missed their marks, the commanding officer nevertheless cried "Score!" with each volley. One of

the actors, portraying a CNN reporter, interrupted the scene, informing audience members that, contrary to reported military intelligence, only one of forty-three Patriot missiles hit its target during the war. In another scene, members of the troupe lined up and delivered famously misleading declarations from American history:

> I have in my hand a list of 205 names known to be members of the Communist Party—people who are still making and shaping the policy of the State Department.
>
> I am not a crook.
>
> I don't recall what was said at the meeting.
>
> I tried marijuana once and didn't enjoy it.
>
> Bill Clinton raised taxes 128 times and enjoyed it every time. I raised taxes once and regretted it.

Repeated over and over again in rapid-fire succession, the lines eventually blurred, with the audience hearing amalgamations such as "I tried marijuana once and . . . enjoyed it every time." Though such musings on public deception were rather weighty, *The Naked Giant* retained a humorous and whimsical feel, especially when focusing on the giant's story. The playwright's bumpkin villagers marveled at the great wonder, paying especial attention to its sizable penis and speculating on what other talents and powers the well-endowed giant might have possessed: "sink[ing] [one's] Battleship in less than four moves," "leap[ing] tall buildings in a single bound," and remembering all the lyrics to Culture Club's 1983 hit "Karma Chameleon."[14]

Perhaps more so than Jacobs, the playwrights encapsulated mixed emotions regarding the hoax over the years, while musing upon the lack of clear-cut heroes and villains. On one hand, in juxtaposing the giant with Watergate and other instances of political deception, the writers certainly drew parallels to Gilded Age and Progressive Era assessments, when men and women believed that the hoax embodied the worst of America. In his review for the *Boston Globe*, Brian MacQuarrie observed in the play a proliferation of "power brokers and petty players who intrude upon and influence our lives." In executing the deception, Hull certainly merited similar scorn as Richard Nixon and Joseph McCarthy, but, still, the writers seemed somewhat fond of the giant maker's ingenuity and wit. The playwrights also cast Turk in a negative light for his aggressive proselytizing as well as for being a representative figure of the religious establishment. An actress donned grotesque garb and portrayed the preacher as a shrill hunchback who morphed back and

forth into Nixon. In *The Naked Giant*, religious professionals exploited the public in much the same way as self-serving politicians and military leaders, and, in exposing this hypocrisy, Hull actually became a more sympathetic figure. Even the public was not entirely blameless in the theatrical version of the affair, however, as playwrights rendered the country folk as dense, rather than purely innocent. At the beginning of the play, Davis Robinson, director and one of the playwrights, promised the audience that *The Naked Giant* would answer the question, "Who is telling the truth?" Still, just as the writers had difficulty in passing definitive moral judgment, MacQuarrie observed the lack of any clear answer on the central question: "Beau Jest's answer seems to be: 'Who knows?'" In part, the lack of response belied a certain modern cynicism. Vietnam and Watergate left modern Americans much more pessimistic about their institutions and nation more generally, a stark contrast to their relentlessly optimistic forbears, who, in the wake of a brutal war, presidential assassination, and tumultuous Reconstruction, maintained a boundless faith in America's future and the possibilities of science. Still, Beau Jest Moving Theater's world was not wholly cynical. As MacQuarrie observed: "There's also a strong feeling of optimism that somehow we'll get it right if we remain skeptical." Nearly a century and a half later, the familiar tale still was teaching Americans the value of skepticism, and, as *The Naked Giant* implied, the hoax's central lesson possessed broad applicability beyond the realm of fossil giants.[15]

Today, no fewer than four museums commemorate the hoax. The Fort Museum still exhibits the modern replica in Fort Dodge. In Farmington Hills, Michigan, Marvin's Marvelous Mechanical Museum possesses one of Carl Franz Otto's imitations, as does the Circus Museum in—of all places— Baraboo, Wisconsin, the same locality where Hull once ruminated upon his scheme. The original giant remains at the Farmers' Museum in Cooperstown. Over the years, the exhibition space has changed numerous times. For a while, in a nod to its original burial context, the giant resided under a large tent. Today, it rests in an alcove inside the museum's main barn.

* * *

In the beginning, there was Cardiff, and so it shall be in the end.

Suffield, Ackley, Fort Dodge, Chicago, and Broome County all have rightful claims as the hoax's spiritual or material birthplace. Nevertheless, Cardiff was the place where the giant's public life began, and from whence

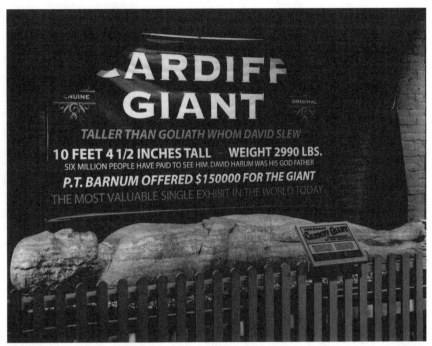

Current exhibit at the Farmers' Museum in Cooperstown, New York. Source: Courtesy of the New York State Historical Association Library, Cooperstown, New York.

it derives its enduring name. How does Cardiff regard the historical episode that, for better or worse, put the hamlet on the map forever?

First, it is worth noting that, today, Cardiff looks much the same as it did in 1869. There are still only a 150 or so residents, and nearly all of them claim European heritage. More than a few structures have endured the passage of time, most notably the Ebenezer Methodist Episcopal Church as well as Daniel Newell's old house, where Stub likely was born. Others long since have crumbled, including Stub Newell's own home and barn, and modern but equally modest structures now stand in their wake. Still, Cardiff has changed markedly in key respects since the days of the giant. The village's economy suffered greatly in the age of the automobile, as engineers in the 1930s forsook the old turnpike route through the village, running modern Route 11 through LaFayette instead. Cardiff never recovered from the loss of traffic and business. Over the years, the village gradually became a suburb, with men and women commuting to Syracuse for employment, rather than plying trades within the tiny village. Cardiff's

agricultural economy eventually fell by the wayside as well, and, today, thick overgrowth covers much of the village's former farmland, including the spot where the erstwhile great wonder once lay.

Through the years, Cardiff never has shied away from its history. Passed from generation to generation, the hoax has become a vital part of village folklore. *LaFayette Town*, written by local historian Roy Dodge, includes one humorous but possibly apocryphal anecdote. As the story goes, in October 1869, a New York City reporter asked Newell for his first thoughts upon seeing the giant. In a playful jab at small-town talk, the Cardiff farmer allegedly responded: "Well, as I looked at him, I says to myself, there is at least one man in Cardiff who will keep his mouth shut." For the seventieth anniversary of the hoax, coinciding with the broader nostalgia movement in the United States, Cardiff residents took steps to commemorate the historical episode. Members of the Tully Valley Grange 646 successfully lobbied the New York State Department of Education for two historic markers. In the spring of 1939, residents installed the signposts along Routes 11-A and 20, the modern versions of their original crossroads. Later that year, villagers gathered for a special supper at the country church, sharing stories about the giant and their parents. Anna and Myron Nichols, the children of Henry, both were present, and, though he was only three when his father discovered the great wonder, Myron Nichols told the *Syracuse Post-Standard* that he remembered the affair "as tho [sic] it happened today."[16]

No one can recall exactly when, but, at some point over ensuing decades, the Route 11-A marker disappeared, and one local historian jokes that it probably ended up in a fraternity house at Syracuse University. The villagers eventually installed a replacement marker, but, this time, placed the signpost on Tully Farms Road, opposite Newell's old property. The marker reads:

THE CARDIFF GIANT
DISCOVERED HERE
OCTOBER 16, 1869.
IT WAS PROVED A HOAX,
ONE OF THE GREATEST PUBLIC
DECEPTIONS IN AMERICAN HISTORY.

In the year of the nation's bicentennial—a time for celebrating local contributions to the American tapestry—Cardiff residents honored their village's unique history not only by performing Drummond and Gard's play but also by staging a sequel hoax, of sorts. Members of the Cardiff Giant Chapter, a local service organization, sculpted an eight-foot female giant,

and, with permission from the current property owner, buried it near where workers discovered the original. Soon thereafter, chapter members arranged for the discovery, and, in a nod to the contemporary equal-rights movement, christened the new colossus Mrs. or Ms. Cardiff Giant. Over the course of that summer, villagers exhibited the female giant alongside Route 20 and in regional parades. Their intent, of course, was not to deceive. Like their parents and grandparents before them, these men and women not only had come to terms with Cardiff's notoriety but celebrated the village's unique place in American history with equal parts pride and humor. Furthermore, this second giant—or umpteenth, depending on one's calculations—gave Cardiff another distinction. The children of these men and women—and, indeed, the rest of America—could look back someday and laugh that Turk had been proven right after all. In Cardiff, New York, at least, there truly had been giants in the earth.[17]

~

Notes

Preface

1. Quotation: John Fanning Watson, *Annals of Philadelphia and Pennsylvania in the Olden Time*, rev. ed. (Philadelphia: E. Thomas, 1857), 2:590.

2. Quotation: Anthony Trollope, *North America* (New York: Harper & Brothers, 1862), 383.

3. Quotation: Otto Julius Bernhard von Corvin-Wiersbitzki, *A Life of Adventure, an Autobiography*, 3 vols. (London: R. Bentley, 1871), 2:320.

4. Seaman: Ezra Champion Seaman, *The American System of Government* (New York: C. Scribner & Co., 1870), 114.

5. Newspaper: *Boston Morning Journal*, January 25, 1870.

Chapter 1: A Giant in the Earth

1. Rives quoted in John Minor Botts, *The Great Rebellion: Its Secret History, Rise, Progress, and Disastrous Failure* (New York: Harper, 1866), 50–51.

2. Fields quoted in "Cardiff and the Civil War," *Newsletter of the LaFayette Historical Society* no. 48 (June 2004): 15. Enlistments and deaths extrapolated from known servicemen within the First Election District, which included both Cardiff and its environs. Cardiff's taxes derived from LaFayette's assessments for 1864.

3. Stevens quoted in Eric Foner, *Reconstruction: America's Unfinished Revolution, 1863–1877* (1988; repr., New York: Harper & Row Perennial Library, 1989), 232.

4. Cardiff quotes from Andrew Dickson White, "The Cardiff Giant: A Chapter in the History of Human Folly—1868–1870," in *Autobiography of Andrew Dickson White* (New York: Century Co., 1905), 2:466–68.

5. Weather: *Syracuse Daily Standard*, October 18, 1869.

6. Emmons's injury: *Marathon Mirror*, May 13, 1865, reprinted at http://www .rootsweb.com/~nytioga/civiln17.htm (accessed June 21, 2006). Emmons's pension: United States Pension Bureau, "List of Pensioners on the Roll from Records for Town of LaFayette," January 1, 1883, United States Military Archive, Carlisle, PA (Photostat furnished by J. Roy Dodge).

7. See affidavits of Newell, Nichols, and Woodmansee in *Syracuse Daily Standard*, October 30, 1869.

8. See affidavits of Stub Newell, Lydia Newell, and Wright in *Syracuse Daily Standard*, October 30, 1869. Livestock holdings: *Syracuse Daily Standard*, November 2, 1869.

9. Observations on Newell: *Brooklyn Eagle*, November 20, 1869.

10. Descriptions of terrain: *Syracuse Daily Standard*, October 18, 1869 and the *Brooklyn Eagle*, November 20, 1869.

11. For circumstances leading up to discovery, see affidavits of Newell, Nichols, Parker, Woodmansee in *Syracuse Daily Standard*, October 30, 1869.

12. Quotation: *The American Goliah: A Wonderful Geological Discovery* (Syracuse, NY: Printed at the Journal Office, 1869), 3.

13. See affidavit of John Haynes in *The Cardiff Giant Humbug: A Complete and Thorough Exposition of the Greatest Deception of the Age* (Fort Dodge, IA: North West Book & Job Printing Establishment, 1870), 26.

14. *The Cardiff Giant Humbug*, 26.

15. Description from *Syracuse Daily Standard*, October 18, 1869.

16. White, *Autobiography of Andrew Dickson White*, 2:467.

17. *Syracuse Daily Journal*, October 20, 1869, and John Rankin, *The Giantmaker or the Mist of Mystery, A True Story*, 126–27, item 72, John C. Rankin papers, 1857–1963, 1869–1902 (bulk), Broome County Historical Society, Broome County Public Library, Binghamton, NY.

18. Houghton: Rankin, *The Giantmaker*, 125. Clark: Joshua V. H. Clark, *Onondaga* (Syracuse, NY: Stoddard & Babcock, 1849), 2:266–68.

19. *Syracuse Daily Standard*, October 18, 1869; and Rankin, *The Giantmaker*, 130.

20. Rankin, *The Giantmaker*, 129.

21. *Syracuse Daily Standard*, October 18, 1869.

Chapter 2: Like Wildfire

1. Chapter title from *Syracuse Daily Courier*, October 18, 1869.

2. Forbes: *Syracuse Daily Standard*. Hearsay: *Syracuse Daily Courier*, October 18, 1869.

3. *Syracuse Daily Standard* and *Syracuse Daily Courier*, October 18, 1869.

4. Gen. 6:4 (King James Version).

5. *Syracuse Daily Journal*, October 20, 1869; and John Rankin, *The Giantmaker or the Mist of Mystery, A True Story*, 137, item 72, John C. Rankin papers, 1857–1963,

1869–1902 (bulk), Broome County Historical Society, Broome County Public Library, Binghamton, NY.

6. Whitney R. Cross, *The Burned-over District: The Social and Intellectual History of Enthusiastic Religion in Western New York, 1800–1850* (Ithaca, NY: Cornell University Press, 1950), 80.

7. Physicians: Rankin, *The Giantmaker*, 136. Quotation: *Daily National Intelligencer*, July 2, 1857.

8. Quotation: John Parsons Foote, *The Schools of Cincinnati and its Vicinity* (Cincinnati, OH: C. F. Bradley & Co.'s Power Press, 1855), 203.

9. Giant skull: "Organic Remains," *The Knickerbocker* 8, no. 2 (August 1836): 128.

10. Quotations: *Baltimore Patriot*, August 10, 1824; *Norwich Courier*, August 3, 1831; and *New York Journal of Commerce*, reprinted in *Daily National Intelligencer*, October 1, 1839.

11. Quotations: "Earthquakes," *Monthly Repository, and Library of Entertaining Knowledge* 1, no. 1 (June 1830): 12; and *New Orleans Commercial Bulletin*, September 30, 1833.

12. Quotations: *Daily National Intelligencer*, September 25, 1823; *New York Herald*, October 1, 1836; and *Daily Cleveland Herald*, September 7, 1854.

13. Rankin, *The Giantmaker*, 136.

14. *Syracuse Daily Standard*, October 22, 1869.

15. Arrival: *Syracuse Daily Standard*, October 18, 1869. Quotation: *Brooklyn Eagle*, September 25, 1858. For more on Boynton's scientific career, see *Syracuse Daily Standard*, October 21, 1890.

16. Marriage: *New York Herald*, November 9, 1865. For more on Boynton's career within the Mormon Church, see "Boynton, John Farnham," *LDS Biographical Encyclopedia*, at http://www.ancestry.com/search/db.aspx?dbid=2028 (accessed July 17, 2007).

17. Quotation on conflict: Lucy Mack Smith, *Biographical Sketches of Joseph Smith the Prophet and his Progenitors for Many Generations* (1908; repr., Whitefish, MT: Kessinger Publishing, 2006), 260. Quotation on Boynton's tolerance: "The Twelve Apostles," *The Historical Record* 5, no. 4 (April 1886): 53.

18. Boynton's examination: Rankin, *The Giantmaker*, 142–43.

19. Newell's conversations: Rankin, *The Giantmaker*, 137–38, 146. Boynton's claims: *Syracuse Daily Standard*, and *Syracuse Daily Courier*, October 18, 1869. My thanks to Kenneth L. Feder for perspective on Boynton's thought process.

20. *Syracuse Daily Standard*, October 18, 1869.

21. *Syracuse Daily Courier*, October 18, 1869.

22. *Syracuse Daily Journal*, *Syracuse Daily Standard*, and *Syracuse Daily Courier*, October 18, 1869.

23. Rankin, *The Giantmaker*, 148–49.

24. Attendance: *Syracuse Daily Standard*, October 19, 1869.

Chapter 3: The Giant Maker

1. Hull's awareness: *New York Sun*, reprinted in *Ithaca Daily Journal*, January 4, 1898. My thanks to Harvey Jacobs for pointing out the God-Adam parallels with Hull's giant.

2. Physical descriptions: *The Cardiff Giant Humbug: A Complete and Thorough Exposition of the Greatest Deception of the Age* (Fort Dodge, IA: North West Book & Job Printing Establishment, 1870), 16; and *Sauk County Herald*, reprinted in *The History of Sauk County, Wisconsin* (Chicago: Western Historical Co., 1880), 550. Quotation: *The History of Sauk County, Wisconsin*, 550.

3. Hull's birth: John Rankin, *The Giantmaker or the Mist of Mystery, A True Story*, 4, item 72, John C. Rankin papers, 1857–1963, 1869–1902 (bulk), Broome County Historical Society, Broome County Public Library, Binghamton, NY. Hull family in 1820: 1820 U.S. Federal Census (Population Schedule), West Springfield, Hampden, MA, Roll: M33_48, Page: 277, Image: 179, John Hull household, jpeg image, (Online: MyFamily.com, 2006), subscription database, [Digital scan of original records in the National Archives, Washington, DC], at http://www.ancestry.com (accessed June 21, 2006). Within the context of George Hull's youth, *The Giantmaker* does mention Feeding Hills in passing. See Rankin, *The Giantmaker*, 38.

4. Parents and siblings: *New York Sun*, reprinted in *Ithaca Daily Journal*, January 4, 1898; and *Binghamton Evening Herald*, October 21, 1902. Specific location derived from nearby entries within the 1820 U.S. Federal Census as well as from contemporary maps.

5. Financial loss and quotation: *New York Sun*, reprinted in *Ithaca Daily Journal*, January 4, 1898. Schooling and eyesight: Rankin, *The Giantmaker*, 3. Suffield relocation: 1840 U.S. Federal Census (Population Schedule), Suffield, Hartford, CT, Roll: 24, Page: 203, John Hull household, at http://www.ancestry.com (accessed June 21, 2006).

6. De Tocqueville quotation: Alexis de Tocqueville, *Democracy in America*, 2nd ed., trans. Henry Reeve (Cambridge, MA: Sever & Francis, 1863), 1:388. Noll quotation: Mark A. Noll, *A History of Christianity in the United States and Canada* (1992; repr., Grand Rapids, MI: William B. Eerdmans Publishing Co., 2000), 243. Hull quotation: Rankin, *The Giantmaker*, 5. The records of the First Baptist Church identify Ruth Hull as a member, while also referencing her passing.

7. Rankin, *The Giantmaker*, 5–8.

8. Rankin, *The Giantmaker*, 8–9.

9. Hull and Bible: Rankin, *The Giantmaker*, 4, 10. Protestant literalism and geology: James Turner, *Without God, Without Creed: The Origins of Unbelief in America* (Baltimore: Johns Hopkins University Press, 1985), 144–45. Anecdote: *Boston Investigator*, August 14, 1844. Cavil quotation: *The Christian Freeman and Family Visitor*, quoted in *Boston Investigator*, November 26, 1845.

10. Hull's quotation: Rankin, *The Giantmaker*, 11.

11. Hull's interview: *New York Daily Tribune*, September 21, 1871. Newell's characterization: Clipping, "Hull At His Old Tricks," n.d., Cardiff Giant Records,

2002.84, Onondaga Historical Association, Syracuse, NY. Anti-Hume quotations: *Columbian Star*, reprinted in *Providence Gazette*, March 24, 1824; and *Vermont Chronicle*, February 21, 1833. Popularity of atheism: Turner, *Without God, Without Creed*, 102. *The Giantmaker* does not indicate whether Hull revealed his atheism to his mother.

12. Hull's interview: *New York Daily Tribune*, September 21, 1871.

13. Rankin, *The Giantmaker*, 11.

14. Census: 1850 U.S. Federal Census (Population Schedule), Springfield, Hampden, MA, Roll: M432_319, Page: 104, Image: 210, Dwelling: 1615, Family: 1764, George Hull household, at http://www.ancestry.com (accessed June 21, 2006). Hull's activities: *New York Sun*, reprinted in *Ithaca Daily Journal*, January 4, 1898.

15. *New York Daily Tribune*, January 24, 1878.

16. John Hull Jr.'s household in 1855: 1855 New York State Census (Population Schedule), Chenango, Broome County, Roll: 809005, Enumeration District: 4, Page: 9, Dwelling: 63, Family: 77, John Hull household (Family History Library) [Microreproduction of original records in New York State Library]. George Hull's statement of marriage: *New York Sun*, reprinted in *Ithaca Daily Journal*, January 4, 1898. John Hull Jr.'s household in 1860: 1860 U.S. Federal Census (Population Schedule), Chenango, Broome, NY, Roll: M653_724, Page: 540, Image: 545, Dwelling: 1755, Family: 1805, John Hull household, at http://www.ancestry.com (accessed June 21, 2006). George Hull's household in 1860: 1860 U.S. Federal Census (Population Schedule), Port Crane, Broome, NY, Roll: M653_724, Page: 659, Image: 664, Dwelling: 168, Family: 158, George Hull household, at http://www.ancestry.com (accessed June 21, 2006). George Hull's solicitation: Rankin, *The Giantmaker*, 25. Broome County did not register marriages in these days, and, even if the couple did marry within a church—an exceedingly unlikely scenario—no contemporary records have survived.

17. 1870 Census: 1870 U.S. Federal Census (Population Schedule), Binghamton, Broome, NY, Roll: M593_906, Page: 82, Image: 166, Dwelling: 511, Family: 573, George Hull household, at http://www.ancestry.com (accessed June 21, 2006). Disgrace: *New York Daily Tribune*, January 24, 1878.

18. *New York Daily Tribune*, September 21, 1871.

19. Cigar shop: *Binghamton Republican*, October 25, 1902.

20. *New York Sun*, reprinted in *Ithaca Daily Journal*, January 4, 1898; and *Binghamton Evening Herald*, October 21, 1902. The latter source suggests that the Hulls may have moved to Connecticut for a brief time, but ultimately returned to Broome County.

21. Issues with law: Statement of "H———" [illegible], n.d., folder 3, Cardiff Giant Records, 2002.84, Onondaga Historical Association, Syracuse, NY. Relocation: *New York Daily Tribune*, September 21, 1871.

22. Colfax quotation: Quoted in Samuel Bowles, *Across the Continent: A Summer's Journey to the Rocky Mountains, the Mormons, and the Pacific States, with Speaker Colfax* (Springfield, MA: S. Bowles & Co., 1865), 408. Ogden's relocation and Hull's arson: Statement of "H———" [illegible], n.d., Onondaga Historical Association.

23. Ogden's problems: *New York Sun*, reprinted in *Ithaca Daily Journal*, January 4, 1898. Revival: Rankin, *The Giantmaker*, 16.

24. Turk's occupation: 1870 U.S. Federal Census (Population Schedule), Oakland, Franklin, IA, Roll: M593_392, Page: 387, Image: 338, Dwelling: 20, Family: 21, H. B. Turk household, at http://www.ancestry.com (accessed June 21, 2006). For biographical information on Turk, see *History of Hardin County, Iowa* (1883; repr., Evansville, IN: Unigraphic, 1974), 323; and *History of Tioga County, Pennsylvania* (Harrisburg, PA: R. C. Brown & Co., 1897), 1:380–81, 402–3.

25. Quotations and developments from *New York Sun*, reprinted in *Ithaca Daily Journal*, January 4, 1898; and Rankin, *The Giantmaker*, 16–17. For the sickness of Ogden's father, see W. A. McKinney, "The History of the Cardiff Giant Hoax," *New Englander and Yale Review* 34, no. 133 (October 1875): 759.

26. Absurdities and giants: Rankin, *The Giantmaker*, 17. Biblical veracity: Turner, *Without God, Without Creed*, 150. Flood: George P. Putnam, *Hand-book of Chronology and History*, 6th ed. (New York: George P. Putnam, 1852), 290.

27. Rankin, *The Giantmaker*, 17–20.

28. Rankin, *The Giantmaker*, 20–22.

29. Discussion: Rankin, *The Giantmaker*, 21–23. Rankin's disclaimer: Rankin, *The Giantmaker*, 12–15.

30. *New York Sun*, reprinted in *Ithaca Daily Journal*, January 4, 1898; and Rankin, *The Giantmaker*, 24.

Chapter 4: Cradle to the Grave

1. Poe's quotation: Quoted in Arthur Hobson Quinn, *Edgar Allan Poe: A Critical Biography* (1941; repr., Baltimore: Johns Hopkins University Press, 1998), 410.

2. Quotation: P. T. Barnum, *The Life of P. T. Barnum, Written By Himself* (London: S. Low, 1855), 44.

3. Quotation: P. T. Barnum, *The Humbugs of the World: An Account of Humbugs, Delusions, Impositions, Quackeries, Deceits and Deceivers Generally, in All Ages* (London: J. C. Hotten, 1866), 193.

4. Barnum's quotations: P. T. Barnum, *The Humbugs of the World*, 11, 20–21. Harris's quotation: Neil Harris, *Humbug: The Art of P. T. Barnum* (Boston: Little, Brown, 1973), 77.

5. Georgia case: *Lowell Courier*, reprinted in *North American and United States Gazette*, April 22, 1850. Iowa case: *New Hampshire Patriot*, reprinted in *Cleveland Herald*, January 25, 1845. Ohio case: *Cincinnati Chronicle*, reprinted in *Scioto Gazette*, October 20, 1847.

6. Montreal case: *Montreal Times*, reprinted in *Cleveland Herald*, April 14, 1845. Edinburgh case: *Caledonian Mercury*, reprinted in *London Times*, December 8, 1847. London reprints: *Galveston Gazette*, reprinted in *London Times*, December 8, 1856; and *Cincinnati Inquirer*, reprinted in *London Times*, November 23, 1858. Australia case: *Salt Lake Daily Telegraph*, May 12, 1866.

7. Fort Langley hoax: *Daily Alta California*, reprinted in *Brooklyn Eagle*, August 13, 1858. My thanks to Kenneth L. Feder for observing the clue within Flucterspiegel's name. Twain quotations: Mark Twain, "The Petrified Man," in *Sketches New and Old* (1875; repr., New York: Harper & Brothers Publishers, 1922), 288, 291. Twain's reprints: *Daily Evening Bulletin*, October 15, 1862; *Milwaukee Daily Sentinel*, November 19, 1862; and *Boston Investigator*, January 7, 1863.

8. Activities in Baraboo: *Sauk County Herald*, reprinted in *The History of Sauk County, Wisconsin* (Chicago: Western Historical Co., 1880), 549–52. Solicitation of brother: John Rankin, *The Giantmaker or the Mist of Mystery, A True Story*, 25, item 72, John C. Rankin papers, 1857–1963, 1869–1902 (bulk), Broome County Historical Society, Broome County Public Library, Binghamton, NY.

9. Meeting with Martin: Rankin, *The Giantmaker*, 25–27. Arson in Baraboo: *The History of Sauk County, Wisconsin*, 549–50. Arson in Ackley: Statement of "H———" [illegible], n.d., folder 3, Cardiff Giant Records, 2002.84, Onondaga Historical Association, Syracuse, NY.

10. Statement of "H———" [illegible], n.d., Onondaga Historical Association.

11. Martin's scouting: *The Cardiff Giant Humbug: A Complete and Thorough Exposition of the Greatest Deception of the Age* (Fort Dodge, IA: North West Book & Job Printing Establishment, 1870), 16. For more on Fort Dodge gypsum, see Robert M. McKay, "Gypsum Resources of Iowa," at http://www.igsb.uiowa.edu/Browse/gypsum/gypsum.htm (accessed June 21, 2006).

12. *The Cardiff Giant Humbug*, 16, 32.

13. *The Cardiff Giant Humbug*, 16–17.

14. Salesman: *New York Daily Tribune*, September 21, 1871. Shipments: "The Biography of a Giant," *The Lakeside Monthly* 6, no. 32 (August 1871): 130. The *Lakeside Monthly* article indicates that Hull and Martin sent samples only after meeting with Burkhardt, but the latter's consternation upon receiving the unsolicited package does not make sense within this context.

15. Chicago quotation: W. Pembroke Fetridge, *The American Travellers' Guides: Harper's Handbook for Travellers in Europe and the East* (New York: Harper & Brothers, Publishers, 1868), 634. Biographical information on Burkhardt gleaned from contemporary city directories.

16. Meeting with Martin Ramkin, 130, 133–34. Partnership: *Buffalo Courier*, reprinted in *New York Herald*, March 16, 1870. Timing of Chicago trip derived from affidavit of Wilson Lumpkin. See *The Cardiff Giant Humbug*, 32.

17. Quarrying: *The Cardiff Giant Humbug*, 17–18, 32. Martin's departure: Rankin, *The Giantmaker*, 33. Shipping Records: *The Cardiff Giant Humbug*, 19. Eyewitnesses: *Iowa North West*, December 9, 1869. In the latter source, Benjamin Gue and G. M. Hull (no relation) refer to giant makers in the plural, so Martin's presence is assumed. For Foley's dubious claim, see *Chicago Chronicle*, reprinted in *Syracuse Herald*, February 25, 1907. According to the quarryman, the Cardiff giant scheme made him rich, though he did not explain why he gave up Hull and Martin to reporters in December 1869 and also why Hull allegedly had paid him in full, but not any of his other

partners. Most likely, Foley was seeking notoriety beyond his years and accordingly overstated his passing connection to the hoax.

18. Rankin, *The Giantmaker*, 33–41; and *The Cardiff Giant Humbug*, 18–19.

19. Rankin, *The Giantmaker*, 33–41; and *The Cardiff Giant Humbug*, 18–19. Newspaper quotation: Quoted in *The Cardiff Giant Humbug*, 19.

20. Arrival: *The Cardiff Giant Humbug*, 20. Gue: *Iowa North West*, December 9, 1869.

21. Payment options: *Chicago Daily Tribune*, February 11, 1870. Sculpture: *Chicago Daily Tribune*, February 2, 1870; and Rankin, *The Giantmaker*, 43–45. Mohrmann's name sometimes appears as "Markman" in retrospectives. The two men may have received initial assistance from John J. Sampson, Burkhardt's foreman. See *Boston Globe*, November 8, 1902. According to Salle, Hull contracted with him directly, but the sculptor likely was protecting Burkhardt, his employer, from the scrutiny of reporters.

22. *Chicago Daily Tribune*, February 2, 11, 1870; Rankin, *The Giantmaker*, 44–46; and "The Biography of a Giant," 130–131.

23. *Chicago Daily Tribune*, February 2 & 11, 1870; Rankin, *The Giantmaker*, 44–46; and "The Biography of a Giant," 130–31.

24. Hull's scouting: W. A. McKinney, "The History of the Cardiff Giant Hoax," *New Englander and Yale Review* 34, no. 133 (October 1875): 764; and *Pittsfield Eagle*, reprinted in *Lowell Daily Citizen and News*, May 2, 1871. Mexico: *Chicago Daily Tribune*, February 11, 1870. McKinney indicates that the Salisbury trip came after Hull shipped the completed giant, but common sense dictates that the giant maker scouted some locations before committing to a shipping schedule. Martin's perspective: *Buffalo Courier*, reprinted in *New York Herald*, March 16, 1870. Eyewitness sighting: *Iowa North West*, December 9, 1869.

25. Preparations: See affidavits in *Syracuse Daily Journal*, January 29, 1870. Shipment: *The Cardiff Giant Humbug*, 20. One report had the giant traveling to Detroit by schooner, but freight records suggest otherwise. See *New York Sun*, reprinted in *Cleveland Daily Herald*, January 10, 1870.

26. Rankin, *The Giantmaker*, 48–114.

27. *The Cardiff Giant Humbug*, 20–21.

28. Hull's awareness of Onondaga County: *New York Sun*, reprinted in *Ithaca Daily Journal*, January 4, 1898. Clark's quotation: Joshua V. H. Clark, *Onondaga* (Syracuse, NY: Stoddard & Babcock, 1849), 2:256.

29. Boynton's connection: *Syracuse Daily Courier*, October 30, 1869.

30. Cousin: *Syracuse Daily Standard*, October 25, 1869. Nephew misidentification: 1880 U.S. Federal Census (Population Schedule), Fenton, Broome, NY, Roll: T9_810, Family History Film: 1254810, Page: 308.2000, Enumeration District: 46, Image: 0753, Dwelling: 327, Family: 332, George Hull household, jpeg image, (Online: MyFamily.com, 2006), subscription database, [Digital scan of original records in the National Archives, Washington, DC], at http://www.ancestry.com (accessed June 21, 2006). More specific connection: McKinney, "The History of the Cardiff Giant Hoax," 764.

31. Dennison Newell in Binghamton: Rankin, *The Giantmaker*, 117. Hull's quotation: *New York Sun*, reprinted in *Ithaca Daily Journal*, January 4, 1898.

32. Partnership: *Buffalo Courier*, reprinted in *New York Herald*, March 16, 1870. Secret and subsequent visit: Rankin, *The Giantmaker*, 117.

33. Pickup: *The Cardiff Giant Humbug*, 20–21. Dennison Newell's visits to a shared relative in the Binghamton vicinity reinforce the likelihood of an Amsbury-Newell-Hull connection.

34. *The Cardiff Giant Humbug*, 21.

35. *The Cardiff Giant Humbug*, 21–23.

36. *The Cardiff Giant Humbug*, 23.

37. Arrival: Rankin, *The Giantmaker*, 118. Hull's return to hotel: *The Cardiff Giant Humbug*, 23. The switch of boxes assumed from later testimony. See affidavits in *Syracuse Daily Journal*, January 29, 1870.

38. See affidavits in *Syracuse Daily Journal*, January 29, 1870.

39. Rankin, *The Giantmaker*, 118–19.

40. Newell's consternation: Rankin, *The Giantmaker*, 127–28, 134, 149–50. Expenses: *New York Sun*, reprinted in *Ithaca Daily Journal*, January 4, 1898.

Chapter 5: Big Business

1. *New York Daily Tribune*, October 19, 1869. Reprints: *Philadelphia Inquirer*, October 20, 1869; *Baltimore Sun*, October 21, 1869; *Missouri Republican*, *Daily National Intelligencer*, and *Chicago Daily Tribune*, October 22, 1869; *Louisville Courier Journal*, October 24, 1869; *Columbus (Ga.) Ledger-Enquirer*, October 26, 1869; and *Daily Alta California*, October 29, 1869.

2. *New York Herald*, October 20, 1869; *Boston Post*, October 21, 1869; and *New York Times*, October 23, 1869.

3. Popularity quotations: *Syracuse Daily Standard*, October 21 & 22, 1869. Poem: *Syracuse Daily Journal*, October 21, 1869.

4. Transportation: *The American Goliah: A Wonderful Geological Discovery* (Syracuse, NY: Printed at the Journal Office, 1869), 10–11; and Andrew Dickson White, "The Cardiff Giant: A Chapter in the History of Human Folly—1868–1870," in *Autobiography of Andrew Dickson White* (New York: Century Co., 1905), 2:468. Parody: *Syracuse Daily Journal*, October 21, 1869.

5. Wednesday & York visitor: *Syracuse Daily Standard*, October 21, 1869. Thursday: *Syracuse Daily Courier*, October 22, 1869. Friday: *Syracuse Daily Journal*, October 23, 1869. Saturday: *Syracuse Daily Journal*, October 25, 1869.

6. White and quotations: White, *Autobiography of Andrew Dickson White*, 2:468. Taverns: *Syracuse Daily Standard*, October 22, 1869.

7. White's quotation: White, *Autobiography of Andrew Dickson White*, 2:469. Houghton: *Syracuse Daily Courier*, October 20, 1869. Responses: White, *Autobiography of Andrew Dickson White*, 2:472; and *The Onondaga Giant, or the Great Archaeological Discovery* (Syracuse, NY: Nottingham & Tucker, 1869), 21.

8. *Syracuse Daily Courier*, October 25, 1869.

9. What-is-it: *Syracuse Daily Journal*, October 22, 1869. Call to Barnum: *Syracuse Daily Standard*, October 19, 1869. Barnum's quotation: P. T. Barnum, *Struggles and Triumphs; or, Forty Years' Recollections of P. T. Barnum, Written by Himself* (Hartford, CT: J. B. Burr, 1869), 768.

10. Smith brothers: Rankin, *The Giantmaker*, 149–50. Stanton: Rankin, *The Giantmaker*, 151–52; Wieting: Rankin, *The Giantmaker*, 150–61. Quotation on lectures: Quoted in *National Cyclopaedia of American Biography*. *The Giantmaker* places Wieting's visit on Thursday, but, given the ultimate timing of the sale, it more likely was Wednesday, coinciding with Hull's arrival in Cardiff.

11. Rankin, *The Giantmaker*, 155–57, 161.

12. Gillett's disposition: Rankin, *The Giantmaker*, 165. Westcott's background: *Syracuse Daily Journal*, July 7, 1873.

13. Quotations: Arthur T. Vance, *The Real David Harum* (New York: Baker & Taylor Co., 1900), 21, 23.

14. Interest: Rankin, *The Giantmaker*, 158. Newell's quotation: *New York Sun*, December 22, 1869. Rival: Rankin, *The Giantmaker*, 159–60.

15. Celebrity and Goliah quotation: *Syracuse Daily Courier*, October 22, 1869. Sale: Rankin, *The Giantmaker*, 161–63. Martin's presence: *Buffalo Courier*, reprinted in *New York Herald*, March 16, 1870. A fellow Marshalltown resident confirmed Martin's trip east. See *The Cardiff Giant Humbug: A Complete and Thorough Exposition of the Greatest Deception of the Age* (Fort Dodge, IA: North West Book & Job Printing Establishment, 1870), 30–31. Goliah was a variant name for the biblical Goliath.

16. Sale: Rankin, *The Giantmaker*, 161–65; and Various documents, folders 4, 9, and 10, Cardiff Giant Records, 2002.84, Onondaga Historical Association, Syracuse, NY.

17. Flag: *Syracuse Daily Journal*, October 25, 1869. Syracuse newspapers reported that the new master of ceremonies was a local man named Wood, but Rankin identified him as the Chicago showman.

18. *The American Goliah*, 5.

19. Archaeological quotation: *The Onondaga Giant*, 9. Author's quotation: *The Autobiography of the Great Curiosity, The Cardiff Stone Giant*, 2nd ed. (Syracuse, NY: Hitchcock & Smith, 1869), 3–4.

20. *Syracuse Daily Standard*, *Syracuse Daily Courier*, and *Syracuse Daily Journal*, October 25, 1869.

21. Reminder: *Syracuse Daily Courier*, October 27, 1869. Observation: *New York Commercial Advertiser*, November 5, 1869.

Chapter 6: Ten Thousand Stories

1. Chapter title from *Syracuse Daily Standard*, October 20, 1869. Quotation: *Syracuse Daily Standard*, October 22, 1869.

2. Headlines: *Syracuse Daily Journal*, October 22, 23, & 28, 1869. Change in opinion: *Syracuse Daily Journal*, October 22 & 23, 1869; and *Syracuse Daily Courier*, October 20, 1869. *Standard*'s defense of petrifaction: *Syracuse Daily Standard*, October 21, 22, & 28, 1869, November 13, 1869.

3. Lady: *Syracuse Daily Standard*, October 22, 1869. Spiritualists: *Syracuse Daily Standard*, October 28, 1869. Barnes's lecture: *Syracuse Daily Standard*, November 29, 1869; and *Syracuse Daily Courier*, November 27, 1869.

4. Goliah: *New York Sun*, reprinted in *Syracuse Daily Standard*, November 30, 1869; and *Syracuse Daily Courier*, October 22, 1869. Og: *Utica Morning Herald*, November 19, 1869. Noah: *Syracuse Daily Standard*, October 26, 1869. White's quotation: Andrew Dickson White, "The Cardiff Giant: A Chapter in the History of Human Folly—1868–1870," in *Autobiography of Andrew Dickson White* (New York: Century Co., 1905), 2:472.

5. Geddes's assessment: *Syracuse Daily Standard*, November 2, 1869. *Courier's* statement: *Syracuse Daily Courier*, October 18, 1869. Bible and mythology: *Syracuse Daily Standard*, November 12, 1869. *New York World's* account: *New York World*, reprinted in *Saturday Evening Post*, November 27, 1869. Leavenworth: *Syracuse Daily Journal*, October 27, 1869.

6. Railroad: *Syracuse Daily Standard*, October 19, 1869. Oswego Falls: *Fulton Times*, reprinted in *Syracuse Daily Standard*, November 13, 1869. Owen: *Rochester Democrat*, October 20, 1869. Bartholomew: *Auburn News*, reprinted in *Syracuse Daily Standard*, November 1, 1869.

7. Quotation: *Hartford Post*, reprinted in *Syracuse Daily Journal*, November 5, 1869.

8. Quotations on historiography: Martha C. Howell and Walter Prevenier, *From Reliable Sources: An Introduction to Historical Methods* (Ithaca, NY: Cornell University Press, 2001), 9.

9. Trade: J. D. B. De Bow, "The Commercial Age," *The Commercial Review*, n.s., 1, no. 3 (September 1849): 236. Longfellow: Henry Wadsworth Longfellow, *Kavanagh, a Tale* (London: George Slater, 1849), 92–93. Lack of material: "American Poetry," *The Knickerbocker* 12, no. 5 (November 1838): 385–86.

10. Flint's quotation: Timothy Flint, *Lectures Upon Natural History, Geology, Chemistry, the Application of Steam, and Interesting Discoveries in the Arts* (Boston: Lilly, Wait, Colman, & Holden, 1833), 298. Priest's quotation: Josiah Priest, *American Antiquities and Discoveries in the West*, 3rd ed. rev. (Albany, NY: Printed by Hoffman & White, 1833), 392. Pidgeon's quotation: William Pidgeon, *Traditions of De-Coo-Dah, and Antiquarian Researches* (1853; repr., New York: Horace Thayer, 1858), 18.

11. *Knickerbocker* quotation: "American Antiquities," *The Knickerbocker* 10, no. 1 (July 1837): 3. Matthews's quotation: Cornelius Mathews, "Our Illustrious Predecessors," in *The Various Writings of Cornelius Mathews* (New York: Harper & Brothers, 1843), 346.

12. *Eagle's* quotation: *Brooklyn Eagle*, September 4, 1868. Bowles's quotation: Samuel Bowles, *The Pacific Railroad—Open* (Boston: Fields, Osgood & Co., 1869), 5. Walker's quotation: Quoted in William Windom, *The Northern Pacific Railway: Its Effect Upon the Public Credit, Public Revenues, and the Public Debt* (Washington: Gibson Brothers, Printers, 1869), 49.

13. Conversation: *New York Sun*, reprinted in *Syracuse Daily Standard*, November 30, 1869. Awe: *The American Goliah: A Wonderful Geological Discovery*, enlarged ed. (Syracuse, NY: Printed at the Journal Office, 1869), 16. "COM": *Utica Observer*, reprinted in *Syracuse Daily Courier*, November 10, 1869.

14. Kneeland's quotation: *New York Independent*, October 28, 1869. "W": *Syracuse Daily Journal*, October 22, 1869. Oneida opinion: "Origin of the Cardiff Giant," *The Circular*, November 15, 1869, 278. Calthrop's opinion: *Syracuse Daily Journal*, October 23, 1869.

15. "Ondiyara": *Syracuse Daily Standard*, October 19, 1869. Eighth wonder: *Syracuse Daily Standard*, November 20, 1869. *Herald*'s assessment: *New York Herald*, November 18, 1869. Pamphlets: *The Onondaga Giant, or the Great Archaeological Discovery* (Syracuse, NY: Nottingham & Tucker, 1869), 20; and *The American Goliah: A Wonderful Geological Discovery* (Syracuse, NY: Printed at the Journal Office, 1869), 5. Towanda native: *Syracuse Daily Standard*, November 1 & 4, 1869. Bricklayer: *Syracuse Daily Standard*, December 23, 1869.

16. Past greatness: *Milwaukee Daily Journal*, October 30, 1869.

17. Call to scientists: *Syracuse Daily Standard*, October 20, 1869. Classic: Robert V. Bruce, *The Launching of Modern American Science, 1846–1876* (New York: Knopf, 1987), 52. British plaudit: Quoted in "State Geological Hall and Agricultural Rooms of New York," *American Journal of Education* 4, no. 12 (March 1858): 786.

18. Examination: *Syracuse Daily Journal*, October 22, 1869; and Rankin, *The Giantmaker*, 172–73, item 72, John C. Rankin papers, 1857–1963, 1869–1902 (bulk), Broome County Historical Society, Broome County Public Library, Binghamton, NY. Hall and reporters: *Syracuse Daily Courier*, October 25, 1869. Hall's letter: *Albany Argus*, reprinted in *Syracuse Daily Journal*, October 26, 1869. Joint statement: *Syracuse Daily Journal*, October 29, 1869. Reprints: *New York Herald*, October 31, 1869; *Philadelphia Inquirer*, November 3, 1869; *Chicago Daily Tribune*, November 4, 1869; *Columbus (Ga.) Ledger-Enquirer*, November 6, 1869; and *Daily Evening Bulletin*, November 12, 1869. For more on Hall, see John Mason Clarke, *James Hall of Albany, Geologist and Paleontologist* (Albany, NY, 1921).

19. Ward's plaudit: "Geology as a Branch of Education," *Massachusetts Teacher and Journal of Home and School Education* 16, no. 6 (June 1863): 188. Ward's assessment: *Rochester Democrat*, reprinted in *Syracuse Daily Standard*, October 26, 1869.

20. Quotations: Quoted in Gordon R. Willey and Jeremy A. Sabloff, *A History of American Archaeology*, 3rd ed. (New York: W. H. Freeman, 1993), 31, 40.

21. McCarty's quotations: *Cincinnati Commercial*, reprinted in *Newark Advocate*, November 9, 1860.

22. Boynton's arrival: Rankin, *The Giantmaker*, 149–50. Boynton's letter: *Syracuse Daily Standard*, October 21, 1869. Reprints: *New York Herald*, October 22, 1869; *Daily Cleveland Herald*, October 23, 1869; and *Missouri Republican*, October 29, 1869.

23. De Hass: Terry A. Barnhart, "Curious Antiquity? The Grave Creek Controversy Revisited," *West Virginia History* 46 (1985–1986): 113–115 and *New York Times*, January 26, 1910.

24. Coin: *Syracuse Daily Journal*, October 25, 1869. Lecture: *Syracuse Daily Journal*, *Syracuse Daily Standard*, November 2, 1869.

25. Olmstead's letter: *Albany Evening Journal*, November 2, 1869. Reprints: *New York Commercial Advertiser*, November 10, 1869; *Daily Cleveland Herald*, November 5, 1869; and *New York Daily Tribune*, reprinted in *Christian Union*, March 26, 1870. For more on Olmstead, see *Salem Review-Press*, reprinted in *Addenda, Old Fort Edward Before 1800*, part 1 (Fort Edward, NY: Honeywood Press, 1956), 77–78.

26. *Syracuse Daily Courier*, October 30, 1869.

27. Howe's letter: *Schenectady Union*, reprinted in *Syracuse Daily Standard*, November 8, 1869. Quiz: *Syracuse Daily Standard*, October 27, 1869. Vocabulary: *Syracuse Daily Standard*, November 1, 1869.

28. Bulkley: *Norwich Bulletin*, reprinted in *Syracuse Daily Journal*, November 1, 1869. Searle: *Syracuse Daily Journal*, November 12, 1869. Stone: *Scientific American*, n.s., 21, no. 24 (December 11, 1869): 373.

29. Hull's version: *Chicago Daily Tribune*, December 30, 1890.

Chapter 7: Ugly Questions

1. Mormon quotation: Ezra Champion Seaman, *The American System of Government* (New York: C. Scribner & Co., 1870), 53. Miller quotation: John Benson Lossing, *Lives of Celebrated Americans* (Hartford, CT: Belknap, 1869), 387.

2. Quotation: "Editor's Table," *The Knickerbocker* 46, no. 5 (November 1855): 532.

3. *Standard*'s report: *Syracuse Daily Standard*, October 18, 1869. *Herald*'s report: *New York Herald*, October 21, 1869.

4. Auburn report: *Auburn News*, reprinted in *New York Daily Tribune*, October 25, 1869. Mark Twain, "The Capitoline Venus," in *Sketches New and Old* (1875; repr., New York: Harper & Brothers Publishers, 1922), 271, 273.

5. *Syracuse Daily Standard*, November 2, 1869.

6. *Syracuse Daily Journal*, October 19, 1869.

7. Confrontation with Fellows: Rankin, *The Giantmaker*, 183–87, item 72, John C. Rankin papers, 1857–1963, 1869–1902 (bulk), Broome County Historical Society, Broome County Public Library, Binghamton, NY. *The Giantmaker* indicates that the confrontation took place on Sunday, but, given items in the newspapers as well as Newell's efforts to sell, Wednesday represents the more likely date.

8. *Syracuse Daily Journal*, October 22, 1869.

9. *Syracuse Daily Standard*, *Syracuse Daily Courier*, and *Syracuse Daily Journal*, October 25, 1869.

10. *New York Herald*, October 25, 1869.

11. *New York Herald*, October 25, 1869.

12. *Syracuse Daily Standard*, *Syracuse Daily Courier*, and *Syracuse Daily Journal*, October 26, 1869.

13. *New York Daily Tribune*, October 26, 1869.

14. Withdrawal: Rankin, *The Giantmaker*, 230–33.

15. *Syracuse Daily Standard, Syracuse Daily Courier,* and *Syracuse Daily Journal,* October 27, 1869.

16. Rankin, *The Giantmaker,* 152, 190, 221–22, 250–51.

17. Interaction with owners: Rankin, *The Giantmaker,* 233. Arrangement: Various documents, folder 5, Cardiff Giant Records, 2002.84, Onondaga Historical Association, Syracuse, NY. The latter collection includes a typed copy of the original contract with fraud protection language. This document likely represents a modified version, as *The Giantmaker* confirms that protection was not part of the original deal.

18. *Syracuse Daily Standard* and *Syracuse Daily Journal,* October 28, 1869.

19. "W" letter: *Syracuse Daily Courier,* October 30, 1869. *Herald's* report: *New York Herald,* October 31, 1869.

20. *Syracuse Daily Standard* and *Syracuse Daily Journal,* October 30, 1869. For legal status of affidavits in 1869, see *People v. Travis,* 4 Park. Cr. R., 213 (Buff. Sup. Ct. 1854). Also see *People v. O'Reilly,* 86 N.Y. 154 (N.Y. Ct App. 1881) for revisions to this law.

21. Reaction: *Syracuse Daily Standard* and *Syracuse Daily Journal,* October 30, 1869; and *Syracuse Daily Courier,* November 1, 1869. Woolworth: *Syracuse Daily Journal,* November 1, 1869. *Standard's* reaction: *Syracuse Daily Standard,* November 1, 1869.

22. Various documents, folder 5, Onondaga Historical Association. This collection includes several assignments to Higgins, dated between November 2 and November 26, 1869. As Newell and Higgins never consummated a deal, it is assumed that these items are drafts.

Chapter 8: The Conquering Hero

1. *Onondaga's Centennial,* ed. Dwight H. Bruce (Boston: Boston History Co., 1896), 1:398.

2. Sensation: *Troy Times,* reprinted in *Syracuse Daily Standard,* November 1, 1869. Dry goods advertisement: *Syracuse Daily Standard,* October 19, 1869. Shoes advertisement: *Syracuse Daily Courier,* October 25, 1869. Oysters advertisement: *Syracuse Daily Journal,* October 27, 1869. Painting: *Syracuse Daily Courier,* October 29, 1869.

3. *New York Commercial Advertiser,* October 21, 1869. For more on *Agave americana,* see *Scientific American Supplement* 22, no. 561 (October 2, 1886; Project Gutenberg, 2005), at http://www.gutenberg.org/files/16360/16360-h/16360-h.htm (accessed June 25, 2006).

4. Examination: *Syracuse Daily Journal* and *Syracuse Daily Courier,* November 4, 1869. Reaction: *Southern Onondaga,* reprinted in *Syracuse Daily Journal,* November 6, 1869.

5. Election results: *New York Times,* November 4, 1869; and *New York Independent,* November 11, 1869. Analysis: *New York Herald,* November 4 & 6, 1869.

6. *Eagle's* quotation: *Brooklyn Eagle,* October 28, 1869. *Herald's* quotation: *New York Herald,* November 3, 1869.

7. *Herald's* quotation: *New York Herald,* November 6, 1869.

8. Hard-Shells: *Troy Times*, reprinted in *Syracuse Daily Journal*, November 3, 1869. Votes for giant: *Rochester Democrat*, November 15, 1869. Onondaga County results and turnout: *Syracuse Daily Journal*, November 3, 1869. The *Journal* reported that a majority of Syracuse citizens voted against "property qualification," but, as the measure in question removed restrictions, citizens actually voted to maintain the status quo. Judiciary Article: *New York Herald*, November 23, 1869; and *Syracuse Daily Journal*, November 26, 1869. County coverage: *New York Commercial Advertiser*, November 5, 1869.

9. *Syracuse Daily Standard*, *Syracuse Daily Journal*, and *Syracuse Daily Courier*, November 6, 1869.

10. Rankin, *The Giantmaker*, 235, item 72, John C. Rankin papers, 1857–1963, 1869–1902 (bulk), Broome County Historical Society, Broome County Public Library, Binghamton, NY.

11. Rankin, *The Giantmaker*, 236. Poem: *Syracuse Daily Courier*, November 6, 1869.

12. Illustrations: *Harper's Weekly*, December 4, 1869.

13. Movements: *Syracuse Daily Journal*, November 6, 1869; and *Syracuse Daily Courier* and *Syracuse Daily Standard*, November 8, 1869. Song: *Brooklyn Eagle*, November 20, 1869. Rescue quotation: *Onondaga's Centennial*, 1:461.

14. *Syracuse Daily Journal*, November 6, 1869.

15. Exhibition space: *Syracuse Daily Journal*, November 6, 1869; and *Syracuse Daily Standard*, November 8, 1869.

16. Monday: *Syracuse Daily Journal*, November 9, 1869. Children: *Syracuse Daily Standard*, November 9, 1869. Thursday: *Syracuse Daily Standard*, November 12, 1869. Friday: *Syracuse Daily Standard*, November 13, 1869. Saturday: *Syracuse Daily Journal*, November 15, 1869. Out-of-town visitors: *Syracuse Daily Standard*, November 14, 1869.

17. Ira Brown: *Rochester Express*, reprinted in *Syracuse Daily Standard*, November 10, 1869. J. J. Brown: *Fulton Gazette*, reprinted in *New York Herald*, November 18, 1869. Morgan: *Albany Evening Journal*, November 11, 1869. Criticism of Morgan: *Syracuse Daily Standard*, November 13, 1869.

18. Wiles: *Cortland Standard*, reprinted in *Syracuse Daily Standard*, November 8, 1869. *Knickerbocker's* opinion: *Albany Knickerbocker*, reprinted in *Syracuse Daily Standard*, November 16, 1869.

19. Imminent departure: *Syracuse Daily Journal*, November 15, 1869. Subsequent attendance: *Syracuse Daily Standard*, November 17, 1869. Fervency: *Syracuse Daily Courier*, November 10 & 17, 1869.

20. Orphans: *Syracuse Daily Standard*, November 16, 1869. Thanksgiving attendance: *Syracuse Daily Standard*, November 20, 1869. Rochester assessment: *Rochester Democrat*, reprinted in *Syracuse Daily Journal*, November 20, 1869. Visit: *Syracuse Daily Journal*, November 19 & 20, 1869; and *Syracuse Daily Standard*, November 20, 1869. Attendance: *Syracuse Daily Standard*, November 20, 1869.

21. Petition: *Syracuse Daily Courier*, November 20, 1869. Westcott's response: *Syracuse Daily Journal*, November 20, 1869.

22. Son: *Utica Press*, September 20, 1924. Offers: *Syracuse Daily Journal*, November 19, 1869. Thorne: *Syracuse Daily Journal*, December 6, 1869.

23. Sale: Contract, December 1, 1869, item 72, John C. Rankin papers, 1857–1963, 1869–1902 (bulk), Broome County Historical Society, Broome County Public Library, Binghamton, NY. For more on Rankin, see *Binghamton Press*, July 12, 1904.

24. Departure: *Syracuse Daily Journal*, November 26, 1869. Attendance: Rankin, *The Giantmaker*, 207.

Chapter 9: The Naked Giant

1. Smith: *Syracuse Daily Courier*, October 29, 1869. Response: *Syracuse Daily Standard*, October 30, 1869.

2. Boynton's letter: *Syracuse Daily Courier* and *Syracuse Daily Journal*, November 17, 1869. Gillett's reaction: Rankin, *The Giantmaker*, 269–70, item 72, John C. Rankin papers, 1857–1963, 1869–1902 (bulk), Broome County Historical Society, Broome County Public Library, Binghamton, NY.

3. Palmer's examination and subsequent characterization: *Syracuse Daily Courier* and *Syracuse Daily Standard*, November 17, 1869. Palmer's assessment of Westcott: *New York Sun*, reprinted in *Syracuse Daily Standard*, November 30, 1869.

4. Westcott's misgivings: *New York Sun*, reprinted in *Syracuse Daily Standard*, November 30, 1869. *Scientific American* on Geraud: *Scientific American*, n.s., 21, no. 20 (November 13, 1869): 310. Westcott's rejoinder: *Scientific American*, n.s., 21, no. 22 (November 27, 1869): 342.

5. *Rochester Express* and *New York Sun*, reprinted in *Syracuse Daily Journal*, November 20, 1869; and *Syracuse Daily Standard*, November 23, 1869.

6. St. John: *Syracuse Daily Courier*, November 22, 1869. Lecture: *Syracuse Daily Courier*, November 18 & 23, 1869; and *Syracuse Daily Standard*, November 23, 1869. Public reaction: Rankin, *The Giantmaker*, 270–71. Criticism: *Worcester Spy*, reprinted in *Syracuse Daily Courier*, November 24, 1869.

7. Degree: Quoted in Brooks Mather Kelley, *Yale: A History* (New Haven, CT: Yale University Press, 1974), 258. Laboratory: Burton R. Clark, *Places of Inquiry: Research and Advanced Education in Modern Universities* (Berkeley: University of California Press, 1995), 26.

8. *Buffalo Courier*, reprinted in *Syracuse Daily Courier*, November 30, 1869; and *New York Herald* and *New York Sun*, December 1, 1869.

9. Joke: *New York Commercial Advertiser*, November 23, 1869. *Courier's* assessment: *Syracuse Daily Courier*, December 1, 1869. Leavenworth: *Syracuse Daily Journal*, November 29, 1869.

10. Walrath: Clipping, "Hull At His Old Tricks," n.d., Cardiff Giant Records, 2002.84, Onondaga Historical Association, Syracuse, NY. Unidentified sources: *Syracuse Daily Courier*, December 1, 1869; and *New York Commercial Advertiser*, November 20, 1869. In a latter-day interview, Walrath did not explicitly cite a book

deal, but his description of activities—and deference to Hull's dictates—suggest that the two men enjoyed some arrangement. For more on Walrath, see Clipping, "Col. E. L. Walrath," June 27, 1894, Col. Ezra L. Walrath folder, Onondaga Historical Association.

11. Albany attendance: *Syracuse Daily Courier*, December 1, 1869; and *Syracuse Daily Standard*, December 4, 1869.

12. Parsons's recollection: *The Cardiff Giant Humbug: A Complete and Thorough Exposition of the Greatest Deception of the Age* (Fort Dodge, IA: North West Book & Job Printing Establishment, 1870), 30. Communication: Benjamin F. Gue, *History of Iowa from the Earliest Times to the Beginning of the Twentieth Century* (New York: Century History Co., 1903), 3:39.

13. Wright: *Syracuse Daily Journal*, December 4, 1869. McNulty: *New York Herald*, December 7, 1869. Page: *Dubuque Times*, reprinted in *Chicago Daily Tribune*, December 10, 1869; and *New York Daily Tribune*, December 11, 1869.

14. *Iowa North West*, December 9, 1869.

15. Martin: *Marshalltown Times*, reprinted in *The Cardiff Giant Humbug*, 30. Newell: *Syracuse Daily Standard*, December 7, 1869.

16. Hull's informal confession: *Syracuse Daily Journal*, December 10, 1869. Lawrence: *Syracuse Daily Courier*, December 20, 1869. Chicago visit: Clipping, "Hull Up to His Old Tricks," n.d., Onondaga Historical Association. Conversation with editors: *Chicago Daily Tribune*, December 10, 1869. It is possible that Henry Salle conducted the interview with the *Tribune*, especially given subsequent jokes in the interview about wholesale rates, but, still, the comments regarding gullibility sound much more like Hull, who definitely was visiting the Garden City around this time.

17. *Syracuse Daily Courier* and *Syracuse Daily Journal*, December 11, 1869.

18. Detective: *Syracuse Daily Journal*, December 21, 1869. McNulty: *New York Herald*, December 7, 1869. Slauson: *Syracuse Daily Journal*, December 10, 1869. Martin: *Buffalo Courier*, reprinted in *New York Herald*, March 16, 1870. Pamphlet: *The Cardiff Giant Humbug*, 27, 29. So, who, then, was Glass? In Syracuse, Joseph J. Glass and Charles J. Glass operated Glass, Breed & Co., a milling business, but no subsequent histories referenced these men in conjunction with the hoax. Along the same lines, no other residents of Fort Dodge cited Glass as a third man. Thus, McNulty and Slauson's memories either were faulty, or the two men unwittingly implicated an innocent bystander. As for the identity of "DETECTIVE," the source almost certainly was not Walrath, who would have approached his friends at the *Courier* instead. I suspect that the writer was Wills De Hass, who pursued the fraud angle in Binghamton. *The Giantmaker* depicts some tension between De Hass and Rankin, with the latter refusing to aid efforts that would undermine Westcott and Hannum's investment. De Hass may well have misinterpreted Rankin's actions, prompting later charges of collusion. See Rankin, *The Giantmaker*, 222–23.

19. *Oswego Advertiser*, reprinted in *Syracuse Daily Courier*, December 17, 1869.

20. Morgan: *Syracuse Daily Journal*, December 20, 1869. McCoole: *New York Evening Post*, reprinted in *Syracuse Daily Journal*, December 15, 1869. Play: *Syracuse Daily*

Journal, December 16, 1869. Woman: *Syracuse Daily Journal*, December 15, 1869. Reconstruction: *Louisville Journal*, reprinted in *New Hampshire Patriot*, January 19, 1870. Nominations: *Southern Onondaga*, reprinted in *Syracuse Daily Courier*, December 17, 1869. Speaker: *Rochester Democrat*, December 1, 1869. Legislature: *Albany Evening Journal*, November 26, 1869.

21. *Syracuse Daily Courier*, December 16, 1869.

Chapter 10: War of the Stone Giants

1. Amendment whispers: *New York Times*, December 17, 1869. Bridge: *Brooklyn Eagle*, November 29, 1869. Visitor: New York correspondent quoted in *Daily Evening Bulletin*, December 17, 1869.

2. *Boston Chronotype*, reprinted in *Brookyln Eagle*, November 2, 1847.

3. Coverage: *Syracuse Daily Standard*, November 25, 1869. Barnum's reaction: P. T. Barnum, *Funny Stories Told by Phineas T. Barnum* (New York: G. Routledge & Sons, 1890), 332. Rankin's characterization: John Rankin, *The Giantmaker*, 283, item 72, John C. Rankin papers, 1857–1963, 1869–1902 (bulk), Broome County Historical Society, Broome County Public Library, Binghamton, NY. Offer: *New York Sun*, December 22, 1869.

4. Rankin, *The Giantmaker*, 279, 285.

5. Rankin, *The Giantmaker*, 284.

6. Coverage and production: *Syracuse Daily Journal*, November 13, 1869. Characterization of Otto: Albert L. Parkes, "A Giant Hoax," *Godey's Magazine* 131, no. 782 (August 1895): 146. Original arrangement: *Syracuse Daily Courier*, December 8, 1869. The *Courier* initially reported one of the investors as a man named Wood, but, according to a later lawsuit, the man in question was not the museum proprietor, but rather Leonard Woods. See *Syracuse Daily Journal*, December 4, 1869.

7. Assessments: *Syracuse Daily Journal*, December 4 & 15, 1869; and *Syracuse Daily Courier*, November 24, 1869. Barnum: *Syracuse Daily Standard*, November 27, 1869.

8. Prince of humbugs: *Albany Evening Journal*, December 18, 1869. According to the *Journal*, Barnum made this comment after seeing the giant at Cardiff, but, given the timing of the report, the location almost certainly was Syracuse. Saxon's quotation: A. H. Saxon, *P. T. Barnum: The Legend and the Man* (New York: Columbia University Press, 1989), 230. Barnum's recollection: Barnum, *Funny Stories*, 332–33. Rankin and the *New York Sun* confirm that it was during the giant's waning days in Syracuse that Barnum first became involved with Otto. See Rankin, *The Giantmaker*, 293–97; and *New York Sun*, December 22, 1869.

9. Parkes' role: Parkes, "A Giant Hoax," 146–47. Ownership squabbles: *Syracuse Daily Courier*, December 8, 1869.

10. *Syracuse Daily Courier*, December 8, 1869.

11. Parkes, "A Giant Hoax," 147.

12. Private exhibition: Parkes, "A Giant Hoax," 147. Allegations: Rankin, *The Giantmaker*, 317; and Parkes, "A Giant Hoax," 147. Coverage: *New York Commercial Advertiser*, December 7, 1869; *New York Sun*, December 7, 1869; *New York Evening*

Post, December 7, 1869; and *New York Herald*, December 7, 1869. Advertisement: *New York Daily Tribune*, December 6, 1869.

13. Exhibition: *New York Daily Tribune*, December 11, 1869; and Parkes, "A Giant Hoax," 147. Attendance: *New York Evening Post*, December 7, 1869.

14. Coverage: *New York Commercial Advertiser*, December 11, 1869; *New York World*, December 9. 1869; and *New York Daily Tribune*, December 11, 1869. Attendance claim: Parkes, "A Giant Hoax," 148.

15. Albany assessment: *Albany Evening Journal*, December 7, 1869. Court: Rankin, *The Giantmaker*, 319; and *New York Sun*, December 22, 1869.

16. *New York Daily Tribune*, December 13, 1869.

17. *New York Daily Tribune*, December 14, 1869; and *New York World*, reprinted in *Syracuse Daily Courier*, December 17, 1869.

18. Coverage: *Daily Cleveland Herald*, December 13, 1869; *Philadelphia Inquirer*, December 14, 1869; and *Syracuse Daily Journal*, December 15, 1869.

19. Arrival: *New York Sun*, December 18, 1869. Albany attendance: *Syracuse Daily Journal*, December 21, 1869. Advertisements: *New York Daily Tribune*, December 21, 1869. Criticism: *Syracuse Daily Courier*, December 23, 1869.

20. Fight: *New York Commercial Advertiser*, December 18, 1869. First two days: *New York Sun*, December 22, 1869. New advertisement: *New York World*, December 23, 1869. Attendance at Wood's: *Syracuse Daily Standard*, December 29, 1869. Winner: *New York Sun*, December 22, 1869. Reprints: *Daily Cleveland Herald*, December 23, 1869; *Chicago Daily Tribune*, December 25, 1869; *New Hampshire Sentinel*, December 30, 1869; and *Idaho Statesman*, January 22, 1870.

21. *Syracuse Daily Journal*, December 18, 20, & 21, 1869; January 4, 6, 12, 21, & 24, 1870; February 5, 1870.

22. Mark Twain, "A Ghost Story," in *Sketches New and Old* (1875; repr., New York: Harper & Brothers Publishers, 1922), 261–62, 264.

23. Reflection: *Binghamton Herald*, reprinted in *Syracuse Post-Standard*, August 1, 1902. Walrath: Clipping, "Hull Up to His Old Tricks," n.d., Cardiff Giant Records, 2002.84, Onondaga Historical Association, Syracuse, NY.

Chapter 11: Hubbub

1. Higgins and Newell: Various documents, folder 4, Cardiff Giant Records, 2002.84, Onondaga Historical Association, Syracuse, NY; and *Syracuse Daily Journal*, February 1, 1872. Higgins borrowed money to make his initial cash payment to Newell. Already having disbursed that money to Hull, the Cardiff farmer could not reimburse Higgins in full. At Newell's direction, Higgins borrowed money from Dennison Newell to repay creditors. The latter ultimately sued Higgins for defaulting on his payments and won the rather bizarre case. Fitch and Ellis sale: *Syracuse Daily Courier*, January 10, 1870. The latter two men are named in *New York Daily Tribune*, September 21, 1871.

2. Initial letter to Leavenworth: *Syracuse Daily Journal*, December 13, 1869. Westcott to Leavenworth: *Syracuse Daily Journal*, December 16, 1869. Wilcox to

Westcott: *Syracuse Daily Journal*, December 21, 1869. Westcott to Wilcox: *Syracuse Daily Journal*, December 23, 1869.

3. Sickness: *New York Sun*, December 22, 1869. Investigation: *Sauk County Herald*, reprinted in *The History of Sauk County, Wisconsin* (Chicago: Western Historical Co., 1880), 549.

4. Proposal: Various documents, folders 3 and 5, Onondaga Historical Association. See also Westcott's affidavit from files of *John Hull v. Amos Westcott and David H. Hannum*, Supreme Court, Broome County Court House, Binghamton, NY. Given that Amos Gillett ultimately sold his share to Calvin O. Gott, the Syracuse horse trader apparently never sought the return of his bank notes.

5. Various documents, folder 5, Onondaga Historical Association. According to Westcott's statement, the owners met with Hull in Syracuse, but, in keeping with *The Giantmaker*'s characterization, Hannum very likely was not there and did not encounter his erstwhile traveling companion for a few more weeks.

6. Quotations: Francis and Theresa Pulszky, *White, Red, Black: Sketches of Society in the United States During the Visit of Their Guest*, 2 vols. (New York: Redfield, 1853), 2:172.

7. Quotation: W. Pembroke Fetridge, *The American Travellers' Guides: Harper's Handbook for Travellers in Europe and the East* (New York: Harper & Brothers, Publishers, 1868), 643.

8. Reaction: *Boston Morning Journal*, January 24, 1870; *Boston Post*, January 24, 1870; and *Boston Daily Evening Traveller*, January 22, 1870.

9. Coverage: *Boston Post*, January 26, 1870. Examination: John Rankin, *The Giantmaker*, 326–29, item 72, John C. Rankin papers, 1857–1963, 1869–1902 (bulk), Broome County Historical Society, Broome County Public Library, Binghamton, NY. For the most part, Rankin provided last names only, so I derived likely identities from well-known scientists, sculptors, and intellectuals of the time. Rankin wrote himself out of *The Giantmaker*'s narrative, but an earlier communication confirms that he headed to Boston with the giant. See John Rankin to Amos Westcott, January 17, 1870, folder 6, Onondaga Historical Association.

10. Confusion: *Boston Daily Evening Transcript*, January 27, 1870; and *Boston Morning Journal*, January 25, 1870. Scientific coverage: *Boston Post*, January 26, 1870. Attendance: Extrapolated from *Boston Post*, February 7, 1870.

11. Mohrmann: *Chicago Daily Tribune*, February 11, 1870. Affidavits: *Syracuse Daily Journal*, January 29, 1870. Westcott's letter: *Syracuse Daily Journal*, January 24, 1870; and *Syracuse Daily Standard*, January 26, 1870.

12. Affidavits: *Syracuse Daily Journal*, January 29, 1870; *Syracuse Daily Standard*, January 31, 1870; and *Syracuse Daily Courier*, February 2, 1870. Boston response: *Boston Post*, February 3, 1870.

13. Attendance: *Boston Post*, February 7, 1870. Examination: *Boston Traveller*, reprinted in *New York Commercial Advertiser*, February 12, 1870, and Rankin, *The Giantmaker*, 330–33.

14. Rankin, *The Giantmaker*, 334–58.

15. Reaction: *Boston Traveller*, reprinted in *New York Commercial Advertiser*, February 12, 1870; and *Boston Morning Journal*, February 5, 1870. Verdict: *Boston Daily Advertiser*, February 7, 1870; and advertisement in *Boston Morning Journal*, February 7, 1870.

16. Spirits: Edward Augustus Brackett, *Materialized Apparitions* (1886; repr., Boston: Elibron Classics, 2001), 168.

17. Reaction: *Boston Traveller*, reprinted in *New York Commercial Advertiser*, February 12, 1870. Wood's Museum: *New York World*, February 4, 1870. Weariness: *Syracuse Daily Journal*, February 8, 1870.

18. Chicago: *Chicago Tribune*, February 2, 1870. Baraboo: *A History of Sauk County*, 551.

19. Chicago publications: *Chicago Daily Tribune*, February 10 & 11, 1870. Reprints: *Syracuse Daily Journal*, February 5 & 11, 1870; *Syracuse Daily Standard*, February 10, 1870; *New York Commercial Advertiser*, February 15, 1870; *Daily Evening Bulletin*, February 10, 1870; *Daily Cleveland Herald*, February 10, 1870; and *North American and United States Gazette*, February 11, 1870.

20. Gott: Rankin, *The Giantmaker*, 361–62. Planned departure: *Boston Post*, February 14, 1870.

21. Quotations: "The Original Cardiff Giant," promotional pamphlet, Cardiff Giant Collection, 1869–1979, Research Library, New York State Historical Association, Cooperstown, NY. For records of Thursday Evening Club, see Thursday Evening Club records, 1846–1999, bulk: 1846–1976, Massachusetts Historical Society, Boston, MA.

22. Flattery: Rankin, *The Giantmaker*, 274. Rankin-Hull: Contract, February 25, 1870, item 104b, Broome County Historical Society. Rankin-Hull-Crocker: Contract, February 28, 1870, item 64, Broome County Historical Society.

23. *Buffalo Courier*, reprinted in *New York Herald*, March 16, 1870.

24. Reprints: *New York Herald*, March 16, 1870; *New Hampshire Sentinel*, March 24, 1870; *Charleston Courier*, March 24, 1870; and *Daily Evening Bulletin*, April 2, 1870. *Tribune's* editorial: *New York Daily Tribune*, reprinted in *Christian Union*, March 26, 1870. Gypsum: *Syracuse Daily Journal*, December 15, 1869. "Dr. Fossil": Referenced in *Syracuse Daily Courier*, December 16, 1869. Skeptic: *Syracuse Daily Courier*, December 17, 1869. Fraud: *Syracuse Daily Courier*, December 14, 1869. Hall's defense: *Syracuse Daily Courier*, December 17, 1869.

25. Quotation: *Chicago Daily Tribune*, February 2, 1870.

26. Grant: *New York Times*, March 31, 1870.

27. Portland: *Lowell Daily Citizen and News*, May 23, 1870. Lowell: *Lowell Daily Citizen and News*, May 31, 1870. Worcester: *Lowell Daily Citizen and News*, June 3, 1870. Saratoga Springs: *Syracuse Daily Journal*, July 20, 1870. Vermont and Springfield: *Syracuse Daily Journal*, December 5, 1870.

28. Hannum-Gott: Contract, January 12, 1871, item 105b, Broome County Historical Society. Various sales: Clipping, "Cardiff Giant Now Stored in a Barn," 1903, New York State Historical Association. Thorne: *Utica Press*, September 20, 1924.

29. Houghton: See Affidavit, July 1, 1913, folder 9, Onondaga Historical Association. New Haven: *New York Daily Tribune*, September 21, 1871. Greenfield: *Syracuse Daily Journal*, June 3, 1871. Troy: *Syracuse Daily Journal*, July 19, 1871.

Chapter 12: At His Old Tricks

1. Chapter title from Clipping, "Hull At His Old Tricks," n.d., Cardiff Giant Records, 2002.84, Onondaga Historical Association, Syracuse, NY. Legal files: Various documents, folders 3 and 5, Onondaga Historical Association and files of *John Hull v. Amos Westcott and David H. Hannum*, Supreme Court, Broome County Court House, Binghamton, N.Y. Westcott: *Syracuse Daily Journal*, July 7, 1873.

2. Sale: *New York Daily Tribune*, September 21, 1871. Profits: *New York Sun*, reprinted in *Ithaca Daily Journal*, January 4, 1898; and John Rankin, *The Giantmaker*, 369, item 72, John C. Rankin papers, 1857–1963, 1869–1902 (bulk), Broome County Historical Society, Broome County Public Library, Binghamton, NY.

3. Thompson's quotation: Hugh Miller Thompson, *"Copy." Essays from an Editor's Drawer, on Religion, Literature, and Life* (Hartford, CT: Church Press, M. H. Mallory & Co., 1872), 161. Reavis's quotation: Logan Uriah Reavis, *Saint Louis: The Future Great City of the World*, 3rd ed. (St. Louis, MO.: Pub. by the Order of the St. Louis County Court, 1871), 103.

4. Barnard's quotation: United States Office of Education, *Special Report of the Commissioner of Education on the Condition and Improvement of Public Schools in the District of Columbia* (Washington, DC: Government Printing Office, 1871), 748.

5. Block: *Syracuse Daily Journal*, January 26, 1872.

6. Ohio case and sarcasm: *Daily Evening Bulletin*, February 11, 1871. Heart: *Daily Evening Bulletin*, August 24, 1871.

7. Cox: *New York Daily Tribune*, January 24, 1878.

8. Walrath: Clipping, "Hull At His Old Tricks," n.d., Onondaga Historical Association. Publication: *New York Daily Tribune*, January 24, 1878. Burkhardt's interview: "The Biography of a Giant," *Lakeside Monthly* 6, no. 32 (August 1871): 128–34. Hull's interview: *New York Daily Tribune*, September 21, 1871.

9. George Hull's movements: *New York Daily Tribune*, January 24, 1878. Helen Hull's sickness: *Binghamton Republican*, June 25, 1879. Presence of family in Elkland: *New York Times*, January 27, 1878.

10. George Hull's movements: *New York Daily Tribune*, January 24, 1878. Boys: *New York Times*, January 27, 1878.

11. Creditors: *Syracuse Daily Journal*, December 10, 1875. Case: *New York Times*, January 27, 1878.

12. *New York Daily Tribune*, January 24, 1878; and *New York Times*, January 27, 1878.

13. Quotation: *Brooklyn Eagle*, April 3, 1877. Historian: Eric Foner, *Reconstruction: America's Unfinished Revolution, 1863–1877* (1988; repr., New York: Harper & Row Perennial Library, 1989).

14. *Times:* New York Times, April 8, 1871. *Eagle:* Brooklyn Eagle, April 17, 1873. Bridgeport meeting: *New York Daily Tribune*, January 24, 1878.

15. Fake tracks: *New York Times*, January 27, 1878. Location extrapolated from ultimate discovery. See *Hartford Times*, reprinted in *New York Times*, November 26, 1877. Preparations and shipment: *New York Daily Tribune*, January 24, 1878; and *Colorado Mountaineer*, reprinted in *New York Semi-Weekly Tribune*, March 8, 1878.

16. *New York Daily Tribune*, January 24, 1878, and *Colorado Mountaineer*, reprinted in *New York Semi-Weekly Tribune*, March 8, 1878.

17. *New York Daily Tribune*, January 24, 1878.

18. *History of the Geological Wonder of the World: A Petrified Pre-Historic Human Being* (New York: Press of Wynkoop & Hallenbeck, 1877), 4.

19. *Democrat:* Quoted in *History of the Geological Wonder of the World*, 6. *Chieftain: Pueblo Chieftain*, reprinted in *Daily Rocky Mountain News*, September 21, 1877. *Tribune: New York Daily Tribune*, October 4, 1877.

20. *Barnum: New York Daily Tribune*, October 5, 1877. *Chieftain: Pueblo Chieftain*, reprinted in *Daily Rocky Mountain News*, September 21, 1877. Keyes and Lancaster: Quoted in *History of the Geological Wonder of the World*, 6.

21. Reaction: *New York Daily Tribune*, October 4, 1877; and *Syracuse Daily Journal*, October 2, 1877. Communication: *Colorado Mountaineer*, reprinted in *New York Semi-Weekly Tribune*, March 8, 1878.

22. Examination: *New York Daily Tribune*, January 24, 1878. Taylor: *History of the Geological Wonder of the World*, 2. Paige: *History of the Geological Wonder of the World*, 3; and *Chicago Inter-Ocean*, December 13, 1877.

23. *Whig:* Quoted in *History of the Geological Wonder of the World*, 7. Quincy: *New York Daily Tribune*, January 24, 1878; and *San Francisco Examiner*, reprinted in *Kansas City Star*, July 28, 1902.

24. Reaction: *New York Daily Tribune*, December 8, 1877; and *New York Times*, December 7, 1877. Examination: *New York Herald*, December 8, 1877; and *New York Times*, December 9, 1877.

25. Advertisement: *New York Times*, December 16, 1877. Museum: *New York Times*, January 27, 1878. Nickname: *New York Times*, December 22, 1877.

26. *New York Daily Tribune*, January 24, 1878; and *Colorado Mountaineer*, reprinted in *New York Semi-Weekly Tribune*, March 8, 1878.

27. Hull's expenses: *New York Daily Tribune*, January 24, 1878. Failure: *New York Daily Tribune*, reprinted in *Daily Rocky Mountain News*, January 31, 1878.

28. For coverage of Dwight's death, see *Binghamton Republican*, November 16, 1878; and *New York Times*, November 20 & 21, 1878. Mistaken identity: *Syracuse Daily Courier*, May 27, 1879. Hull had two nephews named Charles. The one in question was John's son.

29. Helen Hull's death: *Binghamton Republican*, June 19 & 25, 1879. Bounty hunting: *Windsor Standard*, October 11, 18, & 25, 1879; and November 1, 1879.

30. Allegations: *New York Star*, January 8, 1880. Response: *Binghamton Republican*, reprinted in *Windsor Standard*, January 17, 1880. Hearst: *American Weekly*, reprinted in *San Antonio Light*, October 3, 1943.

31. West Superior: *Tully Times*, July 17, 1886. Initial death report: *Chicago Herald*, reprinted in *Davenport Morning Tribune*, December 10, 1890. Hull's reaction: Clipping, "Hull At His Old Tricks," n.d., Onondaga Historical Association. Robbery: *Olean Democrat*, December 25, 1890. Subsequent reports: *Milwaukee Daily Sentinel*, December 29, 1890. Retrospectives: *Chicago Daily Tribune*, December 30, 1890; and *Binghamton Evening Herald*, April 2, 1891. Newell and Walrath: Clipping, "Hull At His Old Tricks," n.d., Onondaga Historical Association. Petrifaction claims: Summarized in Clipping, "Hull At His Old Tricks," n.d., Onondaga Historical Association.

Chapter 13: A Tall Tale

1. Gott, MacWhorter, Yale: *New York Sun*, April 9, 1899. New Haven exhibition: *New York Daily Tribune*, September 21, 1871. Published article: Alexander MacWhorter, "Tammuz and the Mound-Builders," *Galaxy* 14, no. 1 (July 1872): 83–100. Reaction: *Daily Evening Bulletin*, June 29, 1872; *Milwaukee Daily Sentinel*, June 17, 1872; and *The Congregationalist*, June 27, 1872. Schlottmann: *London Academy*, reprinted in *Syracuse Daily Journal*, October 29, 1874. American reaction: *Albany Journal*, reprinted in *Cleveland Daily Herald*, November 6, 1874. German imitation: *Syracuse Daily Journal*, March 29, 1881. White: Andrew Dickson White, "The Cardiff Giant: A Chapter in the History of Human Folly—1868–1870," in *Autobiography of Andrew Dickson White* (New York: Century Co., 1905), 2:483–84. Disappointment: *New York Sun*, April 9, 1899. Cautionary tale: *Independent*, July 29, 1880.

2. Case: *Fitchburg Daily Sentinel*, October 29, 1875. Appeal: *Calvin O. Gott vs. R. M. Pulsifer & Others*, 122 Mass. 235, 1877 Mass. LEXIS 105 (Mass. Supr. Ct. 1876–1877).

3. Exhibitions: *Syracuse Daily Journal*, December 4 & 17, 1874, and June 14, 1879. Missouri: *Missouri Democrat*, reprinted in *Syracuse Daily Journal*, April 20, 1871. Ireland: *Congregationalist*, June 28, 1876; *Milwaukee Daily Sentinel*, July 10, 1876; and *New York Herald*, reprinted in *Galveston Daily News*, January 2, 1878.

4. Pine River: G. A. Stockwell, "The Cardiff Giant and Other Frauds," *Popular Science Monthly* 74, no. 13 (June 1878): 202–3. Pine River reaction: *Inter Ocean*, October 25, 1875. Trumansburg reaction: *Inter Ocean*, July 12, 1879; and *Galveston Daily News*, July 13, 1879.

5. Retrospectives: *New York Daily Tribune*, September 21, 1871; W. A. McKinney, "The History of the Cardiff Giant Hoax," *New Englander and Yale Review* 34, no. 133 (October 1875): 759–69; and Stockwell, "The Cardiff Giant and Other Frauds," 197–203. Later summation: *Cleveland Daily Herald*, reprinted in *Syracuse Daily Journal*, August 12, 1881.

6. Park: *Fitchburg Daily Sentinel*, May 6 & 30, 1879. Renovations: *Fitchburg Daily Sentinel*, May 5, 1881. Opera house: *Fitchburg Daily Sentinel*, June 15, 1883. Negotia-

tions: *Fitchburg Daily Sentinel*, June 4, 1883. Anecdote: Arthur T. Vance, *The Real David Harum* (New York: Baker & Taylor Co., 1900), 100. Hannum and Rankin: John Rankin, *The Giantmaker*, 362–65, item 72, John C. Rankin papers, 1857–1963, 1869–1902 (bulk), Broome County Historical Society, Broome County Public Library, Binghamton, NY. Rankin's ownership: Contract, April 10, 1901, item 63, Broome County Historical Society.

7. Hudson fire: *Syracuse Daily Journal*, May 2, 1881. Dakotas: *Syracuse Daily Journal*, February 24, 1885. El Paso: *Buffalo Express*, reprinted in *Arizona Republican*, August 23, 1899. Barnum in Syracuse: *Syracuse Daily Journal*, July 28, 1871. Daly's Theater: *Springfield Union*, reprinted in *Fitchburg Daily Sentinel*, March 19, 1887.

8. *History of Hardin County, Iowa* (1883; repr., Evansville, IN: Unigraphic, 1974), 323.

9. *New York Sun*, reprinted in *Ithaca Daily Journal*, January 4, 1898; and *Syracuse Daily Journal*, December 21, 1897.

10. Communication with Hull: Rankin, *The Giantmaker*, 1–2. Rankin: Vance, *The Real David Harum*, 92–94. See also John Rankin, "The David Harum I Knew," *Home Magazine* 14, no. 2 (February 1900): 122–29.

11. Bastable: *Syracuse Evening Herald*, November 5, 1899. Merrill: *Milwaukee Journal*, December 9, 1899.

12. Royalties: Clipping, "Charles R. Sherlock," May 26, 1902, Charles R. Sherlock folder, Onondaga Historical Association, Syracuse, NY.

13. Rankin's sale: Contract, April 10, 1901, item 63, Broome County Historical Society. Syndicate: *Fitchburg Daily Sentinel*, June 27, 1902. Exhibition: *Fitchburg Daily Sentinel*, August 17, 1901. Promotion: Clipping, "The Cardiff Giant," 1901, Onondaga Historical Association. Wood: Clipping, "Famed Hoaxes of Onondaga Now History," 1929, Onondaga Historical Association.

14. Introduction: Rankin, *The Giantmaker*, 1–4. Quotation on Lew: Rankin, *The Giantmaker*, 2–3. Final chapter: Rankin, *The Giantmaker*, 366–69. I suspect that most of *The Giantmaker* was written during the early 1870s, either by Crocker or Walrath, as Rankin's tone seems generally inconsistent with the majority of the manuscript. I base this assumption also on Henry Martin's prominent role up through Fort Dodge. If Hull and Rankin commenced writing around the turn of the century, the two men likely would have omitted the late blacksmith altogether.

15. Ownership shares: Rankin, *The Giantmaker*, 268, 368. Investigation: Rankin, *The Giantmaker*, 272–77.

16. Mead letter: Leon Mead to John Rankin, March 29, 1903, item 34b, Broome County Historical Society. Preface: Rankin, *The Giantmaker*, preface.

17. Sala's claim: *San Francisco Examiner*, reprinted in *Kansas City Star*, July 28, 1902. Hull's rejoinder: *Binghamton Herald*, reprinted in *Syracuse Post-Standard*, August 1, 1902. To confuse matters further, J. Sala of Troy, NY, claimed for decades that he was the sculptor of the Cardiff giant, and, indeed, this man may have fashioned the Irish imitation. See *North American and United States Gazette*, January 23, 1873; and *New York Herald*, reprinted in *Galveston Daily News*, January 2, 1878.

18. *Binghamton Leader*, October 23, 1902; and *Binghamton Evening Herald*, October 21, 1902.

19. Obituary: *Binghamton Press*, July 11, 1904. Quotation: Rankin, *The Giantmaker*, preface.

20. Strong: Josiah Strong, *Our Country: Its Possible Future and Its Present Crisis* (New York: Pub. by the Baker & Taylor Co., for the American Home Missionary Society, 1885), 113. Carnegie: Andrew Carnegie, *Triumphant Democracy: Sixty Years' March of the Republic*, rev. ed. (New York: C. Scribner's Sons, 1893), 5.

21. Theodore Roosevelt, "Nature Fakers," in *The Works of Theodore Roosevelt: Presidential Addresses and State Papers*, exec. ed. (New York: P. F. Collier & Son, 1910), 1344–45.

Chapter 14: Coming Home

1. Lawsuit: *Fitchburg Daily Sentinel*, February 8, 1912; and *Boston Globe*, March 10, 1912. Advertisement: *Fitchburg Daily Sentinel*, September 23, 1912. Sale: *Otsego Farmer*, November 11, 1912. Calkins sale: Edwin Calkins to Ralph C. Lawrence, June 10, 1913, Cardiff Giant Collection, 1869–1979, Research Library, New York State Historical Association, Cooperstown, NY.

2. San Francisco: *Oakland Tribune*, July 20, 1913. Rebate: *Syracuse Post-Standard*, June 16, 1948. Exhibition: *Syracuse Herald*, August 5, 1913. Attendance: Extrapolated from Edwin Calkins to *Syracuse Post-Standard*, July 25, 1913, folder 10, Cardiff Giant Records, 2002.84, Onondaga Historical Association, Syracuse, NY. Sideshow: *Syracuse Herald*, September 12, 1913.

3. Affidavit, July 1, 1913, folder 9, Onondaga Historical Association.

4. Mulroney: *Iowa Messenger*, reprinted in *Palo-Alto Tribune*, January 14, 1914; and *Des Moines Register and Leader*, reprinted in *Lincoln Daily News*, January 5, 1914. Gypsum: Cyrenus Cole, *A History of the People of Iowa* (Cedar Rapids, IA: Torch Press, 1921), 405. Schultz: Secretary to Clarence S. Brigham, n.d., Cardiff Giant Miscellaneous Files, Fort Dodge Chamber of Commerce, Fort Dodge, IA. Wake: *Daily Northwestern*, May 21, 1921.

5. Ellen N. La Motte, "The Cardiff Giant," in *Snuffs and Butters* (1925; repr., Freeport, NY: Books for Libraries Press, 1970), 191. La Motte does not make clear whether her giant is the original or an imitation, referring to the statue alternately as "the Cardiff Giant" and "a Cardiff giant."

6. Purchase: Secretary to Clarence S. Brigham, n.d., Fort Dodge Chamber of Commerce. Exhibition arrangement: Contract, June 2, 1925, Fort Dodge Chamber of Commerce. Pride: *Emmetsburg Democrat*, September 28, 1927. Lease: Clipping, "Cardiff Giant, Idle After Fair, Looking for Job," November 3, 1934, Fort Dodge Chamber of Commerce. Homecoming: *Syracuse Herald*, August 12, 1934. Parade: *Syracuse Herald*, September 23, 1934. Film: *Syracuse Post-Standard*, September 5, 1954. Tour: *La Press*, January 19, 1935.

7. Arrangement: Various documents, Fort Dodge Chamber of Commerce. Purchase and exhibition: Clipping, "Cardiff Giant Now Property of Des Moines Man,"

August 1935, Fort Dodge Chamber of Commerce. Photograph: Leo. A. Borah, "Iowa, Abiding Place of Plenty," *National Geographic* 126, no. 2 (August 1939): 165. Son: Gardner Cowles, *Mike Looks Back* (New York: Gardner Cowles, 1985), 56. According to Cowles, he purchased the giant from a circus in Texas, but the account does not dovetail with extant records.

8. Visit: Cowles, *Mike Looks Back*, 56–57. Mencken's quotation: H. L. Mencken, "The Library," *American Mercury Magazine* 7, no. 16 (February 1926): 252.

9. Folklore: Carl Carmer, *Listen for a Lonesome Drum: A York State Chronicle*, illus. Cyrus Le Roy Baldridge (New York: Farrar & Rinehart, 1936), 251–53, 255; and Olive Beaupré Miller, *Heroes, Outlaws & Funny Fellows of American Popular Tales*, illus. Richard Bennett (New York: Doubleday, Doran & Co., 1939), 213–16, 221, 224. Directive: A. M. Drummond and Robert E. Gard, *The Cardiff Giant* (Ithaca, NY: Cornell University Press, 1949), 5.

10. Lord: Clifford Lord, "The Farmers' Museum," *New York History* 24, no. 1 (January 1943): 5. Dunn: James Taylor Dunn, "The Cardiff Giant Hoax," *New York History* 29, no. 3 (July 1948): 375.

11. Cooper: James Fenimore Cooper, *Wyandotté, or The Hutted Knoll* (1859; repr., New York: D. Appleton & Co., 1881), 10.

12. Stephen Jay Gould, "The Creation Myths of Cooperstown," in *Bully for Brontosaurus: Reflections in Natural History* (New York: Norton, 1991), 45.

13. Replica: Clipping, "The Second Cardiff Giant," n.d., Onondaga Historical Association.

14. *Time* review: R. Z. Sheppard, review of *American Goliath: Inspired by the True, Incredible Events Surrounding the Mysterious Marvel Known to the Astonished World as the Cardiff Giant*, by Harvey Jacobs, *Time* (November 10, 1997): 104. Play: Beau Jest Moving Theater: Davis Robinson and Libby Marcus, *The Naked Giant*, dir. Davis Robinson, Massachusetts College of Art, Boston, MA, May 20, 1992.

15. Review: Brian MacQuarrie, review of *The Naked Giant*, by Davis Robinson and Libby Marcus, directed by Davis Robinson, Massachusetts College of Art, Boston, MA, *Boston Globe*, May 21, 1992.

16. Newell quote: J. Roy Dodge, *LaFayette, New York: A History of the Town and its People* (Manlius, NY: Manlius Press, 1975), 167. Commemoration: *Syracuse Post-Standard*, August 16, 1939.

17. Female giant: *Syracuse Herald-American*, May 9, 1976.

~

Bibliography

A Note on Sources

Source material for the Cardiff giant hoax runs the gamut from dauntingly voluminous to maddeningly incomplete. Newspapers and legal documents offer a wealth of information on the giant's career after October 1869, while George Hull and others furnished ample detail on prior activities from cradle to grave. Still, even with sources such as *The Giantmaker* and personal recollections, there exist gaps within the larger narrative, leaving room both for speculation as well as competing claims. Where primary and quasi-primary sources present incomplete or contradictory versions of events, I have endeavored to provide the simplest explanation supported by the extant historical record, while also furnishing detail on which sources guided my telling of the story. For especially pertinent issues, I explain my editorial judgment both in the notes and in the text, indicating which sources proved most trustworthy in given cases.

In the realm of primary sources, the Onondaga Historical Association represents the most extensive repository on the hoax. The organization's collection includes copies of legal documents related to the original sale as well as subsequent arrangements and amendments. The archive also includes files from *John Hull Jr. vs. Amos Westcott and David H. Hannum*, and the deposition of a Binghamton tax collector shed much light on George Hull's activities in that city. The Broome County Historical Society offers its own wealth of primary source material, most notably *The Giantmaker* as well as the personal papers of John Rankin. The latter collection includes several giant-related materials, among them Rankin's purchase agreement, publishing contracts with Hull and Samuel Crocker, as well as documents related to latter-day ownership. The Division of Rare and Manuscript Collections at Cornell University holds some of this same material as well as a second copy of *The Giantmaker*. For

researchers interested in the giant's ownership status over the first half of the twentieth century, the Fort Dodge Chamber of Commerce and the New York State Historical Association possess ample correspondence, contracts, as well as newspaper clippings. The latter organization and the Onondaga Historical Association each offer extensive clipping libraries, and these collections introduced me to key retrospectives as well as reports of imitation giants over the years.

This book very much is a story of the common man, and many of its critical characters never even merited passing reference in local history books. To learn about these men and women, I leaned heavily upon the census as well as contemporary city directories. Even where scientists were concerned, I found biographical materials generally lacking. For the full career of John Boynton, I drew upon disparate materials from the Onondaga Historical Association as well as from records of the Church of Jesus Christ of Latter-day Saints. The Fort Edward Historical Society kindly shared information on Lemuel Olmstead, while fragments of Wills De Hass's career emerged from administrative correspondence at the National Anthropological Archives.

The story of the Cardiff giant intersects with many larger currents in American history, and accordingly I have drawn a great deal from secondary works. For the exceedingly broad topic of religion in America, Mark A. Noll's *A History of Christianity in the United States and Canada* provided an excellent overview, while, in my specific discussion of the Second Great Awakening in New York, I drew more directly from Whitney Cross's *The Burned-over District*. James Turner's *Without God, Without Creed* was an invaluable resource as I framed my discussion on atheism and the authority of the Bible.

For any survey of nineteenth-century science, historians must consider both successes and failures. In providing historical background on the rise of the scientific profession, I culled material from Robert V. Bruce's *The Launching of Modern American Science, 1846–1876*, as well as Gordon R. Willey and Jeremy A. Sabloff's *A History of American Archaeology*. For the corresponding consideration of quacks and hucksters, Ann Anderson's *Snake Oil, Hustlers and Hambones: The American Medicine Show* offered a concise and effective overview. For the many archaeological frauds covered in this volume, I repeatedly consulted two key works of scholarship: Kenneth L. Feder's *Frauds, Myths, and Mysteries: Science and Pseudoscience in Archaeology* and Stephen Williams's *Fantastic Archaeology*.

P. T. Barnum not only played an important role in the Cardiff giant affair, but his professional career was inextricably tied to so many aspects of the story, including popular scientific literacy as well as the art of deception. A. H. Saxon's definitive *P. T. Barnum: The Legend and the Man* furnished the majority of biographical material in this book. Like any historian interested in the great showman, I am deeply indebted to Neil Harris for his seminal *Humbug: The Art of P. T. Barnum*. This work is a thoughtful consideration of Barnum's aesthetic and informed several sections within this study, including the tension between common men and experts, popular faith in the possibilities of science, as well as the dynamic between hoaxers and their audiences. Both Harris and Saxon furnished insight into the broader museum cul-

ture, but I also leaned heavily upon Andrea Stulman Dennett's *Weird and Wonderful: The Dime Museum in America*. Dennett's book also yielded numerous instances of colossal men within contemporary theater, and, along with Walter Stephens's *Giants in Those Days: Folklore, Ancient History, and Nationalism*, guided my discussion of giants within popular imagination.

Of the many books devoted to nineteenth-century American journalism, I found George H. Douglas's *The Golden Age of the Newspaper* a particularly valuable overview. This work informs several sections, including the emergence of the penny press, the Civil War's influence upon newspaper culture, as well as the gradual move toward sensationalism. For nineteenth-century American literature and romanticism more generally, I culled material from a multitude of sources, but found John P. Mc-Williams's *The American Epic: Transforming a Genre, 1770–1860* and the scholarly reference work, *Encyclopedia of the Romantic Era*, particularly useful.

The literature on Reconstruction and the Gilded Age is vast, but several general histories proved indispensable, among them Eric Foner's *Reconstruction: America's Unfinished Revolution, 1863–1877*, Sean Dennis Cashman's *America in the Gilded Age*, as well as Alexander B. Callow's *The Tweed Ring*.

For the discussion of nostalgia in the 1920s and 1930s, Lawrence W. Levine's *The Unpredictable Past: Explorations in American Cultural History* was particularly valuable.

Several local histories provided me with rich detail and color. For the history of Cardiff and LaFayette, the best and most authoritative source is J. Roy Dodge's *LaFayette, New York: A History of the Town and its People*, while *Onondaga's Centennial* and Franklin Chase's *Syracuse and its Environs* offered the best surveys of Syracuse's history. The discussion of the Onondaga Indians draws from these sources, but more directly from the chapter "Onondaga" in the *Handbook of North American Indians*. To keep citations concise, other general contextual sources are listed in the bibliography.

When presenting modern equivalencies of currency within the text, I employed the same model as Kenneth Ackerman in *The Gold Ring*, multiplying contemporary sums by twenty to approximate modern value. Finally, in regard to methodology, the structure of this book adheres closely to historical chronology, but, when offering broad analysis of religious reception and popular scientific opinion, I occasionally drew from sources outside predominant chapter timelines, most notably in chapter 6. I kept such timeline breaks to a minimum, and, when drawing sources in these cases, I took care to select letter writers who were not responding to specific developments, but rather were musing upon the great wonder more generally.

Manuscript Sources

Cardiff Giant Collection, 1869–1979. Research Library, New York State Historical Association, Cooperstown, NY.

Cardiff Giant Hoax Miscellany, 1870–1902. Division of Rare and Manuscript Collections, Cornell University, Ithaca, NY.

Cardiff Giant Miscellaneous Files. Fort Dodge Chamber of Commerce, Fort Dodge, IA.

Cardiff Giant Records, 2002.84. Onondaga Historical Association, Syracuse, NY.

Rankin, John C. Papers, 1857–1963, 1869–1902 (bulk). Broome County Historical Society, Broome County Public Library, Binghamton, NY.

Works Relating to the Cardiff Giant

1870 U.S. Federal Census (Population Schedule), Oakland, Franklin, IA, Roll: M593_392, Page: 387, Image: 338, Dwelling: 20, Family: 21, H. B. Turk household, at http://www.ancestry.com (accessed June 21, 2006).

The American Goliah: A Wonderful Geological Discovery. Syracuse, NY: Printed at the Journal Office, 1869.

The American Goliah: A Wonderful Geological Discovery. Enlarged ed. Syracuse, NY: Printed at the Journal Office, 1869.

The Autobiography of the Great Curiosity, The Cardiff Stone Giant. 2nd ed. Syracuse, NY: Hitchcock & Smith, 1869.

Baum, L. Frank. "The True Origin of the Cardiff Giant." *Rose Lawn Home Journal* (July 1, 1871). L. Frank Baum Papers. Special Collections Research Center, Syracuse University Library, Syracuse, NY.

"The Biography of a Giant." *Lakeside Monthly* 6, no. 32 (August 1871): 128–34.

Boning, Richard A. *The Cardiff Giant.* Illustrated by Joseph Forte. Baldwin, NY: Dexter & Westbrook, 1972.

Borah, Leo. A. "Iowa, Abiding Place of Plenty." *National Geographic* 126, no. 2 (August 1939): 143–182.

Calvin O. Gott vs. R. M. Pulsifer & Others, 122 Mass. 235, 1877 Mass. LEXIS 105 (Mass. Supr. Ct. 1876–1877).

The Cardiff Giant Humbug: A Complete and Thorough Exposition of the Greatest Deception of the Age. Fort Dodge, IA: North West Book & Job Printing Establishment, 1870.

Carmer, Carl. *Listen for a Lonesome Drum: A York State Chronicle.* Sketches by Cyrus Le Roy Baldridge. New York: Farrar & Rinehart, 1936.

"Correspondence," *Scientific American,* n.s., 21, no. 20 (November 13, 1869): 310–311.

"Correspondence," *Scientific American,* n.s., 21, no. 22 (November 27, 1869): 341–343.

Cowles, Gardner. *Mike Looks Back.* New York: Gardner Cowles, 1985.

David Harum. Directed by Allan Dwan. Paramount Pictures, 1915.

David Harum. Directed by James Cruze. Fox Film Corp., 1934.

Drummond, A. M., and Robert E. Gard. *The Cardiff Giant.* Ithaca, NY: Cornell University Press, 1949.

Dunn, James Taylor. "The Cardiff Giant Hoax." *New York History* 29, no. 3 (July 1948): 367–377.

Franco, Barbara A. "The Cardiff Giant: How the Public Was Fooled." Master's thesis, State University of New York College at Oneonta, 1967.

Gould, Stephen Jay. "The Creation Myths of Cooperstown." Pp. 42–58 in *Bully for Brontosaurus: Reflections in Natural History*. New York: Norton, 1991.

History of the Geological Wonder of the World: A Petrified Pre-Historic Human Being. New York: Press of Wynkoop & Hallenbeck, 1877.

Jacobs, Harvey. *American Goliath: Inspired by the True, Incredible Events Surrounding the Mysterious Marvel Known to the Astonished World as the Cardiff Giant*. New York: St. Martin's Press, 1997.

John Hull v. Amos Westcott and David H. Hannum, Supreme Court, Broome County Court House, Binghamton, NY.

Kammen, Carol. "Giants in the Earth." *Heritage* 11, no. 1 (Autumn 1994): 24–29.

Kelland, Clarence Budington. *The Lady and the Giant*. New York: Dodd, Mead, 1959.

Kimball, Gwen [pseudo.]. *The Cardiff Giant*. New York: Duell, Sloan & Pearce, 1966.

La Motte, Ellen N. "The Cardiff Giant." Pp. 187–206 in *Snuffs and Butters*. 1925. Reprint, Freeport, NY: Books for Libraries Press, 1970.

MacWhorter, Alexander. "Tammuz and the Mound-Builders." *Galaxy* 14, no. 1 (July 1872): 83–100.

McKinney, W. A. "The History of the Cardiff Giant Hoax." *New Englander and Yale Review* 34, no. 133 (October 1875): 759–69.

The Mighty Barnum. Directed by Walter Lang. United Artists, 1934.

Miller, Olive Beaupré. *Heroes, Outlaws & Funny Fellows of American Popular Tales*. Illustrated by Richard Bennett. New York: Doubleday, Doran & Company, 1939.

The Onondaga Giant, or the Great Archaeological Discovery. Syracuse, NY: Nottingham & Tucker, 1869.

Parkes, Albert L. "A Giant Hoax." *Godey's Magazine* 129, no. 782 (August 1895): 145–50.

Perrin, Pat, and Wim Coleman. *The Mystery of the Cardiff Giant*. Logan, IA: Perfection Learning, 2004.

Pettit, Michael. "'The Joy in Believing' The Cardiff Giant, Commercial Deceptions, and Styles of Observation in Gilded Age America." *Isis* 97 (2006): 659–77.

Plymat, William N., Jr. "The Cardiff Giant: The Greatest Discovery of the 19th Century." Photocopy, Research Library, New York State Historical Association, Cooperstown, NY.

Rankin, John. "The David Harum I Knew." *Home Magazine* 14, no. 2 (February 1900): 122–29.

Robinson, Davis, and Libby Marcus. *The Naked Giant*. Directed by Davis Robinson. Massachusetts College of Art, Boston, Massachusetts. May 20, 1992.

Roosevelt, Theodore. "Nature Fakers," in *The Works of Theodore Roosevelt: Presidential Addresses and State Papers*, exec. ed. New York: P. F. Collier & Son, 1910.

Sears, Stephen W. "The Giant in the Earth." *American Heritage* 26, no. 5 (August 1975): 94–99.

Shebar, Sharon Sigmond, and Judith Schoder. *The Cardiff Giant*. Illustrated by Dave Sullivan. New York: J. Messner, 1983.

Sheppard, R. Z. Review of *American Goliath: Inspired by the True, Incredible Events Surrounding the Mysterious Marvel Known to the Astonished World as the Cardiff Giant*, by Harvey Jacobs, *Time* (November 10, 1997): 104.

Sherlock, Charles Reginald. *Your Uncle Lew: A Natural-born American*. New York: Frederick A. Stokes Co., 1901.

Standiford, Natalie. *The Stone Giant: A Hoax that Fooled America*. Illustrated by Bob Doucet. New York: Golden Books, 2001.

Stockwell, G. A. "The Cardiff Giant and Other Frauds." *Popular Science Monthly* 74, no. 13 (June 1878): 197–203.

Tribble, Scott. "Giants in the Head: The Cardiff Giant Hoax in American Historical Consciousness: 1869–1998." Undergraduate thesis, Harvard College, 1998.

Twain, Mark. "A Ghost Story." Pp. 257–65 in *Sketches New and Old*. 1875. Reprint, New York: Harper & Brothers Publishers, 1922.

———. "The Capitoline Venus." Pp. 266–73 in *Sketches New and Old*. 1875. Reprint, New York: Harper & Brothers Publishers, 1922.

Vance, Arthur T. *The Real David Harum*. New York: Baker & Taylor Co., 1900.

Westcott, Edward Noyes. *David Harum: A Story of American Life*. New York: Appleton, 1898.

White, Andrew Dickson. "The Cardiff Giant: A Chapter in the History of Human Folly—1868–1870." Pp. 465–85 in *Autobiography of Andrew Dickson White*. 2 vols. New York: Century Co., 1905.

You Are There. "February 2, 1870: The Cardiff Giant," first broadcast January 22, 1955, by CBS Television. Directed by Bernard Girard and written by Jack Bennett.

Reconstruction and Gilded Age America

Ackerman, Kenneth D. *The Gold Ring: Jim Fisk, Jay Gould, and Black Friday, 1869*. 1988. Reprint, New York: Carroll & Graf Publishers, 2005.

———. *Boss Tweed: The Rise and Fall of the Corrupt Pol Who Conceived the Soul of Modern New York*. New York: Carroll & Graf Publishers, 2005.

Botts, John Minor. *The Great Rebellion: Its Secret History, Rise, Progress, and Disastrous Failure*. New York: Harper, 1866.

Callow, Alexander B., Jr. *The Tweed Ring*. New York: Oxford University Press, 1966.

Cashman, Sean Dennis. *America in the Gilded Age: From the Death of Lincoln to the Rise of Theodore Roosevelt*. New York: New York University Press, 1984.

Foner, Eric. *Reconstruction: America's Unfinished Revolution, 1863–1877*. 1988. Reprint, New York: Harper & Row Perennial Library, 1989.

Gillette, William. *The Right to Vote: Politics and the Passage of the Fifteenth Amendment*. 1965. Reprint, Baltimore: Johns Hopkins Press, 1969.

Stover, John F. *American Railroads*. 2nd ed. Chicago: University of Chicago Press, 1997.

———. *The Routledge Historical Atlas of the American Railroads.* New York: Routledge, 1999.

Religion in America

Arrington, Leonard J. *Brigham Young: American Moses.* 1985. Reprint, Urbana: University of Illinois Press, 1986.

Bates, Irene M., and E. Gary Smith. *Lost Legacy: The Mormon Office of Presiding Patriarch.* Urbana: University of Illinois Press, 1996.

Bishop, Morris. "The Great Oneida Love-in." *American Heritage* 20, no. 2 (February 1969): 11–16, 86–92.

Braude, Ann. *Radical Spirits: Spiritualism and Women's Rights in Nineteenth-Century America.* 2nd ed. Bloomington: Indiana University Press, 2001.

Carmer, Carl. "The Farm Boy and the Angel." *American Heritage* 13, no. 6 (October 1962): 5–9, 80–91.

Carwardine, Richard. *Evangelicals and Politics in Antebellum America.* New Haven, CT: Yale University Press, 1993.

Cross, Whitney R. *The Burned-over District: The Social and Intellectual History of Enthusiastic Religion in Western New York, 1800–1850.* Ithaca, NY: Cornell University Press, 1950.

Gaustad, Edwin S., and Leigh E. Schmidt. *The Religious History of America,* rev. ed. San Francisco: Harper San Francisco, 2002.

Hatch, Nathan O. *The Democratization of American Christianity.* New Haven, CT: Yale University Press, 1989.

Huguenin, Charles A. "The Amazing Fox Sisters." *New York Folklore Quarterly* 13, no. 4 (Winter 1957): 241–76.

Johnson, Curtis D. *Redeeming America: Evangelicals and the Road to Civil War.* Chicago: I. R. Dee, 1993.

Kirtland Council Minute Book. Edited by Fred C. Collier and William S. Harwell. Salt Lake City, UT: Collier's, 1996.

Larrabee, Harold A. "The Trumpeter of Doomsday." *American Heritage* 15, no. 3 (April 1964): 35–37, 95–100.

Noll, Mark A. *A History of Christianity in the United States and Canada.* 1992. Reprint, Grand Rapids, MI: William B. Eerdmans Publishing Co., 2000.

———. *The Scandal of the Evangelical Mind.* Grand Rapids, MI: W. B. Eerdmans, 1994.

———. *America's God: From Jonathan Edwards to Abraham Lincoln.* New York: Oxford University Press, 2002.

Smith, Lucy Mack. *Biographical Sketches of Joseph Smith the Prophet and his Progenitors for Many Generations.* 1908. Reprint, Whitefish, MT: Kessinger Publishing, 2006.

Torbett, David. *Theology and Slavery: Charles Hodge and Horace Bushnell.* Macon, GA: Mercer University Press, 2006.

Turner, James. *Without God, Without Creed: The Origins of Unbelief in America.* Baltimore: Johns Hopkins University Press, 1985.

"The Twelve Apostles," *The Historical Record* 5, no. 4 (April 1886): 33–54.

Winn, Kenneth H. *Exiles in a Land of Liberty: Mormons in America, 1830–1846.* Chapel Hill: University of North Carolina Press, 1989.

Science and Scientists in America

Anderson, Ann. *Snake Oil, Hustlers and Hambones: The American Medicine Show.* Jefferson, NC: McFarland & Co., 2000.

Armstrong, David, and Elizabeth Metzger Armstrong. *The Great American Medicine Show.* New York: Prentice Hall, 1991.

"Boynton, John Farnham," *LDS Biographical Encyclopedia,* at http://www.ancestry.com/search/db.aspx?dbid=2028 (accessed July 17, 2007).

Bruce, Robert V. *The Launching of Modern American Science, 1846–1876.* New York: Knopf, 1987.

Clarke, John Mason. *James Hall of Albany, Geologist and Paleontologist.* Albany, NY, 1921.

A Descriptive Narrative of the Wonderful Petrifaction of a Man into Stone as Perfect as When Alive. Philadelphia: Stereotyped by Slote & Mooney, 1854.

"Earthquakes," *Monthly Repository, and Library of Entertaining Knowledge* 1, no. 1 (June 1830): 11–13.

Flint, Timothy. *Lectures Upon Natural History, Geology, Chemistry, the Application of Steam, and Interesting Discoveries in the Arts.* Boston: Lilly, Wait, Colman, & Holden, 1833.

"Geology as a Branch of Education," *Massachusetts Teacher and Journal of Home and School Education* 16, no. 6 (June 1863): 183–190.

Hoyt, Edwin Palmer. *The Improper Bostonian: Dr. Oliver Wendell Holmes.* New York: Morrow, 1979.

Jaffe, Mark. *The Gilded Dinosaur: The Fossil War Between E. D. Cope and O. C. Marsh and the Rise of American Science.* New York: Crown, 2000.

Loewenberg, Bert James. "Darwinism Comes to America, 1859–1900." *Mississippi Valley Historical Review* 28, no. 3 (December 1941): 339–68.

Ludovici, L. J. *Cone of Oblivion: A Vendetta in Science.* London: M. Parish, 1961.

McKay, Robert M. "Gypsum Resources of Iowa," at http://www.igsb.uiowa.edu/Browse/gypsum/gypsum.htm (accessed June 21, 2006).

"Organic Remains," *The Knickerbocker* 8, no. 2 (August 1836): 125–132.

Scientific American Supplement 22, no. 561 (October 2, 1886; Project Gutenberg, 2005), at http://www.gutenberg.org/files/16360/16360-h/16360-h.htm (accessed June 25, 2006).

"State Geological Hall and Agricultural Rooms of New York," *American Journal of Education* 4, no. 12 (March 1858): 784–794.

Archaeology and Antiquarianism

"American Antiquities," *The Knickerbocker* 10, no. 1 (July 1837): 1–10.

Conn, Steven. *History's Shadow: Native Americans and Historical Consciousness in the Nineteenth Century.* Chicago: University of Chicago Press, 2004.

Feder, Kenneth L. *Frauds, Myths, and Mysteries: Science and Pseudoscience in Archaeology*, 5th ed. Boston: McGraw-Hill, 2006.

Gosden, Chris. *Anthropology and Archaeology: A Changing Relationship*. London: Routledge, 1999.

Pidgeon, William. *Traditions of De-Coo-Dah, and Antiquarian Researches*. 1853. Reprint, New York: Horace Thayer, 1858.

Priest, Josiah. *American Antiquities and Discoveries in the West*, 3rd ed. rev. Albany, NY: Printed by Hoffman & White, 1833.

Silverberg, Robert. *Mound Builders of Ancient America: The Archaeology of a Myth*. 1968. Reprint, Athens: Ohio University Press, 1986.

Trigger, Bruce G. *A History of Archaeological Thought*. 1989. Reprint, Cambridge: Cambridge University Press, 1993.

Willey, Gordon R., and Jeremy A. Sabloff. *A History of American Archaeology*, 3rd ed. New York: W. H. Freeman, 1993.

Williams, Stephen. *Fantastic Archaeology: The Wild Side of North American Prehistory*. Philadelphia: University of Pennsylvania Press, 1991.

Barnum and Museum Culture

Barnum, P. T. *The Life of P. T. Barnum, Written by Himself*. London: S. Low, 1855.

———. *The Humbugs of the World: An Account of Humbugs, Delusions, Impositions, Quackeries, Deceits and Deceivers Generally, in All Ages*. London: J. C. Hotten, 1866.

———. *Struggles and Triumphs; or, Forty Years' Recollections of P. T. Barnum, Written by Himself*. Hartford, CT: J. B. Burr, 1869.

———. *Funny Stories Told by Phineas T. Barnum*. New York: G. Routledge & Sons, 1890.

Bondeson, Jan. *The Feejee Mermaid and Other Essays in Natural and Unnatural History*. Ithaca, NY: Cornell University Press, 1999.

Dennett, Andrea Stulman. *Weird and Wonderful: The Dime Museum in America*. New York: New York University Press, 1997.

Harris, Neil. *Humbug: The Art of P. T. Barnum*. Boston: Little, Brown, 1973.

Saxon, A. H. *P.T. Barnum: The Legend and the Man*. New York: Columbia University Press, 1989.

Sellers, Charles Coleman. *Mr. Peale's Museum: Charles Willson Peale and the First Popular Museum of Natural Science and Art*. New York: Norton, 1980.

Stephens, Walter. *Giants in Those Days: Folklore, Ancient History, and Nationalism*. Lincoln: University of Nebraska Press, 1989.

Thompson, C. J. S. *The Mystery and Lore of Monsters: With Accounts of Some Giants, Dwarfs and Prodigies*. London: Williams & Norgate, 1930.

Hoaxes

Barnhart, Terry A. "Curious Antiquity? The Grave Creek Controversy Revisited." *West Virginia History* 46 (Annual, 1985–1986): 103–24.

"Editor's Table," *The Knickerbocker* 46, no. 5 (November 1855): 518–550.

Evans, David S. "The Great Moon Hoax." *Sky & Telescope* 62 (September 1981): 196–198.

———. "The Great Moon Hoax." *Sky & Telescope* 62 (October 1981): 308–11.

Huguenin, Charles A. "The Pompey Stone." *New York Folklore Quarterly* 14, no. 1 (Spring 1958): 34–43.

Kimiecik, Kathy. "The Strange Case of the Silver Lake Sea Serpent." *New York Folklore Society Newsletter* 9, no. 1 (Summer 1988): 10–11.

Lepper, Bradley T., and Jeff Gill. "The Newark Holy Stones." *TIMELINE* 17, no. 3 (May–June 2000): 17–25.

Quinn, Arthur Hobson. *Edgar Allan Poe: A Critical Biography*. 1941. Reprint, Baltimore: Johns Hopkins University Press, 1998.

Sassaman, Richard. "The Tell-Tale Hoax." *Air and Space/Smithsonian* 8, no. 3 (August/September 1993): 80–83.

Tribble, Scott. "The Great Viking Hoax." *Western Pennsylvania History* 90, no. 3 (Fall 2007): 48–57.

Twain, Mark. "The Petrified Man." Pp. 288–92 in *Sketches New and Old*. 1875. Reprint, New York: Harper & Brothers Publishers, 1922.

Walsh, Lynda. *Sins Against Science: The Scientific Media Hoaxes of Poe, Twain, and Others*. Albany: State University of New York Press, 2006.

Newspapers in America

Douglas, George H. *The Golden Age of the Newspaper*. Westport, CT: Greenwood Press, 1999.

Merriam, George Spring. *The Life and Times of Samuel Bowles*. 2 vols. New York: Century Co., 1885.

Mott, Frank Luther. *American Journalism: A History, 1690–1960*, 3rd ed. New York: Macmillan, 1962.

Roggenkamp, Karen. *Narrating the News: New Journalism and Literary Genre in Late Nineteenth-Century American Newspapers and Fiction*. Kent, OH: Kent State University Press, 2005.

Stevens, John D. *Sensationalism and the New York Press*. New York: Columbia University Press, 1991.

Romanticism, Philosophy, and Literature

"American Poetry," *The Knickerbocker* 12, no. 5 (November 1838): 383–388.

Cooper, James Fenimore. *Wyandotté, or The Hutted Knoll*. 1859. Reprint, New York: D. Appleton & Co., 1881.

Encyclopedia of the Romantic Era, 1760–1850. 2 vols. Edited by Christopher John Murray. New York: Fitzroy Dearborn, 2003.

Falnes, Oscar J. "New England Interest in Scandinavian Culture and the Norsemen." *New England Quarterly* 10, no. 2 (June 1937): 211–42.

A Historical Guide to Ralph Waldo Emerson. Edited by Joel Myerson. New York: Oxford University Press, 2000.

Howell, Martha C., and Walter Prevenier. *From Reliable Sources: An Introduction to Historical Methods*. Ithaca, NY: Cornell University Press, 2001.

Longfellow, Henry Wadsworth. *Kavanagh, a Tale*. London: George Slater, 1849.

Mathews, Cornelius. "Our Illustrious Predecessors," in *The Various Writings of Cornelius Mathews*. New York: Harper & Brothers, 1843.

McWilliams, John P., Jr. *The American Epic: Transforming a Genre, 1770–1860*. Cambridge: Cambridge University Press, 1989.

Moreland, Kim Ileen. *The Medievalist Impulse in American Literature: Twain, Adams, Fitzgerald, and Hemingway*. Charlottesville: University Press of Virginia, 1996.

Newman, Russell T. *The Gentleman in the Garden: The Influential Landscape in the Works of James Fenimore Cooper*. Lanham, MD: Lexington Books, 2003.

An Oxford Companion to the Romantic Age: British Culture, 1776–1832. Edited by Iain McCalman et al. New York: Oxford University Press, 1999.

Smith, Roger. *The Norton History of the Human Sciences*. 1st American ed. New York: W. W. Norton, 1997.

Thurin, Erik Ingvar. *The American Discovery of the Norse: An Episode in Nineteenth-Century American Literature*. Lewisburg, PA: Bucknell University Press, 1999.

Works Relating to Onondaga County

Beauchamp, William Martin. *Past and Present of Syracuse and Onondaga County, New York*. 2 vols. New York: S. J. Clarke Publishing Co., 1908.

Blau, Harold, Jack Campisi, and Elisabeth Tooker. "Onondaga." Pp. 491–99 in *Northeast*, vol. 15, *Handbook of North American Indians*. Edited by B. G. Trigger. Washington, DC: Smithsonian Institution, 1978.

"Cardiff and the Civil War." *Newsletter of the LaFayette Historical Society* no. 48 (June 2004): 11–15.

Chase, Franklin H. *Syracuse and its Environs: A History*. 3 vols. New York: Lewis Historical Publishing Co., 1924.

Clark, Joshua V. H. *Onondaga*. 2 vols. Syracuse, NY: Stoddard & Babcock, 1849.

Clayton, W. W. *History of Onondaga County, New York*. Syracuse: NY: D. Mason & Co., 1878.

Cusick, David. *Sketches of Ancient History of the Six Nations*. 1827. Reprint, Bristol, PA: Evolution Pub., 2004.

Dodge, J. Roy. *LaFayette, New York: A History of the Town and its People*. Manlius, NY: Manlius Press, 1975.

Onondaga's Centennial. Edited by Dwight H. Bruce. 2 vols. Boston: Boston History Co., 1896.

Schneider, Philip F. *Notes on the Geology of Onondaga County, N.Y.* Syracuse, NY: Hall & McChesney Printers, 1894.

Sweet, Homer De Lois. *New Atlas of Onondaga County, N.Y.* New York: Walker Bros., 1874.

United States Pension Bureau, "List of Pensioners on the Roll from Records for Town of LaFayette," January 1, 1883, United States Military Archive, Carlisle, PA.

Works Relating to Other Localities

Andreas, A. T. *A. T. Andreas' Illustrated Historical Atlas of the State of Iowa*. 6 vols. Chicago: Lakeside Press, 1875.

Binghamton and Broome County, New York. Edited by William Foote Seward. 3 vols. New York: Lewis Historical Publishing Co., 1924.

Binghamton, Its Settlement, Growth and Development. Edited by William S. Lawyer. Boston: Century Memorial Publishing Co., 1900.

Celebration of the Two Hundred and Fiftieth Anniversary of the Settlement of Suffield, Connecticut, October 12, 13 and 14, 1920. Suffield, CT: By Authority of the General Executive Committee, 1921.

Cole, Cyrenus. *A History of the People of Iowa*. Cedar Rapids, IA: Torch Press, 1921.

Gue, Benjamin F. *History of Iowa from the Earliest Times to the Beginning of the Twentieth Century*. New York: Century History Co., 1903.

History of Broome County. Edited by H. P. Smith. Syracuse, NY: D. Mason & Co., 1885.

History of Hardin County, Iowa. 1883. Reprint, Evansville, IN: Unigraphic, 1974.

The History of Sauk County, Wisconsin. Chicago: Western Historical Co., 1880.

History of Tioga County, Pennsylvania. Harrisburg, PA: R. C. Brown & Co., 1897.

Krug, Merton E. *History of Reedsburg and the Upper Baraboo Valley*. Madison, WI: Democrat Printing Co., 1929.

Lathrop, J. *A Plan of West Springfield*. Boston: Pendleton's Lithogy, 1831.

"Our County and its People": A History of Hampden County, Massachusetts. Edited by Alfred Minott Copeland. 3 vols. Boston: Century Memorial Pub. Co., 1902.

Hull Family Genealogy

1840 U.S. Federal Census (Population Schedule), Suffield, Hartford, CT, Roll: 24, Page: 203, John Hull household, at http://www.ancestry.com (accessed June 21, 2006).

1850 U.S. Federal Census (Population Schedule), Springfield, Hampden, MA, Roll: M432_319, Page: 104, Image: 210, Dwelling: 1615, Family: 1764, George Hull household, at http://www.ancestry.com (accessed June 21, 2006).

1855 New York State Census (Population Schedule), Chenango, Broome County, Roll: 809005, Enumeration District: 4, Page: 9, Dwelling: 63, Family: 77, John Hull household (Family History Library) [Microreproduction of original records in New York State Library].

1860 U.S. Federal Census (Population Schedule), Chenango, Broome, NY, Roll: M653_724, Page: 540, Image: 545, Dwelling: 1755, Family: 1805, John Hull household, at http://www.ancestry.com (accessed June 21, 2006).

1860 U.S. Federal Census (Population Schedule), Port Crane, Broome, NY, Roll: M653_724, Page: 659, Image: 664, Dwelling: 168, Family: 158, George Hull household, at http://www.ancestry.com (accessed June 21, 2006).

1870 U.S. Federal Census (Population Schedule), Binghamton, Broome, NY, Roll: M593_906, Page: 82, Image: 166, Dwelling: 511, Family: 573, George Hull household, at http://www.ancestry.com (accessed June 21, 2006).

1880 U.S. Federal Census (Population Schedule), Fenton, Broome, NY, Roll: T9_810, Family History Film: 1254810, Page: 308.2000, Enumeration District: 46, Image: 0753, Dwelling: 327, Family: 332, George Hull household, jpeg image, (Online: MyFamily.com, 2006), subscription database, [Digital scan of original records in the National Archives, Washington, DC], at http://www.ancestry.com (accessed June 21, 2006).

Amsbury Family Files. Broome County Historical Society, Broome County Public Library, Binghamton, New York.

Bliss, Aaron Tyler. *Genealogy of the Bliss Family in America.* 3 vols. Midland, MI: A. T. Bliss, 1982.

First Baptist Church Records, 1833–1872. Kent Memorial Library, Suffield, Connecticut.

King, Cameron Haight. *The King Family of Suffield, Connecticut, its English Ancestry* A.D. *1389–1662 and American Descendants* A.D. *1662–1908.* San Francisco: Press of the Walter N. Brunt Co., 1908.

Olds, Edson B. *The Olds (Old, Ould) Family in England and America.* Washington, DC: 1915.

Ogden Family Files. Broome County Historical Society, Broome County Public Library, Binghamton, New York.

Vital Records of West Springfield, Massachusetts, to the Year 1850. 2 vols. Boston: New England Historic Genealogical Society, 1944–1945.

Other

Bailey, Thomas A., and David M. Kennedy. *The American Pageant: A History of the Republic,* 9th ed. Lexington, MA: D. C. Heath & Co., 1991.

Bowles, Samuel. *Across the Continent: A Summer's Journey to the Rocky Mountains, the Mormons, and the Pacific States, with Speaker Colfax.* Springfield, MA: S. Bowles & Co., 1865.

———. *The Pacific Railroad—Open.* Boston: Fields, Osgood & Co., 1869.

Brogan, Hugh. *The Penguin History of the United States of America,* 2nd ed. London: Penguin Books, 2001.

Brown, Henry. *A Narrative of the Anti-Masonick Excitement, in the Western Part of the State of New York, During the Years 1826, '7, '8, and a Part of 1829.* Batavia, NY: Printed by Adams & M'Cleary, 1829.

Carnegie, Andrew. *Triumphant Democracy; Sixty Years' March of the Republic,* rev. ed. New York: C. Scribner's Sons, 1893.

Clark, Burton R. *Places of Inquiry: Research and Advanced Education in Modern Universities.* Berkeley: University of California Press, 1995.

Corvin-Wiersbitzki, Otto Julius Bernhard von. *A Life of Adventure, an Autobiography.* 3 vols. London: R. Bentley, 1871.

Crunden, Robert Morse. *A Brief History of American Culture.* 1990. Reprint, Armonk, NY: North Castle Books, 1996.

De Bow, J. D. B. "The Commercial Age," *The Commercial Review,* n.s., 1, no. 3 (September 1849): 225–239.

The Democratic Party of the State of New York. Edited by James K. McGuire. 3 vols. New York: United States History Co., 1905.

Ely, Richard T. *Taxation in American States and Cities.* New York: T. Y. Crowell & Co., 1888.

Fearnow, Mark. *The American Stage and the Great Depression: A Cultural History of the Grotesque.* Cambridge: Cambridge University Press, 1997.

Fetridge, W. Pembroke *The American Travellers' Guides: Harper's Handbook for Travellers in Europe and the East.* New York: Harper & Brothers, Publishers, 1868.

Fitz, Reginald. *The Thursday Evening Club of Boston, 1846–1946, An Historical Sketch.* Boston, 1946.

Foote, John Parsons. *The Schools of Cincinnati and its Vicinity.* Cincinnati, OH: C. F. Bradley & Co.'s Power Press, 1855.

Johnson, Paul. *A History of the American People.* 1997. Reprint, New York: Harper-Perennial, 1999.

Kelley, Brooks Mather. *Yale: A History.* New Haven, CT: Yale University Press, 1974.

Levine, Lawrence W. *The Unpredictable Past: Explorations in American Cultural History.* New York: Oxford University Press, 1993.

Lincoln, Charles Z. *The Constitutional History of New York from the Beginning of the Colonial Period to the Year 1905.* 5 vols. Rochester, NY: Lawyers Co-operative Publishing Co., 1906.

Lord, Clifford. "The Farmers' Museum." *New York History* 24, no. 1 (January 1943): 1–14.

Lossing, John Benson. *Lives of Celebrated Americans.* Hartford, CT: Belknap, 1869.

Lowenthal, David. *George Perkins Marsh, Prophet of Conservation.* Seattle: University of Washington Press, 2000.

Mayfield, John. "Being Shifty in a New Country: Southern Humor and the Masculine Ideal." Pp. 113–35 in *Southern Manhood: Perspectives on Masculinity in the Old South.* Edited by Craig Thompson Friend and Lorri Glover. Athens: University of Georgia Press, 2004.

Mencken, H. L. "The Library." *American Mercury Magazine* 7, no. 16 (February 1926): 251–255.

The National Cyclopaedia of American Biography. New York: James T. White Co., 1893-19—.

New York in the War of the Rebellion, 3rd ed. Compiled by Frederick Phisterer. Albany, NY: J. B. Lyon Co., 1912.

People v. O'Reilly, 86 N.Y. 154 (N.Y. Ct App. 1881).

People v. Travis, 4 Park. Cr. R., 213 (Buff. Sup. Ct. 1854).

Pulszky, Francis and Theresa. *White, Red, Black: Sketches of Society in the United States During the Visit of Their Guest*, 2 vols. New York: Redfield, 1853.

Putnam, George P. *Hand-book of Chronology and History*, 6th ed. New York: George P. Putnam, 1852.

Reavis, Logan Uriah. *Saint Louis: The Future Great City of the World*, 3rd ed. St. Louis, MO.: Pub. by the Order of the St. Louis County Court, 1871.

Seaman, Ezra Champion. *The American System of Government*. New York: C. Scribner & Co., 1870.

Spencer, Mark G. *David Hume and Eighteenth-Century America*. Rochester, NY: University of Rochester Press, 2005.

Spielvogel, Jackson J. *Western Civilization: Comprehensive Volume*, 5th ed. Belmont, CA: Thomson/Wadsworth, 2003.

Strong, Josiah. *Our Country: Its Possible Future and Its Present Crisis*. New York: Pub. by the Baker & Taylor Co., for the American Home Missionary Society, 1885.

de Tocqueville, Alexis. *Democracy in America*, 2nd ed., trans. Henry Reeve. Cambridge, MA: Sever & Francis, 1863.

Thompson, Hugh Miller. *"Copy." Essays from an Editor's Drawer, on Religion, Literature, and Life*. Hartford, CT: Church Press, M. H. Mallory & Co., 1872.

Trollope, Anthony. *North America*. New York: Harper & Brothers, 1862.

Trusts, Pools, and Corporations, rev. ed. Edited by William Z. Ripley. Boston: Ginn & Co., 1916.

United States Office of Education, *Special Report of the Commissioner of Education on the Condition and Improvement of Public Schools in the District of Columbia*. Washington, DC: Government Printing Office, 1871.

Unto a Good Land: A History of the American People. Edited by David Edwin Harrell Jr. et al. Grand Rapids, MI: William B. Eerdmans, 2005.

Watson, John Fanning. *Annals of Philadelphia and Pennsylvania in the Olden Time*, rev. ed. Philadelphia: E. Thomas, 1857.

Windom, William. *The Northern Pacific Railway: Its Effect Upon the Public Credit, Public Revenues, and the Public Debt*. Washington: Gibson Brothers, Printers, 1869.

Welsch, Roger L. *Mister, You Got Yourself a Horse: Tales of Old-Time Horse Trading*. 1981. Reprint, Lincoln: University of Nebraska Press, 1987.

Index

~

About the Author

Scott Tribble is a freelance writer whose work has appeared in the *St. James Encyclopedia of Popular Culture*, *TIMELINE*, and *The Boston Globe*. He received an A.B. in history from Harvard College and an A.M. in American civilization from Brown University. A native of Boston, Tribble currently lives in Columbus, Ohio.